BLAZING FIGURES

BLAZING FIGURES

A LIFE OF ROBERT MARKLE

J.A. WAINWRIGHT

Wilfrid Laurier University Press

WLU

This book has been published with the help of a grant from the Canadian Federation for the Humanities and Social Sciences, through the Aid to Scholarly Publications Programme, using funds provided by the Social Sciences and Humanities Research Council of Canada. We acknowledge the support of the Canada Council for the Arts for our publishing program. We acknowledge the financial support of the Government of Canada through the Book Publishing Industry Development Program for our publishing activities.

Canada Council Conseil des Arts
for the Arts du Canada

ONTARIO ARTS COUNCIL
CONSEIL DES ARTS DE L'ONTARIO

Library and Archives Canada Cataloguing in Publication

Wainwright, Andrew, 1946–
 Blazing figures : a life of Robert Markle / J.A. Wainwright.

Includes bibliographical references and index.
Issued also in electronic format.

ISBN 978-1-55458-182-5

 1. Markle, Robert, 1936–1990. 2. Painters—Canada—Biography. I. Title.

ND249.M355W33 2010 759.11 C2009-904195-2

ISBN 978-1-55458-210-5
Electronic format.

 1. Markle, Robert, 1936–1990. 2. Painters—Canada—Biography. I. Title.

ND249.M355W33 2010a 759.11 C2009-904196-0

© 2010 Wilfrid Laurier University Press
Waterloo, Ontario, Canada
www.wlupress.wlu.ca

Cover image: *The Beguiling Assault* (detail), by Robert Markle, from the collection of Marlene Markle. Back-cover photo of Robert Markle from Library and Archives, Art Gallery of Ontario. Cover design by David Drummond. Text design by Blakeley Words+Pictures.

Excerpts from Gordon Lightfoot's songs "The Last Time I Saw Her" (page 90), "Canadian Railroad Trilogy" (page 92), and "If You Could Read My Mind" (page 93) used with permission of Alfred Publishing, Van Nuys, Calif.

Excerpts from Murray McLachlan's song "Barroom Ladies and Michaelangelos" (page 129) used with permission of Peermusic Canada Inc., Toronto, Ont.

Every reasonable effort has been made to acquire permission for copyright material used in this text, and to acknowledge all such indebtedness accurately. Any errors and omissions called to the publisher's attention will be corrected in future printings.

Printed in Canada

for Marlene

The dead, when approached closely enough, will always spurn the definitions with which we try to capture them, even if, to us, a definition feels like an embrace rather than a violation.

– Diann Blakely

I always feel the appeasement of the picture comes before the appeasement of myself.

– Robert Markle

CONTENTS

List of Illustrations / ix
Acknowledgements / xi

I
Gesture: July 5, 1990 / 2

II
Indian Blood: Hamilton 1936–1955 / 6

III
Early Figures: Toronto 1955–1960 / 26

IV
The Inner Circle: Toronto 1960–1965 / 50

V
Glory Days: Toronto 1965–1970 / 82

VI
Promised Land: Mount Forest 1970–1978 / 118

VII
Visions of Johanna: Toronto and Mount Forest 1978–1983 / 168

VIII
Meeting Places: Mount Forest 1983–1990 / 196

IX
Afterlife: 1990– / 240

Source Notes / 257
Bibliography / 271
Photograph Acknowledgements / 273
General Index / 275
Index of Works by Robert Markle / 287

LIST OF ILLUSTRATIONS

Untitled (Table Dancer), 1990 / 2

Indian Blood, 1979 / 6

Commemorative plaque: Mohawks at Tyendinaga / 9

Nelson, Bruce, and Minnie / 11

Robert and the Alouettes football team, 1952 / 14

Robert and Marlene, c. 1956 / 17

Robert and Blackie, c. 1945 / 19

Robert in his Delta High School art class, 1953–54 / 23

Untitled Landscape, 1956 / 26

Robert, 1957 / 32

Robert in Hamilton, 1957 / 42

Marlene and Robert on their wedding day, 1958 / 47

Burlesque Series VI, 1963 / 50

Robert astride motorcycle, with painting, Toronto, 1963 / 58

Lovers II, 1963 / 60

On the Runway, 1965 / 62

Publicity poster, Artists' Jazz Band, 1965 / 76

Jazz Lover, 1989 / 82

Michael Sarrazin and Robert, 1971 / 89

Gordon Lightfoot, c. 1971 / 91

The Artists' Jazz Band, 1970 / 108

Cover drawing for *Moving Outward*, 1970 / 114

Marlene: Summer Bronze IV, 1967 / 116

Domesticity I, 1988 / 118

Robert, Nobi, and Gord, early 1970s / 123

Deep Purple Privacy, 1971 / 125

Robert at Maple Leaf Gardens, 1976 / 133

Stephen Williams and Robert at the Mount Forest arena, c. 1976 / 134

Robert on television as Rembrandt, 1974 / 140
Jean Jacket, 1975 / 154
Graham Coughtry, Robert, and Jim Jones on Ibiza, 1978 / 164
Robert and Patrick Watson, Paris, 1978 / 166
Robert with Courbet's *The Painter's Studio*, Paris, 1978 / 167
The Beguiling Assault, 1981 / 168
Edward Grogan, 1981 / 170
The Sound of the Mountain, 1979 / 182
The Brutal Night, 1980 / 184
Robert in the Markleangelo's Cadillac, 1980 / 189
The Glamour Sisters, 1982 / 192
Robert and Av Isaacs, 1982 / 193
Robert on the porch, 1982 / 195
Country Twang, 1989 / 196
Mohawk: Meeting Place, 1984 / 200
Marlene and Robert, Mount Forest, 1985 / 207
Robert's mural for Freiburger's, Mount Forest, 1987 / 211
Class Act II (Buffalo), 1987 / 214
Magritte's Forest, 1987 / 216
Robert with Otis Tamasauskas and Harold Klunder, Priceville, 1987 / 217
Robert in Otis Tamasauskas's studio, 1987 / 219
Creation Whirligig, 1988 / 220
Robert playing sax, near Mount Forest, 1988 / 224
Hanover Hustle, 1988 / 225
Conversation Series (Gordon Rayner), 1988 / 227
A Likeness of Being, 1989 / 230
Robert in the farmhouse studio, 1990 / 231
Robert with the Harley-Davidson, 1989 / 239
Rooms: West Wall, 1990 / 240
Drawing: farmhouse interior, 1990 / 253

ACKNOWLEDGEMENTS

My special thanks to Marlene Markle, who shared with me so much of her remarkable life with Robert, providing facts and insights that would not otherwise have been available.

I am grateful to Robert's sister Susan Maracle, his brother Mitchell Maracle, and his boyhood friends Jack Foster and Ray Hanson for shedding such crucial light on his early life in Hamilton.

Robert had many friends, colleagues, and former students whose love and deep respect were evident as they remembered their time and experiences with him. Their detailed and insightful contributions were vital to the telling of his story: Gordon Rayner, Richard Gorman, Harvey Cowan, Nobuo Kubota, Patrick Watson, Michael Sarrazin, Stephen Williams, Paul Young, Dennis Burton, Michael Snow, Av Isaacs, John Reeves, Gordon Lightfoot, Rae Johnson, Vera Frenkel, Diane Pugen, Tom Hill, Don Obe, Craig Kenny, Tim "Spider" Noonan, Kenny Lehman, Patricia Beatty, Kenny Baldwin, Hanna Trefelt, Ruth Grogan, Murray MacLauchlan, Marty and Helen Poizner, Peter Stollery, Jack Aldersley, Emmett Maddix, Paul Gwartzman, Stephen Centner, Anna Hudson, Dennis Reid, Peter Goddard, Scott Townson, Laura Berman, Sheryl Wanagas, Dawn and Beth Richardson, Jerri Johnson, Lorne Wagman, Kathryn Bemrose, Thomas Hendry, Vaughn Gillson, and Ronald Weihs.

Graham Coughtry passed away in 1999, before I had the chance to speak with him about his thirty-four-year relationship with Robert. But I met Graham in Ibiza in 1970–71, as well as on other occasions in Ontario in Robert's company. Their love for one another was undisguised, and Graham's spirit was undoubtedly part of my creative process as I wrote this biography.

Marlene Markle, Ruth Grogan, Lorne Eedy, Clayton Ruby, and Leo Makrimichalos generously allowed their Markle paintings to be reproduced for inclusion in this book. Thanks to Noel Saltmarsh at See Spot Run Photography. The Art Gallery of Ontario provided reproduction of four Markle works and many of the personal photographs that appear here.

The Tyendinaga Band Administration Office and Chief Donald Maracle supplied important historical information about the Mohawk Territory and genealogical records. Barry Callaghan, who edited and titled Robert's "Blazing Figures" essay in *Exile* (1979), gave his permission to use the title for this book.

Dalhousie University research funds enabled several trips to southern Ontario for research and interview purposes. Art Gallery of Ontario library archivist Amy Marshall Furness made my visits to the gallery archives a true pleasure. Rob Kohlmeier at Wilfrid Laurier University Press perceptively edited the manuscript. Lisa Quinn at the Press gave valuable advice early in the process.

Thanks to those who never knew Robert personally but who supported my research and desire to tell his story with their friendship and hospitality over a five-year period, especially Victor and Tania Li, Carol Ann Goddard, Larry Gaudet and Alison Smith, Ken Sherman.

The understanding and advice of my partner Marjorie Stone made everything possible. I would not have written this book without her constant presence in my life.

BLAZING FIGURES

Untitled (Table Dancer), 1990 (acrylic and coloured inks on canvas, 132.4 × 186.0 cm)

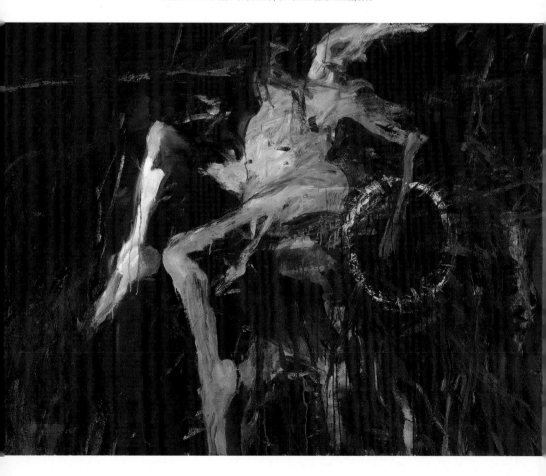

I

GESTURE: JULY 5, 1990

The main street of Mount Forest, Ontario, interrupts Highway 6's smooth run north to Owen Sound with two sets of lights and traffic surprisingly heavy for a small town. Cars and pickup trucks jockey for parking spots outside the Mount Royal Hotel, Freiburger's supermarket, and many other low-rise business establishments. To get to the Markle farmhouse, you turn east onto Sligo Road at the north end of town. The paved road runs straight for two kilometres or so, then takes a long slow curve to the north just before it passes the cemetery, where pines and deciduous growth shadow the gravestones and their many tributes to lives lived locally over the past one hundred and fifty years. Not far beyond the cemetery, the road crosses a short bridge over a shallow tributary of the Saugeen River, and two hundred metres later the pavement gives way to a combination of graded stone and dirt. You keep going for another few kilometres and turn east again onto Concession Road 12. The farmhouse is a minute away.

The previous day had been Marlene Markle's fifty-fourth birthday. She and Robert had celebrated by going to an auction and having dinner at a Mennonite restaurant. The next morning Robert wasn't in a good mood, perhaps due to one of the headaches brought on by his high blood pressure combined with his usual beer consumption of the night before. Marlene went off to her secretarial job at the Main Street office of Ward Mallette, the chartered accountancy firm that had provided her with a steady income over the past eleven years. Sales of Robert's paintings had always been irregular and inseparable from his lifelong habit of working slowly, without deadlines in mind—something for which his constant dealer, Av Isaacs, often chided him. At four o'clock,

3

Marlene walked down the street to the Mount Royal's tavern, where Robert could usually be found in the late afternoon downing brews with members of the UIC Flyers or awaiting friends from the city. One such friend, Stephen Williams—a writer and former advertising executive with J. Walter Thompson, who had bought a farm west of town because of his friendship with Robert—would be delayed in Toronto and never make it to the meeting they'd planned for 7:30 that evening. After a beer with Marlene, Robert told her she should go home to put on the barbecue and that he'd follow shortly. It was a vital pattern in their relationship since their marriage in 1958—the independent artist experiencing life on his own terms but maintaining firm expectations of domestic order, and his supportive wife, also his muse, who rarely questioned this way of things. Part of the pattern included the fact that "shortly" often stretched into hours. So while Marlene prepared the hamburger meat, salad, and french fries, Robert stayed on at the hotel. Later he went over to Doug Kerr's mother's house, on Egremont Street, with Doug and a few others. Robert was very fond of Doug because of their shared love of popular music and, more especially perhaps, because of their shared Native background. He loved their banter that went back and forth about "wagon-burners" when the mostly white drinkers who formed the nucleus of the Flyers, and with whom he'd played hockey and softball for years, started their joshing about Native tax evasion. Doug's mother liked Robert a lot, and before he left for home that night gave him an afghan blanket she'd made that he had greatly admired.

Robert loved speed. He'd owned motorcycles since his teenage years in Hamilton, and in 1969 had nearly died on a bike on Toronto's Don Valley Parkway. He loved to "move, all wine white gleaming chrome and black sixfifty ..." through landscapes of "tilting trees [and] black washes" where "charcoal brush paint paper *see*: hills and deep cuts through softly found summerbronzed flesh and hanging tracks and promises." But he was also, according to his close friend Gordon Rayner, who'd known Robert since his days at the Ontario College of Art, a "most careful driver." This assessment is corroborated by his Flyers buddy Craig Kenny, who emphasizes that Robert was always very aware of what was going on around him on the road. Further testimony to his ability behind the wheel is provided by Marlene, who asserts, "He was a better driver when he'd been drinking than I was sober." He had to be, because Robert often drove under the influence, and his drinking had probably been a factor in the 1969 accident as well as his later excursions into the ditches alongside Sligo Road. At fifty-three, however, he didn't ride bikes much anymore, and after drinking sessions

he usually obeyed the speed limits along the country roads. Unfortunately, he rarely wore the seatbelt in his maroon Ford pickup.

It was 10 p.m. and the moon was almost full in the clear sky as Robert drove the truck over the Saugeen tributary bridge. He was wearing his green Red Man Chewing Tobacco cap and ever-present black T-shirt and blue denim jacket. The $1.25 in change in his pocket was all that was left from the Mount Royal festivities. It's impossible to know how drowsy he was with a blood–alcohol concentration of 198 mg/100 mL, more than twice the legal limit, but it is evident, despite his driving skills, that his response to any sudden demand would be slowed.

Ahead and off to Robert's left, moving east on a sideroad toward him, a young man named Kevin Horsburgh saw the pickup coming and correctly judged he had enough time to turn his tractor north onto Sligo Road and pull over to the right so the truck could safely pass. Indeed, a full ten seconds elapsed between the time Horsburgh started to turn and the moment Robert hit his brakes in a last-moment effort to avoid a crash. Maybe he had dozed off. Maybe he was gazing at the moon's luminous possession of the sky like a perfectly realized brush stroke on a darkened canvas. Wide awake and looking straight ahead, even with only his low beams on, Robert could not have failed to see the white lights on the rear of the tractor, the amber lights flashing at roof level, and the one working red tail light atop the left rear fender. But he made no effort to steer around Kevin Horsburgh. A six-metre skid mark ended at the point of impact, where the truck's right front corner smashed into the tractor's right rear tire at eighty kilometres an hour.

Robert, without seatbelt, launched forward, the dashboard on both sides of the steering column shattering with his knees' forceful blow, his torso slamming against the steering wheel, its deformed circle leaving deep impression marks on his abdomen, the right atrium of his heart rupturing along with the left anterior ventricular wall and the periocardial sac on his left side. The police report stated impassively, "There was also a spiderweb pattern of cracks in the windshield directly in front of the driver's position … the result of driver impact." The violent collisions that had already occurred would strongly suggest Robert was dead before he touched the glass, but it is perhaps more fitting to imagine that the figure painter's final gesture was to mark a clean, framed space with the lines of his own body.

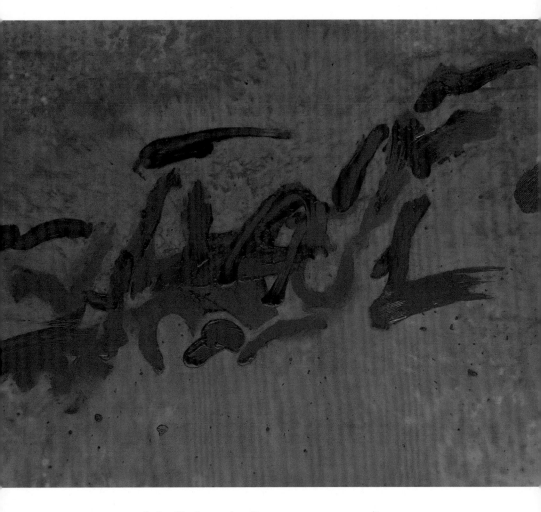

Indian Blood, 1979 (acrylic on canvas, 120 × 150 cm)

II
INDIAN BLOOD: HAMILTON 1936–1955

Tyendinaga Mohawk Territory sits on the shore of Lake Ontario's Bay of Quinte just east of Belleville, Ontario. By the lake is a stone cairn that serves as a memorial to those Mohawks who arrived to take up land claims on May 22, 1784. Captain John Deserontyon and about twenty Native families had been loyal to the British Crown during the American Revolution, and the land had been promised to them as a reward for their service and as compensation for their losses. Chief Joseph Brant, who had led the Native Loyalists against the American colonists, had reminded the British of what they owed, and the Tyendinaga land was part of a grant whose largest sector was an area extending ten kilometres on either side of the Grand River in southwestern Ontario that became known as the Six Nations Reserve. In English, Tyendinaga means "placing the wood together," but it is derived from "Thayendanegea," the Mohawk name of Joseph Brant.

The tract of Tyendinaga was formalized on April 1, 1793, when Governor John Graves Simcoe granted the Mohawks over 36,400 hectares, the approximate size of a township. Because the Natives were not allowed to own this land or to sell it without the governor's permission, consistent non-Native takeovers reduced the grant area by the mid-twentieth century to about 7,300 hectares (about five by eighteen kilometres), making the reserve the sixth largest in Canada. The twenty original families had grown to over two thousand residents, with several thousand more band members living outside the territory.

Nelson Maracle was one of those reserve residents, born in Shannonville in 1852. He was a gardener when he met another Mohawk, Susan Leween, and married her in September of 1893. As a young and articulate man

in November 1877, Nelson wrote a letter to his Member of Parliament in which he made his case for a land claim within the reserve:

> In the year 1872 I was allotted the South West quarter of lot number five in the second concession of the township of Tyendinaga, Mohawk Reserves. In the year of 1873 I sold my land to Michael Claus for a team of horses which was worth about $150.00. In February '75 he leased the place for five years for a rental of fifty four dollars a year—Claus has another farm viz: lot no. 26 west part 2 Concession for which he receives a rental of $90.00. I wish to get my place back again as I have no land at all. I think Claus is already paid for the team I got from him and ought to give up my land. I would ask your assistance in the matter. I have spoken to the councilors on the subject and they are willing for me to get back my land[;] hoping you will instruct them to act in the matter and you will greatly oblige
>
> Yours truly
> Nelson Maricle [*sic*]

Despite the rather curious nature of this claim, Nelson was supported in a letter by the Tyendinaga Indian Lands agent, Matthew Hill, who wrote to the Minister of the Interior in Ottawa, "At the time he parted with the land he was young and did not appreciate the value of it." Although no record can be found to reveal the outcome of the issue, another official recommended that Nelson be allowed to repay Michael Claus the original purchase price and repossess the land.

Nelson and Susan's only son, Bruce, was born at Tyendinaga on November 29, 1897, and spent his boyhood there with his three sisters before moving to Hamilton in his teens. Like many of his Native peers, Bruce became an ironworker. In the year that Nelson made his land claim, Amelia Claus, who might have been directly related to Michael, was born. She became a cook and schoolteacher and met a farmer, George Clute, who leased land on the reserve. Clute's Mohawk ancestry is not certain, nor is it certain that he and Amelia married. They did have three children, however, the youngest of whom, Kathleen, was born a leap-year baby on February 29, 1904. The family moved to Hamilton when Kathleen was young, but she didn't stay long in the city and returned to Tyendinaga, where she was raised for a while by her maternal grandmother. Kathleen and Bruce met briefly there when she was a girl, but it

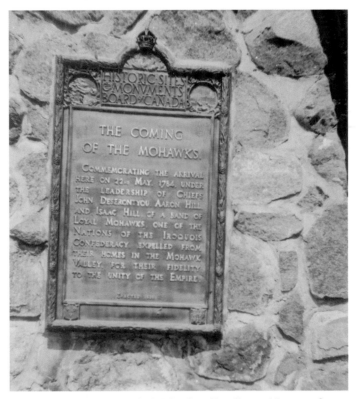

Plaque citing the arrival of Mohawks at Tyendinaga, May 22, 1784

wasn't until later, when Kathleen was a young teen and in Hamilton, that their relationship was established. Amelia had rented a room in her house to Bruce, and he would wait at Kathleen's school to walk her home after classes. Eventually Bruce gave her an engagement ring, a rare practice in Native circles, and they were married in an Anglican church in Buffalo, New York, where Bruce was then working. Their first house in Hamilton was on Balmoral Avenue, near Gage Park in the central part of the city. Their first child, Lois, was born in Buffalo in October 1929, followed by Mitchell on Balmoral Avenue in September 1932. Robert Nelson Maracle appeared on August 25, 1936, in Hamilton General Hospital. Four years later, in September 1940, the youngest child, Susan, was born at home. Balmoral Avenue was as far back as Robert could go for family memories. About his Native past and the ongoing Mohawk struggle for justice he knew very little for many years.

The Iroquois had been joined in a confederacy of nations under the Great Law of Peace since at least 1570—some say since 900 CE. They

had united because of ongoing internal conflict more than from threats from other tribes such as the Adirondacks. Iroquois lore has it that a Huron holy man, Deganawida (Two River Currents Flowing Together), was responsible, along with Hiawatha (a different figure from the chief in Longfellow's famous poem), for convincing the nations to give up their self-destructiveness and unite. Legend has it that the Huron village in which Deganawida was born was on the site of what became Tyendinaga. "The central symbol for the Great Law is a tall white pine known as the Tree of peace.... The roots symbolize the three main principles of Iroquois life: soundness of mind and body, justice and law for everyone equally, and military power to ensure self-defence and to enforce justice."

At the beginning of the eighteenth century, a group of Caughnawaga Mohawks, having made peace with the French, pushed north out of present-day New York State, where Dutch and English settlement was increasing. They settled at Kanesatake, on territory they believed had been set aside for them on the shores of the Lake of Two Mountains, which is part of the delta widening of the Ottawa River where it empties into the St. Lawrence. In reality this land was part of a grant made by the French king to the Sulpicians, a missionary order in New France. Following the English defeat of the French in the Seven Years War, the Royal Proclamation of 1763 gave protection to Native peoples on the land they occupied. The Mohawks took such protection to mean ownership. The difference on this issue between the Mohawks and non-Natives created hostilities that have lasted for two hundred and fifty years.

The Mohawks at Kanesatake and the sister territory of Kahnawake, south of Montreal, fought the Sulpicians, the British Privy Council, and the Canadian and Quebec governments over the selling off of land in the two communities, over the imposition of the federal Indian Act in 1876 that was designed to assimilate Native peoples and to allow the federal government to determine who was to be designated as an Indian, over the mid-1950s construction of the St. Lawrence Seaway through essentially appropriated sections of Kahnawake territory, over the underpriced purchase of part of Kanesatake called the Commons for the building of a golf course in 1959, and in armed struggle against police and army units that were sent to quell unrest. These Mohawk struggles were part of a Canada-wide Native resistance to the rejection of land claims that were, until recently, continually spurned by the federal government and by courts that declared the claims had no legal basis. In 1959, Six Nations traditionalists attempted to seize control of that reserve and declare it separate from the rest of Canada, and the RCMP were sent in to evict

Nelson, Bruce, and Bruce's younger sister Minnie, circa 1930

various chiefs and clan mothers. Since then, despite headline-grabbing settlements such as the one the Nisga'a reached in British Columbia in 1996 and the Inuit achieved in 1999 that resulted in the formation of Nunavut, overall progress has been very slow. At the present rate of negotiations it will take one hundred and thirty years to resolve the over eight hundred outstanding claims.

In addition, the Mohawks and other Native peoples virulently opposed the pernicious residential school system that took Native children from their parents and family structures beginning in the 1830s and through most of the twentieth century (the last school did not close until 1996), as well as government policies and agreements such as those inherent in the Meech Lake constitutional accord that spoke of Canada's "two founding races" with no mention whatever of aboriginal peoples. An Ojibway–Cree member of the Legislative Assembly of Manitoba, Elijah Harper, voted

against the Accord in the spring of 1990 and prevented the legislature from achieving the unanimous consent necessary for the agreement to become law. For the Mohawks, matters came to a head that same spring and summer. They organized armed "warrior" opposition to further appropriation of the Kanesatake Commons land in a seventy-three-day standoff known as the Oka Crisis, named after the nearby Quebec town. In solidarity their Kahnawake allies seized the Mercier Bridge over the St. Lawrence for the second time in twenty-two years. Violence erupted on July 11, six days after Robert's death. The Quebec Provincial Police were replaced at the two sites by several thousand Canadian Army troops, and national and international attention was focused on the situation.

Over the last decade of his life, Robert schooled himself about his Native ancestry and produced works of art that represented his knowledge of Mohawk symbolism and traditional narrative. Had he lived, his colleague Diane Pugen feels, he would have been radicalized by Oka, and events there and elsewhere—such as at Ipperwash Provincial Park, Ontario, where in 1995 members of the Ojibway Stoney Point Reserve mounted a protest in a land dispute—would have further shaped his creative expression in his increasingly expanded recognition of who he was and where he had come from. It is difficult to believe, were Robert alive today, that he would not be somehow involved in the struggle at Tyendinaga over land claims that has seen Mohawks blockading national railway lines between Toronto and Montreal. The main issue for the reserve inhabitants is the annual removal of tens of thousands of tonnes of gravel from a quarry that is on land never ceded by the Bay of Quinte band. This removal has continued during negotiations for compensation and while "toxic junk" is dumped at the edge of the gravel pit. The combination of Native rights and environmental degradation on his ancestral homeland would be difficult for Robert to ignore. In the 1980s "he had many ideas for [a] television series on saving the planet," and in June 1990, when a friend suggested they drive to Oka and take supplies to the Mohawks, Robert replied with absolute seriousness, "We could get a helicopter." It was clear, his friend says, that "he really felt his people were up against it."

In the early days of the Second World War the Maracle family moved to 299 Adeline Avenue. The house sat on the corner of Barton Street in the city's Parkdale area, a neat white dwelling with black trim that was called a Large 6, in reference to its six rooms plus main-floor bathroom. The stairs began just inside the front door, and on the other side of the hall

was the living room with its oil stove and the kitchen behind. Off the kitchen were two bedrooms, one of which was for Bruce and Kathleen. The other served as Kathleen's sewing room, where she made the open-collared shirts that Robert liked so much and clothes for the other children. Upstairs, Lois and Susan shared a bedroom until Lois moved out in the late 1940s; Mitchell and Robert's room was on the northeast corner of the house overlooking Mahoney Park (Mitchell left to work as an ironworker with his father when Robert was still in public school). Robert's later description of the move to Adeline Avenue from Balmoral Avenue wasn't positive: "During the war, my father then still alive, we moved from central Hamilton, a small city, smoke air, fully dependent on the steel factories crowding the bay shore, its sludge reeking of industry, the centre of this town down to a war time housing project, pre-fab wood slat up in a jiffy, accommodations mired in muck and unmade sidewalks, the east end, new neighbours, new schools, new friends ... and we waited around to grow up." But he got used to the new place quickly and made two close friends in Jack Foster, who lived around the corner on Ivon Avenue, and Ray Hanson, who was two blocks away on Julian Avenue. With other boys they played endless games of lacrosse, football, and hockey, depending on the season, in the park across the road.

The neighbourhood was working-class, mainly white, with many of the residents working at Dofasco or Dominion Steel. Mitchell remembers there being one black family in the east end, while Susan recalls a single Italian family moving into Parkdale. However, Jack Foster, who had to deal with his own father's racial biases, insists that he grew up, just around the corner from Robert, "in a diverse community" that gradually filled with persons displaced by the war. There were other Native families in Hamilton, including the family of Kathleen's older brother Bert, but issues of race and ethnicity weren't topics of conversation in the Markle household. Such avoidance of what was sometimes the harsh reality of Canadian racism was revealed in Kathleen's decision to change the family name from Maracle to Markle, at least as far as daily usage was concerned. Though the children's name remained as Maracle on their birth certificates, she evidently felt it wasn't a particularly good thing for them to be perceived as Native. Mitchell believes his mother didn't know about government benefits for Natives that would have helped the family with housing and education, but Susan insists that Kathleen was aware of funds for Natives and rejected the idea. For his part, Bruce wasn't happy with the name change and at work was always known as Bruce Maracle, but he usually went along with what Kathleen wanted, including the purchase of

Robert (fourth from right, back row) as a member of the Alouettes football team, 1952

the housing project dwelling that she applied for as any non-Native would have done. Family background and Mohawk heritage were not discussed with the children.

Mitchell didn't know any Natives outside the family until he went to work with his father and discovered that seventy-five per cent of the iron-working crew was Mohawk. He and Susan both describe their public school experience, several years apart, when they, along with their class-mates, were asked about their national backgrounds. Everyone, according to their teachers, had ancestors who had come from somewhere else. Confused by the question, brother and sister replied they were Canadian. This wasn't good enough for the teachers, but it was certainly good enough for Kathleen, who insisted who or what they were, apart from being Canadian, was none of the school's business.

The reasons for Kathleen's unwavering attitude are open to debate, but when her children were young, in the 1930s and '40s, she would have been aware of government control over Native identity, of the laws against self-governance, citizenship, and voting, and she would have known that Natives were unable to leave their reserves without official permission. She also knew that thousands of Native children were enrolled in residential schools across Canada. In fact, in the 1940s "about 8,000 Indian children—half the Indian student population"—were in these schools, and their enforced attendance wouldn't change in some

cases for several decades. She would have had some sense, given her own reserve experience, that the numbers of violent deaths, suicides, and jailed Natives were stunningly high, and that on and off the reserves the high-school completion rate for Native students was dramatically lower than that of their white counterparts. Perhaps one of the most important factors in Kathleen's decision to raise her children without reference to their Mohawk heritage was that more than half the Native population in Canada was receiving social assistance of one form or another. She and Bruce had achieved an economic independence she was proud of, and it is likely she did not want their achievement measured or contextualized by any racially based standard. Her children were to be given every chance in life without impediments thrown up by individual or collective discrimination. If the government didn't recognize them as Canadian citizens, she made them so.

Outside of school, there were more direct ways for the Maracle/Markle children to encounter their racial heritage with the prejudices of others, and it seems that Robert met them in Mahoney Park. Jack Foster describes watching Robert play lacrosse by himself in the park at the age of ten or eleven, throwing the ball against a building wall and catching it skilfully with his webbed stick. Some strange boys came along and made disparaging remarks about Indians and their connection to the game. Jack was surprised—he and Robert had never spoken of such things—but he could see that Robert was hurt by what had been said. Robert himself wrote revealingly about what he called "the red apocalypse" that occurred a few years later:

> The first rush hit during a happy conversation with a few
> boys from old delta high in the setting red light of a steel
> town sunset Saturday, after four furious hours running
> hard through sand and the sweatstained silt of the lacrosse
> arena midtown, scrambled and fought, our sticks carving
> arcs through that Hamilton dust, we chased that ball *i chased*
> *that ball* and i made that team, i had my sweater and couldn't
> wait to tell the gang and later, later in the light of the flames
> of dofasco did tell them. they said they figured I would. no
> wonder....
>
> what the hell was all that about?
>
> but i was too busy growing up to grind out that kind of crap,
> and my life was too full to listen for those kinds of signs.

> i was on that team and when we went into the brantford
> reserve to play those guys i wept only for my side.

In 1985 Robert would journey to Tyendinaga to obtain his Native status card, his perceptions of "sides," especially those to do with "artist" versus "*Native* artist," complicated by his feeling good because he could see, and for the first time proudly wear, the features of those who "looked like me." In Hamilton, meanwhile, he lived at a distance from his heritage: "i really [knew] nothing of bountiful harvests and streams swollen with fish, no more than anyone else.... i did know then not to fuck up the landscape ... to *care* for your environment, to wish it well. this to me was merely good manners.... i spent time in my youth playing cowboys and Indians and having a great time. terrific time. i won as many games as I lost. ray hanson taught me archery.... his father was a champion, he would tell us tales of deerhunting, one true arrow at fifty yards. he made me a bow, gave me arrows. i was good at that."

The house at 299 Adeline was a haven of love and self-respect. Bruce and Kathleen had a shared sense of humour, and were not overly strict, but there were certain house rules: swearing wasn't allowed, nor was the command "Shut up," and family members were never to yell at one another. Dinner was always ready at a certain hour, and if you weren't there you didn't eat unless you had a very good excuse. Dark was curfew time, and the children were expected to look after one another, the older ones making sure the younger were all right. Since Lois and Mitchell had left home by the time Susan was seven or eight, it was Robert's duty to watch over her. She followed him everywhere, whether he wanted her to or not. He liked to read to her, and she used this to get him to take her with him to the park or elsewhere, saying she wouldn't listen to his stories if he left her behind. They also listened to their favourite radio programs together, shows like *The Lone Ranger* and *Inner Sanctum.* On Friday nights Kathleen would give them 25 cents and send them off to the store for bulk ice cream, mostly vanilla. On weekends they could go to the Normanhurst Community Centre, down Barton Street, established in part through a loan from Bruce. Movies were shown there on Saturday afternoons, sports figures gave talks, and lessons were given in such things as tap dancing and painting.

Mitchell and Susan emphasize that there were always books at home, and Jack Foster remembers Churchill's memoirs and a biography of Rembrandt lying around the Markle house. This was Kathleen's influence, said Mitchell, and for most of his life Robert had a book close at

Robert and Marlene, circa 1956

hand. Music was important, too. Kathleen liked listening to classical music on the radio, and Bruce played a little fiddle and could tap dance, though he didn't take himself seriously in either activity. Robert took violin lessons for a while when he was in public school and played the harmonica. He and Jack would sit together on the Adeline Avenue stairwell and sing popular songs like "Nature Boy," which had been recorded first by Nat King Cole and later by Frank Sinatra and Sarah Vaughan. It had gained an even wider audience as part of the soundtrack of a 1948 film titled *The Boy with Green Hair*, directed by Joseph Losey, which Robert and Jack would see.

Kathleen was known for her culinary skills and made sure her children were well fed, including Robert, who was "a very skinny child too weak to do this or that." At the age of eight he wasn't even a metre and a half tall and didn't weigh more than twenty-two kilos, though he was not sickly and seldom missed a day of school. It was at Christmastime that his

mother surpassed herself in the kitchen and in decorating the house, creating delightful memories of the special day for her two sons especially. Mitchell describes her being up all night and providing "amazing" chicken and dumplings for breakfast, cookies and cakes for snacks, and ham and turkey for supper. "She would start getting ready for Christmas in September," he said. Adeline Avenue was the acknowledged centre for the family celebration, as Uncle Bert came over with his three children, along with other relatives. The effect on Robert was powerful, and as a Christmas present in 1967 he would write a memoir of tribute and longing for his mother that would be published years later in *Toronto Life* magazine under the title "In the Heart of the Heart of Christmas."

> Even now I wonder how my mother did it all. Everything was beautiful. The good dining-room table was covered with lace that was older than I was, a table set with grace and charm. Shining silver, long tapered candles, a centerpiece of holly.... Rich red cloth napkins startling against the fine china. In the kitchen we could see the warm glow of great things simmering, filling the house this crisp good morning with smells of wonder.... The *luxury* of a cloth napkin tucked into the neck of my shirt and my hair combed for dinner. It was here that I learned ritual and excellence; at my mother's Christmas table I understood family and a celebration of family rites that would color and shape the meaning of all the important events of my future. Christmas dinner was a time selfishly our own, rich in tradition, richer in warmth, a meal of such sharp focus that it explained everything.... Our Christmas was the beginning of the ongoing spark of family, and it was placed properly within us by our mother on those days when we understood continuity but not change, when life was surely simpler, and absolutely right.

This rightness and sense of security were present from Robert's first schooldays, in grades 1–4 at Fairfield School on Barton Street, and they continued through his days in grades 5–8 at Ballard School, farther away, near Kenilworth and Main Streets. He, Jack, and Ray Hanson would pay fifteen cents to watch *Hopalong Cassidy* at the Kenilworth Cinema. In hot weather they'd follow the pipeline beyond the Parkdale Lumber Company, cross the railway tracks, and take the path to van Wagoner's Beach, where they'd swim in the as-yet-unpolluted Hamilton Bay and lie

Robert with the first Blackie, circa 1945

around on the stony strand talking about the fortunes of the Hamilton Tiger Cats football club and what they wanted to do when they grew up. In the winter, they'd play pickup hockey on the Mahoney Park ice rink, but they had their most fun on the street with hockey sticks and a tennis ball or rubber ball that was often stolen by one in the seemingly endless line of Markle spaniels named Blackie. The children had chores to do after school such as getting the ashes off the coal in the furnace and bringing in new coal from the bin. As other kids did, they shovelled snow and cut the lawn and had part-time jobs like Robert's paper route for *The Hamilton Spectator*. It was a good, secure life that for half of the 1940s was connected to the community involvement in the war effort. There were scrap metal drives and paper collections to raise funds to support the troops. The steel factories were booming with armament production, and the textile mills supplied uniforms and other apparel. Meanwhile, Bruce was making good money building bridges and other superstructures in the U.S.

Mohawks had been employed as ironworkers since the last decades of the nineteenth century. For those who want to see it, there is an apparent and possibly unsettling mythic context for high-steel reality in the Mohawk creation story in which a Sky Dweller falls to earth and becomes the first terrestrial being. But history is more harsh and mundane. In the 1860s, when the Victoria Bridge was erected across the St. Lawrence River twelve kilometres downstream from Kahnawake, Mohawks were hired to convey stone to the site; and when the CPR began building a new bridge even closer to Mohawk land twenty years later, the Natives showed such ability on the trestles and spans that three riveting gangs were hired by Dominion Bridge. It was, said one company official, "like putting ham with eggs." That the violence was not containable in such a comforting domestic metaphor became evident on August 29, 1907, with the collapse of the unfinished Quebec Bridge and the death of seventy-five men, thirty-three of whom were Mohawks. That figure represented almost half of the seventy adult males from Kahnawake who worked in high steel that summer. Rather than deter the Mohawks, the incident seems to have inspired them. By 1915, 587 out of 651 adult males in Kahnawake were members of the structural steel union, and in the 1920s and '30s they and other Mohawks began to migrate to New York State and in particular to Manhattan, where the skyscraper-building boom was in full swing. In 1927 a U.S. federal court ruled that the Mohawks could pass freely over the international border, citing the Jay Treaty of Amity, Commerce and Navigation in 1794, which confirmed the right of aboriginal people to trade and travel between the U.S. and Canada.

Non-Natives began to formulate their own myths about Mohawk fearlessness and agility high above rivers and city streets. Some insisted on a genetic explanation, while others spoke of a warrior code that was somewhat akin to Hollywood portrayals of stoic Indians who never blinked in the face of death. A more likely reason for such ready participation in a dangerous trade is that Mohawks and other Native peoples had few economic and professional opportunities in a prejudiced world, and ironworkers could make a great deal of money. Ironically, they were doing a job that most whites didn't want, much like those demeaning service tasks for the downtrodden that remained out of sight and out of mind to the privileged. Since high-steel work was very visible, and at the core of industrial advance in the twentieth century, only cultural essentialism could keep the Natives in what many whites saw as their proper place.

According to Mitchell Maracle, his father worked all over North America at the height of the Depression and was home only once or twice a month

or, if the job wasn't too far from Hamilton, on weekends. When Mitchell quit high school, at the age of fourteen, Bruce gave him ten days to find a job and then hired him to carry water in a dipper to his own crew. Mitchell soon graduated to girder work and another crew, and his visits home became irregular as well. Susan Maracle attests that Bruce was a superintendent of construction on the Peace Bridge, between Fort Erie and Buffalo, which opened in 1927, and could remember lost plans in his head. There is no record of Robert's boyhood thoughts and feelings about his father, but later in life he provided a memorable reflection on Bruce's experience, paying poetic tribute to what he clearly saw as a kind of artistry: "my father used to tap dance hundreds of feet in the air, on girders of steel smaller than the length of his boot, dance and shuffle, pure joy (high) in his eyes." He also imagines Bruce or his brother falling: "during his fall he hallucinates, a man caught in cable and steel, torn at the arm, shower of red, the iron cable stops, he continues, falls out of the shower to rough planks, steel reinforcing rods, and sand, a powder death." More important at the time was his pride in Bruce's ability and reputation: "innovations in steel construction were being made in the states. the border didn't exist for my father, he was down there when it was all happening. occasionally he would be asked to work at home in Hamilton. because he would know the craft of special problems. you can hear a cello being plucked in the gage park bandshell from quite a ways off. the soft clarinet passages of a military march. my father worked on the bandshell in gage park. one of the first to be built. i like the idea of that." When his father did come home after two or three weeks of travel, bringing presents from the States, "it would be like Christmas." He did not fall from high steel, but when Bruce Maracle died, in October 1948, his family's situation changed irrevocably.

That autumn Bruce was working twelve hours a day seven days a week in Buffalo, living alone in a rooming house or hotel, and too busy to visit Hamilton. One night he went to sleep with a cigarette in his hand and set his bed on fire. He died of asphyxiation just short of his fifty-first birthday. Susan remembers a policeman coming to the front door with the news as she and her mother were making grape jam in the kitchen. When adult relatives appeared to console Kathleen, Robert held Susan's hand and told her he'd take care of her. His own sense of loss is revealed in the ending to the "red apocalypse" passage about lacrosse: "you know, my father wasn't there for my great moment when norm marshall announced to the spectators and the fans at home that the goal was scored by Markle.... no, my father left me in that blaze of orange only hotel fires in buffalo have,

smoke that left me ranting, with my arms around my sister (he never really left my sister). This was all earlier. I was alone in that Hamilton dust … goal by markle …"

Both Mitchell and Susan emphasize that Bruce might not have tolerated Robert's artistic aspirations and erotic pursuits had he been around as the budding artist matured through his teens. But if Bruce's death freed Robert to pursue his own desires and to display his own talents, his father's absence was at the heart of his subsequent teenage experience: "fathers die. kids chase and call us injun and savage, the time goes by, memories and death, for and against … summers into baseball games on silent east end streets, summers away, trying to make do, fatherless, fun times, all the joys of not knowing, time creeping up, football with the inevitable girls down all the streets in the world, touch football and always hitting them (gently) in their young just about now breasts …"

The family closed ranks to deal with the loss and the financial burden. As the youngest two, Robert and Susan were given special attention in the aftermath of their father's demise. Years later, Robert wrote about the great deal of caring that he got from Mitchell, and the hours Lois's boyfriend and future husband, professional hockey player Steve Kraftcheck, spent reading to him and his sister—"uncle remus stories with perfect accents. we demanded that: *she's gwinna git yo brer rabbit!*" Bruce left no pension but some life insurance. His drinking companions at the Kenilworth Pub offered to pay his tab, but Kathleen did so instead. She took on work as a seamstress, Lois and Steve contributed to the household income, Mitchell sent money home, and Robert's part-time jobs added a few more dollars. For a while he worked as a clerk at Cicero's grocery store on Parkdale Avenue, where in addition to his regular duties he made signs to advertise specials in the store window. Jack Foster recalls Robert working as an usher at the Rio Theatre on Parkdale and letting his friends into Saturday matinees for free. The ushers, of course, got to watch the movies themselves, comedies like *At War with the Army*, with Dean Martin and Jerry Lewis, and science fiction dramas such as *The Day the Earth Stood Still* and *Destination Moon*. After seeing one of these dramas, Jack says, "We'd stare at the sky and talk about possibilities."

Jack also says Robert began to show artistic ability at Ballard Public School and that the art teacher, Mr. Cudmore, recognized this. Susan recalls Kathleen taking her and Robert to the Hamilton Art Gallery when Robert was about twelve. Susan was bored, but Robert stood transfixed by a painting and announced, "Someday I'm going to paint like that." Shortly before his death he told a newspaper reporter of his memory of himself

Robert (extreme left) in his Delta High School art class,
in a newspaper photo of 1953–54

and his boyhood friends playing with a rubber-stamp kit: "He was unable to acquire the stamp (which made animal prints) from his playmates, so he decided to draw designs on his own." It was in his teens, however, as a student at Delta High School on Main Street East, which he entered in the fall of 1950, that his talent became obvious. Dan Logan, the art teacher, could see he was gifted, something Ray Hanson experienced first-hand. Ray remembers that Robert was always drawing, and one day when they were sitting at the Markle kitchen table he sketched all the dents and ridges in the ashcan by his back shed, something he would emulate decades later in a Mount Forest sketchbook of domestic items. He and Ray made comic books together. Ray would draw the frame and Robert would fill it in with pictures. Ray insists that Robert "was different from the rest of us because he was so darn talented with his drawing." This difference began to manifest itself despite a high-school environment that, twenty-five years later, Robert felt had held back anyone with "original thought and some vestige of individuality." He grew his hair longer and withdrew from constant street and park games with other boys. Even so, the Delta High School magazine stated in 1955 (his last year of high school) that Robert had been awarded the Howard Williams Gold Ring for Art.

Encouraged by a friend of Kathleen who taught art at the Normanhurst Community Centre and who would later aid in his application for an IODE

entrance scholarship to the Ontario College of Art, he took lessons on Saturdays from a woman on Ottawa Street. Whatever financial priorities there may have been in the house, his mother appeared determined to encourage his aptitude. None of this, however, predicts Robert's remarkable turn towards creative expression in a variety of forms and the growing vision of drawing, jazz, and strippers on a single canvas in his mind. As if anticipating the studio seclusion of his future, he purposefully indulged this vision when he was alone, away from family and friends.

With Jack and Ray he was doing ordinary adolescent things—talking and fantasizing about girls with reputations, watching Brando in *The Wild One* and buying a motorbike to cruise up and down the city streets, getting hooked on pool and playing for hours in a parlour opposite the Kenilworth Hotel. Robert couldn't afford the bike and had to return it when he couldn't keep up with the payments, but not before he sped away from a stop sign so quickly that Ray Hanson, his passenger, fell off and lost his pants after catching them on the frame. At sixteen, though, Robert could afford a Harley 74, and in Buffalo, just a ninety-minute ride away, he discovered the women and music that combined to yield his "first foray into full space. Space itching to leave a mark. My mark."

> Sixteen years of age (I lied!) and sipping stars. This was the
> time of Dakota Staton, the Red Prysock band, and Jimmy
> Smith and the driving blues of black America, Race Music.
> The Hound, turn around ... Ray Charles. *I've Got a Woman.*
> Tenor Sax. Black crowds moving, sweat, glistening shadow.
> Reginald Marsh in the steamy summer nights of black
> Buffalo. The Stage Door, strippers so close you could smell
> them. Memory as smell. Little whiffs. Is there a tube of paint
> that contains that?

At the Palace Burlesque, Robert saw Lily St. Cyr and Rose LaRose and was held for the rest of his life by the "beads of sweat forming in the purple light blush of a statuous inner thigh." He bought a record by Charlie Parker, who hadn't long to live, and in Rochester went to see John Coltrane, who had twelve years more. He was light-years beyond Hamilton, and boyhood was receding fast: "the music came at me relentlessly, Coltrane pushed everything he knew through that reed, and the music ran into time and space and the smokey haze of the Rochester night. He played enormously long sets, hours, with the band building. It was exhausting, exhilarating, incredibly dangerous music, it ran everywhere, changing, I remember

reaching for it, knowing instinctively that I had to make it mine." Then Robert learned something from Coltrane that stayed with him his entire career. On the way to the washroom between sets, he found the musician in a little room, standing "with his face to the far wall, hunched over his soprano saxophone, running through scales, *practicing!*" Those who would later complain that Robert could have produced much more work than he did never saw the 6:1 ratio of paintings and drawings he destroyed to those he kept. The recurrence of marks on paper and canvas was his equivalent of Coltrane's scales.

But the jazz artist was an influence, not a muse, and certainly not the *proactive* muse who dominated Robert's painterly vision. In a description of one Buffalo stripper he remembered over twenty years later, Robert captured the essence of his relationship with those he transformed into expressionist figures and who with even greater power transformed him:

> One night in the dark spice of the Palace Burlesque the
> girls came and went. But the parade shifted radically into
> another reality. One girl, tall, lithe, incredibly white in the
> stage glare, she wore layers and layers of silk and she was
> constantly peeling away those whisps of clothing, baring
> more and more, forming herself in the languorous dance.
> She finished with feathers gently spilling from her breasts,
> and she danced to the music of a tenor saxophone player just
> out of the spotlight. That's all. The pit was silent. That player
> wrapped her with his whisperings, they were lovers, and he
> was the only man I envied. *Could I use you for awhile?*

The final italicized question is not only the painter's but the dancer's as well. His suggests a controlling view of the *artist's model* who needs his brush to become more than she is. Hers arises from her established sense of self as an *artist model* moving, quite apart from his attempted possession of her, before his palette eyes.

As Mitchell says, "He didn't want to just paint signs, so he was going to go to [art school] regardless" of obstacles. The money came from Kathleen, Mitchell, Lois and Steve, Robert himself, and the IODE entrance scholarship. In September 1955 he moved to Toronto and entered the Ontario College of Art.

Untitled Landscape, 1956 (oil on masonite, 30 × 40 cm)

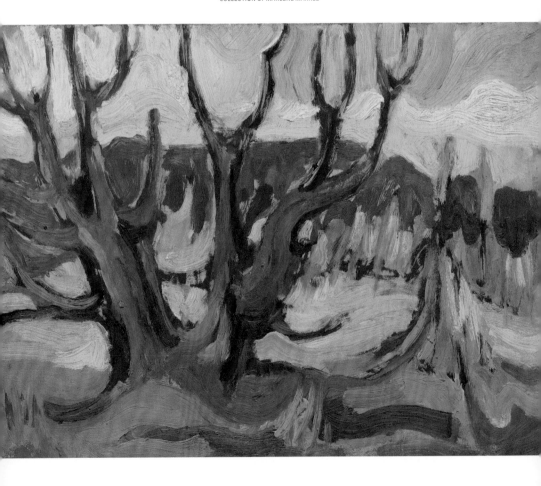

III

EARLY FIGURES: TORONTO 1955–1960

Robert's Toronto experience between 1955 and 1957, his first two years at OCA, consisted of two major components: college life, and the Toronto art scene and the figures who inhabited it. They were not, of course, mutually exclusive.

The Ontario School of Art, established by the Ontario Society of Artists in 1876, was incorporated as the Ontario College of Art in 1912. By the mid-1950s it was one of only four art (and design) colleges in Canada, and the only one between British Columbia and Nova Scotia. Hence, it could draw on the many established artists based in central Canada for its faculty. Arthur Lismer was vice-principal in 1919, and J.E.H. MacDonald began to teach there in 1922 and later became principal. But, as the only school in the middle of a very long national block, OCA provided a rather traditional curriculum and, with one or two notable exceptions, teachers were out of touch with the contemporary art world and its avant-garde precursors.

Dennis Burton, who graduated at the end of Robert's first year and went on to achieve major status as a painter, is the most outspoken critic of those who ran the classrooms. Although he was excited and challenged to be at art school, "the teachers were a problem because they were all disappointed, unhappy Canadian painters ... who weren't sympathetic to the new art world and didn't read art magazines." In the OCA library, Burton looked at books on Miró, Picasso, and American abstract painters such as Mark Rothko, but in class the only kind of acceptable art was representational and photographic realism. The heroes of Burton's teachers were the Renaissance triumvirate of Raphael, da Vinci, and Michelangelo; after that came Rembrandt and no one else worthy of worship. OCA was,

for Burton, an art school "dedicated to preserving an Italian, Roman Catholic concept of visual art."

Burton's views are substantiated by his contemporaries, other artists who, like him, went on to successful careers, though they are more generous in their overall assessment and less direct in their criticism. Richard (Rick) Gorman, for example, describes the teachers as "laid back" but stresses their tightly organized curriculum. Work in first year was a "grind" rather than something students looked forward to every day. Things got better after that; you "could stray and experiment" and approach subjects on your own terms. Hana Trefelt, who entered first year with Robert, says she didn't have to do much to gain acceptance to the college—just draw a "perspective of a chair" and make out a cheque for around $125. She found "some teachers gave instruction, some didn't." Although she took painting and drawing from such luminaries as Jock Macdonald, Fred Hagan, and Harley Parker, she never learned how to mix paint and was left to paint "straight from the tube." Paul Young emphasizes the conservative nature of the program, exemplified by the fact that there were "only a couple of abstract painters, Jock Macdonald and maybe Gus Weisman." Nevertheless, he felt he did develop his drawing skills, probably along the lines described by Rick Gorman: "Carl Schaeffer, who headed the painting department, taught us techniques.... In the city he showed us old garages, garbage cans, fire escapes, and taught us how to draw in pen and ink and graphite pencil. We could spend a month on one drawing." John Reeves, who became a leading photographer, underlines the "tremendous presence of the Group of Seven" at the College but points out that "issues of draftsmanship were at the heart of artistic expression" for the teachers and that artists such as Degas, Toulouse-Lautrec, and (despite Dennis Burton's view) Picasso were central to the study of drawing.

Robert's views on OCA aren't known, though Paul Young says he liked Jock Macdonald, and Robert himself noted that drawing instructor Eric Freifeld had defended drawings of his that were considered "too sexy" by others. He left behind little commentary on his time at the school, though his paean to Telford Fenton, a fellow student later known as a master colourist and for his vibrant portraits and New York street scenes, reveals Robert's involvement in the ambience of his formal training days: "Twenty-five years ago to be in art school was to be lashed inescapably to the majesties of ideas, and we both saw commitment reeking in our wakes. We would sit for hours in bars, nursing beers and talking over sketch-pads about the beauty of line and the value of Prussian blue as a base for dramatic shadow. And we would often drink to tears, thinking

of Rembrandt, and the enormity of our futures. Art in those days was touched by the sublime."

The bars included the Beverley Hotel on Queen Street, with sawdust on the floor and beer at five cents a draft, and the more upscale Town and Colonial Taverns, where jazz musicians from Art Blakey to McCoy Tyner to Billie Holiday performed. Here Robert would drink and talk with Rick, Paul, Dennis, and the two artists who became his closest friends, Graham Coughtry and Gordon Rayner.

Gord and Robert had met at the Villa Crispin, a large three-story Victorian house on Charles Street east of Yonge, rented out by artists who turned its large living rooms into studios. Although Robert had undoubtedly heard of Coughtry, because of the artistic success this recent (1953) OCA graduate had already earned, he was probably introduced to him by Larisa Pavlychenko, a long-haired Ukranian-Canadian who entered OCA in 1955, the same year as Robert, and who later married Graham. The "terrible trio," as Gord described them at Graham's funeral in 1999, had not yet made the Pilot Tavern, then on Yonge Street just north of Bloor, their boozing and conversational mecca, the place where they would meet almost daily through much of the 1960s, but in the early days there was no shortage of watering holes or words. When they saw John Huston's film *Moulin Rouge*, about the life of Henri de Toulouse-Lautrec, Robert announced, "Man, that's it! If you can drink all that booze and get all those broads, I'm sure I want to be an artist."

What kind of a figure did the boy from Hamilton cut in this world of sawdust, ideas, and sublimity, a boy who tried to go back to Adeline Avenue almost every weekend for his mother's home cooking and the safety of the familiar? Everyone who knew him in those days emphasizes how skinny he was on his five-foot eight-inch frame. His hair was long (though not by the standards of the later '60s). He wore thick-rimmed black glasses and dressed unrebelliously in Hush Puppy shoes, corduroy pants, and the open-necked shirts with their wide collars that Kathleen had made for him. But Rick Gorman remembers that, despite this conventional outfit, he "talked like a jazz musician from California or New York." He had a memorable sense of humour that usually manifested itself in the form of ironic jabs at friends and strangers alike but that was, for Hana Trefelt, in the beginning at least, combined with a "sweet" personality, even though she and Robert could be "very feisty" in their give-and-take on various issues. Dennis Burton, in his typical blunt fashion, says Robert back then was a "Mohawk Indian boy with a loud mouth who could draw really well." This is a particularly interesting comment, because most of

Robert's close friends and colleagues found out about his Native status incidentally and not because he talked about it with them, though Paul Young insists Robert's Mohawk ancestry came up the first time they met in the lunchroom lineup at OCA. John Reeves became aware only gradually that Robert was Native, and it didn't matter at all, he says, because "there was no discrimination in our world"—a brave claim that referred to the small and closed society of bohemians who hung out together. But Dennis Burton confirms Reeves's view in his insistence that "we were colour-blind because we were enamoured with American jazz musicians." It may jar today's readers to hear Gord Rayner's report of exchanges between Robert and his friends along racial lines:

"You fuckin' Indian, you can't hold your booze."

To which Robert would reply, "White man got pimples."

But if Reeves, who came from Burlington, essentializes Robert, it is as a "lakehead soul brother" who displayed the "romantic toughness" of that western Lake Ontario region.

The one good friend of Markle's perhaps best qualified to speak of discrimination is sculptor Nobuo (Nobi) Kubota, who for years played with Robert in the Artists' Jazz Band and who, as a Japanese Canadian, heard band members refer laughingly to "a wee nip in the air" as he came into the room. But Nobi states confidently that the issue of race for Robert must have been very much as it was for him. They didn't talk about it directly. "Who I was hinged on my friends and the kind of art I chose to do…. We didn't think Bob Markle 'Indian,' even though we would have been open to him bringing this up." Until the last several years of his life, except in one or two notable artworks, Robert kept his Native identity quite distinct from his creative expression. Certainly when he was starting out, like Nobi, he didn't want to be celebrated as a race-based artist. Dancer-choreographer Patricia Beatty, who didn't meet him until the late 1960s, feels strongly that his ironic (often sarcastic) humour was a defensive weapon with which he confronted and unsettled virtually everyone he met before they could confront and unsettle him. This weapon, according to Beatty, was wielded largely because Robert, as a Native, was trying to keep up with the "white guys" and to keep himself at a protective distance from the pain they could cause. Though there may be some truth to this, it is difficult to gauge to what extent Robert's tactic of taking the offensive in pub-conversation warfare, when the beer was flowing as fast as the words, was based on racial insecurity. His intelligence and warm-heartedness drew admirers to him like moths to a flame, and since he couldn't afford to admit everyone to the inner circle of friendship and familiarity,

he kept his flame deliberately too hot for some. In other words, a test had to be passed that wasn't palatable to all. The basic polarizing nature of his personality was evident to Marlene: "You either loved him or you hated him." Robert described himself at this time as an "arrogant, self-centered prick [who] knew I still had lots to learn, and was eager to do so."

Robert's first Toronto address seems to have been a house on Baldwin Street, but soon he moved to a single room on the third floor of an Orthodox Jewish household at 91 Beverley Street, just north of Dundas. The low ceiling of this room sloped down to the window overlooking the street. It contained a little closet, a bed, an easy chair, a hard chair next to a small eating table, a hot plate for cooking soups and beans, and— Robert's pride and joy—his battery-operated portable record player. From this room he would sally forth to school, to taverns, to art galleries, and to jazz clubs, or take the record player into the OCA sunroom, where he and Rick Gorman would listen to Dave Brubeck, Gerry Mulligan, and other jazz musicians every noon hour. Often they would trade paperback books, cool upbeat mysteries by Erle Stanley Gardner and Donald Lamb, and vigorously praise the great artist novels—Irving Stone's *Lust for Life* and Joyce Cary's *The Horse's Mouth*. Enamoured of the story of van Gogh and Gauguin, and especially their Parisian experience, they would sit in the Gerrard Street Village west of Yonge Street and say, "This could be Montmartre.... We weren't calling each other 'Vincent,' but we felt we could be like them and they like us. Our adventure was what other artists had gone through."

Sometimes Robert would play pool with Paul Young, usually on green baize tables across from the Pilot on Yonge Street. Young describes him as "a master at pool" who "kicked my ass." Robert told Young that he'd lied to his mother more than once in high school, telling her he had a part-time job when he was really pool hustling on Kenilworth Avenue. The two friends hustled together and made spending money: "He did pot shots and I did safeties." Of a late afternoon or evening, Robert might go to Rick Gorman's studio near the corner of King and Bay Streets, which he shared with an aspiring young actor named Donald Sutherland, and look across at the cigar-smoking figures in green eyeshades who populated the *Toronto Star* newsroom. Or he'd turn up at Harvey Cowan's place on McCaul Street to get fed and watch programs on Harvey's little black-and-white television, like the two-hour jazz special in December 1957 on CBC's *Seven Lively Arts*. Featured, among others, were Count Basie, Thelonious Monk, Billie Holiday, and the saxophonist who would become Robert's favourite, Lester Young.

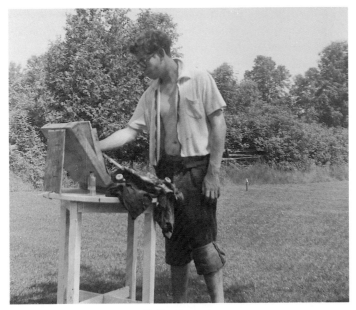

Robert in 1957

Rick Gorman describes their shared love for jazz in unforgettable terms. They would frequent pianist Clem Hamburg's House of Hamburg on Bloor Street just east of Avenue Road, which was an after-hours club where stars came to play when their gigs at more formal venues were finished. But one night in early 1956 Robert took Rick, Larisa Pavlychenko, and another OCA student, Garry Cooke, to the Melody Mill, a rooming house for musicians on Jarvis Street north of Carlton. Musicians would jam in the unfinished basement in the early-morning hours, playing to whatever audience could fit into the cramped space. On this night, the three friends sat impatiently on an old couch with a more relaxed Robert for at least an hour opposite a small, empty platform before they finally heard footsteps on the stairs. A group of black men came down. One of them tuned up his bass, another sat behind the piano and did scales along with the trumpet and sax players, and the drummer fiddled with the cymbals. Robert said quietly, "Look," and pointed to the two jazz giants, trumpeter Clifford Brown and drummer Max Roach, who had performed the previous evening at Massey Hall. The group swung into action and played until 6 a.m. while the aficionados soaked up the sound and sight of the best in the business. When it was over, Rick says, "We walked up the middle of the street, our long shadows stretched in front of us, our feet hardly touching the ground. We ended up at Robert's place and ate French toast just like

breakfast at the Waldorf-Astoria." John Reeves's metaphor of those times is memorable: "We were awash in music." It was, he says, all a prelude to the synesthetic experience of painting and sound, the music composed as it was played and the paintings composed as they were painted. These were also the overture days to the Artists' Jazz Band, formed in 1958, whose original members were Gord, Robert, Graham, Rick, and Nobi Kubota.

What was the professional art world that Robert stepped into in the mid-1950s, and what were the artistic influences on him? In his essay "On Portraiture," about his friend Telford Fenton's efforts to paint Robert Markle thirty years after they met at OCA, Robert indicates the weight of Group of Seven influence and his nascent awareness of New York abstract expressionism when talking with an old Peterborough painter of "department store art shows and nudes-on-velvet galleries" whose work, nonetheless, possessed "a truth of some sort." In the summer after his first year at art college, Robert was "the token student on a soil testing crew for the Department of Highways in rural southern Ontario. His description of his efforts to paint on days off, while his fellow crew members fished or played pool, is telling in its emphasis on the anxiety of influence:

> I remember lugging my art supplies through the
> underbrush[;] blackflies buzzing and the hint of sweet
> water in the filtered air, I charged into that magnificent
> landscape determined to find and make art. Behind every
> tree, beside every lake, a Tom Thomson or the tangled
> confusion of a J.E.H. MacDonald panorama lay waiting for
> my brushes. These were deeply felt journeys of discovery for
> me, wonderful afternoons spent roaming "Group of Seven"
> woodlands with gessoed plywood panels, paint tubes and
> turpentine, wire-bound sketchpads, all the stuff necessary to
> start teaching the eyes to see.

But it wasn't all the stuff necessary, and when he tells the aging painter that he's going to be a "big-time artist," the old man gives him a look that tells him he's young "and had things to learn." His informal education over the next few years would move him far beyond woodlands boundaries.

In 1927 Clarence Gagnon, who had studied in Paris and returned to Quebec to employ realism and impressionism in his depiction of habitant lifestyles and country landscapes, spoke out against the Group's

sway in Canadian art: "Nothing can be done to change matters as long as the Group of Seven will fight and dictate to all other artists in Canada, nothing will happen to make things better." Other Quebec painters, like John Lyman and Alfred Pellan, brought back eclectic Parisian influences shaped by Fauvism, cubism, and surrealism, but it was Paul-Émile Borduas who in the 1940s gathered together a group of young artists and writers who were opposed to the formalism of the art establishment and began to assert "the liberating necessity of art." It was a philosophy and practice of creativity that found its manifesto in Borduas' treatise *Le Refus global* in 1948. What he voiced was something the young Robert Markle had not yet articulated but would quickly learn to live by in his anglophone-Toronto enclave. To Borduas, "social change lay in a change of attitude through the individual's realization of his potential. For him art was such a realization, but only if it was truly free.... In more immediate terms that spiritual freedom could only be attained through emotional and intellectual freedom."

Robert may or may not have been aware of the *Refus global*, and it is impossible to say how many Borduas paintings he saw while at OCA, though Borduas did have regular showings of his work in Toronto from the early 1940s on. But as a young artist who would have been attracted to the belief celebrated by Borduas of "the magic of each individual freed from the compromises of rationality and pragmatism," he would have been increasingly open to the radical intuitive gestures of younger Quebec painters such as Jean-Paul Riopelle, whose work was internationally known by the early 1950s. Riopelle's abstract expressionist paintings—"indescribably complex in their weaving of colour and texture, worked with brush and palette knife, splattering and dripping with equal attention to each part of the surface"—were New York–influenced, and New York painting was having a great impact on the Toronto art scene at precisely the time Robert was looking for guidance beyond that provided at OCA.

New York certainly influenced the group known as Painters 11, which, Paul Young says, "cracked open the scene" in Toronto. Organized by William Ronald and eventually including such luminaries as Jack Bush, Harold Town, and Jock Macdonald, the members held their first exhibition as a full group at the Roberts Gallery on Yonge Street in February 1954. Gord Rayner and Dennis Burton saw them the next year at Hart House at the University of Toronto. They "died" over the Ronald pieces in particular, says Rayner: "They were so energetic and powerful, like nothing we'd seen before.... His palette was brilliant, not like [Willem] de Kooning's awful palette, a northern light as opposed to the dull light of

the Bowery" (though of course de Kooning's palette was "very effective"). To Rayner, Ronald was like a predecessor to Pierre Trudeau: "We had something of our own [in painting]. He gave us a direction, and wasn't trying to attain something that was established and had its parameters." According to critic Kay Woods, Ronald and his compatriots—in contrast to the traditional artists of the Ontario Institute of Painters—represented "the vague gropings of the primitive man" rather than time-honoured values inherent in the creative impulse: "To express his ideas and feelings for beauty the artist must select from nature. And by means of conception, composition and style, form the objects of his picture into a unified and harmonious whole. The traditional artist, each with his own individual discernment of beauty, is not too concerned with passing fashions. We are therefore confident that traditional art with its infinite variety will be vindicated by artistically intelligent people."

Together only six years after that first show, Painters 11 had an exhibition with American abstract artists at the Riverside Museum in New York City in April 1956. As Robert, Gord, Dennis, Graham, Rick, and Paul were increasingly attracted to what de Kooning, Jackson Pollock, Mark Rothko, and others were doing in New York, this would have been, for them, the legitimization of a new Canadian art. But it was the Painters 11 members' assertion of their own individuality, and their refusal to work within those common parameters beloved by the Ontario Institute and spurned by Gord Rayner, that gave them a genuine basis of influence on younger artists. As they proclaimed in the brochure for the Riverside show, "There is no manifesto here for the times. There is no jury but time. By now there is little harmony in the noticeable disagreement. But there is a profound regard for the consequences of our complete freedom." Three years later, at a show at the Park Gallery in Toronto, they declared, "What might seem novel here in Ontario is an accepted fact everywhere else. Painting is now a universal language: what in us is provincial will provide the colour and accent; the grammar, however, is part of the world." Reading these statements from Painters 11 and seeing their works, as it is certain he did, Robert would have been strongly encouraged to pursue his own path while recognizing that he was inexorably grounded in, and shaped by, an expressive combination of the local and universal. Individuals in Painters 11 had their distinct interests and commitments: Macdonald in his "painting as a direct expression of spiritual values through abstraction"; Bush in his profoundly realized movement "from the conventions of Canadian painting (established and sustained by the Group of Seven) through Abstract Expressionism to the large-scale colour-field paintings that

brought him national and international recognition"; Town with his "powerful images of sweeping gestures, loaded planes of colour, and complex masses of drawing"; and Ronald "whose forms seem to rip away from the ground, as if the very activity of painting can barely be contained within the format of a picture."

Reactions to this artistic surround varied among the emergent OCA group and their friends. Jock Macdonald became a mentor to Rick Gorman. Gord Rayner, after being thrown out of Northern Vocational School at the age of fifteen (and "not proud of that"), settled at the commercial art firm of Wookey Bush and Winter, on Avenue Road, where he learned a great deal about design and topography by looking over Jack Bush's shoulder. One day he saw William Ronald and Harold Town "screaming and rolling on the floor over what their manifesto was going to be." Graham Coughtry, who was initially influenced by social-realist draftsmen like Americans Ben Shahn and David Stone Martin, was often critical of Bush's abstract paintings, telling his colleagues, "This is crap," but he could be equally dismissive of realist landscape work. Michael Snow recalls him stating that "every damn tree has been painted." Coughtry, as Robert would become, was already a recognized expressionist painter of the figure who had been part of a Hart House show with Snow in 1955 that Toronto mayor Nathan Phillips declared "offensive"—perhaps most irritated by Snow's picture of a woman holding a rooster: *Woman with Cock in Hand*. Robert's main influence of the day (and, indeed, for decades after) was the Dutch-American de Kooning, who did things "wrong" such as "put the figure in the middle of the canvas and asked, 'Why the fuck not?'" Robert loved that, and said so. Rayner replied that "human imagery had been dead since 1900," and he, Graham, and Robert would endlessly debate the merits of what they were seeing in galleries, newspapers, and art magazines (they couldn't afford to go to New York). The main thing, Rayner says, was to "accept your influences and paint through them."

So Robert, according to Gord, had to "paint through" doing "second-rate versions of Coughtry" (just as Gord admitted he was doing second-rate versions of de Kooning). He also had to paint through his classical stage and move beyond being, as Dennis Burton says, "the kind of artist OCA wanted to produce in regard to muscularity, light, and shape." He was from the beginning a consummate draftsman who, Paul Young insists, "could memorize the entire silhouette of a human being," and other shapes for that matter. Young remembers he and Robert being hired to paint seasonal decorations at a large Toronto car dealership in December of 1956 or 1957. Across a full twelve metres of window Robert

painted freehand a Santa Claus with sleigh and reindeer without any pre-
liminary sketch. Says Young, "It was a perfect fit and not a single mark
required alteration…. There are only a few people on the planet who can
do that." Art critic Peter Goddard concurs: "Markle may be the most tal-
ented technician of his generation. As a draftsman he was unsurpassed."
It wasn't all visible accomplishment, however, and Paul Young glimpsed
the Hamilton boy make do with what was at hand without public display
as they spent a day sketching in the Humber Valley. "I had finished my
piece and wandered over to his location; it was always fun to watch him
work. To my astonishment he was deploying river water and black dirt to
make washes, having long since run out of ink. As usual, his picture was
far superior. 'Necessity is a mother,' he said."

Despite the Roberts Gallery showing of Painters 11 and the Hart House
exhibitions, the gallery situation in Toronto wasn't too exciting until Av
Isaacs came along. Apart from the Roberts Gallery—which according to
Dennis Burton mainly showed the work of OCA teachers, Jock Macdonald
being an exceptional figure in an otherwise conservative crowd—there
was the previously mentioned Park Gallery, the Laing Gallery on Bloor
Street west of Avenue Road, which occasionally featured avant-garde
painters such as William Ronald, and places like the rather staid Eaton's
College Street and Simpson's department stores, where more traditional
fare was hung. As Ihor Holubizky has said, "Eaton's stood for quality, and
if it could satisfy Anglo-Saxon values in furniture, it could by extension
satisfy them in paintings." It is worth noting, however, that in October 1953
the Simpson's store agreed to an exhibition of seven painters who would
become members of Painters 11, called Abstracts at Home. For Av Isaacs,
Douglas Duncan's Picture Loan Gallery at Yonge and Charles Streets
"was the most stimulating." Duncan "was the only dealer at that time who
showed younger artists like … Harold Town. He also exhibited artists who
had yet to be properly appreciated, such as David Milne and Paul-Émile
Borduas. As far as I was concerned he was the only game in town."
 Avrom Isaacs started a framing business on Hayter Street, one block
north of Gerrard, in the late 1940s with his University of Toronto friend
Al Latner. They sold frames for graduate diplomas and photos and the
occasional painting. Eventually they started to handle art supplies and
to hang paintings as well, including ones by Graham Coughtry, with
whom Av lived for two years in the early 1950s in a Summerhill Avenue
apartment—an experience he called "my B.A. in Fine Arts." Al Latner

sold his half of the partnership to Av in 1950, and for the next five years Av operated a tiny art gallery out of the shop, once selling a Coughtry for $200. In 1955, taking the framing business along as support, he opened the Greenwich Gallery at 736 Bay Street, where the first exhibition in February 1956 included works by Ronald, Coughtry, and Michael Snow. Two months later Graham had his first solo show there. Critic Barrie Hale described Av's manifesto that accompanied the gallery opening "as the closest thing Toronto had to the *Refus global* of Borduas." Av wrote,

> In choosing this exhibition to mark the opening of the
> Greenwich Gallery I have endeavoured to present a visual
> statement of the gallery's aims for the future. While these
> five young painters [Coughtry, Ronald, Snow, Gerald Scott,
> and Robert Varvarande] represent diverse directions in
> painting, their work suggests, I believe, a common standard
> of artistic integrity and it is my earnest intention to adopt
> this standard and grow with it as it grows, rather than trying
> to adjust to any mythical "level of public taste." I hope to
> make the level which is evident here attractive and easily
> accessible to the public by making it possible for people to
> buy paintings by contemporary Canadian painters on a time
> payment basis and by featuring low priced Canadian and
> European graphic art. Arrangements are also being made to
> exchange exhibitions with galleries in other countries and
> this, along with a planned program of discussion evenings
> and similar events, should help to make the Greenwich
> Gallery one of the centres of artistic activity in Canada.
> This opening exhibition conveys some of the excitement
> and optimism I and the painters involved feel toward these
> prospects. I also make the best frames in town.

The Greenwich became part of the local literary scene as well, with its gallery poetry night organized with Toronto's Contact Press. Among those who read between 1957 and 1962 were Irving Layton, Al Purdy, Leonard Cohen, and Gwendolyn MacEwen. Av's honest self-assessment of how, as a gallery owner and dealer, he learned as he went along reveals the serendipitous nature of his attachment to the emergent artists who came to be associated with him: "The artists in my first show ... had nothing in common except the fact that I chose them: they were people I was sensitive to. I picked them out of instinct. I was totally insecure for perhaps the first

five or ten years. I didn't know whether I knew anything or not. I went with what I felt was good, but I didn't know if I was on the right track."

Part of Av's strength was not only to believe in his artists' talent but in their ability to spot other painters of merit. It was Graham who asked Av to look at Gord's work, as well as that of Joyce Wieland, and the result was a Rayner–Wieland show at the Greenwich in 1959, just before Av gave in to demands from those same artists that he rename the gallery after himself. It was inevitable that Robert would end up there, though his entry wasn't due only to a fellow-artist's recommendation.

Another factor in the encouragement of Robert and his associates to believe in what they were doing was that some perceptive critical voices were being heard in Toronto in response to the groundbreaking work of Painters 11. For example, of the group's first show at the Roberts Gallery, Pearl McCarthy wrote in *The Globe and Mail*, "there are great differences of temperament and approach, and this collection will be best appraised by leaving aside all debate on the merits of representational versus abstract art and looking at these pictures for what they are." In the *Toronto Telegram*, Rose Macdonald said, "the show … pulls the visitor up by the boot straps." In *The Toronto Star*, Hugh Thomson wrote, "The show has one common denominator—it gives conservatism a polite but firm kick in the pants and blazes independent trails." Elizabeth Kilbourn and Robert Fulford were two other critics who supported the new painters, the latter championing Coughtry in particular. In 2000, Fulford would cite the opening of Av Isaacs's frame and gallery shop as one of twenty significant events that influenced Canadian culture in the twentieth century. Things were happening in the Toronto art world as Robert Markle began the journey that made him one of its most infamous denizens. He had his creative companions for the trip, but he didn't have his muse until he met her in the fall of his second year at OCA.

Marlene Shuster was seven weeks older than Robert, and had been born in Toronto to Jewish parents, Jack and Esther. Her father had emigrated to Canada from Poland in 1920 at age ten, and her mother, whose parents were Polish Jews, had been born in Toronto in 1914. Jack Shuster had met Esther Calstein—with "eyes like moons"—at a hairdresser's shop, and they were married not long after, on March 22, 1935. When Marlene was very young, the family lived in a flat above a College Street store between Beatrice Street and Montrose Avenue, not far from Sniderman's Music Hall and Grace Street Public School, where she was a pupil. During the

Depression, Jack held a variety of jobs before learning to be an upholsterer. He was a "fine craftsman" who made his own tools and repaired everything around the flat, including the family's shoes. Marlene remembers being hoisted onto his shoulders to watch the D-Day celebrations in June 1944, and later that same year moving with her four-year-old brother to a red-brick house at 234 Maplewood Avenue in the Vaughan Road–St. Clair Avenue area. The lower-class neighbourhood was mainly gentile, with some ethnic mix. There were big old trees on the lawns, and the house, with its backyard and garage, was more spacious than the flat.

At Humewood Public School, nearby, Marlene played on the basketball and baseball teams and completed grade 8. She attended high school at Vaughan Road Collegiate. At lunchtime would come home and listen to fifteen-minute soap operas on the radio. and after school she'd hear programs like *Backstage Wife* and *Pepper Young's Family*. At night she listened to *Inner Sanctum*, as the Markles did in Hamilton. Her parents encouraged her reading, and she would haunt second-hand bookstores with her father, buying Hemingway novels, books on history and philosophy, opera librettos, and comics. Music too was important in the family. Jack loved opera, and since his best friend was Italian and also loved opera, there were many "aria-versus-aria battles." She and her father sang all the time in the house and carried on their duets in the car her parents eventually purchased. There was no record player, but they did have her maternal grandmother's piano, so Marlene took lessons for a few years and passed some Royal Conservatory exams. There were two movie houses nearby on St. Clair Avenue West: the old Christie, which charged six cents, and the newer Vaughan, which charged ten. Here she could see recent films such as *The Red Shoes*, with Moira Shearer, and reruns such as *Waterloo Bridge*, with Vivien Leigh. The Pix, on Ossington Avenue south of Dundas Street, was further away, but it was just a few doors from the home of her maternal grandparents, so her parents let her go to the movies while they visited on a Saturday afternoon.

Several aspects of Marlene's upbringing particularly prepared her for her relationship with Robert. Jack and Esther were easygoing as parents and "very demonstrative physically." Since "they didn't hide their bodies," physical expression and nudity were never of concern to her. There was an un–Orthodox Jewishness in the Shuster home. The family didn't keep kosher and Jack and Esther rarely attended synagogue, though they always spent high holidays with relatives around the tables of both sets of grandparents. Marlene, like Robert, loved the music and ritual of Christmas. Although of course the family did not officially celebrate the

holiday, Marlene was allowed to decorate a small evergreen branch with tinsel and to give presents to her parents. Being Jewish outside the home wasn't easy. Marlene had been called names like "dirty Jew" during her College Street childhood and recalls the only time her father slapped her bum was when, after something hateful had been said to her at the age of six or seven, she ran upstairs crying, "I wish I wasn't a Jew." She has strong memories as an older child of encountering two relatives from France, a couple who had been in concentration camps, and being aware they were "in great pain and very damaged."

Marlene worked at odd jobs such as babysitting from her early teens, including a stint at a factory "out of the nineteenth century," where she sat at a table covered with mail and cut and sorted coupons from cereal boxes. From the age of fifteen through the summer after high-school gradua- tion, she worked behind a counter at the Simpson's store at Yonge and Queen Streets, saving money so she could be the first member of her fam- ily to attend university. She liked to draw as a young child, she remembers, but found when she entered high school, at Vaughan Road Collegiate, that art wasn't taught in a very structured way, despite the annual need for operetta set designs. So Marlene sketched landscapes and people on her own. She didn't have much guidance at home either, although Jack and Esther were fond of the landscape and still-life reproductions they hung on their walls. Only years later did she discover that they too liked to draw. During her year in grade 13, she debated between attending OCA and studying art and archaeology at the University of Toronto. In the end she applied to the former and in September 1956 was admitted without a portfolio. Apparently there was little competition for entry into the foun- dation year, which was held mainly at the Bayview campus (later Glendon College, part of York University). She had a "wonderful first year," taking classes in drawing, lithography and etching, painting, colour theory, and English literature, but what changed her life utterly was her meeting with Robert Markle.

When she was standing in line waiting to register in September, she heard a male voice say, "So you want to be an artist." She turned and saw a skinny youth with long black hair and glasses sitting on a countertop with a friend. Despite her subsequent discovery that he was dating other women, she was attracted by his interest in everything and his excitement about so much. He had a genuine curiosity about her work and listened closely to what she said about it and other things. They soon went out for ten-cent drafts at the Turf Tavern, where Marlene says the smell made her sick, perhaps because she hadn't drunk beer before. After that, they just

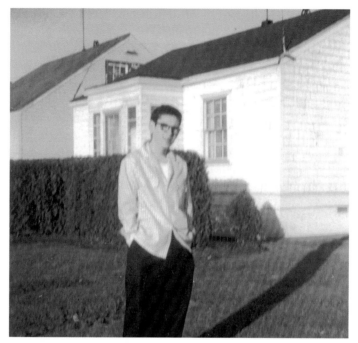

Robert in front of Jack Foster's house, Ivon Avenue, Hamilton, 1957

talked and nothing physical happened for a while until one day "there were sparks." She saw how sensitive and self-concerned Robert could be when, outside his rooming house one day, they met an OCA girl with whom he'd been involved. He spoke to her in a very kind way, explaining that their relationship was over, then abruptly left her standing on the sidewalk.

Although "it was hard to keep our hands off one another," they didn't sleep together for quite some time. When they eventually did, in Robert's room on Beverley Street, he was solicitous of Marlene's inexperience and gave her a book on sexual knowledge to read. In those days, she says, young couples seldom lived together before marriage, so there was no pressure on her and Robert to do so, but early on he told her he was Native, which might suggest he was serious about the relationship. He did take her home on several occasions to Adeline Avenue in the winter of 1957, though this was no guarantee of commitment, since he had done the same with several other girls previously. They travelled either by bus or hitchhiked on the Queen Elizabeth Way. The family, along with Blackie the dog, welcomed her. Kathleen cooked memorable meals to offset Robert's grilled-cheese-sandwich student diet, and Marlene felt very

comfortable there. In Toronto they went to "tons of movies," sometimes as many as three a day on weekends, and visited the Art Gallery of Ontario, the Eaton Auditorium, where they saw Andrés Segovia, and places like the First Floor Club on Asquith Avenue, which was a coffee bar that became an after-hours jazz venue for fans and visiting players. Robert had already introduced her to his favourite musicians on his portable record player.

A complication in the developing relationship, however, was Marlene's recent move with her parents and brother and sister to a small bungalow in Thornhill, one block north of Steeles Avenue about a kilometre west of Yonge. Since the subway ended at Eglinton Avenue, she had to catch the Richmond Hill bus every night to get home, which she did without fail. The trip could take well over an hour, and often she would leave Robert late at night, ride north, sleep for a few hours, and get up for the trip south to OCA early in the morning. There was tension at home about this, particularly since Jack and Esther hadn't met Robert, and one night Marlene arrived at the bungalow to find she couldn't open the front door. Thinking her parents had shut her out, because the door was never locked, she turned around and went all the way back to Beverley Street. It turned out to be a misunderstanding, but even so Jack and Esther didn't meet Robert until 1958. Meanwhile, despite distance and time, the long journeys continued.

Robert was still going home to Hamilton most weekends, and from here he sent Marlene letters about his hitchhiking adventures to and from Toronto as well as his thoughts about who he was and what he wanted to do. They are a young man's thoughts, and he expresses his feelings for her in a similar vein:

> I sat there riding … felt that Hamilton wasn't far enough,
> yet I didn't know where to go—it frightened me to think
> like that—thinking problems that have no answer. I had
> the driver let me out—must have thot I was crazy—I just
> wanted to breathe air and walk … there are so many
> questions I want answered—so many times I ask myself these
> unanswerable questions … what is this life all about—what
> makes me walk—what makes me want to paint—what is
> happiness Marlene—why do I want it so—why do I pick
> up a pencil, a brush, look at a flower, see a face—and miss
> you—rain hit me pretty hard—I didn't mind and soon found
> shelter in a construction pipe…. you are teaching me life….
> you need not worry about me leaving you …

I love you because not only are you intelligent and
beautiful … but also because you are wonderfully feminine.…
About paint, rubbish, about line—something less, about you,
the world.… You are more than I. You make me live.

I'll get there [New York] or die! … Words?—I looked one
up—ART—many definitions, only one didn't confuse me—
"commonly used abbreviation for the name Arthur."

In the summer of 1957, Marlene worked for Toronto Parks and Recreation as a playground supervisor while Robert was away again with the Department of Highways crew. He wrote her regularly while on the road and from the Lake Simcoe cottage of Paul Young's parents, where he spent a week in June. There he swam, painted, and found the Island Grove landscape "flat and green … leaving painting completely to one's inventiveness." His voice in his letters is gentle, reflective, and full of affection for her.

In the fall Marlene enrolled in OCA's advertising-art program. In her own words, she soon found she was "terrible at it," and Carl Schaeffer, the director of the Drawing and Painting program, granted her appeal to make the transfer. She was very happy with her work and receiving praise for it, but Robert was becoming increasingly impatient with her for no explained reason. His actions in Fred Hagan's etching class one fall day can perhaps be understood as an unconscious response to his anxieties about his impending career and the fact that he was in love with one woman when he was just beginning to glimpse the need for many women in his life, not only in personal terms but as assets in his creative expression. Marlene had gone silent in the face of his disapproval about something, and Robert picked up a bottle of etching acid and threw it across the classroom in her direction. It missed, but Fred Hagan was angered and reported Robert to the principal. Everything happened very quickly. Although another OCA teacher, Harley Parker, spoke on his behalf, Robert was expelled from OCA. There was no appeal. Marlene made a spontaneous decision to quit the school and "walk out into the world with him." They didn't talk about the expulsion or future plans, though Marlene certainly wondered what they were going to do. Robert would now lose his IODE scholarship, his part-time job painting signs wouldn't pay the rent, and she couldn't ask her parents for financial support when she was no longer in school. Feeling "ashamed and guilty," she didn't tell Jack and Esther why she'd quit OCA but announced, simply, that she'd decided to get a job.

There was little reaction from Robert's friends to his expulsion. According to Rick Gorman, it wasn't a big deal, because such things were an expected part of the artist's life. Art school was never going to determine whether or not you had the goods as an artist. After all, Greg Curnoe, also born in 1936, who became an immensely successful Canadian painter, had quit OCA halfway through his second year. In Rick's own third year, he "stayed home from the mostly boring classes and painted." Hana Trefelt thought the college had overreacted by kicking Robert out but had every confidence "he was going to do what he was going to do." Robert owed no explanation to anyone, except perhaps his mother. While there is no record of what or when he wrote to her about his expulsion, Kathleen's letter to him indicates her concern for what had happened and her support for her son: "They had no alternative [but] I am and will always be on your side regardless of what comes. You will never be a failure. Don't even take that attitude." Although she believes that Robert "will go on to greater things," she feels he is "overworked and tired out" and not getting enough rest or eating properly. She suggests he might need a psychologist, and mentions her belief in God—"something you will turn to sooner or later." Whatever his private needs in his increasingly complex existence, there is no evidence that Robert ever sought therapy or religious solace in the face of what he called "the terrible beauty of creation." It was art that would sustain him, because "You don't have to believe in angels to paint them, just understand that they are believed."

Marlene found employment almost immediately in a trade magazine office near St. Clair and Yonge, where she touched up photos for the art director. When he quit the firm, not long after, she went with him to work out of his house for a number of months. She was still living at home and making the long commute north and south when, in the early fall of 1958, Robert began to get anxious about the question of marriage. Marlene admits she hadn't had many matrimonial thoughts, but one night, at the Eglinton subway station, "he pushed me up against the wall and said in an aggressive way, 'We're getting married.'" Despite Marlene's assertions that common-law relationships were then unusual, people did live together, and artists and their partners were probably high on the list of activists in this regard. Given Robert's later reputation as a rebel and iconoclast it may seem surprising that he would be concerned about official sanctification of his association with anyone, but Stephen Williams, who became one of Robert's closest friends during the 1970s and '80s, emphasizes that Robert "was the most middle-class conservative guy I've ever met" and "very committed to the institution of marriage." Indeed, most of his early

friends were as well. Graham and Larisa married in the early 1960s and, despite a stormy relationship, stayed together until his death in 1999. Gord married several of his partners over the next few decades, and Rick, Harvey, and Paul all tied the knot at least once.

If Larisa was a woman who led an independent professional and personal life away from her artist-husband for considerable periods of time, Marlene was different: "I was foolish, totally in love. All my energy went in one direction, and everything nurturing in my nature came out." What this meant in practical terms was that she was prepared to support Robert as an artist and give up any aspirations of her own: "I stopped drawing once I left school. I didn't think about it. He was my whole focus."

She had found stable employment as a receptionist in the office of Dr. Coleman Solursh on Palmerston Avenue, who paid her $35 per week and raised it to $40 when she announced she was getting married. Robert, meanwhile, was working at Banner Signs, near the corner of Dupont Street and Spadina Avenue, painting commercial signs and billboards. For the next two years he went to the shop every day, the only time in his life, except for his later teaching of art, that he held a day job. He also supplemented his pay by pool hustling, mainly at the Bloor Subway Billiards Room, for beer and hockey-ticket money. He usually won more than he lost, because of his "soft hands." During this period they often saw Helen and Marty Poizner, because Helen and Marlene had attended Vaughan Road Collegiate together and because the Poizner house on Hilton Avenue, where Helen and Marty had an apartment, was a gathering place for a disparate group of characters, friends of Marty's from the University of Toronto's architecture school—Nobi Kubota and Harvey Cowan—and others from OCA. According to the Poizners, "Marlene was the least likely person to hook up with Robert. His personality was so abrasive and irreverent compared to hers. He was certainly an interesting character, however, who didn't quite know what to do with all of us or we with him." Graham might have "cut a more elegant figure than Robert," but, the Poizners stress, the members of the painter crowd were all "wild and full of themselves, certain that the establishment didn't understand them."

Despite their combined steady income, Marlene's parents were unhappy about her impending marriage. Nevertheless, on November 8, 1958, they drove down in their panel truck with her younger sister Louise to the Unitarian Church on Avenue Road. Kathleen, on the other hand, when she heard the news, "started to cook right away," and she and Susan attended the wedding, along with Mitchell and his Polaroid camera. Robert and Marlene had rented a basement apartment at 15 Oakmount

Marlene and Robert at the Unitarian Church, Avenue Road, on their wedding day,
November 8, 1958

Road, north of Bloor Street and directly across from High Park. Next to
the furnace room were a fold-out bed and a table with a few chairs. The
space was so small that the bathtub—which was located in the kitchen-
ette—was where the beer was cached for the party. Garry Cooke from
OCA was Robert's best man, and Paul Young was there as well, along with
Graham and Larisa, the Poizners, and Jack Foster from Hamilton with
his wife, Adeline. Everyone got along, including the parents of the bride
and groom. Kathleen told Jack and Esther to let her know if "my son" did
anything to make Marlene unhappy. Part request, part command, it was
a signal of her love for her son and her daughter-in-law, but neither she
nor Marlene's parents could influence the extraordinary unfolding of the
next thirty-two years.

Marlene emphasizes the "day-to-day struggle" of the burgeoning painter's
life. Robert would draw with anything at hand, because he couldn't often
afford paint. When he could, he'd paint landscapes in oil on masonite. One
of these untitled works (see page 26) from 1957 is a 30-by-40-centimetre
realist-expressionist portrait of a double-trunked dead tree foregrounded
against a green-brown swath of forest and hill. His early draftsmanship is
evident in the delineation of the tree's branches rising from the trunks in

assertive outline against a van Gogh sky of pastel yellow, white, and blue. More striking from this period is an oil-on-paper portrait of Marlene in muted ochre and green tones. It is not exactly a lifelike reproduction when compared with photos of Marlene at this time, but sharpens her features as if to pay tribute to her self-confident, even penetrating gaze. Robert's predilection for nudes was not yet evident in his work, even if, as Rick Gorman insists, he was going to the Victory Burlesque "three or four times a month" in his second year, but his thoughts about drawing and painting were strongly influenced by a visit he and Marlene made to the Albright-Knox Art Gallery in Buffalo before their marriage. There Robert saw works by de Kooning, Pollock, Rothko, and Barnett Newman "live" for the first time and was "transported":

> I remember immersing myself in the de Koonings, the
> doorways of fire of Rothko, the rich elegance of Barnett
> Newman, large canvasses filled with colour and light.
> Brutal slashes, I remember reeling before my first Jackson
> Pollock.... when guys tell me that the figure is dead, of no
> purpose, in doing so they imply that it was the Rothkos and
> Newmans, and especially the Pollocks, that took it away from
> me, I know how little they see. Those guys gave me more
> space to work with, larger eyes, and they taught me a way of
> seeing that made me content, my figures even more vital.

In Toronto, only Coughtry was exploring the gestural aspect of the figure in ways Robert wanted to, but Graham had five years more experience and it was natural Robert would be directly influenced by him, though not for long. Over and over, Robert's fellow artists and those in the business, like Av Isaacs and Dennis Reid, stressed that "Robert could draw." Reid, now Director of Collections and Research at the AGO, says that from the beginning Graham was more engaged with the form and structure of bigger canvasses, while Robert "became calligraphic and intensely personal [in] a kind of poetry.... His making something big on a smaller scale is what distinguished him from others." Robert himself, in a 1979 interview with Joan Murray of the Robert McLaughlin Gallery, looked back on his early association with Graham-as-painter, revealing the influence but also the distinction between them: "Coughtry was considered a very erotic painter but I've always considered him not so. For instance, he's very lush and he has what I would consider a fantasy approach to eroticism but he's never been really hard core in that his figures have always been disguised

by the manner in which he paints and so very quickly in his paintings the content ... wasn't the eroticism of his subject matter but the eroticism of his colour ... bankers could have one of Graham's pictures on their wall and justify it in terms of colour and visual excitement."

Clearly the implication is that the same bankers would be put off by Robert's eroticizing of subject matter, which was why it would be Markle's paintings and not Coughtry's that were deemed to be obscene when Dorothy Cameron's gallery was busted by the Toronto Police Department's Morality Squad in 1965. When Murray asked him if he was the first to introduce strong eroticism into his work, Robert confidently replied, again distinguishing himself from Graham in the very early 1960s: "Yes I was the first, I think I was the first because I was the most honest about it in that I made no pretence of hiding the erotic aspects of my work."

In the spring of 1959, with Marlene's $40 per week and Robert's income still steady from Banner Signs, they moved to a larger apartment at 436 Avenue Road, just south of St. Clair. This was the top floor of a three-storey house, with a kitchen, a bedroom, and a separate studio for Robert, for which they paid $100 a month. If they weren't well off, they were reasonably comfortable, since, as Marlene remembers, they could eat very well for about $10 a week. They stayed on at Avenue Road for three years, but soon the apartment studio wasn't big enough for him and Robert rented studio space downtown with Michael Snow and another artist, Robert Hedrick. There he did drawings on paper and minimalist landscapes on canvas. In 1960 his small black-and-white drawing of a figure was singled out at an AGO show by Coughtry as juror and Robert Fulford as critic: "the first picture I ever showed I called ... Victory Burlesque or something like that and it was an outrageously erotic drawing influenced by the way that Graham drew but very much my own in that it was a very sensuous drawing of a girl that was sticking her ass in front of the audience and it was unmistakably bawdy...." If the picture indicated where he was going with his work, his involvement with the Isaacs Gallery beginning that same year helped propel him there.

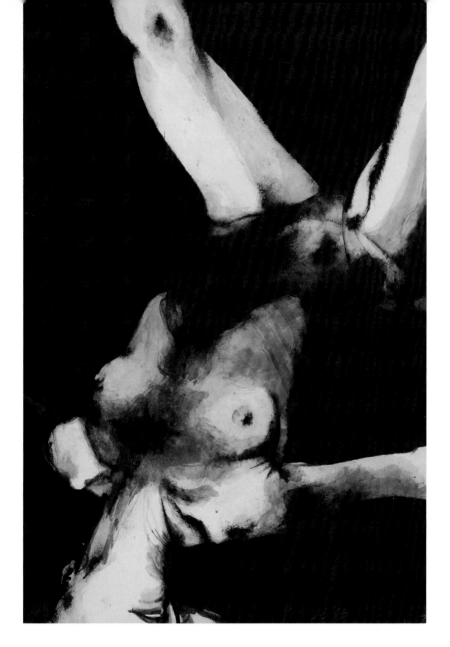

Burlesque Series VI, 1963 (tempera on paper, 88.6 × 58.5 cm)

IV

THE INNER CIRCLE: TORONTO 1960–1965

In early 1960 Larisa Pavlychenko, who was working for Av Isaacs at his gallery on Bay Street, made plans to go to Europe for an extended period. She mentioned Marlene to Av, and he hired her for $45 a week to sweep the floor, water the plants, and learn to frame the paintings of the artists he was showing and those of other clients as well. (The framing shop would support the gallery until the mid-1970s.) Marlene gave Dr. Solursh a week's notice and began work at the gallery in June. Robert had quit his job at Banner Signs and was drawing and painting full-time, meaning that he could dedicate as many hours as he wanted to his art. It's unclear exactly when he signed with Av to be his exclusive dealer, but he undoubtedly did so because Graham Coughtry had spoken to Av about his work and Robert knew it would be consistently displayed in a public venue along with that of other artists who were gaining attention. After the AGO show noticed by Fulford, Robert was part of the Sculpture by Painters show at the Isaacs in October 1960, and two group painting exhibitions there the next fall and winter. He was clearly producing a lot during this period, because in 1962 his work appeared in six group exhibitions at the gallery.

In March 1961 the Isaacs moved to 832 Yonge Street, in the heart of what Peter Stollery calls "the Oasis," an approximate area stretching east–west along Bloor Street between Church Street and Spadina Avenue and extending a block or two north to include the Yorkville–Cumberland blocks and south to take in Charles Street. Although "there was a worldliness to the area," says Stollery, the Oasis was "essentially white" and carefully welcomed the new wave of urban immigrants that arrived in the neighbourhood during the late 1950s, including the Hungarians fleeing

51

Communist wrath in Budapest in 1956. This whiteness, which did not contain all the colours of the spectrum, was the result of what Robert Fulford called Toronto's "'Closed-on-Sundays, frown-on-weekends' tradition," the city having been "built by Puritan hands and created in the Puritan mould." In addition, said Fulford, Toronto "rarely has time for culture. The artist's place in all this is difficult." It wasn't just Toronto, of course. When the National Gallery of Canada held a major retrospective of Canadian art in 1967 to celebrate the Centennial, "it included one nude among three hundred works." Politics and styles in the street would bring enormous change to views of acceptable morality, especially in terms of sexual liberation, and Robert and his colleagues were in the vanguard of this liberation's creative expression. The art critic Barrie Hale placed the Isaacs, on Bay Street and later on Yonge, at the centre of "a bohemia, our equivalent of Paris before the First World War, Berlin in the 1920s, and New York in the early 1950s." The Isaacs move did signal a shift of cultural focus from the Gerrard Street Village to a new nucleus of artistic activity, although many would say the borders of the village were simply being expanded. It was Av Isaacs's intention to promote Canadian art and artists out of his instinctive response to the need for "self-exploration" in a country that, approaching its one hundredth year of existence, was "ready to consider the possibilities of a new visual expression for nationhood in the 1960s, as significant as the association made between the Group of Seven and the Canadian landscape decades earlier."

Av may have continued to make the "best frames in town," but it was his crucial vision, first articulated in his Greenwich Gallery manifesto, that he carried with him to Yonge Street. That vision would provide a context for his dealings with the growing *community* of artists who, while sharing with their older colleagues "a high regard for the physical properties of paint and an expressive brashness ... were more part of 'the scene.' They frequented the same anti-establishment bars and clubs, as well as one another's studios, talked about books, and shared a passion for music.... this new and youthful Isaacs group, confidently innovative, soon represented the leading edge of avant-garde art in the country." Ihor Holubizky writes, "The Isaacs Gallery was their Pantheon, somehow imbued with their collective energy and able to deliver the joy of sensory as well as intellectual experiences." The impact on the art audience was undeniable, as filmmaker Cynthia Scott emphasizes: "Walking north on Yonge Street, except for Britnell's bookstore across the way, seemed utterly lacking in pleasures or culture ... in the good sense of the word. Then I was in front of it—the gallery. Even as I walked in, I felt the tremor and the Canadian

landscape shift. Inside this place were contemporary perceptions, energies, a pulse I did not know existed."

By the mid-1960s, however, Barrie Hale and Ian Carr-Harris would suggest, for different reasons, that the heady times had passed—Hale because Toronto galleries began to exhibit more international, and mainly American, art, and Carr-Harris because he believes "the male-centred notion of the heroic individual" artist failed to come to terms with the social and political realities of the 1960s and with the fact that cultural "identity is not necessarily portable." "What was required," says Carr-Harris, "was not artistic vision, but cultural critique." While the artists themselves could not control the marketplace, leading Gord Rayner to say in 1968, "I am a happy has-been at the age of 33," Carr-Harris, writing in 1992, somehow overlooks artists' participation in such communal activities as the Isaacs-sponsored "Stop the Spadina Expressway" movement in 1970, which did not emerge wholly formed from the foreheads of one-dimensional misogynists and which was instrumental in preventing the construction of interchange ramps and access roads that would have scarred the landscape of the Oasis. Nor does he consider the posters created and donated by Robert, Gord, Harold Town, and others in 1972 to the Browndale Camps to raise money for emotionally disturbed children, or the 1966 letter from the art director of Warrendale, an Ontario centre for such young persons, thanking Robert for his "present of paper to children in our art centre." Carr-Harris would also appear to dismiss the vital cultural critique of establishment mores at the heart of the struggle of the Dorothy Cameron Gallery in 1965 to protect erotic expression from scorched-earth accusations of pornography. What Robert was trying to accomplish with his art was deeply connected to this struggle, and his aims had much to do, despite Carr-Harris's views to the contrary, with "women's freedom.... women coming out of their own bodies and taking their own shape and going back into their own bodies again." That Robert saw clearly the relationship between his work and what was going on in the world during the mid-1960s is especially revealed in his comments to Patrick Watson when interviewed on CBC television's *This Hour Has Seven Days* about the charges of obscenity against his drawings in the Cameron Gallery show: "The same day or that weekend [May 21–23, 1965], *Time* magazine runs a photograph of a Vietnamese with his head chopped off—what's going on? ... And I'm talking about love and something beautiful and they lock me out."

Whatever his involvement with the Isaacs and the Toronto cultural scene, Robert pursued his own singular vision in his art. In his February

1979 interview with Joan Murray, he considered the nature of erotic expression with which he was engaged for his entire career, and which in the early 1960s the figure of the stripper came to embody:

> I'm not motivated by tissue or the skeleton or muscles or any of that stuff. I'm really motivated by the aliveness and the enormous energies and electricities and excitement of the figure.... Now whether it comes out in explicit drawing or whether it comes out in a very, very vague veiled kind of large painting which ... brings on itself other considerations ... it's still there.
>
> I used to give an exercise at school with drawing where I'd have the model take a very sensuous pose—lying on her back.... It was like many of the drawings that I've done with one foot up and that kind of thing, and it would be like one pose and I'd say, 'Right now I want you to draw this figure as if she's just waking up. Then draw it like she's just been laid, draw it like she's waiting for her lover, draw it like she's had good dreams.' In other words, it's exactly the same pose, it doesn't change what the artist puts into it and what he wants to do and how you draw it, it's exactly the same set of circumstances. Now you see, that's erotic art. Erotic art is not pictures of people fucking, erotic art is not all that.... In the Louvre I some huge paintings by Delacroix and all those guys in which ... a woman's foot or ankle [was] painted so tenderly and so beautifully that that's what it was about, and that is erotic and that's what I want to do.

At the heart of the erotic was the movement of the female figure, and in particular the dancer-stripper, not in an explicit, sexually obvious fashion but in ways that "made her flesh change shape, becoming a true expression of what she was." He wanted, as he said, distinguishing himself from Michael Snow, not "to turn the figure into a recognizable module, an image that would sum up for him the problems of figure as content in such a way as to give him absolute control," but to "build a vision around constant change, the figure moving, falling, seducing. She left real traces, and I was interested in what might be done with those traces." The crucial complicity between artist and figure depends on a mutual recognition of need and self-aware response each to the other. Robert articulated this *sharing* of space and expression in his ironically titled 1989 essay "The

Painter and His Model." In this piece, which could with equal validity have been called "The Dancer and Her Artist," speaking of his relationship to the stripper in the topless bar as artist model, he was also describing himself as artist in the studio: "She moves with an amazing and splendid fury, fighting, in that bleak interior, not to win a point, but to preserve her very existence." When he added, "the Artist understands the event, he makes it his own by entering into her celebration, by leaving his," the male and female pronouns could readily have been reversed. In a 1985 application for a University of Calgary project, he stated unequivocally, "My imagery has always been the figure *as a point of departure*" (emphasis his), stressing that the moving female did not belong to him in some controlled manner, because she was, like him, an agent of her own presence and absence.

In the mid-1980s he began to place his own profile in his paintings, not to indicate that his eyes grasped everything but so "the male gaze [itself] becomes an object of scrutiny." Artist, stripper, *and audience* became one in their "dialogue or polylogue" to break down gender, class, and other barriers of privilege. In other words, who could tell the dancer from the dance? But in the early 1960s, long before his direct appearance in his own work, Robert was attempting to convey "empowered manifestations of the female that [were] celebratory rather than sinister." When he said that back then he had eschewed the classical-academic approach to his subject matter, and "wanted to do a figure that just wasn't there," he meant, among other things, to avoid drawing an essentialized dancer-stripper perceived by too many as seamy and without self-respect. Who *was* there was a "heroine, a giant [who] had strength and the courage that comes from a real sense of herself. And she let me share." He reminded himself of the fragility of these heroines when he went backstage at the Victory and the Casino to talk with "the wonderwomen of the strip." What he found was that the "constant state of daring" might have been something upon which he could build a vision, but that for the women themselves there were "too many corners sheared off too many dreams." In his 1977 *Toronto Life* essay "The Moral Shape of Sexy Sadie," he wrote, "There is a space, a distance, between men and women that has no culture, only a mysterious emotional life. Within this space compassion lies side by side with violence. It's a strange and devastatingly lonely landscape, the only topography I find worth mining." The artistic results of such mining could be worthwhile only if the artist's physical desire for the dancer could be "conquered," so that desire could grow into the "romance" of expression for both. The basic sexual charge of the stage/studio encounter was never denied: "Sometimes my work is like a one night stand: necessarily honest,

often brutal, never polite." It's just that "often … an image of astonishing beauty will occur, transforming the ordinary into the sublime."

His awareness of the stripper as artist certainly had its roots in his visits to Buffalo's Palace Burlesque, where he saw Lily St. Cyr "come on stage absolutely naked … take a bath, and then put her clothes on, and end up her act fully clothed, and it was just as erotic as the other way around." His own role as artist was intimately bound up with the dancer's when, in those early burlesque days, he first "wondered if paint and charcoal could ever retrace the life of breathing flesh as it articulated its dominion of space and time." Perhaps it was then he realized that to be commensurate with those of the stripper his works would often have to seem like acts themselves. His admission that he couldn't do without this muse figure— nor she without him—is contained in their shared condition as artists who cannot escape their very human condition: "I wouldn't have to do anything else if I could do a drawing so sensuous that I'd never have to see another woman again, if I could paint a picture so erotic that I'd never have to fuck again." Since this isn't possible, the two partners in creativity, to paraphrase singer Peggy Lee, have to keep painting/dancing.

The surmise is endless, but Robert's encounter with an Arthur Murray Dance Studio instructor may have sealed his fate before he left Hamilton for OCA. At a fair he won $150 worth of lessons at the local studio, and when he stepped onto the floor it was "the first time I held a really beautiful woman in my arms." Just as there were steps to be followed, there were social codes in place to keep the teacher and her student at a distance despite their fairly intimate contact. She was teaching him something of the art she had mastered, and he could hold her for a while, but then he was on his own, trying to keep the rhythms and results of those steps in his head and translate them for another kind of partner, his audience.

While he often sketched in the bars and strip clubs, Robert did his real work in his studio from memory and with a female figure constantly at hand. Marlene became the dancer whose movements he could shape, while the one on stage left her own traces in his head. Marlene's ready participation in this creative process furthered the collaboration necessary for the artist to *see* what he wanted to draw or paint and also to transfer this vision to paper or canvas: "On one wall of my [Spadina] studio there is a series of photographs that seem to be the substance of everything I've been doing, or talking about…. It's a series of black and white shots of my wife rolling to my directions on a flowered blanket, she's against a white wall, with her head towards me and the camera, she's nude, and she's choreographing her body in such a way as she moves and as I click

off the pictures, she reveals to me the kind of figure image that she knows I'm searching for." Indeed, it was the very familiarity of Marlene's body, along with her willingness to wear the stiletto heels and boas of the stage performer, that complicated the artist–model relationship: "And this seems to be a good time to introduce the enormous role my wife has played in my life's search for the figure. I've been told, countless times, that the figure I see, the figure I eventually use, is simply a confirmation of what I'm already living with, that it is my wife's body that consumes me, and that all my so-called searching is no more than confirmation of its worth." Sometimes Marlene became the performer herself in the painter's imagination, blurring the line between strip club and studio:

> Good afternoon ladies and gentlemen and welcome to this
> our second show of the day. the management of the victory
> theatre, toronto's one and only home of fine burlesque has
> for you today a fine lineup of beautiful girls from all over the
> world, and each one of them I'm sure will do their utmost
> to entertain you. and remember, the more you show your
> appreciation, the harder these girls will work for you. the
> more you give, the more you will get, and some of the girls
> we have here today have a lot to give. well, we have a big
> show for you and let's get right to it, let's have a nice round
> of applause for the beautiful and exciting, direct from new
> york, the beautiful … marlene!

Sometimes Robert just focused on who was in front of him: "the paint charcoal paper there ready, eyes take her in and so … the line grows my hands moving the charcoal moves across the paper first the line, up the leg the muscles all strong and fine bulging up to the knee over across and down … I look and the line now to the hip striped suntan and the belly round the tight stretch rib then the breast over the nipple tough erect now into the arm neck head hair end of paper … there's only one marlene …"

Dennis Burton's claim that "We knew [Marlene] could draw and everyone respected her [for that]" is called into question by Gord Rayner's admission that the Isaacs group of male painters were "blind to creative women's tribulations." Painter and feminist Rae Johnson attests to this blindness when she refers to the "misogynist undertone" in their put-down of Joyce Wieland, "who was "just as brilliant" as her more famous husband, Michael Snow. Whatever the case, Marlene stopped drawing when she

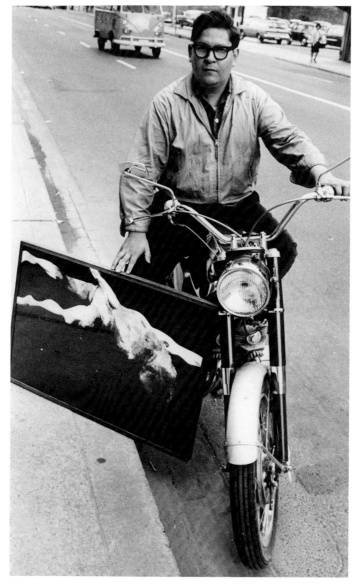

Robert on his motorcycle with painting, Toronto, 1963

and Robert left OCA and became a muse who never quite believed in her own beauty, as if perhaps it couldn't replace what had been surrendered. "I regret I didn't enjoy myself as much as Robert enjoyed me," she says, but emphasizes she has no regrets about *her* choice based on her belief in his vision and talents from the very start.

Without disputing Marlene's importance, Gord Rayner is critical of the concept of the muse and, implicitly, of her in this role. For Rayner, the muse is a "simple symbolic abstraction like a bearded God that sits in Heaven until you discover she isn't there." He suggests that Robert "didn't have to adjust enough to what his women wanted to do," and so could romanticize them without question. Furthermore, in unromantic fashion, Rayner points to a basic male reality behind Robert's haunting of the strip clubs: "Robert saw strippers through really sticky, smoky glasses. He had a hard-on and fantasies about them, and went to the Zanzibar [and other clubs] because it turned him on…. He wanted to make art and women were a medium." Hana Trefelt also places Robert's response to burlesque figures firmly in the "excited male" category but stresses that the result was "not misogynistic work." Vera Frenkel, who later gained international fame as an installation artist, met Robert in the late '60s "at the height of my feminist consciousness," and took him to task for what she saw as his exploitation of Marlene. To her, despite his very powerful and erotic images, he was a male artist painting naked women on "a level of display more intimate than I thought was acceptable." She decided that Marlene, muse figure or not, was "being betrayed by the combination of his using her as a subject/creature" but admits that gradually "my sense of betrayal shifted into my sense of the work, since she accepted it." For Frenkel, the work revealed Robert as a major artist whose creative efforts didn't eliminate gender issues but left them unresolved: "He was as close to a Zen master as a Western painter could be. His brushwork was so intuitive and immediate. He painted in the moment … and gave himself to what you were seeing." This high praise is reflected in Dennis Reid's comment that Robert's calligraphically based figures were a "language of visual poems or songs." If the dancer-muse was a siren embodying those songs, Robert was what Reid calls "an artist of tone," a voyager through "degrees of darkness and light" into an understanding of what Rae Johnson refers to as "the emotional content of the figure." For Johnson, a student at the New School of Art in the mid-1970s, what outweighed the limitations of Robert's purposefully mocking question to her—"Who do you think you're going to be? Emily Carr?"—was the feeling that he conveyed, through his fearlessness about his work and his love of life, that "anything was possible."

From 1961 to 1963 Robert produced his *Burlesque Series*, a large number of charcoal-and-tempera-on-paper drawings of dancer-strippers classic in form, recognizable beings evoked by line and shadow and caught in pose-

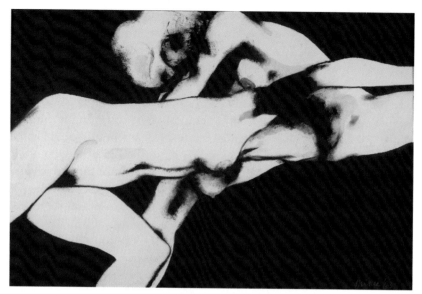

Lovers II, 1963 (tempera on paper, 58.6 × 89.1 cm)
COLLECTION ART GALLERY OF ONTARIO / PURCHASED WITH FUNDS DONATED BY AGO MEMBERS, 2001

like positions that suggest movement has occurred and will occur again but not in the viewer's moment of encounter (see page 50). Their faces are usually turned away or hidden, but breasts, thighs, and arms are fully realized. Their presence is amplified by Robert's shaping of them out of the white paper that remains after much of it has been blacked in, and by the bleeding of the blackness into the whiteness at strategic points of contact, such as the cleft between breasts and between buttocks or the backs of knees. Not in the series but altogether memorable is the stylized, almost sedate, *Lovers II*, which would gain notoriety in the Cameron Gallery raid. Here two tempera figures with elongated torsos and limbs merge where one's head seems to meet the other's open crotch, activity deemed by the magistrate at Dorothy Cameron's trial to be akin to gross indecency "if practised in the community." By this he presumably meant if practised *at all*, since it is unlikely anyone would engage in such an act publicly. But there is a gentleness of form and line in the confluence of bodies that belies the judgment of indecency, and rather than the obscene lesbian exchange seen by the morally censorious, the representation of a woman "coming out of herself," as Robert suggests, has much more to offer.

Av had shown these new drawings in the large group exhibitions at the Gallery in 1961–62, but it was not until April 27–May 12, 1963, that Robert had his first solo show at the Isaacs—mainly, Av says, because "he

could never seem to get himself ready." Many of the twenty to twenty-five charcoal and tempera drawings were from the *Burlesque Series* and what Marlene calls the "blatant, stark, black-and-white" nudes hung on the gallery walls in their 0.6-by-1-metre walnut frames under "harsh theatrical lighting." The majority of them sold for between $90 and $125 each, for which Robert received his 60 per cent after Av's commission was deducted. According to Av, publisher John Bassett bought three of the drawings but realized only a few years later what kind of women the figures represented. Elizabeth Kilbourn reviewed the show favourably in *The Toronto Star*, and Robert's already-present confidence in his work was given a boost.

Through 1964–65 Robert produced his *Falling Figure Series* in charcoal on paper. The lightness of line contrasts with the mass of the bodies suggested by powerful shadings especially on the upper torso. The focus is on the action of tumbling through space "in utterly impossible ways," as Ruth Grogan says, because "there is nowhere the weight falls." What is noticeable too is the occupation of the entire frame from top to bottom or side to side, with the head invisible behind an arm or beyond the border. Wherever the weight falls, the impression of gravity is very strong—the figure has come from above and will soon disappear below. As much as any rendition of it, these pictures are Robert's illustration of the de Kooning maxim he loved so much: "Content is just a glimpse." If they maintain the curved and flowing energy of strippers' bodies, the figures are not in high heels and G-strings; there is no obvious performance aspect to their movement, except insofar as the model has arranged herself and has been rearranged by the artist's vision to convey the possibility of dancing in air. Several drawings in the series are titled and numbered *Marlene* (as in *Marlene III*, 1964), an homage to the singular shape that served as Robert's "every body."

Nothing he had previously done prepared viewers for the lithograph *On the Runway* and the charcoal-and-tempera *Paramour* in 1965. In the former, a near-Gothic duplicated nude figure stands in high heels with arms upthrust, one hand holding a streaming boa or flaming torch (one becoming the other, it doesn't matter which) in front of a nebulous, perhaps menacing shape (white fire or her discarded costume) that might devour or protect her. Occupying and threatening to break through the framed space, the "emotional content" of this work is palpable and marks Robert's development as an artist.

Paramour provides to the unthinking viewer nothing more than an explicit sexual pose, with the white female figure emerging from the

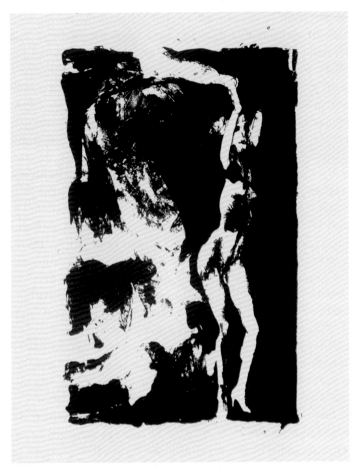

On the Runway, 1965 (lithograph, 55 × 35 cm)
IMAGE TAKEN FROM SLIDE

upper half of the blackened paper, her legs spread as widely as possible and her opened crotch precisely centred in the framed space. For the moralists, this is the lascivious display of the stripper without restraint, all she really has to offer in the end—in-your-face sex rather than a coy display to the viewer. There is no doubt that the sexual candour of the drawing is intentional. Robert saw nothing shameful or pornographic in what he called the "tough black cunt," only in the hiding of it, "an act of self-destruction." As for presenting it to those who would never enter the burlesque hall or strip club, "Art is not art unless it threatens your very existence." However, there is much more to the drawing than blatant sexual exhibition. The figure's face, directly above the crotch, offsets

the apparent aggression of the opened legs with a self-contained expression that looks thoughtfully away to the lower right of the frame, clearly not preoccupied with any perverse readings of lower body language. Her right arm emerges from forceful shading to cross her stomach above the crotch in a restful gesture that confirms the figure's comfort with herself. This is not a rendition of poet Wallace Stevens's "body wholly body / fluttering its empty sleeves" or, for those who would condemn *Paramour* in the Cameron Gallery raid, empty "female genitalia." This is, as Robert's title indicates, a lover through whose body is glimpsed a depth of being that deserves embrace.

After his one-man show at the Isaacs, Robert gained further attention as part of an exhibit the same year at New York City's Banfer Gallery along with William Kurelek and two others. In 1963 he contributed two works to the Exhibition of Contemporary Art of the Americas and Spain, these chosen by a Spanish curator who also selected pieces by Coughtry and Town. Another large group exhibition took place in March 1964 at the Isaacs, and in January 1965 the gallery showed Interim Works by Four Artists: Rick Gorman, Michael Snow, Joyce Wieland, and Robert. Av, somewhat impatient with Robert's rather deliberate progress, never saw him as a "breakthough artist" but as an artist whose work was constantly evolving and becoming more accomplished. Gord Rayner says Robert was "very interested not in perfecting but in developing his technical abilities to an extremely high standard"—technical abilities to do with such things as "touch, putting the brush on in certain ways, learning to stop." He was taking his own time, but his star was certainly rising when the raid on the Eros 65 show at Dorothy Cameron's gallery, two doors north of the Isaacs, created a perception of his art he would immediately confront and struggle to transcend for the rest of his career.

John Reeves describes Dorothy Cameron as an "amazing animator of opportunities for contemporary artists" who had introduced Quebec artists like Micheline Beauchemin and Yves Gaucher to Toronto. Her gallery "catered to the WASP *avant-garde*," wrote Kildare Dobbs, and, Reeves adds, "she showed art she thought people should *see*, not what she could necessarily sell." In April 1965, Dennis Burton had an extremely successful show at the Isaacs that showed women in various stages of undress and focused fetishistically on garter belts in stimulating display that was sometimes essentially sexual, sometimes more revelatory of generational and personal style. In May, Cameron decided to hold a show titled Eros 65

that would include some Burtons, Towns, Markles, and others, and to place a sign in her window that read "Adult Viewing Only." The catalogue stated the show would present love "in its various forms, normal and perverted," and claimed that the gallery took "no moral stand on the work presented—simply an aesthetic one." There is no doubt Cameron, a skilled publicist, wanted to provoke attention. The gala opening night was attended by a large crowd that included Toronto celebrities such as Pierre Berton, and prominent reviews appeared in the weekend papers. At the show itself, one attendee was Peter Rickaby, the city's Crown prosecutor, who didn't like what he saw of open-door sexual material and called in the police department's morality squad. Cameron was asked to take down one Markle piece from the wall. She refused, and charges were laid. Rickaby was to make his own case in court. Five of the seven drawings seized were Robert's, including *Lovers I*, *Lovers II*, and *Paramour*. In straightlaced Toronto at that time, words were one thing and visual art another. You could buy a copy of *Lady Chatterly's Lover* at Britnell's and elsewhere, a freedom established by the Supreme Court of Canada in 1962. But visual art supposedly left nothing to the imagination. Robert's "crime," according to Rae Johnson, "wasn't the nudity, it was that he had the audacity to expose sexuality, not the airbrushed replica of women in *Playboy*, but the fecund beauty of sweat and flesh and pubic hair." For Rickaby, what Robert had done was akin to performing a sex act on the City Hall steps, where it became "indecent and obscene."

It was the May 24th long weekend, and the morning after opening night Robert and Marlene hopped onto their Triumph 650 and rode down to New York City. On the advice of Michael Snow they stayed at the Van Rensselaer Hotel, on East 11th Street, in a "huge room with a tiled bathroom out of the 1920s." They visited the Museum of Modern Art, the Guggenheim, and private galleries, and were "blown away" by what they saw there as well as by the energy that flowed along New York streets. They ate at the Horn and Hardart automat, which they called "Horny Harry's," and drank Orange Julius from stands on the teeming sidewalks. At night they strolled along 42nd Street and through Greenwich Village and later watched Sonny Rollins from "only three feet away" as he played his sax like the jazz colossus he was. When they got back to Toronto on the Tuesday morning, the papers were full of the Cameron bust and Robert was famous in a way he had never anticipated.

Neither Cameron nor the artists were arrested, but she was charged under the Criminal Code for exposing obscene pictures to public view. Her acerbic response threw down the gauntlet to her persecutors and

the persecutors of contemporary art. She declared the police were "servants of a dirty-minded public who see filth where it doesn't exist." Magistrate David Coen, chairman of Ontario's committee on obscene literature, supported her when he appeared on a Toronto television news program and stated that *Lovers I* was "not obscene." Indeed, the drawing had "already been reproduced for the July issue of *Canadian Art Magazine*, which [would] be sold across the country." *The Hamilton Spectator* tracked down Robert's mother, who not only defended her son but criticized the media's attention to sensationalism rather than talent: "'She said,' says Markle, 'that my son has been painting in Toronto for twelve [sic] years, and that she thought it was outrageous that this was the only time his hometown newspaper took any notice of him.'"

The trial, on October 5–6, was, as Robert Fulford wrote, "a comedy of mutual incomprehension." The prosecution, led by Rickaby himself, saw *Lovers II* as the grossly indecent depiction of "a nude woman, laying [sic] on her back with her legs open and another woman with her head face down in the other woman's female genitalia area." "Perhaps a photograph or drawing of an act of intercourse is not itself obscene," Rickaby argued, "but if put up on a billboard, then it is a different matter and becomes obscene…. the essential quality of an act of intercourse is the *privateness* of it." The defence brought in expert witnesses, but "with the exception of critic Harry Malcolmson, who candidly opines that some of the pictures are 'gamey' and that the title Eros 65 was adopted as a come-on for the offending show, the experts are unable to see that the pictures have much to do with sex." The merits of artistic form rather than subject matter were underscored. For example, the director of the AGO, William Withrow, referred to the pattern of dark and light. "The flamelike figures as they flicker across the surface, the highly abstracted forms, put an emphasis on pattern."

But in his November 25th judgment, the magistrate, Fred Hayes, would have none of this abstraction and concluded, "There is in each exhibit an excessive emphasis on the theme [the undue exploitation of sex] for a base purpose." Cameron was fined $50 per guilty drawing—not a heavy financial punishment. But there was more at stake here than money, and she decided to take her case to the Ontario Court of Appeal. There she lost, and, despite a benefit held for her at the Park Plaza hotel, she lost her gallery too, because of the legal costs involved. She wasn't, as she said, "Joan of Arc," but certain puritan judges had certainly burned her at morality's stake.

The day after Hayes's judgment was handed down, Robert told the *Toronto Telegram*, "In no other area of endeavour could a layman make

his own opinion felt in this way." Alan Jarvis, past director of the National Gallery of Canada, was appalled: "You might say that Canadian art has been struck a sickening blow by a blunt instrument." Harold Town's eloquent invective went further: "At what precise moment was the Gestapo born? Where did the Inquisition begin? Who first thought of Siberia and where does one go to get a degree in the certification of obscenity? To that dark corner of the mind where tyranny is born."

Such public declarations made no impression on polished court benches. The rather predictable Court of Appeal response is summed up in the words of the justice who wrote the majority decision: "They [the works of art] lie not in any gray area of doubt; they are of base purpose and their obscenity is flagrant." What is interesting, however, is the opinion of the one dissenting judge, Bora Laskin (who would later become Chief Justice of the Supreme Court of Canada). Laskin wrote eloquently of freedom of expression under the law that must take into consideration "that individual creativity … in art … gives measure to our culture." He also showed a critical nuance in response to the art he saw in court, though Magistrate Hayes would have lumped him with the other "experts" who couldn't see what was right in front of their eyes: "Any gross sexual aspect became dissolved in the forms of the figures, their movements and spatial position, and in the relationship achieved against the background of the tones of the drawings. To me, at any rate, some of the Markle drawings have an abstract character." That Laskin had not turned away from the human exchange was indicated when he daringly raised the issue of "love" in the drawings, wondering why none of his colleagues had considered the possibility of its presence. *The Globe and Mail* had already indicated that Robert's work deserved a more complex response than Rickaby, Hayes, and their like were prepared to provide: "The dominant theme [of Markle's drawings] was the human figure, human being, the soul … in the world today attempting to form at least temporary communication with another human being."

Since Laskin's dissent had not been framed "around a point of law" (359), there could be no appeal by Cameron to the Supreme Court of Canada. It's regrettable that the judge and the artist could not have discussed art further over a few beers—not in the staid Osgoode Hall lounge, where they would have maintained their official roles, but in a more relaxed atmosphere in which Bora and Robert could have come out of the closets society had designed to keep them in the dark about one another.

The media had been paying attention to the legal procedures and the issue behind them, and on February 6, 1966, Robert appeared on tape

(with Graham as his silent partner) on CBC Television's *This Hour Has Seven Days*, hosted by Patrick Watson and Laurier LaPierre. The half-hour interview was edited down to seven minutes, but in the broadcast tape Robert defended his work directly and metaphorically against charges of obscenity. When Watson asked him if his drawings were erotic, he replied, "I certainly hope so." He went on to explain, somewhat elliptically, that just as "a sunset [is] designed to get the sun to go down, yet it can still arouse you ... I want to move people, I want to reach them, touch them." He said he had every intention to arouse sensuously, not sexually. He wasn't surprised that certain people, responding to his specific illustration of the breasts, legs, and thighs of two women touching, would see lesbian activity, but the magistrate's point that it wasn't necessary to put these figures in these positions to achieve artistic merit "shouldn't be an issue. What he's really saying is that if I had separated the figures ... it would be all right if they didn't touch.... Just a little eraser.... Would that have been okay?" He then makes his telling statement about the decapitated Vietnamese man in *Time* magazine in comparison to his efforts to portray "love" and "something beautiful." Watson later described him as a "teacherly uncomplicated self." It was the beginning of their close twenty-five-year friendship.

The Markles's daily life had become at once more simple and more complicated. In 1962 they had moved to a new home at 1 Webster Avenue, near Davenport and Avenue Roads. Here for $125 per month they had the second and third floors of a house with a studio upstairs and bedroom, kitchen, and living room below. Marlene was now making $60 a week at the Isaacs, and the price of food was still cheap if they ate at home, so they were reasonably comfortable, especially when Robert made some money from his art. Whenever he did so, much of the extra income went into "new toys," like the 250-cc Honda motorbike purchased after the 1963 solo show or increasingly sophisticated sound equipment in the form of a Harmon-Kardon tuner-amplifier or Thorens turntable. Marlene admits they didn't know much about finances. When they took out a loan from Beneficial Finance, for example, to buy the sound system, they were surprised to learn they'd have to pay interest on the interest for any late payments. They liked to frequent the cinemas, such as the New Yorker on Yonge and the King on Vaughan Road, that showed French New Wave features by Godard and Truffaut and films by Kurosawa and Chinese directors. Some Sunday afternoons, they would walk up and down Yonge between Bloor and Queen and see the B horror movies out

of the Hammer Studios by Roger Corman and others. On the odd Friday night they would go to Jack and Esther's for chicken dinner and next day hitchhike to Hamilton, where visiting Robert's family was "like walking into warm Jell-o." On the Saturday nights they were home *Hockey Night in Canada* was the television ritual. Friends like future MP and senator Peter Stollery would come over for cheeseburgers, french fries, and beer, and they'd root ferociously for Punch Imlach's Maple Leafs. Robert and Marlene went to a lot of Leaf games at Maple Leaf Gardens, paying $2 each to sit high up in the grey seats, or getting better tickets from scalpers and occasionally from Av's brother.

A significant aspect of this routine was Robert's socializing at the Pilot Tavern, located just north of the Yonge–Bloor intersection since 1944 and a block from the Isaacs. Most days he would work in the studio then drop by the Isaacs in mid-afternoon to see Marlene. The beer-drinking was usually well under way by 5:30 or 6 p.m., when the gang would have gathered—Graham, Gord (who in the early '60s lived on Yonge Street just a couple of blocks up from the gallery), Rick, Paul, and numerous friends and acquaintances. Dennis Burton said he "couldn't handle their amount of booze" and would leave early, and so would Nobi Kubota, who had a "straight job" with an architecture firm and had to rise early in the morning. Budding actor Michael Sarrazin, who for a while worked in the 3 Sevens Restaurant across the road, would turn up after work. Patrick Watson was also often there, and says the regular "drinking was not just a release but almost a status or a project [as] they rejoiced in their outrageousness together, nourished by mutual affection." Later, Robert would write, "Harold Town would stop in sometimes and want to take one of us outside. He had a habit of calling us 'the world's oldest, floating avant-garde in the history of art.'" Group of Seven member Fred Varley would often sit alone at a table by the door. One afternoon in January 1961, Robert and Gord went up to him and, to his surprise, wished him a happy eightieth birthday.

Marlene would usually join the crowd for one beer and then go home to make supper, a ritual unbroken by Robert's habit of not turning up on time. "His place was always set," regardless, and she might have gone to bed when eventually he came home, which he always did. He would ride his bike the short distance to Webster Avenue and park it under the rear balcony. Once it was stolen but returned "in pieces" and put back together after the theft was reported to his biker friends.

Marlene was concerned about his drinking, especially because it often "cut us off from one another." Robert could get drunk very quickly and go

off in another world listening to music. If he didn't go to the Pilot in the afternoon, this was frequently how she found him when she arrived home after work. But she never nagged him about it, and there were "no fights because neither of us were good fighters" and "he wouldn't have changed anyway." An even more difficult problem was that there were other women in Robert's life, from the beginning of his relationship with Marlene. She finds it difficult to explain her tolerance for this except to say that from childhood she determined that people should be free to explore if they weren't hurting anyone. Her own pain was contained by the respect she held for his artistic life, which expanded such exploration, and by the love she had for him: "As strong as he was in many ways, he was very frail in others, and I never wanted to challenge that.... He was easily, deeply hurt." Robert always told her she was the hub of his existence, and even while he was involved in a nearly six-year relationship with a married woman, from the early to the late 1960s, he came home to Marlene every night.

Not surprisingly, his male friends and the women he knew with whom he wasn't involved respond somewhat differently to his amorous adventures during this time. Most of the men tend to talk of what Robert got from Marlene and stay at a distance from judgment. Gord Rayner says, "Marlene tolerated a lot," and Harvey Cowan proclaims she "gave him a lot of room and he took it." John Reeves speaks of her "unusual supportiveness" and stresses that Robert's "promiscuity was autonomous and not out of dissatisfaction." Av Isaacs sees her as "his muse who took care of him," though it's important to note that Av "resented" Robert's treatment of her. Once when he brought up the subject of Robert's affairs, Marlene told him brusquely, "That's something we'll settle between ourselves." Don Obe and Patrick Watson do approach the complex nature of what was going on. Obe states that although Marlene "indulged him totally … he would have put himself in a lot more dangerous situations without her," and Watson says that while Robert "had somehow perceived that his home life with Marlene was almost indestructible, so he could violate the integrity of it … he had an enormous sense of guilt." Watson also stresses that Marlene was "her own person" and "not victimized" by Robert.

On the other hand, the women are concerned with the impact of his conduct and Marlene's acceptance of it. Ruth Grogan thinks of Marlene back then as "immensely romantic and dedicated to his genius.... she forgave him because of art." Helen Poizner pulls no punches when she states that "he was mean-spirited to Marlene.... Never in all those years did she mouth a word of criticism about him or his activities," though she admits "he really loved her. I can see that now." Hana Trefelt bluntly

asserts, "She acquiesced to him constantly. His personality was very strong," but adds, somewhat paradoxically, "He was the baby who ordered and she accepted it." Vera Frenkel, as already mentioned, saw Marlene for quite some time as "betrayed." Ruth Grogan describes as "deliberately perfectionist behaviour" Marlene's maintenance of home rituals and schedules that were expected but constantly damaged by the ragged actions of her artist husband. Perhaps her actions were an attempt to frame her own experience in ways that would match the resolute drive of Robert's creative expression.

Graham Coughtry and Gord Rayner were Robert's closest friends during the early 1960s, and although others, such as Patrick Watson and Michael Sarrazin, soon became important fixtures in his life, the refiner's fire of their shared artistic experience was at the heart of his deep love for the two painters. Marlene describes Graham Coughtry as a handsome Oscar Wilde dresser in paisley vests and long scarves. Robert called him affectionately a "tightpants dandy." Coughtry's gentle sense of humour went along with his looking at the world through "half-closed eyes" and balanced Robert's more aggressive, direct-stare ironies. Harvey Cowan and Don Obe point to his soft-spoken, often shy presence in conversation; in this he was the opposite of Robert, who usually went loudly for the jugular of any subject. Robert Fulford confirms this view and touches on another matter of character: "Coughtry was quiet, sweet-tempered, and not notably ambitious." Av Isaacs says Graham was "not as self-disciplined as he could have been," and Harvey Cowan views Graham at times as coasting on his laurels. He didn't seem to waste his time away from the easel, however, as he was very well read, especially in poetry (he loved the work of the thirteenth-century Persian poet Rumi), and he was initially an intellectual mentor to Robert. Vera Frenkel emphasizes that when Graham was away in Ibiza, "his absence was a felt absence, and he was talked about in every conversation" of the group. There could be no doubt as to his talent as a painter. Elizabeth Kilbourn, in *Great Canadian Painting*, states that Coughtry's November 1961 show at the Isaacs made him, "almost overnight, one of the most celebrated painters in Canada." Of his *Two Figure Series* exhibition at the Isaacs in October 1964, Harry Malcolmson wrote, "The sustained energy and concentration of this tour de force is unprecedented in Canadian art, and with the exception of certain of Picasso's efforts, I can recall no similar examples of such virtuosity in modern art." British critic Charles S. Spencer, reviewing the National Gallery of Canada's exhibition

of Canadian painting at London's Tate Gallery in 1963, said of Graham's work that it was "Francis Bacon without the crazed anguish."

If Graham started out as a kind of "older brother" to Robert, they soon became equals, sharing a high regard for abstract expressionism and a passion for jazz, and valuing the exchange of ideas on a great many subjects as well as painting. They were both expressionist painters of the figure, and what Graham wrote about de Kooning for his own 1976 retrospective at Oshawa's McLaughlin Gallery, Robert understood implicitly: "The thing about de Kooning that has always been important to me is the way he turned the image into an actual way of painting, spread it all over the canvas, and still retained traces of what the image was to begin with; it's a marvellous combination of seeing and then having an emotional response that is translated into a way of painting."

Gord Rayner says that Graham and Robert were both romantic in their work, but Graham was a "lover of great juicy paint" while Robert quickly began going "somewhere else" with his black-and-white strippers: "I suspect he had a conscious plan to simplify." Despite their distinct development as artists through the '60s, a deep personal bond persisted. "Where does graham stop … and I begin," Robert wrote, and when Graham was gravely ill in hospital from heart disease in the 1970s, he provided a moving paean to their friendship:

> Daylight leaving, and I think about us because I can't see
> him there alone. I see myself there with him, and I see
> in this atrocious time just how our lives are so entwined.
> This danger is like a charged magnet, we spring together,
> again edges dissolving. Up until now we lived our lives with
> a healthy space between us. He had a way with the world,
> and he had his way of explaining it. He taught me so much,
> gave me so much, we saw things with a growing sharing, we
> felt things with security. And now, as I watch him dangling
> on the ends of tubes and machines I want somehow to link
> up with him now that he [is] in so much need, to somehow
> take those terrible tubes and with them give him anything
> I might have that might help…. *where would I be without
> him?* And he knows that my kind of arrogance couldn't or
> wouldn't conceive of any Life of Art without him. So I'm not
> surprised when, for no apparent reason other than will, he
> wakes, turns, and welcomes me.

That welcome on Graham's part was certainly full of feeling. When Robert was hospitalized after his motorcycle accident, in 1969, Graham would do a series of caricatures of Robert-as-patient done up in extravagant bandages and casts and surrounded by stiletto-heeled women. On a more serious level, in the fall of 1967 he wrote to Robert from Ibiza, "Find a way here because you need it and we need you to make it complete," but the most extraordinary indication of his love for Robert was offered in the same letter when he quoted a line from the Persian poetry he knew so well, most likely from the thirteenth-century *Mantequ't-Tayre* (The Conference of Birds), by Attar: "The tyranny of the grief of separation from the nightingale is extending its clamor to the pavilion of the rose."

When Marlene met Gord Rayner, he was "flamboyant, gregarious, and energetic." He liked to seduce women and tried his charms on her, buying her lunches and talking about their having an affair. But when she reminded him how much Robert valued their friendship, he never persisted. While Hana Trefelt feels that Gord didn't respect women, Vera Frenkel views him in the 1960s as a "tough teddy bear, all machismo," and Patricia Beatty states candidly, "Gord had balls." To Harvey Cowan, he was a "shit disturber" who liked to break the rules, and Don Obe indicates he did so through "strongly expressed opinions and great punning ability." Whatever one thought of him, Gord was making waves as a painter.

He didn't have the formal training that Graham and Robert had received at OCA, but a number of factors—his vital apprenticeship in design and typography at Wookey Bush and Winter; the influence of Bush, de Kooning and the abstract colour-field artists; immersion in Eastern thought and writers such as Beckett and Kerouac; and subsequent travels in the 1960s to North Africa and India—resulted in an eclectic array of styles, subject matter, and media. He was particularly influenced by the boyhood summers he spent at Charlie's Place, the last-standing cabin of an original group of four by some Magnetawan River rapids near Georgian Bay. His regular returns to this wilderness retreat as an adult yielded paintings "characterized by brilliance of colour and breadth of gesture." He invited Robert, Graham, Nobi, and others to Charlie's, where the creative energies flowed: "We found rusty implements, marvellous pieces of junk, where the loggers had passed through years before. We would make found-object sculptures, place them in the fields and deep in the bush, like silent, sacred totems, only to return the next year to find them crumpled, tilted and fallen. So we'd reconstruct them differently, giving them a new existence. Some are still there, rusting in the elements."

In an unpublished piece, Robert recalled his early days with Gord as something of a clash of egos:

> well, he never went to art school, "who needs it? all you gotta do is read books on philosophy" … memorable phrases, insights, searing into my young mind on this, our first encounter, years back, we were in one those crowded rooms to reach across a sea of students-looking-for-free-booze-live-the-life-of-the-artist, one of those sound bouncing rooms that one seems to find in all the towns and cities, where you meet all the would be, will be, just you wait and see greats gather, to scream and shout art! … and ready to prove. so, first encounter, and he counters with that, and I bleary off to find solace in some skirts to think of: there is an arrogant bastard, he'll never make it …

Robert's artistic affinity with a friend he saw as occupying "his space like it was his own, a self made man," thoughtful and sensitive, is revealed in a quotation from Gord in his unpublished notes: "[Art is] really a kind of searching and finding and shedding … it's a lot of getting rid of creation, you know." On his travels, Gord would write Robert, who didn't cross the Atlantic until 1978, about the delights of Istanbul, Afghanistan, and India, telling him to read Borges's *Ficciones*, first published in 1944. Robert's response was to praise the man's action and the painter's combining of vision and lived experience: "the gordon rayner story, one long never ending act of love, passion, delight, joy … the eastern feats, sensations to conquer, and heights of fancy, fanciful fantasy … and the ever moving spectre, the good things seen, felt, pondered, to peruse the over there horizon, see the art … coming…. his eyes scan horizons, finding places for him to occupy … that's what an artist does."

Although Gord writes about Graham playing his trombone against the sounds of the Magnetawan rapids, there is no indication that the "terrible trio" brought its instruments to Charlie's Place on the mid-'60s long weekend that marked Robert's first visit. The cabin, according to Marlene, was "deep in the woods, accessible down a four-wheel drive track, and then by canoe." Robert had resisted going—"I don't eat fish and I don't like bugs!"—but they arrived, as Gord says, "dressed in black from head to toe. Leather everywhere—splattered with mud, mind you, for the [bike] had spilled on the treacherous road into camp." The one big room with bunks and a wood stove had coal-oil lamps and a battery-operated radio,

and the group, which included Nobi and writer John O'Keefe, smoked dope, listened to music, played chess, and ate the basic camp food that Graham and Gord loved to cook. They also did some art, as was the habit of the host and his guests. Robert had brought a Super 8 camera and filmed a nude Marlene in black and white as she walked through the forest and lay on rocks and in the river as part of an ongoing figure-in-the-landscape project. At night the cabin "trembled" with the sound of Robert's snoring.

Gord offers a hilarious description of a Magnetawan "baptism" that, at the same time, contains loving respect for Robert's origins and sense of ritual:

> After some three or four days and long lamp-lit nights, filled
> with boozy geniality and drawing and laugher and John Col-
> trane, Marlene quietly suggested it was bath time for the
> great Bullfrog Man.
>
> Stalwart, demanding we not peek, he strode down the
> bank to the river's edge, and, standing like totem, allowed
> his lady to slip the blackness from his head-held-high form.
> Of course we were all peeking; in fact, I recall a camera click-
> ing among the muffled giggles.
>
> But quickly there was silence, as surprise folded into a
> sense of awe. This man, this Roberto, had underneath the
> biker façade the broad shoulders of a strong Mohawk native.
> He was not at all obese, but instead was skin-tight, like a pink
> balloon, without a jiggle in sight.
>
> Slowly he dipped a toe into the river. Then further, up to his
> knees, where he stood, defiant, arms crossed [*sic*] his chest,
> while Marlene gently scrubbed him down and up. Someone
> said, "The river is sacred, once again."

While aspects of Robert's relationship with Marlene are certainly on display here, it is hard not to imagine Robert's tongue firmly in his cheek as he performed for his friends. His own memories of that weekend are a poetic tribute to his bond with Gord:

> a quick glance at that rayner north ... now gone ... that huge
> wooden remembered table there where all the dark candle
> kerosene lamplight call to creativity through all those nights
> of small drawings, charlie books and booze, catching up on

> girls-through-the-mail postcards and letters laden with the
> grand thoughts of woods and bush, the sound of nearby
> water rushing, what a place, those beautiful summers spent
> swimming and running, sun, movies we made there, and our
> writing, word meanderings … here's that table, bloodred
> with thoughts and exposed hearts, gracefully balanced on
> our sleeves.

This trip was not Robert's only exposure to the north. One summer while they were living on Webster Avenue he spent ten days teaching drawing to a group of would-be artists in Atikokan, Ontario, between Thunder Bay and Fort Frances. Marlene reports that he "loved the wilderness," though not to the extent that he mentioned this trip in his written notes.

In the early 1960s, and for some years after that, Robert, Graham, and Gord personified for one another David Silcox's maxim of the time: "Back then, we thought we could do anything. So we did." They painted separately, and met at the Pilot, other bars and taverns, and their own homes for endless bouts of talking and drinking. But mostly what they did together was play jazz. From his Hamilton days, Robert had succumbed to jazz, music whose rhythmic and improvisational compositions represented in sound the gestural, formal, and emotional configurings of his painting:

> And through it all, American music. How it shaped me. Miles
> Davis, Bud Powell, jazz at the Phil[harmonic]. Dizzy Gillespie
> ('dis band should disband …'), Thelonious Monk, Clifford
> Brown, Sonny Rollins, the beaming, driving rhythms of Max
> Roach. And the tough, searching sounds of Coltrane, long,
> long lines. Through it all. Music wrapped around those
> glistening dancers: blurring bodies. Hard bop, a saxophone
> in tears, *my baby is about to leave.*… Driving gangs of bands,
> the music burned into my new life: music rushing into a new
> view of space, the wake of figures. My mark.

He bought his first Charlie Parker record "in a filthy basement record store" in Buffalo, listened to the giants of jazz filter through the smoky haze of the city's strip clubs, went to Rochester to see Coltrane and, later, saw some of the same musicians and others of their quality in Toronto taverns such as the Town and the Colonial and the magical basement of the Melody Mill. With Graham, Gord, Rick Gorman, and Nobi Kubota

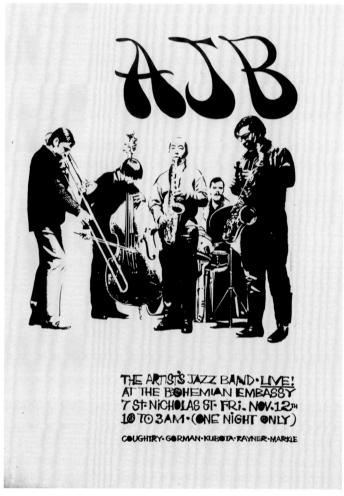

Poster publicizing a concert by the Artists' Jazz Band, 1965.

equally enthralled by jazz on its own terms and by its free-form connection to painting, the formation of the Artists' Jazz Band was inevitable.

Gord Rayner, in typical swaggering fashion, says of the AJB, "I invented it completely." He also insists the first sessions of what Robert would call "the *Rashomon* of jazz bands" began in 1958 with Rick, Graham, and Nobi—but Nobi didn't graduate from architecture school until 1959 and says it wasn't until then that he met Graham, who was living in an apartment studio at the office of Irving Grossman, his first employer. Not until after that, Nobi insists, did they get together with Robert. Marlene agrees, because it wasn't until 1959, when they were living on Avenue

Road, that Robert took his first sax lessons. At any rate, they played for some time at Gord's studio on Yonge Street until Av invited them into the gallery, where they would practise at night and play at openings. Word got around, and they began to accept invitations from various festivals and clubs. Eventually, Gord says, "we would play every major university in southern Ontario."

Nobi remembers them all loving different kinds of jazz. He himself preferred Johnny Hodges, while Robert was enamoured of Lester Young, whose music "was ingrained on his soul." Rick, as a bass player, liked Charles Mingus, who would, with his band, break into free form then return to the melodic line. "I learned a lot about painting listening to Mingus," says Rick, who as a result often heard visual images before he saw them. Harvey Cowan, who joined later on electric violin, was influenced by Ornette Coleman, whom he saw play the violin at the Colonial. Michael Snow, who, from 1961 on, jammed with the band whenever he was in town and had played professionally in New York, felt a kinship with Thelonious Monk. Nobi points to the AJB as part of the "exuberance and excitement of the times—abstract expressionism, the avant-garde, Jack Kerouac and the Beat Generation, Zen Buddhism, John Cage, Timothy Leary, LSD, love-ins, the Beatles, and on an on." "None of us had technical abilities," Nobi maintains, except for Michael and, to some extent, Gord on drums. Michael says, "I'd been making a living playing jazz, and the AJB seemed pretty silly. But I gradually started to hear what was going on and appreciate it." Since they couldn't play, he has since asked himself, how could they play? Their music was an extension of conversations they had about art and music, filled with ideas, so "interesting stuff got made up." "But the thing that baffled me in a way, it still does, is that, how, where does it come from? That Bob could have played so much good music without really having a pinch of knowledge, and it's not just knowledge, that whole pyramid of stuff that Trane [John Coltrane] was working out. I mean, I still find that amazing." The good music arrived, he remembers, "as a cumulative thing when everyone had smoked enough dope or drunk enough whisky." But Rick Gorman insists they painted on booze and did music on drugs. Dennis Burton recalls dropping in on one session where there was "a pile of dope on the table ten feet high."

Sometimes Graham would score a tune, but Harvey says that they didn't much play what had been written down. There were concepts of spaces and sounds that sometimes complemented and sometimes clashed with one another. What they produced certainly wasn't to everyone's taste outside the band. "We could empty the place," Nobi deadpans about their public

performances at places like the Ottawa club Le Hibou. Harvey Cowan admits that people walked out at first "until they grew towards our kind of music and we became better." There were success stories too. Harvey recollects an Andy Warhol show in 1965 at Toronto's Jerrold Morris International Gallery where "nothing sold" of the Elvis and Liz Taylor prints. Afterwards, the AJB played at a private party for Warhol at the studio of Painters 11 member Tom Hodgson. Harvey says this was during their six-month period as a pseudo-rock group, and they rented electric instruments for the occasion. Warhol's reaction was that they sounded like New York bands, only better. Harvey also remembers playing at an AGO opening in a side room when two thousand people left the big court band and came to hear the AJB. But it's Rick Gorman's tale of Sarah Lawrence College that is most memorable. For some reason Robert didn't go along with the band to a show of paintings at the Bronxville, New York, campus, about a thirty-minute ride north of Manhattan. That show must have taken place before 1966, the year the college became co-educational, because when the band peeked out from backstage they saw only young women in the audience. There were about six hundred of them, "all beautifully spoiled brats with Breck hairdos, cashmere sweaters, argyll socks, and saddle shoes." It was intimidating, and skepticism was written all over the six hundred faces as the curtain went up. But the band sucked it up, gave a great performance, and received a standing ovation. At the reception afterwards, about thirty-five girls gathered in a semicircle around Graham, who sat in a stuffed chair and intoned about Rimbaud. Gord states categorically, "Only Rick got laid!"

Not everyone liked what they heard, however. Patrick Watson felt the music was a "total puzzle," while Stephen Williams, who didn't hear them until the 1970s, "couldn't stand it" and would leave the "boys' night out" after listening for only a few minutes. John Reeves "never understood it" but admits it must have been fun to play. Perhaps former art students Dawn and Beth Richardson express the greatest resistance in their view of the AJB efforts as "musical nails on blackboards." But what the AJB members were doing as they played was at the heart of their individual and collective expression as artists who were following their own paths while remaining intensely aware of the tradition they were part of:

> Improvisation … demands a willingness to reconsider existing patterns but also depends on a familiarity with convention. Jazz, even in its freest forms, cannot completely step away from previous frames of reference, and rarely even tries. To play "free," ostensibly without the prescribed struc-

ture of chord changes, still constitutes a self-conscious en-
gagement with tradition, resisting or opening up recurring
models that have come before. Moreover, the standards that
govern all group improvisation, free or otherwise, are egali-
tarian and libratory—privileging the abilities to listen to
other voices, contribute through self-expression, and, ideally,
validate the selflessness and charity on which the success of
collective extemporizing depends.

Robert, Graham, Gord, and Nobi remained at the core of the band dur-
ing the 1960s, despite Graham's absences in Spain. At times it grew to eight
or nine members, particularly after Gord moved to his studio on Spadina
Avenue. Other double bassists besides Rick Gorman included working musi-
cians Terry Forster and Ian Henstrich, while Jim Jones played electric bass.
Professionals Wimp Henstrich and Kenny Baldwin added to the saxophone
section along with Robert and Nobi. The amateurs, says Nobi, "couldn't
have read a note of music if our lives depended on it. Nor did we know the
difference between a chromatic scale and a tetra chord." But Hana Trefelt,
who "could let go into jazz as I could into painting," and had lived with the
great American saxophone, flute, and clarinet player Eric Dolphy, appreci-
ated the fun the group was having: "There was a gut creative response of
male excitement about a form." Av presented mixed-media concerts at the
Isaacs Gallery beginning in 1965, and these included live and electronic
music and performance art. He liked the experimentation inherent in the
AJB's sounds and in 1973 produced their album, which included Michael
Snow on trumpet and Harvey Cowan on violin. Av, who fronted expenses
for his artists while they worked, always expected to make some money back
on the sale of their paintings, so to help pay for the album the band mem-
bers did prints that were sold simultaneously with the music. Despite Peter
Goddard's 1974 comment that on the album "only [Robert's composition]
'Markle-O-Slow' manages to sound as if the band found an original idea
and knew what to do with it," Gregory Gallagher wrote three years later in
The Canadian Composer that "the debut album, as a whole, proves that its
members are veterans of spontaneous musical interaction. It also shows that
warmth and ease that comes with longstanding personal relationships." But
Gallagher also placed the band in a larger cultural context:

In the AJB—and in other contemporary soloists and
ensembles—I believe we have an original vehicle for
exploration beyond accepted limits. Often artists and

musicians in a North American cultural environment are considered to be "eccentrics," "crazy," or "immature" for not fitting in with whatever the current norms dictate. This, of course, is precisely what they are trying *not* to do; they are seeking out the unknown, pushing at their own limits, and in the course of doing so they are creating a means of personal expression. The AJB is about the here and now of nine [*sic*] original Canadian artists.

Gallagher was not alone in his vision of the band. The highly respected editor of *Coda* magazine, John Norris, had this to say:

The shock waves of these [1973] recordings will be felt long after the final note has been sounded.... How dare these upstart amateurs come through with the intensity and vividness of New York's best when the jazz spectrum of the established (recognized) musicians is still solidly based in the past.... What started out as a bizarre approximation of the jazz world's most satirical stylists has developed into a musical identity and unity of purpose that transcends itself. Their music is together—in the sense that they understand the forms within which they work and have the confidence to execute the most daring ideas that come to mind.

These views certainly harmonize conceptually with Nobi's beliefs about the AJB: "Art represents a form of expression unfettered by restrictions. For my life the experience of the AJB comes closest to the realization of that ideal—to be free of limits, to create one's own order and form."

Don Obe, who would play a significant role as editor of Robert's published writings, posits the significance of the personal-to-public movement of the creative process shared among the Isaacs crew: "Great moments are better than great expectations. That's why so much art in this country comes out of the energy of a circle of friends." Their individual drawings and paintings were imbued with this energy, but, as Robert said, it was the communal expression of music that made it possible: "When each of us paints, we remain alone. But with the band, it's totally different. Then we really explore one another." Perhaps Nobi best captures the spirit of this group of artists and the times they lived in before the 1960s imploded under the weight of overdose, burning cities, war, and caricature, and before there was more going of separate

ways (though the mutual respect and affection remained intact through subsequent decades): "That magic period will never happen again, especially a certain naïveté that the future was bright. The air was clean and so was the Magnetawan River we drank from."

Jazz Lover, 1989 (acrylic on masonite, 91 × 122 cm)

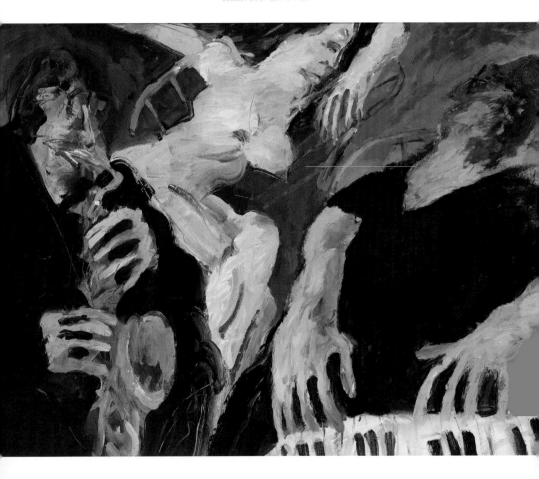

V

GLORY DAYS: TORONTO 1965–1970

T he last half of the 1960s for Robert was marked by the expansion of his close friendships with, among others, Patrick Watson, Michael Sarrazin, and Gordon Lightfoot; his involvement with the New School of Art and his extraordinary reputation as a teacher; his published writings on a wide range of subjects in newspapers and magazines, including his experience with mentors and editors Don Obe and Tom Hedley; his ongoing association with another woman, which threatened his relationship with Marlene; and a remarkable outpouring of female forms on paper representing his credo that "Drawing is the first draft, the first sip of the world around you, and drawing is the final mark." He was still searching for the figure that wasn't there.

After their exchange about the Cameron bust on *This Hour Has Seven Days*, Robert and Patrick Watson crossed Yonge Street to the Celebrity Club for a beer. Watson had felt during the taping of the show "a tremendous sense of connection with him," and "after that we never stopped having a conversation." Much of Watson's side of their discussions of "poetic, visual, aesthetic, and musical issues" was grounded in his undergraduate education at the University of Toronto and his time as a doctoral student at the University of Michigan. Given his extensive experience in the interviewing of cultural and political figures, he was an astute judge of people, and in the beginning it was Robert's intellect and character, not his artistry, that Patrick admired. "It took me a long time to find my way into it [his work]," he says, but Robert's "incredibly comprehensive and integrated imagination" and his love of drawing conclusions out of his intensely lived experience held Patrick's attention. Early on, Harvey Cowan assessed Robert as the "most intellectual" member of the Isaacs

group—"so wise and full of wisdom and insight"—and Dennis Burton states that he was "intellectual and erudite … hip to literature, music, and film … of all those guys he was the most original." High praise, but Watson goes further: "He was a naturally gifted philosopher who, had he had academic training, would have been one of North America's most eminent philosophers." One of their exchanges was about the idea of order. Robert thought that of all impulses that are distinctively human, the drive to impose order was the foremost (unlike the sex drive, for example, which is not uniquely human). Patrick responded by asking if he thought he could derive a theory of justice from this, and Robert replied that it would be difficult but possible, and that order was an antecedent to the need for justice. When the idea of order becomes the practice of order, as in Patrick's noting of Robert's always organized studio, Stephen Williams's view of Robert's basic conservatism comes to mind.

Patrick respected Marlene's moral and personal strength, and while he was surprised at her tolerance of some of Robert's behaviour, he could see from the beginning that the "hallmark of their marriage was conversation between them … it was utterly authentic." It was also a conversation profoundly—some might say hypocritically—connected to the couple's perceptions of the sanctity of domestic union. If Robert had an obvious double standard—made apparent when, despite his own womanizing, he threw Marlene out of their Webster Avenue apartment after she'd given another man an "innocent kiss" at a party—so did Marlene. When Patrick, not yet divorced from his first wife, once showed up at their place with a woman to whom he was "not exactly married," Marlene tolerated the situation but made it clear she didn't approve. Robert's "standard," however, included being emotionally helpful to Patrick and his wife when their marriage broke up in the 1970s. If Robert seemed able to compartmentalize his life when it came to sexual relations and gender concerns, this was not the case with his creative expression, according to Patrick: "He respected those women [the dancer-strippers] and was grateful to them. There was no separation between leaning boozily over the rail and going to the canvas." While this may be so, Patrick does appear to rationalize some of the impact of Robert's verbal aptitude, especially in relation to his affairs with other women: "I don't think he ever told a lie in his life. Well, this may be technically untrue, but he told disagreeable truths, which is what you did with someone you loved." There can be a fine line for listener-lovers between disconcerting honesty and hurtful action.

Patrick had built a geodesic dome cottage on an island in Go Home Lake, which opened out via two rivers into Georgian Bay, and this property,

with his enthusiastically granted permission, became an occasional haven for Robert, Marlene, and their close friends. For Robert, finding "another charlies, even better"—because of its creature comforts such as electricity, indoor toilet, and running hot water—was like having wilderness with room service. It allowed him to slow down and observe nature ("a transparent butterfly looking through the sun and leaves and summer sky and winds warm pulling light and tree"); drive boats ("I did learn how to run the small boat, just fine, and having a good time when through no fault of mine RAN OUT OF GAS and had to row the goddam thing to the goddam gas station jesuschristfuckshit OAR BROKE!!); swim ("I do like the water and it IS warm and all that but it takes me so goddam long to get in"); and draw ("lovely long gentle drawings the charcoal racing knowing across the too sunglare picture ready for keeping…. hundreds of landscapes, beautiful, in my [sketch]book").

Go Home Lake must have reminded him of his summers with the highway crew, when "Behind every tree, beside every lake, a Tom Thomson or the tangled confusion of a J.E.H. MacDonald panorama lay waiting for my brushes." Only now he had so much more he could bring to his consideration of the landscape. To open Robert's sketchbook is to enter a world where the paint is still wet on the paper and the vigour of colours summons the intensity of light on Georgian Bay waters and the hues of treed shorelines. The paintings occupy the full range of space between the right and left margins and the top to bottom of each double page. Figures in and of the landscape stretch and arch over and around deep blues and blacks. The conveyance of energy and motion in the trees, undergrowth, waterfalls, and skies through the collision, overlapping, rising, and falling of colours is remarkable.

The most memorable drawings are those in coloured inks done between 1968 and 1972 in which islands of trees glow in greens, blues, mauves, and glints of orange, and steep rock faces drop down in layered shadings between water and sky. In one sketch, vague fish shapes move beneath the surface off a deciduous–coniferous mixture, and in another a sailboat glides by masses of green growth and one giant pine shape reaching heavenward. These are not Group of Seven emulations, but they do represent a kind of homage to a vision of the outdoors that was not Robert's usual glass of beer. This tribute is especially visible in the picture of a lone pine beside a boulder perched above the lake, though the solid mauve display of branches, without the specific delineations of line and shape in Group paintings or in Thomson's *West Wind*, suggests a different kind of artist. That these many works remained sketchbook material and

were not transformed into full-scale paintings indicates that Robert was taking a break from his regular subject matter. But even on holiday, he was an artist and could not remain indifferent to "rocky canada country [where] the water surrounds you warm and wanting ... and you fall in."

In the summer of 1967 Robert and Marlene had two weeks alone at the dome. They left the motorcycle at the marina and took the twenty-minute boat trip across to the island. At first there was the excitement of the new and the freedom of such privacy together, but then "terrible August weather" closed in. Marlene made pine-cone chess pieces so they could play games. Robert filled his sketchbook. They listened to the radio and read a lot. But eventually Robert became "a little antsy" and talked of going home early. Marlene, on the other hand, loved the entire experience, especially because she could be with Robert twenty-four hours a day, which was impossible in an urban environment. Robert wrote a letter to a Toronto lover, telling her "you are my summer." Neither of them happy, husband and wife returned to the city "and into sadness and long nights of mind wandering and shattered thought projections." When they got home, she cried in bed and explained to him that she wanted more of this experience. Robert wasn't sympathetic and said bluntly that it wasn't what he wanted.

Despite the brief periods Robert was able to spend at the Watson cottage while Patrick was in residence, their relationship was primarily urban-based, and together they celebrated the colours and bright lights of the city. On one occasion Patrick, a licensed pilot, flew Robert down to New York, where he responded to the art in P.J. Clarke's saloon and celebrity hangout with an enthusiasm almost equal to that with which he responded to de Kooning's masterpieces in the Museum of Modern Art, breaking down, as it did, the barriers between the so-called high and the apparent low in creative expression:

> centre of town, p.j.'s and they have these huge hundred
> pound blocks of ice in the urinals, these huge blocks and
> you go, the piss steaming into the cuts and worn crannies of
> all those that have gone before, a gentle hiss and the stream
> steam billows whitecloud soft ... the ice now a quiet cold
> clear stand of shapes and turns, bent ice sweep, no more
> [henry] moore, holes and tears, beer art ... piss sculpture ...
> everyone an artist in art town....
>
> ... *content is just a glimpse*
>
> and jesus Christ what the hell can i possibly say?

rooms full of splash and tough drawing, rose reds and
oranges that … sit in space like that summer glint like beer
and foamhead and city. rushing blues on yellows screaming
hot, traffic stream of newyork intent, super flesh beauties,
lots of wackoff there, good room to work in, colour blocks of
whites and tear, a line folding and finding through his space,
a green that first sits, then wanders, then holds the canvas
like some hopeful lover or like me through some purple,
some purples … pinks and yellows out of summer bronzes,
Christmas greens startled by dirt and mud red … christ, i've
got to flip through the catalogue to see such glimpses ….

and we are all artists and it's all art and we all are …

Michael Sarrazin was born in Quebec City in 1940. His family soon
moved to Montreal, and there he took high-school acting lessons and
then attended Loyola College. At twenty, he spent a year in New York tak-
ing private classes with legendary drama coach Lee Strasberg and later
did some theatre in Montreal. As he explains, virtually all of the acting
jobs that were available in English-language television were generated in
Toronto, so that's where he went in 1963. He worked as a waiter at the
3 Sevens, across from the Isaacs, and stripped furniture and did window
displays in department stores to make ends meet between infrequent
auditions for television roles. When he delivered coffee to the gallery, he
would often hear a "bellicose guy in the back," and then one afternoon in
the Pilot he met this same "loud-ass guy with a funny pigeon-toed walk"—
a guy who Michael would later come to believe "acted out to cover his shy-
ness." For two years they were inseparable. "He and Marlene became my
life." Once again, the basis of a close relationship with Robert was "long,
wonderful conversations," usually at Webster Avenue. Michael would show
up at 10:30 or 11 in the morning, stand in the street, and have Robert
wave him up. They'd talk until the Pilot opened in early afternoon, and
had "running dialogues about everything." Robert was not only a friend
but a mentor to the aspiring actor, who was having doubts in his struggle
to succeed, telling him the integrity of art and life is about jeopardy, and
that anxiety is art's bedfellow—"We all go through it." They drank a lot
together, and though Marlene says "beer was a basis of their friendship,"
she adds that Robert could get "pissed off" when Michael became uncom-
municative after consuming too much.

Always interested in painting, Michael went to all the gallery openings, including the first night of Eros 65, and soon knew the Isaacs crew well. He'd party with them and get invited to Gord's loft on Spadina when the AJB was playing, midnight to dawn. "It was a tribal kind of thing," he recalls, "at first you had to sit with the girls." The music wasn't all that easy to listen to, but, as Michael himself would discover, it was great to be a player. One night Gord got up from the drums to get a beer from the fridge, handed the sticks to him and said, "Why don't you play for a minute." The minute turned out to be an entire set, and from then on— even after he'd been away for long periods in California—Michael was an honorary member of the band.

Everybody went crazy when Michael finally landed a Hollywood contract—seven years at $300 a week from Universal Studios—but Michael himself was not that impressed, as he was getting more and more CBC drama work and was enjoying his life in Toronto. He sat on the contract for a winter, and only after encouragement from Robert and the others did he sign it—in a booth at the Pilot. The studio agreed to let him commute for a year first class between Los Angeles and Toronto. At first he did some television work, such as CBS's *The Virginian* and some B westerns. His big break came in 1967, when he made *The Flim Flam Man* with George C. Scott, a comedy about con artists on the run. Robert wrote a piece on him in the *Toronto Telegram* in July of that year in which he examined the pressures on an emerging star: "They're uptight because he doesn't have an answering service. Can't understand it. Why he might miss a very important phone call. The phone is the industry." The reviews of *The Flim Flam Man* were very favourable and led to a leading role with Jane Fonda in *They Shoot Horses, Don't They* (1969) and a strong supporting part in *Sometimes a Great Notion* (1971), with Henry Fonda and Paul Newman. Whenever he got lonely or bored, Michael would call Robert and they'd talk for hours. There were "borders" on their conversations, though— "places you didn't go with him," such as his relationships with women. "He had little compartments and he worked his way through them." Robert rarely talked about his family, but he did show Michael a picture he carried in his wallet of his father in full Native headdress. Interestingly, one thing he did stress was that "he didn't want to be around professional Indians."

In 1968, Michael fell in love with actress Jacqueline Bisset during the making of *The Sweet Ride* with her. He brought her to Toronto when they had finished shooting. Marlene took her shopping on Spadina, where "heads turned, men *and* women." That the Hollywood lifestyle had come briefly to Toronto was evident when "Jackie" offered to go to the

Michael Sarrazin and Robert at the farmhouse, 1971

liquor store for Michael and Robert and returned with nine bottles of scotch. When he came to town, Robert spoke about how good it was to have Michael back, but he recognized that their relationship, however vital it remained, had shifted because of distance and the toughness of Tinseltown: "he's tired, Michael, trying to retain some semblance of integrity, of intelligence, feet on the ground, stability, sense of purpose, in that giant Disney-like, California dream-fed suicide … movie town USA … closing in, ready to eat you alive, and all you want to do is work, just to survive, try for art." He would help Michael resist death by stardom with "good sounds, good talk, good women, good love for one another."

A significant aspect of Robert's relationship with Gordon Lightfoot is that he wrote about it in national newspapers and magazines over the ten-year period 1967–1977. They had met in early 1966, when Robert was assigned to draw Gordon for an article on him by Jack Batten in the *Canadian Magazine*. Batten had certainly seen Robert's cover drawing of Bob Dylan for Toronto's *Telegram Showcase* when one of Lightfoot's biggest influences had appeared at Massey Hall in November 1965. Gordon went over to Robert's studio on Webster Avenue and sat and played the guitar while Robert drew. The result, says Lightfoot, "even looked like me, sort of." But when the several-day session was over, they were friends: "He painted, I

wrote songs. We had something in common." They toured the Yorkville district together, taking in such acts as John Kay and the Sparrows at the Riverboat before they became Steppenwolf. Gordon went to the Isaacs and admired Robert's work in the back room of the gallery, where Av always had his artists' work on the walls. "Don't ever let Ken Danby paint you," Robert told him, but one day Lightfoot would.

Gordon spent some afternoons at the Pilot, feeling "honoured and intimidated" to be there, but noting that "Robert was the magnet who drew people together and got them involved in conversation." Gordon was under contract to United Artists and expected to produce, and with all the daily drinking he couldn't understand how the members of the group got any work done. "I felt their Pilot recreation was going to catch up with them," he says, but he began to realize they worked "in rushes: work-party-work." Gordon recognized that he and Robert did know when it was time to settle down, because "putting an art collection together for a show was like putting an album together." Marlene recalls that Gordon had a small apartment and a new baby with his then-wife Brita, so writing at home was difficult. For several months he came over to the third-floor studio to compose songs. Although Robert was an avid supporter of Gordon's work, he would tell him when he thought a song didn't measure up. This was his first response to "The Last Time I Saw Her," which appeared on the third Lightfoot album in 1968. It apparently "wasn't avant-garde enough." Maybe that was his way of dealing with lush lines such as "Her lips were like the scented flowers inside a rain-drenched forest," but eventually he came around, because he quotes the song extensively in his first article on Gordon, which appeared in the *Telegram Showcase* in January 1967.

In this piece, only his second published work, Robert was interested not in analyzing song lyrics but in talking about the cultural context of Lightfoot's burgeoning career and in displaying the felt experience of a Lightfoot performance at the Riverboat. He was also interested in establishing, ironically but nonetheless firmly, his connection with Gordon: "One of the things, one of the many things that cemented our relationship was our ability, so-called, to relax at the friendly game of snooker. We both love it. I'm humming Early Morning Rain, moving around the table, playing beautifully. I ask him how come he isn't joining in. He says, 'I don't see you drawing!' Smart guy."

The main focus is on Lightfoot on the small stage with bassist John Stockfish and guitarist Red Shea (misspelled "Shey" throughout the article) and on the absence of barriers between performers and audience because of Lightfoot's effective voice and lyrics. It's a view of the artist

Gordon Lightfoot, circa 1971
PHOTO © EARLY MORNING PRODUCTIONS

written for those who already know his work, an insider's view that takes little critical measure of what's going on. When Lightfoot sings one of his most famous songs to date, "The Canadian Railroad Trilogy," Robert calls it a masterpiece. This may be a valid judgment, but it's also an interesting

91

cover-story article in the *Canadian Magazine* that came out just a few weeks later.

Lightfoot was world famous now, his songs covered by singers such as Elvis Presley and Barbra Streisand. "The Wreck of the Edmund Fitzgerald" reached Number 2 on the *Billboard* chart in late 1976. As before, in the article, Robert laments the lost days as he and Gordon talk and drink at the Brunswick Tavern—"two old friends with too little time to spend together." In the Massey Hall performance there is an easy movement through Gordon's "wealth of material," though the consummate artist stretches his music, "finding new twists and shapes to his lyrics," and leaves "his audience in the glowing glare of the houselights wanting more." Robert's connection to Gordon is again personal and about shared experience, but Lightfoot is so big now that it seems the only way Robert can approach him is through a door with a star imprinted on it. Celebrities, *including Robert Markle*, come backstage and to the party afterwards at Gordon's Rosedale home. We're reminded of those who couldn't make it but who have been here before: Dylan, Baez, Kristofferson. Lightfoot is in the position of being able to turn down a cover story by *Rolling Stone* magazine. In the end the mystique of the song–performance combination is lost beneath talk of the "business" of music and Robert's worry about his good friend's future. Throughout the article a thin veneer of joviality and pseudo-profound exchanges covers the cracks in the floorboards of their relationship. There would be no book. Not long after, they ceased to communicate even in an irregular fashion. Gordon disappeared into his eighty-ninety road shows a year and Robert into a dark personal period in his life before emerging into the brilliant light and form of his final decade. Gordon remained immensely loyal to Robert as a painter, purchasing several of his works before his death. "Bob never left my mind," he says today, despite the extended silence between them.

In addition to the first Lightfoot piece and the article on Michael Sarrazin, Robert published two character profiles in the *Telegram Showcase*, one reverent story on Gordie Howe and a fan's-notes piece on singer-songwriter Tim Hardin. To write on hockey was second nature to the Mahoney Park skater and *Hockey Night in Canada* buff. He was delighted to obtain box seats for a Maple Leaf–Detroit game on a Saturday night in March 1967 and watch, close up, the entrance of the "huge guys like warriors, all shiny skates, masculine, serious, clomp, clomp, on the cement floor," and, when the game began, to take in the "startling pace, sounds like thunder

moving up through the haze, sticks slicing the air, blades carving the ice and a magnificent order felt, touched as the play goes on." Then the "great man" appears, and "actually seems to be *telling* everyone how to play the game.... This giant, moving through, blazing, carving his space over the ice-scraped, sharp blades, perfect noise, stick, puck, control!" What Howe can do on the white canvas leads to Robert's key response to him in his final sentence: "Love this man, he's the artist in this mug's game."

As for the Tim Hardin interview-article, it simply wasn't up to Robert's usual standards. In late December 1968, over dangerous roads, Robert had driven down to Woodstock, New York, with Patrick Watson, and spent several hours of heavy drinking and talking with the man who'd written, among other songs, "If I Were a Carpenter," which would be covered by Bobby Darin, Harry Belafonte, and Johnny Cash. As in no other article he authored, Robert's writing rambled in self-indulgent fashion with little, if any, evident editorial shaping unless the intention *was* entirely to let Robert try to reproduce his booze- and drug-laced immersion in fandom through a lazy display of hazy language and clever hipness of attitude. Robert didn't know Gordie Howe, but he knew hockey and No. 9's place in it, and of course he knew Lightfoot. But the Tim Hardin adventure seems to have arisen from his fragile condition as an admirer, and in his attempt to compensate for the gap between star and devotee he fell into the trap of overwriting.

Much better was his first *Telegram Showcase* item, in November 1966, "Chips with Everything." This prototype for two more sophisticated cuisine articles in the 1970s was a hilarious paean to fatty foods, which at this time were of no concern to health-department officials or general consumers. Robert loved fries with the cheeseburgers Marlene made every Saturday, and washed down gravy-covered platefuls of them with beer in the Pilot and other taverns. But he was picky about how they should be cooked as well as their texture and their presentation on the plate, which often couldn't contain enough to satisfy his appetite. As an adult he was five feet eight inches tall, and when he over-indulged in food and drink his weight ballooned and he carried 250–260 pounds on his short frame.

Between the chips piece and initial Lightfoot articles, he produced a celebration of the dancer-stripper for a middle-brow audience that wanted the risqué but not the raunch. Appearing in *Showcase* in March 1967, "Golden Spike-Heeled Fascination Four Legs Moving ... Why?" delivers the impact of the moving figure in her feathery finery with just a hint of complexity and danger: "with her heavens bound in sequins ... floating through the shadows ... stepping lithe, long legs mincing on

spiked heels…. Now it's night time, and she'll come sneaking, sweeping in to tear away at your night dreams, wet with the sweat of her haunting." It is worth noting two of Robert's suggested titles for drawings of this woman, designations that indicate all along she is part of the artist's expression and life: *A Gestured Silhouette* and *Marlene Moving.*

The editors of Robert's writing throughout the 1960s and '70s were not lacking in experience. Don Obe was a journalist and editor at four major newspapers as well as *Maclean's* and *Toronto Life.* Tom Hedley turned *Telegram Showcase* "into a well-informed insert" and went on to become editor-in-chief of *Toronto Life* and an editor at *Esquire.* When Obe first met Robert, probably in the Pilot, his impression was of a "whiny-voiced fat Indian" whom he couldn't connect either with the drawings he'd seen or with the person he'd heard and read so much about. But Robert's reputation as an Eric Hoffer–type intellectual was soon confirmed for Obe by his "sharp and philosophical" verbal commentaries and his writing, which "wasn't the institutional voice of journalism." In writing about himself as well as he did, Robert was a "persona unleashed" comparable to Hunter S. Thompson of gonzo journalism fame but "without the nuttiness," Obe recalls. "You couldn't edit him; you had to have a conversation with him during which he would write stuff. We'd talk, he'd do a draft, we'd sit down and rewrite it…. I never suggested cuts but wrote polite notes about what could go." For a major piece, such as the one on Lightfoot, Robert was paid $800, certainly more than enough to buy a few rounds of beer and a new toy. In 1990, looking back at Robert's written work after his death, Obe wrote, "God, the stuff reads beautifully: lyrical and honest and funny and self-mocking and self-possessed and *wise.* I'd only half-realized the debt that I, in my tight-assed journalism, owed him. He took amazing risks and made me an accessory to them—the editor as henchman, covering the door."

Robert also wrote for other venues. In 1969 he produced reviews of de Kooning and Rayner shows for *artscanada* and provided a two-page essay (plus drawing) for the collection *Notes for a Native Land,* in which various writers and artists tried to come to terms with their feelings for Canada. The latter piece may be his most intensely realized presentation of the energy and force of the figure in the landscape:

> landscape notes: sunshades great grey washes, paper
> speckled, charcoal love-line flesh now summer gold, behind
> the knee … *explosions* grey to blue blueblack sparkled black
> north-night skynight black with still a touch of the sun

there … into yellow orange, paperglare sun selections
falling rolling big strides into lakes and damp and belly
breasts back arch … landscape figure twisting, turning …
curl …

… and *fields* in mesh, paint on paper, landscape legs open
to catch some sun turning fire, orange jewel, yes … and yes
the land fleshforest easy-moving softly turns and glides, look,
her legs bend and reach, tilting trees, the sun sunred, black
washes and all the way to Canada and the city smiles and
highways and yes Canada and she says, turning to meet
you … it was a good try … orange to sunshade.

Robert's extracurricular talents and his place at the heart of the Toronto
scene were noticed in 1967 by Jim Mossman, writer-producer-director
of the BBC public affairs show *Panorama*. According to Barrie Hale,
Mossman wanted to create "an impressionable picture of the town—rapid
expansion, cracking at the seams of its Scotch-English laces." Mossman
spent a twelve-hour day filming at Robert's Yonge Street studio, at Gord's
Spadina Avenue studio for an AJB session, and while Robert rode his bike
all over the city. The edited result prompted Hale to proclaim, "Oh to be
in Toronto when Markle's Toronto is here."

Dennis Burton describes how he, sculptor-painter Robert Hedrick, and
John Sime, "an English entrepreneur," decided to start an art school in
Toronto in 1965 because the artist-teachers at OCA had "a stick-in-the-
mud attitude compared to writers, poets, musicians, and playwrights." As
well, he says, no one of any note had graduated from the college since
the mid-1950s in the fields of fine art, sculpture, and painting (Burton
seems to have forgotten Rick Gorman, who graduated in 1958 and since
then had three solo Isaacs shows plus fifteen group exhibitions. That first
year, with Burton, Hedrick, Ken Lywood, Diane Pugen, Arthur (Mickey)
Handy, and Paul Young as teachers, the New School of Art held classes
for between twenty and forty students at 65 Markham Street, just south of
Bloor. The New School was part of the larger Three Schools of Art that
offered a variety of part-time courses during the day, at night, and on
weekends. The full-time visual arts program "was supposed to produce
a generation of artists." This generation, says Diane Pugen, who taught
drawing and anatomy, "had a sense of their own freedom and sought to

fulfill their selves as opposed to having a concern about making a living. They didn't want or care about the formality of a university degree, but were looking for life experience and the true-life artist to teach them."

The published goals of the New School were as follows:

1 to produce an environment to stimulate the serious art student
2 to provide the student with the best possible staff available [lack of funds eliminated any non-Torontonians as teachers]
3 to eliminate the conventional academic format and substitute the workshop environment
4 to eliminate academic standing as a prerequisite for entry to the school
5 to provide a four-year course aiming at the artistic independence of the student
6 to produce an alternative to the Ontario College of Art

The best possible staff, for Burton, meant working artists, regardless of teaching experience, who would be most comfortable in a workshop environment. He also wanted a higher profile for the school, so at some point in mid-1966 he walked into the Pilot and offered positions to Robert, Graham, and Gord, telling them they could teach anything they wanted to.

"Well, whaddya think?" said Robert after Burton had left.

"We need the money," Gord replied. And they suddenly had day jobs.

For all of them, "teaching was terrifying initially," says Gord, "then our egos took over." They taught two days a week for $15 per class. Soon there were roughly sixty students in first year, with half that number in the second year; only a few stayed the full course. No portfolio seemed to be required for entry, though Jerri Johnson remembers taking a sheaf of contour line drawings to her interview with Robert in 1967. He was businesslike and formal but also kind. Their conversation focused on the role of passion in art and belief in oneself. "Only *you're* doing what you're doing," he told her. Dawn and Beth Richardson suggest that the premise of being a student at the school was that "anyone can do art." That did not mean, of course, that everyone was an artist. As Gord told his students while encouraging their exploration of the materials of painting, "I can't really teach you how to paint." Regardless of any different approaches and teaching methods, "every one of us cared deeply for our students," Diane Pugen insists. She emphasizes that her generation of painters was "less influenced by the art-speak around them and more concerned with … the experience of making art…. The integrity of the artist is what we tried

to impart to our students, to empower them." Lorne Wagman reports that "Most of the time Robert adopted a speaking tone of mock derision, openly transparent after just a few minutes with him. He perhaps affected that to discourage those who were not fully committed, but he also seemed to be wary of over-directing those who knew what they wanted and only needed an inspiring place to work in." When he recognized Wagman's innate talent he told him. "You may as well quit the school, there's not much we can teach you. Just get a studio and keep on painting." Wagman took that advice and had his first group show at the Isaacs Gallery in 1978 and a solo show there eight years later.

The New School shared its first building with another teaching facility, run by Sime, and with some private apartments, so the poorly heated classroom area was communal and crowded. In 1967 the school moved to a space above the Poor Alex Theatre, on Brunswick Avenue, where there were separate rooms for classes and students had their own studio space. Outside was a parking lot where Robert led furious games of ball hockey at lunchtime. "Like a big kid [who] had more fun than anybody, his exuberance was irresistible."

The most formal class was Dennis Burton's in art history. As for the rest, as Laura Berman and Sheryl Wanagas put it, "we didn't have subjects, but teachers." Graham's classroom style was apparently loose and not very technical. Students tend to remember his kindness. Rae Johnson calls him "a quiet genius whose expression when he looked at your work spoke volumes." Gord was more flamboyant and outspoken. One day he asked Rae when critiquing her efforts, "Have you been smoking a lot of dope? Because people who *do* think things are better than they are." But Dawn and Beth Richardson insist Gord "gave us a lot of freedom" and only "came down hard if he thought you were faking it."

Robert could be tough too, but Rae remembers how she learned from him in life-drawing class: "He only let us draw with really thick charcoal and two-inch house painters' brushes in red, yellow, and blue primary colours. This allowed us to get maximum control of crude instruments." They painted on disposable newsprint, as if to emphasize that what they were doing was nothing special, but Rae found they were able to capture the energy of the model: "His critiques consisted of him sitting on the model stand with drawings spread at his feet. He would point at the drawings with a yardstick, retracing in the air lines and forms and directions of energy. He spoke of images having humour, and if he said anything was 'pretty good' it was a high compliment." Jerri Johnson recalls that at other times Robert taught his own technique of drawing with ink-and-water washes

and took care to assess everyone on an individual basis. Laura and Sheryl refer to his remarkable "strength of line" when he illustrated technique for them with his pen or brush, and his accompanying inspirational emphasis on the need to "master the craft" of drawing. Laura says he taught them "to see and paint the space between objects. It has taken me years to come to terms with that."

Paul Young, who joined the staff a year or two after the others, recalls that Robert "was always talking to the students about the power behind the marks they were making ... that they made a mark out of their interior life and should think about it first and then release it before a second thought. You make the mark out of the barrel of a gun and it hits the surface running." One day Paul overheard him talking to his students about the integrity of artists: "'You bring to the work the sum total of what you are,' Robert said, while ... his fat little fingers inscribed a double arc of the most indescribable beauty. He actually glowed, and, of course, the students adored him." There was more than simple adoration at work. Young's further testimony is a vital indication of the depth of Robert's impact on those he taught: "I never met a man wearing a teacher's mantle who had more power. One could easily make a list of over twenty practising artists whose lives were altered and, in some cases, utterly saved by Markle's direct intervention in their creative thought processes." Ronald Weihs, now a successful theatre director and scriptwriter, underlines Robert's impact: "I still see Markle clumping into class in his boots, jingling. He was arrogant, belligerent even. He was smart. He used language beautifully, with precise, truculent carelessness. He said unforgettable things, throwing them away.... 'Art is like shitting. If you have roses in you, every once in a while you shit a rose. Rembrandt was shitting roses ninety per cent of the time.'"

Vera Frenkel, having interviewed Dennis Burton about the school for *artscanada*, and having observed Robert, Graham, Gord, and the others, felt she was "a witness to what they thought was revolutionary.... They saw themselves as breaking new ground ... and took their practices and relationship to their students very seriously, although they affected a bad-boy stance." That stance was much in evidence around the young female students, whom Robert would deliberately provoke by saying, "Oh, hi, girls, are you exchanging cookie recipes?" or "This isn't a place to hang out until hubby gets home." Those who heard such remarks or others like them sometimes judged Robert harshly. Hana Trefelt bluntly stresses that the attitude implicit behind the statements belonged to a time when "women were not part of the group except to fuck," and those around

the "self-indulgent" male artists "were mostly groupie girls even if they did art." On the other hand, if Rae Johnson was concerned about the "misogynist undercurrent" expressed in views of Joyce Wieland and her work, she also emphasizes that "it was tough for women then. It still is, but [Robert] toughened me up." Dawn Richardson declares, "He was more of a feminist than she [Wieland] was.... Robert was not a misogynist.... He listened to you as if you were the only person in the room." (She adds that his listening included his male students, "who mimicked him but loved him.") While admitting that it was "a man's world," Laura Berman asserts "there were no sexual overtones with us.... We spoke our minds and asked questions," and Sheryl Wanagas states, "It was invigorating and validating to have in-depth conversations and arguments with the opposite sex." They feel that Robert's provocations were just a "test. You had to deal with it." No one of these women, not even Hana Trefelt, believes that Robert's drawings and paintings were misogynist in nature. What always stood out above all was his "jaw-dropping draftsmanship," but his love for the female form "in all its luscious poses" was clearly evident, as was the "pure beautiful sensuous energy" inherent in his work.

For Diane Pugen, who lived with then married Dennis Burton, "you had to be twice as good" as a woman artist to survive in the male artists' world. As for her personal relationships with them, she says "I never played around, so they had no sexual power over me." Diane didn't drink, and Robert would make fun of her vegetarian lunches at the Brunswick Tavern, across the road from the school, though he respected her skill at ball hockey. The often humorous but also edgy side of the gender relationships among colleagues is exemplified in a story Diane tells of an arm-wrestling contest at Gord's studio when the painters had left the New School in the late 1970s and formed Art's Sake, on King Street West. Robert had bested Graham, and Diane took him on, knowing "[she] had to win, no matter what." When she eventually brought Robert's arm down, Gord and another painter, Ross Mendes, "jumped out of the washroom with shaving cream and a razor," pulled Robert's T-shirt up over his arms and head, and shaved his armpits, because he was always telling Diane that she never shaved her armpits or legs as she should have.

As she got to know Robert better, Diane learned that the "belligerence that scared people—you never knew how to take his remarks: was he was joking or serious?"—masked an intelligence and sensitivity that left their mark. At faculty meetings "he was the one sane voice amidst all the egos. Whatever kind of issue was being discussed or argued, Robert would sit quietly through the whole thing and then he would say in his inimitable

way, 'Look guys …,' and it would be so straight and to the point … he could cut through the crap and basically come to the crux of the matter and bring us to an understanding."

Much of the teacher–student exchange took place at the Brunswick Tavern, which served as a kind of extended classroom where Robert would "hold court like a knowledgeable king bee" in the late afternoon and often well into the evening. Laura Berman recalls the Brunswick as a "bizarre place … where a little person would always get up and sing 'Oklahoma,'" and Rae Johnson remembers the "midget Donny [and] his arresting loud operatic voice" as well as the other acts—"part freak show, part vaudeville." Paul Young insists that in the Brunswick "ninety per cent of the time we were talking art. Discussion went on for hours about such things as where the artistic life comes from. It was an opportunity for students to have close personal contact with artists and their lives." This is confirmed from the student's point of view by Jerri Johnson, who remembers "intense conversation in the language of art" at the tavern. "This was where our ideas were challenged." In addition to art they discussed politics, movies, books—a smorgasbord of subjects that became more varied as more beer was consumed and as movie stars, writers, and other culturally prominent friends of Robert dropped by.

Vera Frenkel, by this time a successful artist in her own right, became a Brunswick habitué. She learned to drink beer and to survive on the receiving end of Robert's "stiletto wit…. His way of bantering was to prod and poke…. I felt tested by him, and would say, 'Yes, but …' It took me a long time to understand the game aspect." For Vera, Robert was "enormously perceptive and could distill a person's character into three words. He created a climate around him of trust, despite his curmudgeonly bad-boy character. Students were sometimes reduced to tears, but they recognized it was for their own good."

One of his most notorious and oft-repeated Brunswick lines was directed at women who were leaving the table: "You can go, but your tits have to stay." If this wasn't misogynist, it was certainly sexist, and on one occasion, after Robert said something of this nature to Vera Frenkel, she threw the contents of her beer glass in his face. More than one Brunswick female claims to have done the same, and so does Patrick Watson. Robert always laughed and wiped away the suds, but in Frenkel's case he indicated his respect for those who resisted his roughshod ways. At a Laing Gallery show a few days later, he told her husband in her presence, "That's quite a woman you're married to. She's terrific." That Frenkel, "at the height of [her] feminist consciousness," took this as an unequivocal compliment

underlines the complex nature of Robert's treatment of women and their perception of it.

His possession of more than a heroic, self-centred view of himself in the New School and at the Brunswick is indicated in a 1967 letter to his mother, in which he parodies sycophantic responses to him and refers to the reality of who he is offstage: "oh, mr. markle, you are just so wonderful and all that talent and such an exciting life you must lead ... meanwhile i'm scrambling for such exciting things as rent and food...." In the same letter he refers to an encounter with another aspect of real life: "a rather tough class though as i had a girl cry and ask such questions as what is conception and why am i here? And what should i do? ... and of course i'm supposed to have some of the answers." On many levels he respected his students, saying they "are good to be with, [with] good minds, talent, a nice healthy learning respect for pain and failure ... the artist's life."

There is no doubt, however, that the "artist's life" included sexual adventures with those whose lack of experience meant personal "pain" was involved as well as pleasure. Robert undoubtedly had affairs with young women at the New School who put themselves in his way or whom he determinedly went after. "Marklechicks," his friends called them. Despite the glowing testimony about Robert's ability as teacher and mentor to young women, Hana Trefelt's view of preying artists and groupies is confirmed by Robert's own view of at least part of the Brunswick Tavern reality: "she is young ... it's my club, my rules and so ... the air now full of that haze that makes things happen, art and the art of closeness, the draughts ready, the tables wet with our school time excitement, and i do feel the groove of things going right and slowly we meet and make plans, first me to convince her of my worth, her desperation, her need for me (she does that) and then of course we meet, make plans, my eyes now really seeing her, devour her now, like looking at some terrific menu, she's there, and she tells me she's ready...."

In this passage Robert depicts himself as a man in charge of seduction, and his mention of the "haze that makes things happen" signals his cynical awareness of how his reputation as an artist and teacher connects to what he can do and get away with. The experience of being "toughened up" for some could have a dark side for others: "i'll probably try to destroy her, hoping she can stand my pace, win, survive, be a great woman, the best she can possibly be, she knows so little right now, yet really ready and all too willing, dangerous game to reveal so much to me...." It's difficult to know how many women played the game and survived and to what extent their own choices led to involvement with him. Despite Robert's

self-promotion in the Lothario role, for Diane Pugen his "involvements with other women were never gratuitous. He didn't use women. He fell in love and truly cared for them, but he would never leave Marlene." Between 1962 and 1968, however, his relationship with Marlene and his view of the "art of closeness" were challenged by a more experienced woman in ways that questioned what love meant and that were not so easy to control.

Angie (not her real name), who was five years younger than Robert, had had a difficult childhood, having lived in a number of foster homes and in a school for troubled children. Marlene says she was "very bright" and remembers Angie telling her how easily she could fool a psychiatrist. John Reeves suggests she might have been part Native, and Diane Pugen is sure she was. Reeves is more certain of her long-legged exoticism. She was married, had a young child, and met Robert while he and Marlene were living on Avenue Road. Robert "was smitten with her ... a fantasy come to life," and began to see her on a regular basis. He would disappear for hours at night, though he was always home with Marlene by the early hours of the morning. When Robert and Marlene moved to Webster Avenue, things heated up, because Angie's place was nearby, and so were convenient places for them to meet. Soon it became clear that Marlene's acceptance of "his standard" would be tested on a long-term basis. She tried to maintain her belief that people had the right to "explore" as long as they weren't hurting anyone, but now she was being hurt. On one occasion after work, she met Robert for a drink at the Hyatt Regency hotel on Avenue Road. Angie was with him and "they couldn't keep their hands off one another ... it was disturbing to me." When she tried to speak to Robert about it, and told him she could accept the relationship but didn't appreciate the public display, he replied, "That's just the way it is." Everyone knew what was going on, and soon Angie was part of the social scene with Robert, sitting in the Pilot booth, attending openings, and even going up to Go Home Lake for a weekend when Marlene was there along with Nobi Kubota and his partner.

Robert drew her, of course, or drew the figure through her. As his nudes became more expressionist in nature through the 1960s, the lines and curves of Angie and Marlene must have become one. But Robert wanted more than fusion on the page, and sent Angie to ask Marlene if they could have a threesome in bed. For all her tolerance of his ways, she answered that this was one request she could not accommodate. If she could do nothing about his sexual and emotional need for Angie, Marlene could at least refuse to surrender her own sexual independence and keep his paramour from literally lying between herself and Robert. That way, for her,

Robert did what he did *outside* of their marriage, leaving the basic foundation intact. It was a gamble, but Marlene was counting on his need for the stability she provided. His escapades with other women were always in orbit around his established sense of home and the security and order he found there. Marlene had never been entirely alone with him in the studio as the dancer-strippers moved in his head, but she would remain a self-determining artist model with an agency that some of the New School girls certainly lacked. As Robert wrote of her in his unpublished notes, "She allied herself with me…. she had strength, and the courage that comes from a real sense of herself. And she let me share."

Angie had that agency, too. To further her education and career opportunities she enrolled in the English program at a Toronto university; Marlene volunteered to type up her essays. Angie also wanted to settle down with Robert and have children, something he couldn't do for her, so she talked about moving away to start a new life on her own. Realizing eventually that he wouldn't leave Marlene, she made the decision to end the physical part of their relationship and in 1968 she moved to British Columbia. There she began a correspondence that allowed in some ways for a greater honesty between them. In one of her first letters she wrote that she knew loving him wasn't going to lead to what she wanted—a home and a family. Although she told him she wanted to have his baby, a month later she revealed that she didn't phone him on his birthday because she would have wanted him to ask her to come back to Ontario. In another letter she said that although she knew she'd been more than a mistress to him, she felt she'd never been able to escape the mistress role when they were with his friends. She did send Christmas presents to him and Marlene, and she indicated her worry in her first year away when she didn't heard from him. It seems clear that by moving Angie was putting their relationship to a test that Robert wasn't likely to pass. After all, he had failed what was essentially the same test in Toronto.

If Robert was never going to abandon Marlene, there was still the issue of what would happen to him and Angie, and she made the decision for him. Since there is no indication in any of her letters that he tried to stop her from leaving, he was probably relieved, no matter how much he still cared for her. In a letter to her in late 1968, he wrote about Gord Rayner's marital difficulties, but a great deal of self-description and self-justification was involved: "i really think a man is just able to love a little stronger than a woman, a creative man, someone who seems to be able to put himself into the greater jeopardy than the woman, therefore he's the one that the roof falls onto … it's difficult for a man to take the sort

of liberal punishment of seeing around him, in his bars and circles, other men who have known his woman … meanwhile the man's in agony, just wanting her back … yet we are what we are, there's no way that at the age of thirty or more, steeped in the art bag and that kind of urgent touch to life, that we are going to change, and the women really do know what we are, what they are getting into."

Elsewhere his letter was full of news about his busy Toronto life—seeing Sarrazin, flying with Watson, "again becoming that great brunswick legend" for his students, playing with the AJB and appearing on CBC Radio. His lyrical address to her in the midst of all this emphasized his feelings but also framed her in a past that he would not allow her to escape: "i have a picture i took of you one sunny afternoon, in this blue room, the blue sofa against the wall, you sitting straight and elegant, your legs crossed, your hair spilling down to touch softly, your breast … your head up and aloof, that just-trace of smile, proud, on your lips, I swear it is the great picture, you look so fine, and you look like my own, real, royal, the great broad, the great woman, great love and i miss you, miss you so much…."

By early 1969, Angie realized he was not coming west, and she wrote in acceptance of this, telling him she wanted to stay in touch but was becoming immersed in her new life. She did return to Ontario for a visit in the early 1970s and went up to the Mount Forest farmhouse where Robert and Marlene then lived. Although it was all very friendly, Marlene says there was now "a strangeness between them." When Angie went back to B.C. their correspondence continued for a while and then she disappeared into her future without Robert.

Between 1963 and 1972 the only solo show Robert had was at the McIntosh Gallery at the University of Western Ontario. That show opened on January 26, 1968, and the work exhibited was mainly from the Eros 65 era. That it continued to create polarities of reaction is exemplified by two reviews, one in the student newspaper of the University of Western Ontario and the other in the *Toronto Telegram*. Student reporter Carsten Jensen, who likely had never met Robert in person, was not threatened by the images that had unsettled Magistrate Hayes three years previously: "Robert Markle has a bad public image—he's greasy, grubby, outspoken, and crude. The important thing is that he's a damn good artist…. His technique is as clear-cut as his subject matter, and as striking…. Markle establishes his artistic credentials beyond any doubt in three studies, No. 8 *Lovers III*, No. 4 *Lovers IV*, and No. 18 *Lovers V*. The detailing is excellently

controlled through a subtle flow of tempera intensity. The outline is Grecoesque in truth and grace."

On the other hand, Lenore Crawford, writing in the *Telegram*, obviously felt comfortable with Hayes's disturbed view of sexuality and desire. It is extraordinary that someone writing for a major city newspaper could parade her prejudices to such a degree under the guise of professional expertise. She insulted not only Robert but also his subjects: "The pictures in the *Lovers Series* depict closeness of nude bodies, but nothing that could be construed as participation in a sexual act. They present clearly, though, sexual perversion. Obviously Markle was intrigued by perverts and he used his expert draughtsmanship to portray them with utmost clarity. Just as obviously he had loathing or contempt for them. Surely he could never be accused of presenting perversion as desirable. The faces are cruel, voracious and mean rather than lustful in even an unbridled animal way."

In a more sedate manner, a female arts student supported Crawford as she wrote in the gallery's guest book, "They are weird. Does he do everything like this? I'd hate to see someone stuck on something like this. It's sure not something you'd see in your grandmother's house." More relaxed and arguably more perceptive was a student comment without gender or faculty connection: "A form I recognize has been made unrecognizable. I think it's great."

In late 1966 the lease expired for the Webster Avenue flat, and the owner wanted to make separate apartments of the second and third floors. Robert and Marlene found a new place over a store at 1091 Yonge Street, near the corner of MacPherson Avenue and opposite the CBC building. As at Webster, the large studio space was on the third floor above the living quarters. They paid $250 per month and stayed for two and a half years. Although he was about a block from the LCBO and a fifteen-minute walk to the Isaacs and the Pilot, Robert was much farther from the artists' neighbourhood in the Spadina–College area, where Graham, Gord, and Nobi lived and worked. It was a bit of a journey to AJB sessions at Gord's studio.

It wasn't far, however, to the Royal Ontario Museum, and in 1969 the sculptor, photographer, and painter John McCombe Reynolds, who was also a freelance CBC producer and a close friend of poet Gwendolyn MacEwen, hired Robert to film MacEwen in the Egyptian Galley of the museum. Reynolds's reasons for doing so are obscure, though they might well have been based on a recommendation from John Reeves, who knew of Robert's talents with a camera and had seen photographs he had taken of Marlene in his studio and the Super-8 film he had made of her on the Mag-

The core of the AJB: Nobi, Graham, Robert, and Gord, 1970
PHOTO BY ARTHUR COUGHTRY

netawan River. It must have been a strange combination of figures among the mummies and friezes—the dignified Reynolds, the almost ethereal poet, and the corpulent, earthy cameraman trying to capture some sense of MacEwen's ancient-Egypt involvement, which was already present in her poems and would expand with her 1972 novel *King of Egypt, King of Dreams.* The result was an eighteen-minute film that never saw the light of day.

In early 1969, Nobi announced he was going to Japan for a year to explore his roots and to follow the dharma bums he'd read about in Kerouac, Ginsberg, and Ferlinghetti. His family was Buddhist, and Nobi would find a Zen master in Kyoto who was also a master calligrapher and who would teach him about Japanese art. The rent was going up at the Yonge Street apartment, and Robert and Marlene were looking for a "sabbatical of some kind," a break from the intensities of their personal and working lives. When Nobi offered his flat on Spadina Avenue for $125 a month, they decided to take it for the year and to "figure things out." Marlene wanted some time away from the gallery. Robert's relationship with Angie was over, but it had taken its toll, and Marlene says he was overwhelmed by the New School demands, perhaps aware he was creating many of those demands himself as the afternoon lord of the Brunswick Tavern.

They moved into Nobi's place in early summer, with a bed, a couple of chairs, the sound equipment, and an agreement to look after Nobi's Volvo, which finally prompted Robert to learn to drive a car. There was also Robert's Triumph 650, candy-apple red and not made for the comfort of a passenger, although Marlene had been just that on their 1965 New York City trip, as well as on rides to Montreal and Rhode Island, where Robert's sister Lois lived. Gord's studio was directly across from them, so they could open their windows and yell at one another. Graham was just down the street. Although the Pilot, with its proximity to the Isaacs, where Marlene was still working, remained the primary watering hole, the AJB members and their associates began to frequent the Paramount Tavern and Grossman's, both on Spadina, where Robert met some bikers and became a kind of honorary member of the Vagabonds. Marlene describes the gang as "not heavy-duty dangerous, but they could be sucked in by others." They wore the colours, but most had day jobs, including one of their more prominent members, Gintz Skudra, whom Robert befriended. Skudra was a "handsome elegant Latvian" whose brother Tom, a photographer and not a gang member, was "very artistic." At the Festival Express rock festival in June 1969 the promoters hired the Vagabonds for "crowd protection" duties while performers such as The Band were onstage. Perhaps it was the sunny weather and university football stadium venue, perhaps the quality of the pot smoked by thousands—the fragrance floated along Bloor Street and into the tree-lined streets of the Annex area—or perhaps it was the basically good nature of the Vagabonds themselves and the absence of dark Rolling Stones rhythms, but there was no end-of-the-'60s Altamont mood or violence at the festival that weekend.

On Wednesday evening, July 9, not long after his move to Nobi's flat, Robert was drinking with Gord and others at Grossman's when he decided to take off with a girl for a drive on the Don Valley Parkway, which he often travelled on the Triumph. Gord told him he was drunk and shouldn't go, but Robert had done such things many times before and seemed to live a charmed under-the-influence existence on his bike. As they were riding south below Eglinton Avenue a passing car came too close and pushed them into the median. The Triumph struck the centre rail. The girl fell off the passenger seat and, although shaken up, received only road burns and minor injuries to hand and arms. Robert, loath to abandon his bike, rode it down the rail, crushing his hands against the steel as he did so. When the Triumph stopped, the impact hurled the midsection of his body against the frame of the bike, rupturing his spleen and liver and breaking several ribs. His head smacked into the V between

the handlebars and was he was concussed, despite the protection of his helmet. People in a factory across the parkway saw the accident and called police. Robert was rushed to St. Michael's Hospital in critical condition. He was in surgery all night for his internal injuries.

After the operation, an orthopaedic surgeon, Dr. Zaltz, asked Marlene, who had slept all night in the waiting room, what Robert did for a living.

"He's an artist," she replied.

"Oh, shit!" came Zaltz's response. In addition to his life-threatening internal injuries, which kept him in intensive care for a week, both of Robert's fractured arms were in casts, his clavicle and all the fingers of both hands were broken, and his hands suffered serious nerve damage. He would spend a month recovering in hospital after the bones were reset.

Marlene took the entire time off work and was with him twelve hours a day, reading mysteries to him and Francis Chichester's *Gypsy Moth Circles the World*. She also read him Mordecai Richler's novel *Cocksure*. Robert laughed long and hard, even though the movement of the four tubes in his stomach caused him great pain. When the time came to go home, the orthopaedics department fitted him out with matching mechanical devices on each forearm that had wires extending down to metal rings around each finger and thumb. These rings were suspended from thick elastic bands so he could exercise all ten digits. Nobody asked about payment for the hospital services. Robert had no insurance coverage, and the doctors and social welfare office had Marlene fill out "needy case" forms. Dr. Zaltz eventually came by the studio and chose several drawings to cover his bill, as did the anaesthetist and the internal specialists. As for the accident itself, the offending car was never found, and no charges were laid, not even for driving under the influence. The charmed existence had saved Robert's life and kept him out of court.

Patrick Watson, involved at that time in a personal crisis of his own, didn't see Robert for a while but sent a telegram offering advice on healing: "Suggest try again forthwith targeting legs and gall bladder instead of arms and liver. This will leave hands free for pinching nurses and preserve a capacity for rubbing alcohol which I am told those places are full of. All you have to do is bribe the night supervisor. Offer her a painting. If above not practicable advise and I will forward a hand-printed copy of 'Toe Exercices [*sic*] and Sensitivity Training' by Masters and Johnson. Write if you get work."

Robert's sister Lois sent him a puzzle game called SOMA: "They say it eliminates tension. Stick with it, remember, *you have always conquered all dragons, and this is just another dragon*." From Hollywood, Michael Sarrazin

sent an ironic message to his artist-Native friend: "Rumour here you angling to replace Venus de Milo in next season's pencil commercials stop strongly advise against as racist elements likely to prefer Ticonderoga over Mohawk stop." Michael was referring to the popular advertisement of Venus-brand lead pencils and their rival Dixon Ticonderoga brand, but of course the connection between mythic artist model and Native artist is inescapable.

In a great deal of pain and downing a lot of pills to mask it, Robert had to be fed, bathed, and clothed for the rest of the summer. Marlene had to return to work, so his mother came from Hamilton for August and September and was aided considerably by a New School student, Ruth Lederer. Gord rigged up a phone-answering device, and when Robert could eventually get around, Micky Handy, his New School colleague, drove him to physiotherapy every morning in exchange for the use of Nobi's car. Dennis Burton gave advice on good jazz to listen to, such as a recent recording by the Miles Davis Quintet with Wayne Shorter and Herbie Hancock. It was, however, quiet, ironic, and somewhat eccentric Ed Grogan who, in helping to care for Robert, became a new close friend. Ed had met Marlene when they were playground supervisors together during the summer before her first year at OCA. He went on to play professional baseball in the American south but couldn't abide the racism, quit the team, and never held a job again. Fortunately, his wife, Ruth, became a York University English professor who, much like Marlene, accepted her husband's unusual approach to life. Prior to the accident, the Grogans had moved to an apartment on Spadina just south of the Markles, and Robert and Ed would go out for breakfast at Switzer's Delicatessen. Ed collected art books (many of which he gave to Robert), shared his considerable knowledge of classical music, and wrote a favourable article on Robert's work, so they had much to talk about.

When the metal rings and elastic bands were removed in the fall, Robert phoned Michael Sarrazin and told him he wanted to buy an electric piano, so the money was loaned with no expectation of repayment. The piano allowed Robert to use his fingers, still too weak to press saxophone stops, and remain a member of the AJB on a new instrument. During the Christmas holidays in 1969 Michael came to visit, and they went to the beer store together. Robert's weak grip gave way under the weight of a twelve-pack and he re-broke his clavicle as he struggled unsuccessfully to hold the case.

The household income during this period depended entirely on Marlene, and there were costs for painkillers and doctors' appointments,

so Gord organized the Beautiful Big Bob Benefit Bash for December 5 at the Masonic Temple, at the corner of Yonge and Davenport. Tickets were $5 each, and Lightfoot and the Downchild Blues Band performed for nominal fees. Hundreds of Robert's friends and admirers attended, and enough funds were raised to help him and Marlene pay off some debts and survive until he could return to work at the New School. He had never addressed the issue of whether he would be able to draw again, and as time passed it was evident his confidence in his ability to do so had been shaken. He needed a project that would force him to make marks on paper rather than wait and hope that confidence, and inspiration, would return. The drawings for Andy Wainwright's collection of poems, *Moving Outward*, were a "godsend."

Andy was a fourth-year student at the University of Toronto when he decided to edit *Notes for a Native Land*. While he'd convinced high-profile cultural figures such as Northrop Frye and Robertson Davies to write pieces about Canada for the $20 honorarium, he wanted edgier contributions as well. Someone recommended "this painter who can write," and the result was a November 1968 meeting at the Yonge/MacPherson studio on a Saturday afternoon when Lightfoot was there visiting. Robert soon agreed to write an article for the book, and he just made the deadline for manuscript submission the following spring. Although not enamoured of the Pilot lifestyle, Andy would sometimes meet Robert and the Isaacs crew there for beers, a very young poet trying too hard to keep up with older and wiser artists who, probably because of the more inclusive Robert, allowed him to sit on the outer fringes of their conversation and occasionally make literary remarks. That he'd read Kerouac and Ginsberg didn't hurt. But Andy made studio visits too, and Robert read and liked the poems he was writing and getting published in university magazines. Robert could write powerful and imaginative prose, but his poetry usually focused on body parts and was rife with sexual cliché and sentimental expressions that Andy once told him were like those of a pornographic Rod McKuen. Andy certainly knew his poetry wasn't on the level of Robert's drawing, but he was nevertheless being published in a medium that Robert couldn't master. And Robert, despite his healthy ego, was generous enough to admit this and inquisitive enough to want to learn from it. In the winter of 1969–70, when Andy asked him if he would provide an already completed drawing for the cover of his first book of poems, Robert decided this was the opportunity he'd been waiting for.

Because Robert's fingers had not regained their usual dexterity, he adopted the shaving-brush technique he would later employ with

house painters' brushes in Rae Johnson's class at the New School. The thickness of the brush handle allowed him to make "different marks than ever before," and with this new-found freedom he created thirteen ink drawings, including one for the book cover, that reflected the poems' images and themes in (with one exception) expressionist figure forms. The sweeping curves of broad lines and the solid oppositions of black strokes and white paper exist in full-page renditions of single and blended figures and smaller, more suggestive outlines of the same shapes. The sexual aspect of these figures is muted because the relationships posited in the poems depend more on metaphoric connection rather than physical experience ("our embrace was so unique / we wondered who had thought of hands before"; "tonight you were a wave washing / over my body / of smooth flat stone"). The most delicate drawing is of an androgynous figure from the Dachau death camp. The one non-human form is the two-page drawing of a car moving between "the trees (black / walls under the sky)" that now hangs on Rae Johnson's wall. There is no self-portrait in the collection, though there is a poetic depiction of Robert under the title "Molson Golden Rag" that pays tribute to his character and the friendship between him and Andy that would last for twenty-two years.

The motorcycle accident "slapped mortality against [Robert's] forehead" and made him entirely dependent on others for the first time since his boyhood. This dependence, combined with his previously expressed need for a sabbatical, pushed him and Marlene toward a different living arrangement that would have to be worked out by the time of Nobi's planned return to Toronto in mid-1970. That arrangement would come by chance. In his professional life, his output between the time of the Cameron Gallery affair and the summer of 1969 had been varied and prolific. Prior to the accident, "he had been thinking miles ahead" about his work, especially about the introduction of colour, though he would have agreed with Cézanne that "drawing and colour are not separate at all; in so far as you paint, you draw."

Four untitled drawings in charcoal on paper from 1966 continue in the vein of the expressionist figures from the previous year, such as the one used in Robert's "Golden Spike-Heeled Fascination" article in *Showcase*. These are leaner, though still full-breasted, Egon Schiele–type figures with dark shadings that fill out their thinly outlined bodies twisted in contortions of desire or pain. If one earlier drawing, left out of *Showcase* because it was considered too risqué for mass consumption, seems to depict one of the two female lovers braced against her partner's hand

Front-cover drawing for *Moving Outward*, 1970

between her legs, these newer figures often seem to flinch beneath the charcoal that creates them. While the shadings to some extent ground them on the paper, these are women only tenuously occupying the white space from which they have emerged, and they forcefully represent rather than inhabit lives lived. In thirteen charcoal and tempera drawings from 1967, however, Robert's figures and their actions fill the frame completely with a display of energized form that suggests, as Paul Young says, the marking of an interior life. These women are not contorted but somehow

curve and flow into transitory positions that will immediately yield to others. The outlines of their bodies are firm enough in most cases but serve as mere guides to the artist's emphasis on light and dark tempera patches that substantiate rather than represent who they are. There is a density and weight to the layered application of the black and white marks that suggest the coming of colour, particularly in the numbered series titled *Marlene: Summer Bronze.*

These 1967 figures exhibit a fullness of sexuality that had been and would remain the focus of Robert's attention, but the next year he offered a sequence of open-legged carnal flauntings that challenged the borders between the erotic and the pornographic. At first glance these appear to be fragmented X-rated body parts—inner thighs and thickly-daubed black crotches thrust at the viewer—but a more careful look reveals the torsos, breasts, arms, and heads at rest or in motion that, like the face in *Paramour,* provide a context and balance for the genital depictions. Once this "elsewhere" of physiognomy is evident, there is no still-life nether-world that simply assails the gaze but rather "grace in [the] desire" of someone "wearing their skin proudly" and the possibilities inherent in such a condition. We should not make the mistake, however, of missing Robert's intention to trouble those who would resist erotic potentials. In at least one of these drawings he parodies the pornographic gaze with a cartoonish overstatement of obsession with labial access and orgasmic discharge. This "churning vagina" threatens to swallow the spectator, who has no alternative forms of vision or resistance.

More important is the remarkable *Drawings for Pale Blue Marlene* series, in tempera on paper, in which a figure's "very sculptural" thick legs and torso are viewed frontally and from below, the upper body receding somewhat in force and dimension until the literally streaming head and hair dominate the top part of the frame. For Corrina Ghaznavi, "the forms are very organic, the curves emphasized and the figure's surface worked and shaded in many layers.... the effect is generally one of spontaneity, fluidity and quick execution." There are drawings from this period that, with a little imagination, might be seen as before-and-after drawings in relation to the *Pale Blue* series. In some, the bare emergence of the figure is visible with minimal shadings in a fineness of line and volume, while in others there is a much more developed surface layering and brushwork complexity that occasionally approaches the abstract.

The *approach* to abstraction is an important part of Robert's work at this time, because he never really left the figure behind, although he took it to levels of expression that "focus more on the dynamic movement than

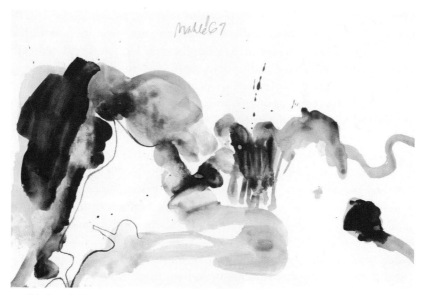

Marlene: Summer Bronze IV, 1967 (charcoal and tempera on paper, 57.5 × 87.5 cm)
COLLECTION OF MARLENE MARKLE

on the contour of the body itself. In the balance of dark blacks against the white of the paper, one at times is hard pressed to find the figure. The viewer has to work backwards to discover a leg and then follow it to a breast or the dark area of the crotch. The eye moves seamlessly back and forth between the abstract composition and the image that is the whirling figure." This assessment by Corinna Ghaznavi, while certainly perceptive, ascribes a success to Robert's efforts that perhaps even he would not have claimed, if that success were to be measured purely by the flawless joining of the non-representational and recognizable aspects of the figure. Ghaznavi suggests not a blending but a simultaneous awareness of the oppositions posited by Herbert Read: "On the one side a coherent image, a more or less precise configuration with its spatial envelope; on the other side only the tracks left by the painter's gestures, the internal dynamics of the painted area." But, along with Robert's loyalty to the figure, perhaps there needs to be room here for Georgia O'Keeffe's concept (and practice) of equivalency: "I long ago came to the conclusion that even if I could put down accurately the thing I saw and enjoyed, it would not give the observer the kind of feeling it gave me. I had to create an *equivalent* for what I felt about what I was looking at—not copy it." In other words, the literal comprehension of the figure, or parts of it, as well as the distinct knowledge of what is abstract, is not always the point. Nothing in drawing

or painting is seamless, but the closest correspondence may be in the artist's and viewer's shared *sense* of the image rather than overt cognizance of what is going on in it.

Robert's first forays into colour in 1968 are, as might be expected, experimental in nature. The sepias, yellows, reds, dark indigos, mauves, and blacks that emerge from the mixture of tempera and coloured inks sometimes fit more or less neatly within the contour lines of arms and legs to intensify their specific shape and dimension. At other times they exist in their own space on the paper, inside and outside the lines as if to stress that shape cannot be predetermined and to emphasize an expansiveness of movement when this is so. In 1969 Robert drew an untitled high-heeled figure who is leaning back in a sitting position with her legs spread in mauve, red, and black inks that form both skin and costume. Only her right leg and high heel exist in charcoal outline with a thin red-yellow band running down her shinbone and part of the shoe filled in with black. The ambiguity of the flesh-dress divide suggests both the eroticism of the dancer-stripper's "taking it off" and of Lily St. Cyr's dressing herself in a suggestive reversal of the strip. How Robert's use of colour would have developed out of these initial drawing/paintings is not known, because his work was violently interrupted by his motorcycle accident. His brush strokes were stilled for at least six months while the damaged nerves in his hands and arms healed. When he picked up the shaving brush in early 1970 it was to see if he could still make his marks on paper.

Dozens of black-and-white tempera drawings done with this same brush were very likely completed before Robert embarked on the ink drawings for *Moving Outward*. This is because tempera is cheaper than ink and because he stored it in large-mouthed jars as opposed to the small ink bottles that would have required some dexterity to handle. As well, in addition to the thick strokes and heavy, though still controlled, delineation of forms, the drawings he did for the book of poems contain fine lines, indeed at times a relative delicacy of expression, that is present in very few of what might be called the preparatory works. The earlier figures were still moving and falling, the draftsmanship was there, but the gap between the implied desire and achieved grace of the artist, as well as of the figure, had yet to be closed. As was usual with Robert, it was the combination of lived experience and creative process that took him forward.

Domesticity I, 1988 (acrylic on paper, 75 × 110 cm)

VI
PROMISED LAND: MOUNT FOREST 1970–1978

Gord Rayner says he was with Robert and Marlene in the late 1960s when the New School crowd visited an Uxbridge farm about an hour and a half northeast of Toronto: "Robert put his arm around Marlene and said, 'This is it.' I knew then I was going to lose them." Whatever Robert's inclinations toward country living in the period before Nobi's return from Japan, all he and Marlene knew was that the city environment was overwhelming them. Robert was "bombarded" by students coming to the door, wanting to talk about personal matters and quite often strung out on drugs and suicidal. His hard drinking and late-hours lifestyle were exhausting and had almost cost him his life on the Don Valley Parkway. He was starting to draw again and needed some space and time to himself, though just how and where these would be found, he hadn't figured out. As for Marlene, she was still looking for that sabbatical from her full-time job at the Isaacs. Then in the spring of 1970 a friend of theirs, Diana Wedlock, asked them if they wanted to see "a place in the country" owned by her parents, who were looking for tenants. In the mid-'60s, Diana had gone to India and brought back a sitar for Robert. He had taken lessons on the instrument and played it with the AJB.

Neither of them knew where Mount Forest was. About a hundred and sixty kilometres northwest of Toronto and located on Highway 6 almost equidistant from Owen Sound to the north and Guelph to the south, the townsite had been settled prior to 1853, when it was officially named after Mountforest in County Wexford, Ireland. With a population of about 2500 people in 1970, it sat on a height of land close to the headwaters of the Saugeen River, a name taken from the Ojibway word *zaagiing*,

Mount Forest, normally a two-hour drive, where they would end up at the dancer-less Mount Royal. Stephen insists that what they did together was "in the tradition of the Victory Burlesque" and that later the strip business became "more about actual sex" controlled by organized crime.

Although Stephen, unlike Robert, was in Toronto almost every weekday, their sharing of the commuting life meant he saw and knew both the city Robert and the country Robert on a regular basis, in ways that most of the artist's close friends did not. Graham, Gord, Nobi, and others from the early days visited the farm occasionally, and Robert usually connected with them on New School days. Patrick Watson would land his plane at a nearby cornfield, where Robert would pick him up, but Patrick visited no more than a few times a year. Michael Sarrazin would fly in from Hollywood less often than that. Sarrazin recalls his winter journey the first time he went up to Mount Forest. Robert had told him to "get a cab" at the airport, and Michael did so without realizing it was a 160-kilometre trip. When he arrived in the deserted, snow-swept town after midnight, a solitary red Volvo was parked on the empty main street. "What took you so long?" was Robert's querulous greeting.

The four or five days a week Robert was at the farm followed a pattern that had been established in the early days, when he and Marlene lived on Avenue Road, Webster Avenue, and Yonge Street. He would draw or paint during much of the day, or read or watch television if the inspiration wasn't there, and in late afternoon drive to the tavern that was the country version of the Pilot as his social centre. If Marlene had shopping to do, she'd join him for a beer, go off, and return to pick him up fairly early. But most days she would have dealt with their basic needs earlier on and he would go into town alone.

At the farmhouse table his place was always set, and he would leave directions about preparation for the meat he liked to barbecue, but often he turned up too late and with too much beer in him to care much about food. This behaviour had its consequences. In mid-December 1974 he received a letter from his Mount Forest lawyer advising that two charges of impaired driving and refusing to provide a Breathalyzer test were set to be tried at the end of the following month. He paid a fine, but he was lucky, through the many years of his over-indulgence, that he never had to serve time in jail. On one occasion he lost his licence.

The habitual Mount Royal crew consisted of local men who were laid off from their jobs in the winter and received unemployment insurance. In the mid-1970s about a dozen of them banded together to form a hockey team they called the UIC (for Unemployment Insurance Commission) Flyers,

and soon they had more than enough members to form two full teams. Every player pitched in $5 a week, and they bought late-night ice time at the town arena for a pickup game that allowed no bodychecking or raising of the puck. To score a goal a player had to hit an orange pylon—one was set up at either end of the ice—but later things became more sophisticated and they made boards with three puck-sized holes in them.

"Enthusiasm made up for the lack of skill," recalls Tim Noonan.

And what kind of hockey player was Robert?

"In *his* opinion?"

After the game, the players would head for a reserved table at the tavern and relive the glory until closing time.

"Robert knew the game," states Craig Kenny. "He was serious about rushes up and down the ice, and would always ask, 'Was my ponytail sticking straight out?'" Marlene remembers him saying "how heavy the puck was" on his stick at first, but that he was determined to get himself in shape. Before the beginning of his second season he cut back on his beer consumption, agreed to eat smaller portions of food by using a little spoon and little bowl, and actually went running up and down country roads. The regimen worked. His weight went down from 230 pounds to 180. That second winter "there was an extraordinary change in his game," and he zealously got up for the new early-morning ice time. In a lengthy article for *The Canadian* that appeared in January 1976, Robert described the need for fitness, his memories of playing the game, and the not overly dramatic results of his efforts. "Starring on My Own Bubble Gum Card" had a large colour photo of Robert in full gear at centre ice at Maple Leaf Gardens, which was his condition for writing the piece. His exploits in the Mount Forest arena weren't quite so glamorous: "I'm freezing my ass off. I'm lying somewhere near the blue line gulping desperately for air with a pair of lungs already strangled by a lifetime of gravy-graced French fries and cheeseburgers with everything.… The only athletic thing I've done these past few years has been quietly climbing back on my bar stool at the Club 22 in such a way that none of the waiters there will realize I've fallen off.… It's going to take some doing. I love the game, but all those years away are going to cost me."

Part of the price would be paid with the memories he evoked and his growing awareness of art's place on the ice, even if the artist's gesture didn't always do justice to the game:

> Crystal mornings in the east-end Hamilton dawn, living right
> beside Mahoney Park's outdoor hockey rink, I could look out

my bedroom window and see the man who watered the rink, a huddled figure spraying water in long curving patterns.... we were Gordie Howes, and we fought over whoever was to be the Rocket, whacking balls and chunks of coal and frozen turds from the milk-man's horse.... And we played until the only light left was the eerie glow of the steel plant fire stack.

You must remember, I'd spent a lifetime learning and practising certain skills necessary for the manifestation of my thoughts. I'm a painter, a good artist. My vision and my craft are so honed that they marry into cohesive, sometimes beautiful work. My hand is equal to my head. But on Sunday mornings my head races down the ice, my blades send showers of bleached spray like the wake of a star, and the game rolls with me. But my hands are woefully incapable of any such grace, they only get in the way. It's like learning to draw all over again, like practising scales.... Things improved. And more important than that, I was beginning to understand the game, from ice level. I was learning how to pace myself, what my limitations really were, the true shape and size of my canvas.

Most important to Robert, perhaps, was the combination of complex insights and shared moments of joy and camaraderie that were always at the hub of his exchanges with those he genuinely liked:

belonging to a team, playing, improving, catching that rare glimpse of the core of something worthy of the search, something inside the game but also inside us all. Inside everything. Instead of kids growing up, men growing down, down to a kind of truth that allows us all to be poets, artists, stars. A truth that even though it might be just a moment, the barest of moments, it gives us all a chance to see the centre of ourselves. Sure, it will vanish with the next sloppy pass, but at least we got the chance to be there....

... that insane time when Bob Park and I found ourselves side by side on the bench during a particularly inept showing by our team, we were being slaughtered and we started to laugh, and couldn't stop; we giggled our way through our turn on the ice like a pair of padded lunatics ... and after

Robert at Maple Leaf Gardens, January 1976, in a photo that accompanied
Robert's magazine article "Starring on My Own Bubble Gum Card"
PHOTO BY KEN ELLIOTT

that same game Peter Blyth, our normally excellent goal-
tender, told us he didn't have time to have a beer with us as
he had to rush his stick over to the Hockey Hall of Fame....
Blaine slapping me on the ass during those interminable
warm-ups saying, "Are ya ready? Are ya ready?"

This article attracted the attention of Ramsay Derry,
editor-in-chief of the trade division of Fitzhenry and Whiteside, who
wrote to ask Robert if he was "likely to write more. Would it turn into a
book? ... I would even be willing to venture into the Pilot Tavern if there
is a possibility of seeing you there when you're in Toronto." Nothing came
of this proposal, but the accolade is undeniable.

The attention to his bodily well-being dwindled by the end of the sec-
ond season, though Robert played for several more winters. A few sum-
mers later, the Flyers formed a slow-pitch softball team and joined a
league. With the Mount Royal sponsoring them, Robert designed caps
and sweaters that prominently displayed an overflowing beer glass and
a leering nude. He played some second base but was mostly a fixture at
catcher, because he could be involved in every play and loved to harass
opposing players with barbs that belittled their skills. Tim Noonan recalls
car trunks full of beer that they drank by the field after a game, but local

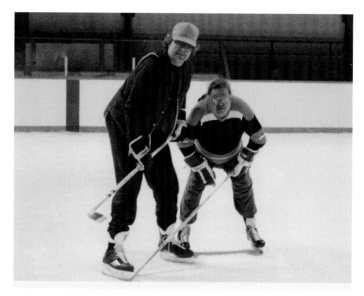

Stephen Williams and Robert on the ice at the Mount Forest arena, winter 1976–77

authorities clamped down on that, so they usually ended up at the tavern or at someone's house.

Outside the locker room and off the ball field the good-time conversations continued, but Robert spoke seriously with the Flyers about who he was and what he did. He answered their questions about his art, taught them that knowledge about drawing and painting didn't have to come out of a university education, and emphasized that art didn't have to be strictly representational in form. When Tim once asked him in the Mount Royal if he did his drawings the way he visualized things, Robert was very pleased with the question and responded at length. He would refer ironically to his reputation as an artist, proclaiming, amid much laughter, "I'm a big-time guy," or bragging, after doodling a Flyer's likeness on a Mount Royal coaster, "You see this? I can really draw." But he would also disappear for a couple of weeks at a time and they would know he was working at home and not to be disturbed.

Robert appreciated the integrity of the Flyers' experience and their perceptive views of life, which they often cloaked in the same self-deprecating irony that he used when referring to his Native heritage, applying a veneer of humour to mask self-awareness. Tim Noonan refers to the bantering between Robert and Doug Kerr, but his growing acknowledgement of his heritage was evident in June 1977 when he wrote to the Mohawk band administration office at Tyendinaga to enquire about his Native status. In

response came a photocopy of his registration "under Band No. 1358" as well as a copy of his father's sheet from the Indian Register "under Band 599." Four years previously, he had submitted a design for the Iroquois ceremonial costume stamp in the series on Canadian Indians to be released by Canada Post. Around that time, his sister Susan says they had a phone conversation about the fact that they had remained unaware for so long about their Mohawk background. They laughed about relating more to the Italians in their Hamilton neighbourhood, who had the same black hair and dark complexions, than to Natives they saw downtown.

"We should have been able to make our own decisions," Robert told her, more seriously. In 1985 when he finally went to Tyendinaga to obtain his Native status card he called Susan again to announce, "I felt so good [being there], because I knew who I looked like." Craig Kenny, who had been employed as an ironworker, asked him about his father's and brother's high-steel experience and was the one who suggested they drive to Oka with supplies for the besieged Mohawks in June 1990.

Robert's first public connection to his heritage was perhaps in his 1971 review in *Books in Canada* of *Out of the Silence: The Enduring Power of Totem Poles*, by Haida artist Bill Reid and photographer Adelaide de Menil. Not wanting to be known as an "Indian artist," he nevertheless treated Native art as equal to that produced in the Western tradition of creative expression of which he was determinedly a part *and* indicated his awareness of the injustice done in the name of cultural essentialization:

> What goes on in the mind of that carver? Is it any different
> than in the mind of a de Kooning, or an Emily Carr? ... If
> art is important then I wonder if these guys are artists. And
> if a man is alive today, where does his responsibility lay [*sic*],
> with his heritage, or with his time.... The last snap is worthy
> of study. Splintered remains of a battered totem lean out of
> roadside scrub and into a No Parking sign. Surrounded by
> sewage pipes, industrial debris, wire fencing, and electric
> wiring.... Ah yes, time and progress, like having hawkers
> flagging postcards outside the Sistine Chapel.

Ironically, he was more connected to such essentialization and to *the* Canadian Indian artist, Norval Morrisseau, than he realized at the time, as revealed in the catalogue of a 1999 show at the MacKenzie Art Gallery in Regina, titled Exposed: Aesthetics of Aboriginal Erotic Art: "Although Morrisseau has consistently painted erotic imagery, these works have

rarely been exhibited and documented, rather they have been hidden away in the vaults of many museums and galleries." Robert resisted the compartmentalization of the Indian artist and told the *London Free Press* in 1985, "I think people should be aware you can be a native Canadian and still understand Christopher Wren is wonderful and Rembrandt is wonderful and Western art is wonderful."

For Robert, 1974 was an important year. In May he was awarded a Canada Council Senior Arts Grant worth $14,500 (with $2000 of that for production costs). The previous fall he had submitted twenty slides of tempera, ink, coloured ink, and acrylic to the Council, saying that he wanted to take some time off from teaching and live and work in New York City "for a while." His application was helped considerably by his having won a competition to do a mural for a reception area in the new federal Food and Drug Building in Scarborough, Ontario, in 1973. Actually a single acrylic-on-canvas painting, 2.3 by 3.8 metres in size, it shows a large, rather undefined female figure in reds and blacks floating face down in or above a deep blue surround that may be water or could be light. Separate lines trailing away from the body suggest an agility in movement more than a dancer-stripper's accoutrements. Robert recognized that the visual horizon of the general public had its limits.

The AJB had continued to be active during this time, and Gord describes a case of Robert's stage fright, which occurred frequently despite that he'd been playing in public for over fifteen years and exuded self-confidence in group situations. The band did some travelling with Graham's retrospective show in 1974, and ended up at Concordia University in Montreal:

> I remember suffering a severe case of stage fright myself
> and a half-hour before the curtain, I went out on the huge
> stage to lie down between the backdrops while the rest of
> the band busied themselves smuggling whiskey, beer and
> other condiments into the dressing room past the belligerent
> security guards. Suddenly I became aware of guttural snorts
> and heavy breathing seemingly within reach immediately to
> my right. Deftly lifting the curtain, there I saw Robert. His
> brilliant brass tenor saxophone atop his belly as he lay there,
> sighing deeply and ever-so-slightly trembling. When he
> opened his eyes and saw me "next door," we both broke out
> in guffaws of laughter and I recall Rob saying between gasps,
> "Hell, Olivier used to puke his guts up!"

However he managed at Concordia, his poise didn't generally disappear when it came time to perform. He had been paying attention to Patrick Watson's 1973–74 television show *Witness to Yesterday*, in which Watson interviewed such historical figures as Queen Victoria, Catherine the Great, Socrates, Judas, Columbus (played by William Hutt), Billy the Kid (Richard Dreyfus), and Norman Bethune (Donald Sutherland). Perhaps inspired by watching Patrick switch roles and play Leonardo da Vinci, Robert suggested Rembrandt as a future subject. Watson thought this a great idea, but was shocked when Robert insisted that he himself would portray the Dutch painter on screen. "Have a fucking great makeup artist, and I'll be Rembrandt—you'll see," Robert told him. That he also wanted to improvise their dialogue rather than work from a script added to Watson's concerns. Marlene says he wanted to use *his* voice to allow Rembrandt to talk about the nude, light, and line, and in preparation he did a great deal of biographical reading about the conditions under which Rembrandt painted in seventeenth-century Amsterdam. He also studied the Rembrandt self-portraits reproduced in the art books Ed Grogan had given him.

"Rembrandt was the only artist daring enough to make the relationship between exposure, embarrassment, and desire a recurring subject of his work," Simon Schama writes in *Rembrandt's Eyes*. It is a statement replete with association to Robert and his work, although of course their subject matter was completely different. Or was it? In the Hermitage in St. Petersburg hangs a Rembrandt painting titled *Danae*, completed in 1636. It is one of the few nudes done by the painter, and the body is based on that of his wife, Saskia. Originally a figure from classical Greek myth, Danae is the daughter of King Argos, who, it has been predicted, will die at the hands of her son. He banishes her to a cave with a nursemaid, but Zeus has fallen in love with her and finds a way into the cave, where he possesses her. Titian had idealized her a century before, making her a beautiful but passive and unattainable woman in his *Danae and the Shower of Gold*; Rembrandt, however, shows her posing provocatively on a bed and gazing at someone beyond the edge of the frame, while the nursemaid—looking rather like Rembrandt himself—peers around the corner of the bed curtain. Danae, who seems to beckon to this hidden figure, is clearly in charge of the situation, much like Robert's dancer-stripper, who is aware of her own physical charms and positions herself to attract the onlooker. What might be at first unnoticed by many viewers of the painting are the overturned red and brocaded high-heeled shoes beside the bed, which Robert would have fixed on immediately as *de rigueur* items for the artist model.

In his preparatory notes for the television show, Robert revealed his sense of connection to the man and painter he was determined to portray. He observed that Rembrandt didn't like to travel. He emphasized that Rembrandt's story of a visit to an older artist paralleled his own experience in Peterborough with the aging painter of nudes on velvet the summer when, still a student, he had worked for the Department of Highways. He imagined Saskia dressed up by the artist "to look like a princess or a fairy queen and then [become] a part of his work." His affinity with the painter's sense of light was evident in his response to a description by Rembrandt of the inside of his father's Leiden mill, which he represented visually only from the outside:

> ... the inside of the mill is flooded with light, the light
> through a small window is then momentarily blocked out
> due to the windmill blades passing by the window ... the
> inside is deep in darkness, rats ... and a wire cage [rattrap]
> hanging in the centre of the mill, hanging from some
> rafters, swaying in the light, casting shadows, this radical
> change of light allowed Rembrandt to see something he
> probably felt before, now he was to see, the colour, texture,
> mass, substance of the air (space) light ... there were
> different sorts of air ... always changing ... space has colour,
> all space ...

The two artists also shared, Robert felt, a "bold style [and] non-concern for 'realism.'" He applied his favourite de Kooning maxim, "Content is just a glimpse," to what Rembrandt was doing with the people and things he painted:

> ... subject matter is unimportant, just the vehicles the artist
> uses to get into the real vision of his world, he uses the marys
> and the josephs and the jesus' [sic] merely as armatures,
> actors in his way of seeing things, armatures on which to
> hang the values of his vision, the artist sees his subject matter
> merely as abstractions, ready made for him to start on ... it
> is the ideas that are the real content of the painting, this has
> always been true, true today, it's relatively easy to see beyond
> the things (paint, brushstroke, donkey, chair, man, etc.) and
> into the ideas of the painting, what really is going on....

What was profoundly important to Robert was Rembrandt's continuing relevance three hundred years after his death:

> ... modern art would seem to r. to be a logical progression
> of his ideas, he would know that under the feeble light
> of a candle, working over the necessary tight work of
> crosshatching into a copper plate, working to reduce a
> background into low light or shadow would be a high, he
> would understand that necessary doggedness of search
> into the space of the picture ... i'm sure he would sense an
> affinity with Pollock and his countryman de kooning, he
> would understand the mystery of paint....

Certainly a strong part of the kinship Robert felt was his physical resemblance to the stocky, overweight Rembrandt. In his notes is a line he perhaps intended to use on the show, but, in the event, did not: "like all fat men i tend to be my own hero." Size and shape can yield imitation but not necessarily equivalency. When the application of makeup was complete, however, and Robert had clothed himself in a cloak and a broad velvet hat that hid his ponytail, the result was "jaw-dropping"—the Mohawk mimicked the Dutch master's appearance as closely as possible, complete with practised ways of sitting that some of the self-portraits reveal. But just as the physical object being painted was only "the armature on which to hang the values of his vision," so Robert's physical interpretation of Rembrandt was simply the enticing hook from which to drape "the ideas of the painting, what really is going on...."

Marlene says that Robert exuded confidence but was "very nervous underneath," which wasn't helped by his enormous hangover. They had travelled down to Montreal and spent the night before the April 24 taping of the show drinking with Patrick and Michael Sarrazin's sister, Enid, and the result next morning was his "gagging on the floor" of their hotel room, with apprehension compounding the effects of the booze. During the long makeup session he fell asleep in the chair, but when he awoke his hands were shaking. When he stood up he moved with some hesitation. He was desperate. The booked studio time was only minutes away.

"Can anyone get me some speed?" he asked. The production crew quickly obliged. Bolstered by the amphetamine, he replied to Patrick's anxious question about his condition, "Don't worry about it." Then he turned to the crew and said loudly, "Let's go, gang!"

Robert as Rembrandt on History Television's *Witness to Yesterday*, April 24, 1974

They shot five rolls of 16-mm colour film that was edited down to twenty-six minutes for the broadcast. According to Patrick, "he was totally at ease being in that Flemish environment.... He surprised me and was certainly a hell of a lot better than I could have imagined." This wasn't just the response of a close friend. The veteran producer-director, cameraman, and others on the set applauded when it was over, and all signed the book on Rembrandt they presented to him. Although Patrick recalls "how convincing he was without acting," Robert called Michael Sarrazin from a Montreal pub and told him, "I have so much respect for what you do. I had no idea how difficult it is."

The twenty-six edited minutes reveal a fascinating portrait of Rembrandt in which the give-and-take between him and his twentieth-century interviewer stresses intention and result in the Dutch painter's art and life. Robert was intensely aware of how he would be seen and heard in tandem with what he had to say. His achievement is that he successfully aligns his minimal movements and modulated tone of voice with the topic under discussion, letting his confident assumption of a role he clearly believed he was born to play make believers of his audience. It is the entire, unedited transcript, however, that reveals the truth of Patrick's perception that while "the substance was all Rembrandt," the figure being interviewed "was Robert" in full control, as usual, of the conversation. Perhaps "was Robert" is more suitably described as Robrandt, who is rather like a Native trickster

figure throughout the interview, challenging viewers to re-imagine their reality: "Tricksters liberate the mind … and they do so in a language game between two people who take pleasure in [the] game and imagination, a poetic liberation of the mind."

In his very first comments (Take 1) Patrick starts to build a case about Rembrandt's interest in women as set against their relative scarcity in his work. Robrandt interrupts him wryly: "Do you think it's a little too soon to talk about women." It's not a question, it's a direction. Patrick tries to ignore this by stating that Rembrandt didn't paint many nudes, but the artist turns the assertion around by asking: "How many naked women have you seen in your life?" He goes on to comment on the subject matter that allowed the definition of space: "I would see a face. I would find it interesting … something I could explore [to] use as a point of departure…." As for the viewer whom Patrick says Rembrandt tries to entice into his work, Robrandt replies, "It is my responsibility to do the best I know how and that demanded the participation of the viewer, but I don't care about the viewer. That's not important."

In Take 2 they discuss the famous group portrait *The Night Watch*, but not before Robrandt gets Patrick to talk about how he'd like to be the subject of a Rembrandt portrait, and to consider the gap between what the viewer wants shown and what the painter actually shows. What if, the artist asks, instead of painting your nose as you think it should look, I used it "as a focal point for the canvas?" This seemingly irrelevant exchange leads into Robrandt's comment that he didn't do with the thirty-three Amsterdam militiamen (and the one little girl) in *The Night Watch* what they expected him to do. He saw them, like so many people in history, as hating their daily work, and presented them in their costume finery to oppose the quotidian ordinary, their apparel representing the best they had to offer and ironically becoming the "definer" of historical event. Later in the interview he admits his strengths and limitations in this regard: "I'd want to paint a blue dress, the client would walk in in a red gown. The blue was important. I saw blue, the client wanted red. I didn't know how to see the way they saw…. All I could do was paint the way I saw things."

Somewhat thwarted in his line of questioning, Patrick pursues the personal, suggesting that Rembrandt's life "was full of errors in judgment" as regards looking after himself and his family. Robrandt, as loyal to Robert as he is to the artist whose role he is playing, defends the painter's obsession with his vision rather than with the practicalities of life that need to be taken care of by others. It is an obsession "with something that you know is there. You've got to find it, you've got to go after it and all that

other business ... I had no time to deal with." Patrick, sensing what his friend is drawing on here, pushes the personal pursuit closer to home: "You were like a child, you wanted somebody else to look after it for you, but if they didn't you weren't going to do it yourself. Isn't that true?" The artist, feeling a little cornered, admits "Even now I can't think about things like that. They get in the way." This focus on lived experience continues in Take 3, in which Patrick presses Rembrandt on his acquisitive nature and how he spent a lot of money on things he couldn't afford. Robrandt's response is evasive and edgy but also challenging to the questioner: "Does it bother you, Patrick? My so-called irresponsibility?"

They also discuss the qualities of artificial as opposed to natural light— "It [artificial] doesn't have the texture that it should have, it doesn't bathe the objects it hits, it simply somehow points them out"—and return from a different angle to the subject of nudes. Here Robrandt focuses on his need to employ objects to "define the space that I was trying to deal with" and, anticipating the 1979 Joan Murray interview in ways, asserts that he wasn't as interested in the muscle and bone of the human body as in "the rhythm of robes ... that cast light off different surfaces." But while Patrick's concern appears to be with the absence of absolute nudity, the artist's focus is on the traces of what is no longer there: "As surface changes it moves away, away from the viewer, moves back into the canvas geared to the space."

Despite his declaration that the politics of the day weren't important and that he "never went out of the house," Robrandt emphasizes that there are different forms of the front lines of experience: "You can never stop learning, you can never stop putting yourself in a position of some jeopardy." It all has to do with art in Amsterdam and Mount Forest: "There was nothing to do between paintings.... That's all there is, work ... every time I open my eyes and see...."

In the last Take 6 Robrandt laments the thin forms of today's women: "I sense a brittleness about them, it's not enough life for me to deal with, it's like trying to paint a landscape with one tree." It's a startling analogy, but he doesn't stay with it, adding coyly, "I'm sure if I had time I could grow to like them." He does interpose one of the things he had wanted to stress about the connection between then and now, between himself and painters like de Kooning: "I see a contemporary painting [and] I under-stand it, it's a very logical extension of what I was doing. The painters today have the luxury of not having to deal with subject matter, they can deal with content, that glimpse...." Toward the end, Robrandt seems to mirror Robert at his kitchen table in Don Owen's film: "Ever get to know

anybody? You talk to people to know yourself. I paint pictures to know myself. I felt that if I knew myself then I knew everyone. I knew everything." Finally, the artist draws the interview to a close, inviting Patrick out for a few drinks with some "very thin, gaunt-looking women."

This experience for Robert was certainly a homage to Rembrandt, and viewers who did not know anything about the contemporary Canadian painter would assume, quite rightly, that they were looking at a reasonable facsimile of the Dutch master and listening to an expression of views more or less in accordance with Rembrandt's own. Also true, however, was Robert's knowledge, as he said in his notes for the program, that "there was no *other*, only one's self facing forever the promise of one's self-discovery."

In October 1975 Robert wrote to James Logan of the Tom Thomson Gallery in Owen Sound to inquire about "some of the monies being kindly offered to some of the artists of this province." He asked for guidance in the matter because, as he said, "when I look over my biography, I can't quite figure out why I'm so broke." Logan recommended him to the Ontario Arts Council, and in due course he was awarded a $500 grant "designed to assist artists of excellence and achievement." Logan also pointed him toward an upcoming artist-in-residence position at the University of Western Ontario, not much farther from Mount Forest than the New School. Robert wrote to the chair of the University Art Committee on February 9, 1976, but heard a week later that another artist had been chosen. Theirs was not a penurious existence, certainly, but Robert and Marlene would have to be thrifty in their life in the farmhouse until she obtained full-time employment in Mount Forest in 1979. He wouldn't have another solo show at the Isaacs until that same year, and sales from the several group exhibitions in 1974–75 were slim. His New School salary paid the rent, put food on the table, and took care of the Mount Royal tab, but any extras (such as the Ski-Doo he had purchased before his BSA 650 motorbike) had to come out of the sale of his work, and these sales didn't always occur at galleries or result in much cash. In 1974 he received $100 as an honorarium for an original cover painting for Patrick's novel *Zero to Airtime*, and in 1976 he provided "figure as landscape" cover drawings for Andy Wainwright's second volume of poems, *The Requiem Journals*, for which he was paid twenty copies of the book. He wasn't alone in seeking other ways to make money. For an Eaton Centre commission for the design of a poster advertising McGregor Socks he received $250. (Joyce Wieland did a similar poster for Bata Shoes and Nobi Kubota for Timex

watches.) This economic difficulty was the main reason Robert went back to his typewriter and produced six feature articles for *The Canadian* and *Toronto Life* between autumn 1976 and December 1977.

His last published piece had been "Alternative Cuisine," in the March 1973 edition of *Maclean's*, in which he continued the celebration of the greasy food menu found in "Chips with Everything" seven years previously. "I love restaurant food," Robert begins, but not in places where the guinea hens are "so delicate" they drive you crazy and you have to "take four Libriums just to calm down enough to tackle them." No, it's the small-town places with Alice Munro waitresses and eclectic cultural ambience that deserve attention:

> Restaurants on the thousands of street corners of the
> thousands of small towns where long-legged schoolgirls
> with names like Loretta and Fay have complex smiles and
> stretch and bend and busy themselves with the beauty
> of the moment. Restaurants that serve toasted westerns
> and chicken salad sandwiches on plain brown and hot
> sandwiches from the grill and if you want … *gravy over*
> *everything.* Restaurants where you tell them what you want,
> wait a while, play some Lightfoot on the box, read the
> literature provided by the placemats (wild game fish of
> Canada, migratory birds of Grey County) and out it comes
> from somewhere in the back behind dirt-splattered swinging
> doors, mysteriously it appears, like a Dürer painting, as if it
> always existed, waiting for me to look its way … *"Do you want*
> *your coffee now or later?"*

The main thing is never to inspect the kitchen of the greasy spoon—"just your plate and your enthusiasm." Don't worry about nutrition either, just taste. So when you transport the best aspects of the small-town restaurant to your home for *Hockey Night in Canada*, dig into the Wonder Bread, the hefty dollops of Kraft dressing, and those thick cheeseburger patties. Spread your meal over the three periods of the game, with coffee or liqueurs at the end: *"Can life get any better?"* Clearly, this was written before Robert had embarked on his fitness regimen for UIC Flyers hockey.

Because his enthusiastic involvement with the Flyers hockey team was at its height in 1975, "Starring on My Own Bubble Gum Card" was a natural subject choice for the newly fit Robert, who would participate in rather than eat through Canada's national game. But in 1977, when money was

at stake, he returned to the places where health issues weren't important and consumption rather than calorie-watching was the rule. "The Glory That Is Grease" came out in *The Canadian* in March. The greasy-spoon romance is still there, but so is a slightly darker tone: "... the grillman. Culinary choreography: he whips eggs and stuff into westerns, frozen patties into banquet-burgers.... He moves with the deliberate rhythm of experience.... A rhythm of another sort is seen in the old man, somebody's grandfather, ... wearing his apron like a shroud, bringing in overladen trays of clean dishes and walking sadly with the dirty ones. He disappears through fly-specked doors at the back, where water runs."

Nevertheless, the creativity of the commonplace could still show to its best advantage, even if over-the-top metaphors were required: "Greasy spoons are stopped time. There's art here, adventure, pure form. Like any temple the greasy spoon is a place of worship, the bubbling fat a Gregorian chant, and the wafer offered has gravy on it." A full half of the article is dedicated to recipes for making "The Bread," "The Meat," "The French Fries," "The Peas," and "The Gravy" for the perfect hot hamburger sandwich, of which one could say, like Toulouse-Lautrec, "when pleasure touched his palate, it's 'like a peacock's tail in the mouth.'"

Things hadn't changed much since *Cowboy and Indian*, and behind every visionary male consumer, of course, there was usually a female cook. Robert liked to barbecue, but Marlene was in charge of the indoor kitchen, and she would have transformed "a bunch of cut-up potatoes" into "deliriously golden brown" fries and roast-beef drippings into "thick, rich, brown, smooth" gravy. Tongue in full cheek, Robert extolled her virtues, but the unabashed mixture of food and female role-playing wouldn't have been savored by everyone: "There are only three things you can do with a woman. You can love her, suffer for her, or you can turn her into art. Well, *that goes double for the hot hamburger sandwich.*" Robert's favourite meal cannot be found on the table of fellow artist and feminist Judy Chicago in her famous painting *Dinner Party*, which was being set as he wrote his article.

What followed in *The Canadian* was the homage to his friend and fellow-artist, "Knowing Lightfoot," and then three pieces for *Toronto Life* after one article there the preceding autumn. Don Obe, who had edited *The Canadian* from 1973 to 1977, moved over to the more fashionable magazine, whose editor-in-chief was now Tom Hedley. The collaborative process of producing an article for *Toronto Life* came out of Hedley's days at *Esquire*, and under his tutelage Robert shifted his voicing of personal experience to a more sophisticated level of cultural statement and accomplished writing style.

In "The Passionate Listener," in the magazine's audio guide, he discusses his choices for a forty-four-album record collection, the figure signifying that he would not be bound to any conventional number. Robert's choices are based on the place of music in his life:

> I paint with music. Music plays while I write, think, love, learn…. Music says the things you cannot. It explains your life to the universe. Music sings your praises and muddles your woes…. The music we play, the music we listen to, should accurately reflect not only who and what we are, but also what and where we want to be…. It's getting up on some fine, crystal-sharp morning and knowing, *knowing* that for the next twenty hours or so, you are going to immerse yourself into the craziest, the loudest, the most intense time imaginable. It's playing music so loud that the world rattles…. Music so powerful that the room loses shape, the room takes on a life, and that life is yours….

Your record collection should, he says, "so perfectly frame" your every sense and perception of the world around you "that you grow inseparable [from it], like the gold leaf and filigree borders that grow out of the greatest Renaissance portraits." The list of albums he provides contains ten classical recommendations (from Bach to Villa-Lobos), fifteen jazz instrumentals (from two fairly early Miles Davis to three fairly recent Gato Barbieri), nine jazz, blues, and rhythm-and-blues vocal performances (from Charles Aznavour to Damita Jo), and several international recordings (from Antal Kocze's *Gypsy* to *Duets from India*). There are two folk/country singers—John Prine and Waylon Jennings—and one rock album, *Pet Sounds*, by the Beach Boys. What's missing, as Robert admits, is just as interesting: "No Lightfoot … no mention at all of the rich work of Charlie Mingus, or Charlie Parker, or Ellington." There's also, he laments, no Glenn Gould, or Mozart by anyone, or a whole raft of cowboy singers. But this secondary list isn't a secondary list at all, just part of music's moveable feast, which lets you listen to trumpeter Clifford Brown "while slowly turning the pages of a definitive book on Rembrandt [or] reading Dr. Hunter S. Thompson and having the rest of your senses *Stravinsky-ized*!" Robert's sounds are those of possibilities, not the one-note tone of prescription.

If "The Passionate Listener" was for urbane readers who would probably feel they already knew a good deal about the subject, "The Aesthetics of

the Drive-In Movie," published that same month, was more down-to-earth. The opening sentences grab inhabitants of chic and pull them down-market in the search for pleasure:

> It all happened so fast. It started, *I think*, when this incredible-looking broad with just about the best pair of tits ever to be almost hidden by a black uplift bra, and this huge, hairy slob all dressed in leather and zippers and silver chains with his belly hanging out and needing a shave and slopping beer from a can all over the place—anyway, these two got real mad at each other and he came at her. First he squirted her with the beer. It caught her full in the face. The beer ran down her throat to the soft inside of her breast, spilling out over the ordered row of red rosettes that always garnish the clasps of those lace and wire wonders: she looked fantastic!

It turns out, of course, that this is a scene from a B flick at the drive-in, where Robert is munching on chopped-egg sandwiches provided by his personal chef and homemade popcorn that he insists he made himself. Indeed, the drive-in space is like an extension of home—your food, your car, your music on the radio, a private experience of the giant screen that allows the film to take you over completely, something you can't find in a crowded movie house. And yet, paradoxically, the drive-in is part of a larger shared experience too, "like the town hockey arena, or the community centre, serving the town and all the surrounding lands." You can always check out the members of the community at intermission—including the family that runs the show, with handyman father, projector-operator son, mother-in-the-kitchen, and daughter-in-the-ticket-booth—all of whom provide Robert with some insight into life's complex simplicities: "I sensed that after a lifetime of work [the father] could look with unerring clarity at his unfolding world the way I could see, over his shoulder through the glass, the sharp edges of all those fantasies cast out onto the screen." But that kind of acquired wisdom and the mother's measured sense of traditional domestic values are somewhat countered by the daughter, with her awareness of changing sexual mores and her yearning for a different kind of life, who, once again, evokes an Alice Munro character: "'This is all right, I guess. I love my family, and this is all okay. I didn't stay in school so there's not much else I could do anyway.... I don't know. Sometimes, when the show's over, I feel like jumping into one of those cars filled with

all those kids with all that time and just driving away...." In the end, the irony is that Robert and Marlene, not kids any more, drive away to the comfort and security of home.

Although back in early 1967 he had written his very lyrical and acceptably mainstream piece on the dancer-stripper, "Golden Spike-Heeled Fascination Four Legs Moving ... Why?" (and done a painting of stripper Gypsy Rose Lee for *Toronto Life* the next year), Robert hadn't published anything on the subject of his painting since then. Contextualized by the heavily moralistic response to the brutal murder of Toronto shoeshine boy Emanuel Jaques in July 1977, Robert's October essay "The Moral Shape of Sexy Sadie" in *Toronto Life* examines the demand for censorship and the condemnation of sexual display by exponents of "provincial puritanism.... all the dirty thoughts that come from dirty minds." He naturally returns to the issues surrounding the 1965 charges against his drawings and Dorothy Cameron and finds that many of the same attitudes and power structures are in place a dozen years later. Times have changed enough, however, to allow Robert to write about the embodiment of his "trace" figure in directly sexual ways that close the gap between imagination and reality: "This is in my mind while Sexy Sadie is waving her G-string and brushing the air with the curls of her pubic hair. Blurring, trembling, naked flesh. Solid, dark nipples reminiscent of those I've painted." The violence of the Yonge Street milieu, and the furious response to it, mean that though "the figure endures" and it's "impossible not to keep these wonderwomen *up there*, high on pedestal shoes, safe from life's little realities," it's time to "sit down and chat with my muse." This must be done to confirm that, within the space the dancer-stripper offers not only to the artist but also to those who see her only as naked, "compassion lies side by side with violence." She is his guide. She takes him back through his journey towards her and what she represents; back through early days with Michael Snow and their talks about "women, form, figure, the problems therein"; back through trips to New York and immersions in de Kooning, Rothko, Newman, and Pollock; back through seedy bars like the Follies Burlesk. She is also his guide through her own past in the "small future" of small-town New Brunswick, the "bad times" of Montreal, and the stripjoints of Toronto, where her proffered "mystery" is cut by "laughter ... like knife wounds."

In the end, he and Sadie are bound by their shared condition—she by being "shut out from Yonge Street's latest moral climate because of the way she uses her figure" and Robert by being "shut out from the mainstream of modern art because of the way *I* use her figure. We are shut out

together, bonded in this way, without bondage." The murder of the shoe-shine boy, as terrible as it is on an individual level, has encouraged the killing of collective sensibilities that include those of the artist; of Denise Bujold (Sadie's real name), "a girl with an inevitable murkiness, cloudi-ness, the result of too many corners sheared off too many dreams"; and of Sexy Sadie, who, despite reminding Robert "of where I am as an artist," tells him after he compliments her beauty, "'Yes, maybe so, but I shouldn't be hurt just because I'm beautiful.'"

There is a disturbing tension between Robert's allusions to the brutal undercurrents of Yonge Street life and the glossy paper and sleek adver-tising images in this upscale magazine. It's a tension with which Robert grapples but cannot resolve with words. There should have been a draw-ing or painting of Sadie on the cover of *Toronto Life* rather than a photo of her, one that would have brought the moral house down with an explosive combination of violence and grace, but maybe he already had done that drawing. In an untitled charcoal-on-paper piece from 1970, the figure's thin limbs are upward extensions of her stiletto heels, the long-legged, full-breasted figure is simultaneously dancing and fleeing as she both recedes into and emerges from a dark cloud of atmosphere or actuality wherein shadowy, distorted outlines of onlookers seem to dwell. She is at once being swallowed by this cloud and wearing it like a cape. Beautiful and desperate, she is for a brief, unsettling moment, more than any other in Robert's panoply of forms, the figure *who is there*.

The last of his 1977 *Toronto Life* articles is such a contrast to "The Moral Shape of Sexy Sadie" that is seems not to have been written by the same writer. Unlike the moral tale of the dancer-stripper, "In the Heart of the Heart of Christmas" provides the safety of an ethical norm of human behaviour in the form of never-forgotten memories of a child's Christmas in Hamilton. It is tempting to impose Dylan Thomas's voice over Robert's as passages of idealized experience unfold: "One Christmas I wanted to listen to the Spike Jones show, but my mother wouldn't let me because she was sure that he would make fun of some Christmas carol and I remember telling her that he would never do anything *like that*, so she let me, and he did! ... I would take my sister's hand and we would cross the road on tiptoe so as not to lose the new keen edge of our skate blades ... and the distant fire stack of the Stelco plant spewed orange fireballs above the trees of the woods that edged the back of the park."

As he approached the darkest period of his adult life, Robert looked back at an innocent time "when we understood continuity but not change, when life was surely simpler, and absolutely right." He believed those days

were still a crucial part of him in the late 1970s, and he would need every facet of that belief to sustain him through the complex affirmation of, and threat to, who he was and wanted to be.

Certainly response to Robert's writing from a variety of readers was very positive. As early as 1967, when he had done only the first Lightfoot portrait, the two pieces on Gordie Howe and Michael Sarrazin, "Chips with Everything," and "Golden-Spike-Heeled Fascination," he received a letter from Peter Synowich, associate editor of the *Star Weekly Magazine*, inviting him to participate in the production of "irregular columns by regular contributors, each writing with authority on some aspect of Canadian life. We want to be illuminating and we want to be provocative. We want to raise some hell!" In 1974, a fan told him, "You write like you paint: sloshing and great purple gobs of feeling in one or two apparently haphazard words/brush strokes." After the publication of "Knowing Lightfoot," another fan wrote, "I wish there were more writers who could be a little more loving and human, as you prove to be." Huron College in London, Ontario, wanted to reproduce "two or three paragraphs" from the same Lightfoot piece in an anthology "for the use of students at the intermediate level." Robert gave his permission and the excerpt appeared that summer. Immediately after his essay on Sexy Sadie, Dorothy Cameron contacted him to say, "I'm writing to thank you for the glorious rich feisty piece on [her]," and it was no accident that in the same month he was contacted by a representative of *Playboy* who was looking for work by Canadian artists "whose work might be suitable for reproduction in a new Canadian section of the magazine." The degree to which Robert's writing and the intellectual side of his public persona prompted respectful reaction in the very circles that might have been expected to object to his portraits of women is indicated in a letter to him from Karen Richardson in June 1977. The former director of Vancouver Status of Women, who had also worked on women's issues in the Department of the Secretary of State, was now looking for "feminist work in public relations, journalism, research politics, human rights, etc. If you hear of anything I would appreciate your letting me know."

A major reason for Robert's ability with words and his solid preparation for the Rembrandt show was his constant and wide-ranging reading of serious and popular literature. In the mid-1970s he compiled "Robert Markle's Definitive Book List," which reveals his eclectic taste and attachment to a variety of genres. The expected books on painters are there—"works on bonnard, cezanne, degas, de Kooning, klee, giacometti, goya, hopper … pollock, schiele …," with specific references to *The Private World of Pablo*

Picasso, by David Douglas Duncan, and *Shunga, Images of Spring: Essay on Erotic Elements in Japanese Art*. His fiction choices included "Anything by Agee, Beckett, Borges, Callaghan, Robertson Davies, Durrell, Joyce (if you can), Mailer, Muriel Spark, Lowry," and "mostly anything by F. Scott Fitzgerald." He was also a devoted fan of Raymond Chandler and Dashiell Hammett. In non-fiction he recommended Edward S. Curtis's *Portraits from North American Indian Life*, Dee Brown's *Bury My Heart at Wounded Knee*, Ann Charters's *Kerouac*, T.E. Lawrence's *Seven Pillars of Wisdom*, works by Hunter S. Thompson, and "anything by Pauline Kael on movies even though she's wrong lots of times." The primary poets on his list were Gerard Manley Hopkins, Irving Layton, Raymond Souster, and Milton Acorn. His interest in the sexual figure led him to *Woman as Sex Object*, by Thomas B. Heiss, *Georgia: My Life in Burlesque*, by Georgia Southern, and *Strip*, by Misty. Clearly his list is male-based, as was his list of jazz musicians and popular singers in "The Passionate Listener." This reflected his upbringing and education and, of course, his natural inclination to hang around with men while painting women. The inclusion of a biography by a woman of one of his favourite male writers, Kerouac, and of Muriel Spark suggests that while he might not have sought out female authors, neither would he reject their treatment of subjects of interest or their challenges to his patriarchal world, such as Sparks's progressive handling of gender issues in her novel *The Prime of Miss Jean Brodie*.

As for the main part of his creative output, after his 1972 Isaacs show Robert separated his coloured ink from his acrylics once again and in 1973–74 produced works in the two distinct media. The coloured inks came first, in the form of highly suggestive contour lines providing carefully chosen glimpses of breasts, thighs, and crotches in ways that made absence the equivalent of presence in the realization of the figure. Sometimes the marks on the page are few—perhaps only seven or eight curved lines appear—but other ink drawings from this period are more liberal in their use not only of line but also of colour and their filling of the frame with almost abstract forms. Here the patches of reds, yellows, and mauves seem to present a second figure who prevents the primary one from disappearing into abstraction altogether.

As for his work with acrylics during this period, a series of nine paintings on foamcore is fascinating because it depicts the same tan, bikini-clad figure in an overpowering landscape of water, sand, and sky that fills three-quarters of each of the small 12-by-18-centimetre frames. Here

for the first time in Robert's work the female figure does not move in or through surrounding space and thereby make herself the centre of attention in it. Rather, she is stilled by the dominant light blues, darker blues, and tans of air, water, and earth, as if she has reached an accord with the natural world for a brief period of occupancy.

Robert's first lithographs in eleven years were the *Victory Series* (*1–5*), done in 1976. These are strongly expressionistic images of strippers from the Spadina Avenue burlesque theatre of that name who, formed from the space left white in a blackened background, are reminiscent of his early tempera-and-charcoal drawings on paper. Dark shadings rather than sharp outlines delineate the profiled figures in the first two pieces, especially in *No. 1*, in which the dancer eludes all exact perceptions of her position and movement. *Nos. 3* and *4*, revealed in profile also, are the most immediately recognizable as stage performers. There is a weight to their nakedness that seems to defy any audience attempt at possession. The final figure calls up some of de Kooning's *Seated Woman* series with its face-on, aggressively outlined posture, all strong swirls of line and precisely positioned black swatches to emphasize nipples, crotch, and belly button. The face itself is, like several of those by de Kooning, distorted and cartoon-like.

Other lithographs followed the next year, including an edition of ten in which the bodies, in the reverse of the *Victory Series*, are rendered almost entirely in black, the surrounding white space in the most memorable of these almost unable to contain the assertion of barely held-together form. One untitled piece, which is not a member of this series, presents a figure striding out from the darkened right side of the image in exploding lines of energy, appearing to replicate herself in outline, if not substance, with the sheer force of her entrance. Robert clearly liked working in this medium, and his results suggest something of Michelangelo's dictum that there is a figure hiding inside each stone waiting to be released by the artist.

The lithography process, with its greasy litho crayon, and the gum arabic and acid that fix the image to the heavy stone, was a large endeavour that reflected the strong presence of the dancer-stripper on Robert's stage. But her delicate, often subtle movements could be lost in that display of strength, and Robert, in the same year, almost as if to counter the weight of his lithographic expression, decided to embroider, on one of his jean-jacket and pants outfits, long-legged figures in multicoloured thread. He was motivated in part by an AGO competition sponsored by a jean company, but he had, in addition, read *Erica Wilson's Embroidery Book* and

had watched Wilson's television show on the subject. He taught himself to do needlework, though not without difficulty. Marlene recalls coming home one day to find the jacket and Wilson's book lying in the snow where Robert had hurled them in frustration at the clumsiness of his fingers.

Though he missed the competition deadline, Robert eventually finished the embroidery project. Nudes lie seductively along the pant legs in combinations of yellow, red, blue, and brown from just above the knee down to the hem. On the front of the jacket, above the pockets, are two smaller figures with large heads and bare shoulders, a single thin torso line joining this upper body area to curved leg outlines below. The *pièce de résistance*, however, appears on the back of the jacket. Across the shoulders float four nymph-like creatures in light and dark flesh tones and brightly coloured crowns of hair, while immediately below is a full-length figure reclining in a wooden chair with slatted back and thin cushion, the kind of chair that Robert called his own on the east side of the farmhouse kitchen table. She has shapely muscular thighs and is wearing leather boots, almost knee-high. Her legs, one of them raised and resting on the arm of the chair, are opened at a slight angle to the viewer, exposing the top of her black pubic swatch in the midst of what seems to be a white bikini mark. She is tightly corseted from her waist to the undersides of her full breasts, which spill out in white array. He eyes are closed and her face is calm. She does not move from this position, by her own choice as much as because she is fixed there by the onlooker's gaze. Except for her headdress hairstyle, the depiction is absolutely real—apart, of course, from the fantasy that summoned her in the first place. Marlene says, "I didn't necessarily sit in the kitchen nude … well, maybe occasionally, but not often." In fact Robert did photograph her wearing the jacket and boots and sitting in the wooden chair. The skilled precision that went into the design of these figures collides deliciously with their uninhibited and playful sexuality. If you imagine Robert putting on the outfit, as he would on his trip to Paris two years later, you can almost hear his joyful laughter as he comes as close as possible to wearing his muse on his sleeve.

In 1977 Robert produced a remarkable twelve-painting series (all untitled) in oil on masonite that included no figures whatsoever. In richly textured brushwork and deep layers of colour he depicted five versions of the Mount Forest farmhouse in starkly white landscapes with occasional outlying buildings closed in by winter. These isolated dwellings and the human life implicit within them lean into the cold wind that has either flattened the snow or sculpted it into drifts. In one painting,

Jean Jacket, 1975 (denim, cotton, embroidery floss, glass beads)
COLLECTION ROBERT MARKLE FONDS, E.P. TAYLOR RESEARCH LIBRARY AND ARCHIVES,
ART GALLERY OF ONTARIO / IMAGE TAKEN FROM SLIDE

a huge bare tree looms over the entrance to a house that seems to suffer beneath its giant branches but to survive nonetheless. In another work, two trees bend as if in homage to an imperishable spirit represented by the bent but not broken house and barn. In two other pieces, the trees themselves are alone and exposed to the elements, their own endurance in question. More than anything else he ever did as an artist, these paintings underline Robert's attention to the realistic details and symbolic overtones of his surrounding physical environment. That this use of oil involved an exploration of the effect of colour on form and mass is especially clear from two abstract pieces in the series reminiscent of works by

Jock Macdonald and Jack Bush. In one, a number of upright shapes that *could be* bottles and jars are created out of a combination of vertical and horizontal brush strokes and different hues to convey diverse surfaces. In the other, the only identifiable shape is a white-grey rectangle composed of similar upright and side-to-side strokes that sits in the midst of separate and ultimately non-representational layers of colours. The image is tactile in impact and unforgettable, but it's not recognizably a Markle, though Marlene feels the rectangle might represent their local drive-in theatre. If nothing else, these twelve works reveal that Robert chose to be an expressionist painter of the figure despite his clearly possessing the ability to be a different kind of artist.

Early in 1977 Diana Wedlock's parents offered to sell the fifty-acre farm and buildings to Robert and Marlene for $15,000, but it was impossible for them to raise the money. Instead, a real-estate acquaintance who drank at the Mount Royal eventually found them another rental house on a hundred-acre farm on Egremont Road 12, closer to town and to the village of Holstein.

"The place was a shambles," says Marlene. "Chickens and ducks had been living in the house." For the first time she could remember, Robert asked her, "What do you think?" By this time she was determined that she wasn't going back to the city and would have a permanent country home no matter what Robert said. The house, where they would spend the rest of their lives together, sat amid fenced fields at the end of a driveway sheltered by tall maple and spruce trees. It had a good-sized kitchen and bathroom on the ground floor, together with a large front room that Robert claimed for working space. For his music equipment he used a smaller ground-floor room. Narrow stairs led to the second-floor bedrooms, including a large one that Robert would later turn into a studio. The rent was $125 per month, the amount they had paid for their prior residence. As they settled in dramatic changes occurred in the Toronto side of Robert's life.

Despite the romance of the Brunswick, there had for some time been growing dissatisfaction with the way John Sime ran the New School of Art. The artist-teachers, by then twenty-eight in number, were being paid $32 per three-hour class, which meant that Robert, after taxes, was bringing home about $100 a week for his two days of work in Toronto. He was also paying for his gas for the 320-kilometre return trip. Dennis Burton indicates that salaries were only one of the reasons for revolt:

We had gotten over one million five hundred thousand dollars in that period [twelve years], as Ontario Arts Council grants, as Canada Council grants, as municipal grants from Toronto, and as private donation. We were used by that English entrepreneur [Sime], who never took out Canadian citizenship, from 1965 to 1977. He pocketed the money and at the end of that period we were still teaching for only twice what we were paid at the beginning. We had no equipment; there was no heat in the winter. He believed in the concept that artists must suffer, therefore your students should wear their mitts and their hats and their earmuffs and their scarves while they do a painting from a nude model, because she's got all the heaters.

The result was that all the teachers quit the New School in April 1977, and by September thirteen of them (including Dennis, Robert, Graham, Gord, and Diane Pugen) started a new school called Art's Sake Incorporated, The Institute for Visual Arts. According to Dennis, Robert came up with the first part of the name. The 2200 square metres of teaching space was on the fourth floor of a building at 284 King Street West and was rented for the first year on the basis of an Ontario Arts Council grant of almost $18,000, with more monies promised for the second and third years. Wintario, the Ontario lottery organization, agreed to provide a basic equipment grant to match the paid tuitions of enrolled students, but that meant no salaries could be drawn from such fees. Prominent fundraisers for the school became involved, including the vice-president of Wood Gundy, a corporate analyst for Imperial Oil, and the program director for the Business Council on National Issues.

Students applied because the Art's Sake press releases put the school and its policies in firm opposition to the program at the more academic and less accessible Ontario College of Art. Whereas the New School in the articulation of its goals had mentioned OCA directly, Art's Sake did not— but made a clear differentiation, by quoting Marshall McLuhan, with their statement that the school was for those who wanted "new images of identity, not careers ... insights, not classified data." What the artist-teachers envisioned was the kind of place that had not been available to them in the mid-fifties and a place that, unlike the New School, they could run themselves. OCA, as far as they were concerned, was stuck in the outmoded framework of previous decades:

> Today the Serious Art Student ... demands an art school
> capable of growth, capable of change—an art school
> fully immersed in the 20th Century, cognizant of 20th
> Century ideas and thought, yet an art school capable of
> understanding this century's acknowledgment of its base in
> the firm footing of Art's past.... In the very particular area of
> Art Education for the Serious Art Student, it has long been
> felt that there exists a real need for just such a school—one
> whose sole purpose is the pursuit of artistic excellence.

To emphasize the difference of Art's Sake as an "official" institution, there were no entrance requirements "other than an inquisitive mind." The school was "free from bureaucratic entanglements with any existing educational complex—it is as open to change as the demands of the students, and the demands of Art dictate." Such high-toned positions, of course, were as ideologically based as those taken by the people at OCA, and, perhaps wanting to interfere with a strict comparison, the Art's Sake crew proclaimed that many members of Toronto's cultural community "fully endorse the School's lofty but sound ideals." Moral support certainly came from critics Barrie Hale and Harry Malcolmson. Northern Telecom Corporation (which became Nortel in 1995) provided some funding.

Several hundred students made inquiries in the summer and early fall of 1977. Sixty enrolled full-time and two hundred attended evening classes, many of them having been rejected by OCA, which indicates that the "alternative" school was, at least in the beginning, a second choice. But chances are these students soon lost any yearning for McCaul Street. Diane Pugen recalls that "at Art's Sake we had less money but were in control, players in our own dream. It was still possible to create in students the belief that art can have meaning for society." The combination of expertise and passion that the now independent artist-teachers brought to the studio—a heated one at that—and the very impressive resumés of its graduates who are practising artists today, suggests that there is some truth to Gord Rayner's claim, however biased it is, that "in its short five-year history it was the best art school on the planet since the Renaissance."

Soon after the school opened, Adele Freedman wrote an article for *Toronto Life* titled "The New Boys Are Actually the Old Boys." In it she praised the remarkable range of experience brought by the various artists to their roles as teachers:

The collective spirit of Art's Sake has worked in the post office, studied art by correspondence with Charles Schultz, illustrated an article in *The Canadian Magazine* entitled "The Geological History and Paleontological History of Canada"… and written liner notes for Gordon Lightfoot albums. It's designed a shopping centre in Kamloops, B.C., created a 105-foot mural for the Eaton Shoe Building [*sic*], and a smaller mural for Mrs. John David Eaton. It's represented in the collections of the Museum of Modern Art and the personal collection of Mrs. Charles Laughton (Elsa Lanchester). It plays jazz, strums reggae, and imitates whale sounds; somewhat incongruously it knows Alice Cooper. It has sent up contemporary art history in a book and made a film about Toronto for the BBC…. If they inherit just a fraction of the vitality, bravado, and self-confidence of their teachers, the next generation of Toronto artists will hit the scene like a bomb.

In 1979, in the same magazine, Norman Snider spoke more specifically about Robert, Gord, and Graham's first-class attributes while surprisingly placing them in a second-class context:

They have proved that in the middle of Nowhere Gulch, despite the isolation, the notion of the romantic artist can survive. They are living proof that one can stay high, live wild, and still produce an accomplished body of work recognized by the society as a whole. In a time and place where artists tend to huddle in sullen, self-protective isolation, these three painters, through their friendships, have kept alive the old ideas of the coterie, the artistic fraternity. And what's more, they have always opened up their milieu to those who want to share the glow.

In the summer of 1978, Kathryn Bemrose took a summer drawing class from Robert, and he told her she should attend full-time. Thirty years later, as a member of the Royal Canadian Academy of Art, she has memories of his teaching methods that underscore his presence and impact in the classroom:

… sitting backwards on a drawing horse, one hand on his knee, painting in black ink wash moving a large fat brush

across a piece of newsprint on the floor. "This time you make the figure come forward by painting lighter as you get closer to the foreground. The darkest part is the furthest away. Now try that and MAKE IT SPEAK! MAKE THE PAINTING TALK. DON'T WORRY ABOUT THE FINGERNAILS AND STUFF LIKE THAT. MAKE IT BREATHE. MAKE IT MOVE. OKAY GUYS GET TO WORK! I DON'T WANNA SEE ANYTHING PRETTY OR ANY OF THAT SHIT. OKAY?" Off we'd go to our spots around the model to make our mess. The more mess the better. We got lost in our work and that was the best place in the world.

Scott Townson, now a highly skilled and successful framer in Toronto, applied to Art's Sake after he read about it in the "Fanfare" column of *The Globe and Mail*. He took two life drawing classes, one of which was with Robert. Wearing a paint-spattered sweatshirt and rubber boots, Robert would put on records by Tom Waits, Waylon Jennings, Willie Nelson, and of course the jazz greats, and walk around among the roughly equal number of female and male students who were attempting their versions of an always reclining nude model.

"Robert once said in class that you should butter your toast like a Zen koan, and that every stroke of the brush should be bullet-proof, though he allowed as how it might be a pain in the ass to do each day." But he also emphasized, "Don't put marks on paper without knowing why." All these years after his accident, he would still make the students buy big chunks of charcoal and a shaving brush so they "couldn't finesse" their lines. He treated everyone much the same, and listened to each of them individually, but some he singled out for further attention. When Scott brought a Charles Mingus record to school, Robert invited him for a drink.

Although nothing could replace the Brunswick, the Wheat Sheaf Tavern at the corner of King and Bathurst Streets became a local gathering spot for teachers and students, with the Spadina Hotel and Paramount Tavern as favourite alternatives. The only slightly exaggerated raunchy atmosphere of his tavern life is captured in a piece Robert wrote about the Paramount for the "The Best of Toronto" issue of *Toronto Life* in 1980:

> Only here, amid the big city grime of Spadina, you can find the real nasty pulse of this town. Pimps, hookers, black, white, red, yellow, the true stink of draft beer and highballs in low glasses. Gambling in the men's can, craps in the

corner, angle-parked cars with their windows elbowed open, the passing of lost eight tracks and radios, all to the throw of the dice. Boozy geniality—the drunks collect, the women strain in high heels, breasts are soaked in beer and sweat. Go there, pack a rod, have a good time, and don't lose your date.

Membership in the outer edges of the Markle inner circle meant you could be asked to meet at the more sedate Club 22, where Robert would introduce you as "an artist friend of mine." He was always the centre of attention in these various drinking establishments, where "rivers of beer" were consumed and "a cavalcade" of artists and famous people stopped at his table. In conversation Robert was always "very opinionated but generous, despite his various rants. He was able to bring diverse people together and make them interesting to one another." Perhaps the greatest compliment Scott pays to Robert is in his insistence that, from that period, "forty or fifty guys would say [he] was one of their best friends." As Peter Goddard wrote in his *Toronto Star* article on Robert in 1973, "With Markle, even friendship, talking, teaching become art forms in a way. He immerses himself in them, experiencing them fully, and then tries to establish some kind of order."

In financial terms Art's Sake survived precariously during its five years of existence. There were problems obtaining the remainder of the $70,000 grant promised by the Ontario government of which the original $18,000 was part. The school's faculty, led by Dennis Burton, became fundraisers. Robert asked Gordon Lightfoot for support ("We like it here, but we're scrambling"), and then went a step further in August 1978 by writing directly to the prime minister, stating that the worth of a nation "is only accurately measured by the creative outpourings of its artisans and artists" and pointing to the "disastrous slicing at the very soul" of Canadian culture caused by federal government cutbacks to the arts. Emphasizing that "Art serves. Art joins. Art communicates," he asked the prime minister what he should tell his students who felt they had a role to play in their country's future but also felt they were being shut out of any say in it.

Pierre Trudeau replied within two weeks with a bland assurance that his government appreciated "the vital importance of cultural activities in … fostering a greater sense of nationhood," but not before politely lecturing Robert on the need for spending cuts that required "some difficult and painful decisions." Perhaps if they had met over a few beers at the Wheat Sheaf, Robert could have talked the PM into providing a

substantial grant not only to Art's Sake but to all cultural organizations. On the other hand, once he had apprehended Robert's gift of the gab, Trudeau might have persuaded him to run for the Liberals.

Apart from infrequent trips to New York with Marlene and Patrick, Robert wasn't an international traveller. Until the mid-1970s, his idea of a long journey was a move from the familiar King Street watering holes to the friendly confines of Club 22 or the Pilot. But in 1975 he decided to visit Michael Sarrazin in Los Angeles, partly at Michael's insistence that Robert see him "on his own turf" and partly because he could get his way paid by *The Canadian* in return for a feature article on his friend's life and career in "fabled sunny California." His willingness to make this trip underlines the depth of his relationship with Michael, because, unlike Blanche Dubois in Tennessee Williams's *A Streetcar Named Desire*, Robert was never happy about depending on "the kindness of strangers," as he would have to do at airports and on the plane.

He had written about Michael's emergence as an actor in 1967, and now he wanted to chronicle the success story of his ten years in Hollywood and the eighteen feature films he'd made there. His plan was to hang out for a couple of weeks and "type up each day's events every night and by the time I'm ready to come back the article will be done. Probably have to do a little polishing though." But the confidence he had in his ability to pull this off began to erode on the plane, unsettled as he was by his own motives for making the trip and by the in-flight film. *That's Entertainment* showed Hollywood "parading out its packaged past, cadavers cavorting to some hidden rhythms, marking time to their faded fames…. I couldn't help but wonder if the inane performance up on the screen was in any way an indication of better times. That there was a time when reasons were simple, ideas easy to come by, and purposes were clear. And above board." What was he supposed to write about Michael? Things like "What's his favourite movie, does he sleep in the nude, does he fall for his leading lady … that kind of stuff makes me puke." No, he would ratchet his vision and story up a notch: "I was on a mission. A trip into the America of my friend to search out that congruent thread that so effectively binds us to our dreams and our inevitable fates." But somewhere between the idea and the reality, the shadow was bound to fall.

Michael picked him up in his "Porsche"—a 1970 Pontiac station wagon that could "go from zero to sixty in about four city blocks"—and drove

him to his new house in Beverly Hills with its "two beds, four plates," and not much else. Virtually the first thing they did after a night of heavy drinking and conversation was to go out and buy a sound system for the house. Michael phoned his business manager to get approval for the purchase. A man protective of his client's finances, the manager pronounced the proposed $200 expenditure reasonable. But this was Hollywood, and Robert wanted his friend to have a new toy worthy of the legendary town. The tuner-amplifier, speakers, and record player cost $5000, and Michael's business manger took months to recover. As for the article, it was never published. Robert's notes reveal some insights into the "distances … painfully evident … between one and one's dreams, one and one's aspirations, one and one's ultimate failure," but he would not apply them to any measurement of what Michael was going through or to his career as a leading man that would never receive the full credit it was due. Mostly Robert jotted down self-centred fan's notes that, properly edited, might have entertained readers without educating them, unless the focus of the entire piece had emerged from his candid one-paragraph assessment of the experience: "There's a tendency when confronted by extremely good fortune, with no apparent effort on anyone's part, to see the event as something manifestly blessed. You really don't look at it too closely. So before you know it, you're up against the very real problem of fixing words to an unwieldy space that never existed in the first place, that what in truth should have been moments of insight are only, under an honest scrutiny, merely silly confrontations artfully contrived by outside destinies."

What he did not try to write about, perhaps because it was so stunningly new to him and took years to absorb, was a trip to France with the AJB in May 1978. The band had continued to jam and perform on various university campuses and even at prestigious clubs like The Kitchen in New York City for the opening of a Michael Snow show in November 1976. The place of jazz in Robert's lived experience and his vision of it as an integration of "fine, fine minds thinking about fine, fine ideas, and playing them with such mastery, such intensity" is captured in the 1974 letter he wrote to the great saxophonist Sonny Rollins. He apparently met Rollins at the Vanguard Club on one of his New York trips, where they had "short but intense talks" about art that "doesn't come out of the blue, or any kind of mystical bullshit, but from art itself." Rollins had listened to and praised the AJB's first album, released in 1973, and Robert was

anxious to extol the virtues of the music they played and to publicize its reception of then and now:

> we start to take on the public, playing concerts and
> artschools and art galleries along with showings of our
> work, and quite slowly but surely something happens that
> we always knew *could* happen: we were starting to be taken
> seriously as musicians as well, we started creating a small but
> incredibly loyal audience consisting of fans, other musicians,
> kids, art students, Coltrane fans, albert ayler fans, weather
> report fans … *music* fans! … we got the record done…. john
> norris and bill smith of coda magazine and the jazz and
> blues record shop deal with a large jazz clientele all over the
> world and are doing the distributing and business handling.
> i understand the jazz composers workshop people are deal-
> ing with the album down there [New York]. we get some air
> play, and the future of the band looks extremely good. we
> even had to join the union!

This success and the release of the AJB's second album, *Live at the Edge 1975–76*, with singer Denyse MacCormack, led to an invitation to play at the Canadian Cultural Centre (part of the Canadian Embassy) in Paris, a gig to be funded by the Canada Council. Robert, Gord, Graham, Nobi, Michael Snow, and Jim Jones decided to go. Gord Rayner describes how difficult it was to get Robert there. Marlene brought him to the Toronto airport "about three minutes before takeoff," and it was clear he was anxious about the trip. When the non-stop flight had to land in Montreal because of technical difficulties, Robert asked Gord to point the way to Patrick Watson's house near Ottawa, said goodbye, and started walking. It was a momentary surrender to nerves that Gord wouldn't accept, and he got him back on the plane.

Arriving in Paris on May 10, the group took up residence at the Hotel Paris-Dinard, in Rue Cassette in the Latin Quarter, where Hemingway had stayed with his second wife, Pauline. The next evening they played a "fabulous concert" at the Cultural Centre near the Place des Invalides, where a small exhibition of their work was held. One audience member, the composer Philip Glass, who had performed at the American Embassy earlier, told the band "how very much he enjoyed our music." For two days after that the group frequented the bars and cafés, where Robert, as usual, held court. "We were lucky to get him out of that country, they loved

Graham Coughtry, Robert, and Jim Jones on Ibiza, May 1978

him so much," Gord reports, describing how Robert would proclaim, *"Je suis le professeur des arts!"* and produce drawings of Harley-Davidsons on table napkins. "No language was necessary, the brilliant cartoons were worth a thousand broken utterances." His French audience— "the beret equivalent of the baseball cap crowd"—drank up the performance with their bottles of Des Rocs Blonde. Even the laid-back waiters at the Brasserie Lipp "treated him like exotic royalty from the New World."

One day, however, Robert went missing, and it was Graham, "aficionado of crime and detective novels, who went into his Sherlock Holmes mode and rightly deduced where Robert would be found":

> Sure enough, there he was. The first thing we were aware
> of was the unmistakable sound of his Vesuvian snoring.
> We were in the underground galleries of the Musée de
> l'Orangerie (or was it the Jeu de Paume?), all marble and
> oval walls, organ music softly drifting out of hidden speakers,
> enhancing *Les Nymphéas*, the huge last paintings of the great
> master Claude Monet. In the centre of this mausoleum-like
> gallery echoed the rasp-throated Robert, surrounded by the
> Maestro's masterpieces, underwater, sound asleep, and afloat
> on a puffy pearl-gray velvet divan.

The postcard he chose for Marlene's parents denoted the more sedate side of his experience, while his message hinted at alternatives: on the reverse of the reproduction of Manet's *Sur la Plage* (1873) he wrote, "Miss Marlene, but this town helps. Next stop Spain. Lots of beer, music!"

On May 14, Robert, Gord, Graham, and Jim flew to Ibiza, where Graham had been trying to get Robert to go for over a decade. Andy Wainwright, who had spent time there in 1970–71, had written to Robert about the unique quality of the Mediterranean light. Although there is no record of Robert's response to the light or anything else on the island, his subsequent use of tone and colour in his work was surely influenced by his eight days in and around the village of Santa Eulalia del Rio, where Graham's *finca* was located. The four amigos ate fresh langostas and lenguado and paella at the *finca* and at restaurants like La Posada, and Chez Juanito, and drank everywhere. They played music as the "AJB de España," and revelled in one another's company. Robert drew,

> sometimes the way Miles Davis plays, like a razor blade.
> Sometimes full and fuzzy-edged, the way Lester Young's sax
> sounded. Always flowing, like all the winds, from breeze
> to bluster, always caressing the curves of the hip, the inner
> thigh, that little heave above the arch on the top of a fine
> woman's foot…. Always, every moment, awake and asleep,
> he drew in his head. Always forming compositions. Always
> thinking, placing, arranging, changing. His subject was
> usually the ladies he saw in and among the rocks and fields
> and folds of their own inherent crevices.

Just as he had described Robert's baptism in the Magnetawan River a dozen years before, Gord paid tribute to a second memorable immersion: "It was here, from the shore of the island that had been conquered and colonized by every major culture in the Mediterranean basin, that Robert decided to wade into the gentle waves. Where the Phoenicians, Romans, Greeks, and Moors had once landed, a large Mohawk from Canada, wearing his Red Man Chewing Tobacco hat, walked into the historic sea up to his knees and stood there, arms again crossed on his chest, as if in private prayer. The Red Man, in turn, had conquered Europe. But this time he left his boots on."

On May 22, they returned to Paris, where Robert stayed with Caroline Bamford, who would later marry Patrick Watson. It was the first time they met, but she knew how much Patrick loved him, "so that would have got

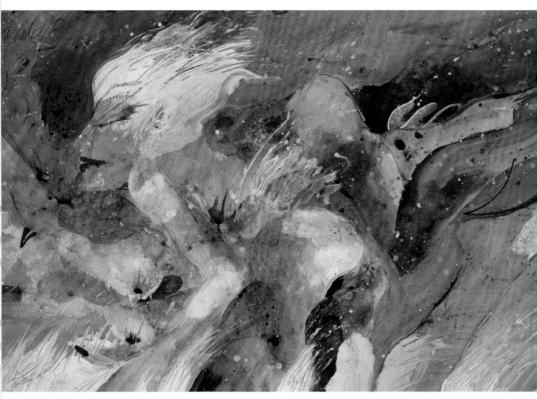

The Beguiling Assault, 1981 (coloured ink and acrylic on paper, 65 × 100 cm)

VII

VISIONS OF JOHANNA: TORONTO AND
MOUNT FOREST 1978–1983

From Paris Robert sent a postcard to 4 Draper Street, just west of Spadina Avenue and Front Streets, in Toronto. It was of "a woman naked to the waist raising her full arms to comb her long blond hair … a reproduction of the Chassériau painting in the Louvre." The postcard stated that he missed its recipient "terribly." Later, from Ibiza, he sent a letter to the same address, telling the same person "that she was all the sun he needed." Johanna (not her real name) was a student in her late twenties at Art's Sake. She had a degree in fine art and had won first prize for a painting in a business firm exhibit that year.

His long relationship with Angie had ended in the late 1960s, but Robert had since then shared beds with young women from the New School and with others he met in Club 22 and elsewhere. He was usually discreet about these brief affairs. Laura Berman and Sheryl Wanagas testify somewhat naively that from the artist-teachers "there were no sexual overtones with us as we were their students." Don Obe claims, rather astoundingly, "They did a lot of messing around but not much fucking. Robert was not a real cocksman." But Marlene knew he was involved with other women, and so did his close friends. Gord, Graham, and the rest knew what Marlene meant to him and were certain he would never leave her, but they also believed occasional lovers were just part of life in the artist's world. Not everyone was so accepting, however. When Robert taught at the New School after the move to Mount Forest, he would usually stay with Ed and Ruth Grogan in their Spadina Avenue flat. Once he phoned to ask if they'd be in or out on a particular afternoon. They told him the latter, and came home later to find him in their bed with a strange woman. "We were both pissed off," Ruth says, and they let him know this. It didn't happen again.

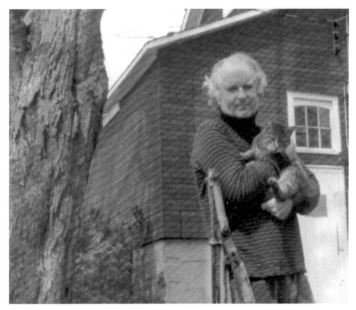

Edward Grogan, 1981

Johanna was different from the casual flings. A striking blond who could have posed for Chassériau, she was older than most of his students, a great reader, and a talented painter in her own right. In addition, it seems that part of the reason for her enrollment at Art's Sake was Robert's reputation as an artist and flamboyant character. He fell in love with her, as he had with Angie, only this time he desired a relationship with his lover that would not entail going home every night to Marlene. In that Art's Sake year when she was in his figure-drawing class, he was intensely focused on Johanna, as his notes reveal:

> She had two rooms on the second floor of the Draper Street
> house. She used one as a studio, the other as her bedroom.
> The bedroom was small, with an inward curving wall, at
> night lights from the expressway threw moving patterns
> across it, the wall would disappear, become mere space for
> the moving light. He thought it could be a source for her
> work, she saw the wall as a source of wonder. That wall, and
> the shunting sounds of the waterfront trainyards would fill
> the room with enough energy to imagine the city accurately
> defined. When he was with her, when they loved she knew
> she was being possessed, by him, by love, by his city.

Quickly she became a muse for his visions of the figure, not replacing Marlene completely but supplanting her as inspiration for the artist who had always left her traces on paper or canvas but now needed a new, lithe reality next to him in his crucible: "After one of his many absences he came back and found her kneeling on the bed, naked but for new high heels, and her painted toenails. A wonderful image of how much of his life he had imposed upon her … he felt surrounded by her, and she was everything to him then, all his fantasies, all his desires.… In the wrinkled traces of the bedsheets are the lines that describe both of them."

Johanna's place on Draper Street was too small for his ambitions, and he looked around for space they could share. He simply announced to Marlene that he wanted to live in Toronto during the week but would return to the farmhouse on weekends. He seemed to know that he could not easily abandon the domestic security Marlene had provided for twenty years, nor surrender the small-town rural life they had established together along with his prized position at the Mount Royal table. But evidently he felt confident he would not have to give these things up, at least not in the near future, and that there would be time to see where things stood.

In the late fall of 1978, he rented studio–living quarters at 89–109 Niagara Street, at the corner of King Street West and directly opposite an abbatoir whose smells permeated the area. The accommodation was a very large room or loft in which he and Johanna had a bed, fridge, stove, bookshelves, and art equipment. Marlene had already heard a lot of talk about a wonderful student painter at Art's Sake, but it wasn't until she paid a visit to Niagara Street and saw Johanna's work on the walls that she knew what was involved. It seemed clear to her that Robert was determined to have his cake and eat it too, and if she wasn't willing to share it with him, he would stay in Toronto for the foreseeable future. His Art's Sake salary could barely cover the rent of the farmhouse and studio and put food on the table, and, though Johanna could contribute a few funds, Robert had an idea to make things more comfortable, one that would initially legitimize the dual life he had planned and give Johanna a sense of independence.

After being turned down for a second Canada Council Senior Arts grant in February 1979 (despite references from Coughtry and Burton), he applied to the Ontario Arts Council to hire a painting assistant to help him make stretchers, prepare canvasses, ready colours, and keep "the studio in optimum operating order—all that frees the artist to work, and in doing that work he, in turn, offers the assistant the opportunity to

from the highway. She was back in her room now, now so devastatingly empty, looking around the studio, the only greens were the ones he left behind, in paint, she knew she was so far behind him now, trapped in a city he loved and she hated, she imagined the steady hum of new air against his windshield and she thought *someday I'll bolt*, putting up new paper.

Transforming her into the artist model didn't help. Being consumed by all her body's lines didn't eradicate the problems. When she dressed for him in blue feathers and high heels, he tried to convince himself there was "some way to touch her, some way that wouldn't … *mar*" and leave her with scars, but in this he failed. The only thing he could do was parody the seriousness of his concern and his love in a separate piece of writing that has a dark edge to its burlesque:

> The girlfriend had windex and a jar of crème for wrinkles, a parttime job, and an inner life of turmoil (doesn't everyone). The girl would polish the decks, crème her jowls … and try to love her man…. That was the good part. The artist: hilarious, good-natured, brilliant, bent on self-destruction and having a good time, creating works of art and being a boor, perceiving difficult truth and falling asleep drunk at 7:30 p.m….
>
> The artist would ask her what she did while he was gone as he glanced at some new painting taking shape, and the laundry on the radiator. "How are all your boyfriends?" he would ask, pretending that his jealous rage was just barely under control.
>
> "Ha!" said the girlfriend, who had spent the weekend reading Eudora Welty. "Boyfriends—now there's an idea!" All this reading had the unfortunate effect of revealing to the girlfriend the difference between real art and her own lazy misdirected dabblings….

If, according to Robert, the lack of stability in the relationship wounded Johanna, Marlene's being reduced to a position of sharing less than half the week with him was devastating. She felt "bereft" when he was away and saddened by the "very formal weekends" without much intimacy. Not only did she have to deal with her own feelings but with his as well. It could

seem like old times when he soaked in the tub, read books, and listened to music, and they still spent Friday evenings at the Mount Royal with Stephen Williams and Marsha Boulton. But a key difference was that his working studio was now in Toronto, and he didn't draw or paint much at the farmhouse. He would, however, share his worries about Johanna, telling Marlene how she would get really angry and throw things, not understanding how he felt about "his women." At one point Marlene told Marsha, "I can't do this anymore," but then she asked herself where she would go. She was tied to the community, the land, and the landscape. At more than one point Robert cried and told her he didn't know what to do. Marlene, playing out a role many women, but fewer men, would condemn as wholly subservient and patriarchically formed, struggled with the possibility he would leave her completely.

Robert was aware of her pain through the filter of his own needs. He was drinking a great deal on weekends and often woke in the morning "swallowed by guilt," unable to recall the exchanges of the previous night but aware destructive things had been said: "He sees the image of his wife clutching at herself in the far edge of a chair. The false making of life through desire. He sees her as an image to poke at, he's afraid of what her face might reveal." It was their shared artistic endeavour that saved him, that put him back in charge again, though where it left Marlene, and Johanna as well, was not something he could properly address:

> He was a figure painter, painting many figures, but obsessed
> by only one. His wife was everything, she was everywhere in
> his work…. He never tired of looking at her, he saw in her,
> in her figure, all the mystery of form and the risky sensuality
> that was his life…. all he needed was to see her moving
> through his space, all he needed was her to remind him of
> just how much work he had to do, just how much he had
> to learn. When he left the city … waving into the rear view
> mirror, he was leaving to work, leaving to fall back into his
> obsession, going towards another life, the other tussle.

Perhaps the muse can live by words alone or by her image captured "jewel-like" by the artist seeing in her "all his colours … all his figures," but Marlene and Johanna both needed more. Eventually Robert would make a choice, not because he refused to ask for any more sacrifice from either of these creative, tormented women but because he saw the painter and the damage done, the emotional interference with his art. He wrote of

Marlene, but also of the fused figure of inspiration who was the combination of the two women he loved, "What am I supposed to do, he thought, as he fussed with his paint. His lonely paint. Painting. Even as he found the perfect colour he saw her drifting away from him, he saw his canvas emptying. Even as he knew that this was a perfect colour he knew that it couldn't help him, even with that perfect colour, that perfect colour spinning off the tip of his brush he knew that he was lost. He was lost."

Robert might have tried to talk to Marlene about Johanna, but it is almost certain he neither spoke to anyone else about his dilemma nor asked for advice. Not surprisingly, those friends and acquaintances who observed the triangle from the outside position he imposed on them had different reactions. The Isaacs crew and AJB members, Gord says, "were upset but didn't say anything." Presumably they were upset because they cared deeply for Robert and Marlene, but their silence appears to have been based on a firm belief in the privacy of the protagonists and the recognition of his male need to hide his feelings. In addition, there was by some a kind of unspoken, and perhaps unconscious, acceptance of the philosophy of suffering articulated by the poet John Berryman: "the artist is extremely lucky who is presented with the worst possible ordeal which would not actually kill him. At that point, he's in business. Beethoven's deafness, Gogol's deafness, Goya's deafness, Milton's blindness, that kind of thing." These are all male artists named by Berryman, so "female muse" could undoubtedly be added to his list of ordeals.

Michael Sarrazin admits that it was "a dark period in both our lives" and they didn't voice the reasons why to one another. Stephen Williams saw Johanna as just another version of the homemaker–domestic figure who took care of Robert, saw the price his friend was paying for his indulgences, but "never had a conversation with him about all this." Av Isaacs had already been rebuffed by Marlene when he tried to talk with her about Angie, and wouldn't go near the new situation. Patrick Watson could not understand why Robert was with Johanna, who "didn't seem to fit" and whose conversation with Robert appeared to lack the intellectual base of Marlene's exchanges with him. He did believe, however, that Robert might leave his "intricately involved" life with Marlene for an "obsession with something [Johanna] represented." Ed Grogan thought Johanna "a really lovely person," but he telephoned Marlene every day Robert was at the Niagara Street studio.

Few, if any, women spoke with Robert about the situation either, probably because they knew that vital aspects of the chauvinist artist world that Robert had come from were still intact for him, if not for them. Laura

Berman liked Johanna but was very disturbed because she was close to Marlene. Both she and Sheryl Wanagas are "still upset by it now," though they emphasize that at the time Robert's "cerebral sexuality" was difficult to resist. Dawn and Beth Richardson agree with Marlene that Robert wasn't doing much work in the period leading up to his meeting with Johanna and that she "got the ball rolling for him in his painting." Patricia Beatty is both critical and understanding of Robert as an aging artist and Native in the white man's world: "As a young woman [Johanna] kept him feeling younger.... His abuse of alcohol and his bravura were a big act and manifestations of [inner] pain." Rae Johnson had a studio in the Niagara Street building during this time. She often saw Johanna "baby" Robert but also saw Robert watch *The Littlest Hobo* with her own young son and genuinely empathize with the youngster's feelings about the canine hero: "What a dog!" Robert would proclaim to the boy's delight. Rae wonders whether Robert and Johanna talked about having a child, but he had long ago told Marlene that he didn't want a family and surely recognized such a conception would have been the ultimate betrayal of his wife and the end of their relationship.

It can be argued that one of the reasons Robert felt himself "lost," helpless in the face of an adversity he willingly embraced, was that he was alone in a crowd of people who loved and admired him, unable to voice, except in written notes to himself, the complexities of what he was going through. But despite his claim that he was nowhere to be found, he was visible in the painting that was pouring out of him as he struggled to keep the faith in one of his primary credos, which linked art and life whatever the consequences: "There is a way to see that reveals everything."

It seemed as if a kind of retrospective was necessary, a gathering together of his dancer-stripper figures and a commentary on them that would go far beyond anything in "Golden Spike-Heeled Fascination" and "The Moral Shape of Sexy Sadie" to at least partially represent the collision of beauty and pain in his relationship with Marlene and Johanna. Barry Callaghan, editor of the literary journal *Exile*, gave Robert the opportunity. In *Blazing Figures*, seventy-seven pages of written text and reproductions of drawings and paintings that appeared in the journal in 1979, it is clear from the beginning that Robert is using the notes on the Sadie piece that he could not work into the glossy pages of *Toronto Life*. The opening paragraphs are taken almost word for word from "The Moral Shape of Sexy Sadie," but the graphic lesbian exchange in a new drawing on the second page is

a sign of prose explicitness to come, a frank verbal display of the dancer-stripper as sexual instrument with any veils of mystery ripped away, whatever shreds of holy material the artist wants to cling to: "I loved her and as I looked into her eyes I saw that all she was doing was fucking.... it was so easy for men to get anything they wanted these days. They only get what I give them, that's all, she said. It wasn't sex, I told her, it was what sex sometimes promised. But she saw her cunt as her lock and key to her salvation, she thought I was nuts."

Juxtaposing images from the *Burlesque Series* (1963), *Drawings for Pale Blue Marlene* series (1968), and such powerfully *human* drawings as *Paramour* (1965) with poses of contoured charcoal figures inserting dildos into gaping vaginas and spreading their legs in blunt carnal provocation (rather than parting them with at least some attempt at evocation), Robert laments the loss of "the old Victory Burlesk ... long tall ladies with skin that glowed blue" and the Palace in Buffalo, "Lily St. Cyr, naked gloss in her bathtub. Rose LaRose, falling out of her dangerous brassiere." These figures from an earlier day held "dreams of some great climax that solves everything, [because] under gauze and dazzle something is happening. Dead Sea scrolls and Mother, piss and perfume, the chocolate counter-part to some sax solo; how safe she is behind that sweet music cloak ... so much *is* behind that sweet cloaking." Now the protective covers and the contrived distances between audience and actual sex have vanished. Back in Buffalo, "a flash of cunt," here in late-'70s Toronto "male masturbation motions, huge hand pumping, hissing through a red slashed mouth. As the lights died and she stooped to pick up her things the man in the front row reached through that unfair distance, touched her ankle, and she leapt back, stumbling, escaping." But she doesn't escape because offstage she performs sex acts: "The typical customer can't figure out why a girl doesn't get horny when she's got an erection staring her in the face.... When you see between five and nine cocks a day you can't." The artist model becomes "just another girl, a woman with no clothes, sweat and stretch-marks, tiny webs of veins, everyday life bruises." Robert refuses to abandon hope in the "traces.... the woman dressed in the mysteries of desire and strength," but he knows what he is witnessing is tragedy. In protest against "the ulti-mate compliment" for these women—"Let's tie her up and get dogs"—he places lines from Pablo Neruda's "Fable of the Mermaid and the Drunks," in which a female figure is cleansed by river water to gleam "like a white stone in the rain" before moving, of her own volition, toward her death.

Blazing Figures ends with the same line as does "The Moral Shape of Sexy Sadie." The artist tells her she is beautiful and she replies, "Yes,

maybe so, but should I be hurt just because I'm beautiful?" This time, however, she and the artist are not bound by a shared condition as victims of an insensitive moral climate. Her pain is her own, inviolable, and her rhetorical question represents acceptance of a brutal reality the artist recognizes he cannot paint over but can still try to paint through.

In order to "paint through," Robert almost lets go of the figure entirely in a series of paintings from 1978–79 in acrylic on canvas, all on a much grander scale than usual. The smallest is 122 by 152 centimetres and the largest 132 by 305. In seven of these paintings the figure (which, Robert said, was "always there" in his work) is barely discernable in semi-abstract form against a frame-filling though not colour-consistent background. In *Indian Blood* (see page 6) this figure is visible through vaguely recognizable head and feet shapes and thickly brushed intersecting lines of dark green and blue that are roughly horizontal in nature to suggest reclining. But these brush marks have their own presence and power that is quite distinct from the figure shape supposedly defining them. There are also two red gesture marks separate from the "body" form. Almost invisible at first glance because so small, there is another mark as well that Robert's notes explain in terms of profound lived experience, but that, without his words, has no direct correspondence with the real:

> The Waverley was an Indian bar. It was the only place in the city where he was truly comfortable. He had made the joke that it was the only bar where his hair wasn't too long or his body too fat. Not entirely a joke. Around him sat the city. Indians behind beer belly barriers. A band playing country and western. In the morning light the sun will vividly glaze the spilled blood on the sidewalk. At [Johanna's] urging he had named one of his recent paintings "Indian Blood." It had, at one of it edges, that kind of scraped red. He thought about a white line that etched through the wash black of this painting. In the dark of the bar a woman in fake fur caught some stray light and glowed. Against the dusty black air of the bar she became something spectacular. She became useful. To him. He saw in her verification of his last reckless act. In this bar was the violence and chance that he bought in bottles at the art store: the white line stays, he thought.

Perhaps as his relationship with Johanna strengthened and he felt the immediate pressures and consequences of loving *and* living with two

women, the figure he had seen so clearly in Marlene's form and had melded with that of the dancer-stripper could not remain coherent in his mind's eye. In *Roiling Clouds*, for example, *if* there is a figure holding the painting together, it is possibly found at the converging point of green and blue lines and surrounding flesh-coloured tones at the centre of the painting. But no viewer, including the artist, could bet everything on this: "In the brushstrokes he saw the frailty of the figure.... Strokes telling him of certain delicacies in his life."

In three other paintings in the series there is, whatever Robert insisted, only abstraction. In *Fields Faraway* the entire canvas is filled with a layered green paint that suggests the surface of an old wall peeling to reveal a lighter colour beneath or the shifting tones of a landscape altered by differing seasonal lights. One thin, sharply defined vertical line emerging from the bottom of the frame and its faint horizontal counterpart appearing from the left side appear ready to intersect at a point on the canvas away from an amoeba-like shape in the lower centre. That projected confluence is what draws and holds the eye. *Adornment's Echo* is an all-black canvas with tiny faint star-like marks on its left half and, by the frame's left edge, larger and more substantial green and red patches of paint that suggest (given the possible heaven-scape) exploding stars or galaxies. A faint, isolated red mark in the lower right adds to the night sky interpretation, though it is tempting to translate coloured gesture marks on blackness into aspects of his ménage à trois.

The Japanese Screen Affords Secrecy ... Even So It Seems to Her That She Waits Forever is a much brighter painting, with washes of orange across the entire 132-by-305-centimetre surface and straight lines of screen frames either empty of material or containing ragged cream and green pieces of it, with one piece of such material, unframed, near the middle of the canvas. The very literary title, possibly taken from a work by a Japanese master or the contemporary writer Yasunari Kawabata, whose novels and stories Robert was devouring, suggests a mind capable of achieving ironic distance, and possibly even separation, from daily problems: "Somewhere, down the hall, he hears music. New lines to think about. Or ignore."

Kawabata figures directly in two 1979 acrylic-on-canvas paintings, both semi-abstract, suggesting the presence of figures in pseudo-calligraphic lettering. In *Kawabata* the entire canvas is black tinged with green. Thick, distinct brush strokes, darker but of similar colour as the background, evoke the prone human form either flying apart or coalescing, but most likely the latter as the colours and implied figure are restful to the eye. In *The Sound of the Mountain*, named after one of Kawabata's most

famous novels, a purple wash descends in lighter tones from the top to the bottom of the canvas. Three abstracted black mountain shapes also descend, becoming less cohesive as they do. At the bottom of the frame is the calligraphic figure in separated heavier brush strokes and different colours that appear to denote different body areas, the prone form delineated in orange, blue-black, grayed blue-green, green, purple-blue, and red. Various small white brush marks remain, redolent of the one such mark in *Indian Blood*. Perhaps the most remarkable aspect of this large work (152 by 138 centimetres) is the depth of field created by the positioning of the human and mountain shapes on the purple wash. While the figure is closer, the mountains seem to recede from the viewer from bottom to top. This distancing effect contributes to the painting's intimation of an oasis of peace amidst the relatively dynamic expression of so many of his other works from this period.

But the supposed attainment of such peace could be deceptive:

> He wondered about the possession of ideas. In the last year
> his paintings had become quite dark…. Left uneasy, he
> kept washing [them] down with colour. Deep reds. Purples.
> Washes until a certain delicacy was found…. But he knew he
> had lost the ability to see anything as his. All the precious
> ideas were blowing away. He couldn't hold on to anything.
> It was as if he had given up all rights to anything that was
> once important to him. He sometimes thought that he was
> walking into his life like a surprised explorer, seeing first
> hand the new interpretation of what once was.

There are other titled paintings with strung-out figure lines and daubed patches barely holding together or strong in their abstract occupation of space (*Waverley Whine, The Remnants of Her Life*), as well as a number of untitled explorations of colour, texture, and brushwork, but at some point in early 1979—not long after his move to the Niagara Street studio—Robert rediscovered the figure in discernible female form. In coloured inks again, mostly with acrylic washes, his expressionist nudes with most of their body areas carefully delineated are arrested in unfeasible positions or move with the energy of those high steppers from the early 1970s. Now, however, they do so in fields of extraordinary colour—blues, mauves, greens, greys, pinks, blacks, flesh tones—that contextualize the *being* of Robert's painted women as never before. In *Swimmer*, an almost angelic figure is bathed in light that seems to pass through her body and

The Sound of the Mountain, 1979 (acrylic and oil on canvas, 150 × 137.5 cm)
COLLECTION OF MARLENE MARKLE

heighten the blues and whites below her. In *Swift Fade*, a pale de Kooning–like stripper with cartoon head and exaggerated mouth moves through clouds of darker flesh tones and even darker shadings with an enduring energy that counters the painting's title.

As the first year of his domestic arrangement with Johanna ended, Robert's confidence in his relationship with a second muse of obsession was evident, and the poses of the slender, blond Johanna were more and more apparent in his work. The colourscapes deepened in richness and tone, exploding around the figure in bright yellows, oranges, and blues, and more subdued but equally strong reddish, green, and blue-black hues. The strength of the female figure is undeniable as she emerges from these already formed scapes *and* creates them with the force of her presence (*Speaking Easy, Sunset Fire*) or hovers as a white ghost who defines the dazzling array of surrounding colours with her spectrum-containing power (*All I See in the Purple Night, Back in the Spell*). In many of these paintings she

is lithe, yellow-haired, and G-stringed, and her body is arched in curves unattainable except on canvas (*Hot Spell, Stilettos*). Her breasts are not large but conically shaped and with prominent nipples that spurt red blood/ink. In at least two works, however (*This Fire Was Sent by Paris* and *At the Angel's Edge*), her contorted, dark-haired form with fuller breasts and more substantial thighs and torso suggests strongly that Robert carried the unexpungable image of Marlene with him wherever he went. This image had the strength of years to it against the seductivness Johanna offered casually in *White Way* and archly in *Glamour Glow* and against her overwhelming sexual charge in *The Brutal Night* (early 1980), in which her spread-legged, impossibly curved figure seems ripe for the taking, yet absolutely *compels* the viewer *to* take. "Art is not art unless it threatens your very existence," Robert once said. But existence can threaten art, as well, and he painted again and again to frame and contain his uneasy life as best he could.

These and other works were displayed at the Isaacs in May 1979 and June 1980—two solo shows within thirteen months coming seven and eight years, respectively, after his previous gallery appearance. In the same period he participated in group exhibitions at galleries in Stratford, Ontario, and Norfolk, Virginia.

In *Artists' Review* Paul Young reviewed the first Isaacs show, which ran from May 19 to June 8, 1979. As might be expected, his remarks were very positive, but Young was an artist himself, and his comments on paintings that included *Kawabata*, *The Sound of the Mountain*, *Adornment's Echo*, *Memories of Sexy Sadie*, and *Indian Blood* were all the more perceptive because he understood Robert's intentions and results:

> In these latest pictures … just below the surface, embedded in the colour and the calligraphy, is the very stuff of life, its glow and aroma … as with Rembrandt, buried within is a comic sense, at once pungent and mischievous. It is, in essence, the art of vibrating, shimmering light…. Technically of course his distinguishing feature is calligraphy—the natural consequence of early experience as a professional lettering artist. More importantly, from that same experience he draws with the special panache and internal elegance of a great communicator and a very public one….

Perhaps because he was a friend who had known Robert for almost twenty-five years, and because he was no doubt prompted by the presence of *Indian Blood*, Young could make reference to Robert's Native

The Brutal Night, 1980 (coloured ink and acrylic on paper, 65 × 100 cm)
COLLECTION UNKNOWN; IMAGE TAKEN FROM SLIDE

background, something that had never been done before in any assessment of his work: "At his best we sense the graceful tread of a profound visualizing cortex, the Indian quite at home in his forest, moving noiselessly through creation. He brings to his work the sum total of who he is." Diane Pugen argues that at this time Robert might have said, "'I'm a Mohawk,' but he didn't know what it meant." It wasn't until the mid-1980s, after his visit to Tyendinaga, Pugen insists, that he "began to find out who he was [and] began to do work that was very true to himself." Nonetheless, Young's remark would have had an impact on Robert, who had already made inquiries about his Native status.

James Purdie in *The Globe and Mail* supports Young's evaluation of Robert's efforts: "The abstract figuration relies as much on shape, texture and the dynamics of internal relationships as it does on the contrasts and complementary interplay of colour.... I think the fourteen paintings in this [1979] show [are] complete, not tentative, though they contain a wide range of possible direction for future development."

The first of Robert's five 1980s shows at the Isaacs opened on June 7 under the title *New Looks at the Limelight: Works on Paper.* It included *Fields Faraway, The Japanese Screen Affords Secrecy,* and several paintings that reflected the glory and threat of Johanna's place in his life—among them *Glamour Glow, White Way, Hot Spell,* and *The Brutal Night.* John Bentley

Mays in *The Globe and Mail* praised "Markle's profane, analytic modern imagination" and the lyrical effects of his technique: "These beautiful, quickly-done chromatic fantasies throb with gutsy energy, which moves, singing, through every key on the colour scale…. Practical splashes, directed washes, combings and draggings of paint electrify the surface of the paintings." Robert proclaimed to Mays that his work was of "women who never had to be liberated because they already were," leaving those who knew of the turmoil in his personal life to wonder where he was situated in relation to such freedom. Mays, who would not have known the details of the farmhouse–studio triangle, celebrated without irony the "arresting expression of Markle's unapologetically macho sexual sensibility." The challenge to that sensibility had already been evident in a review of the Norfolk, Virginia, group exhibition (which included Graham's work) three months earlier: "Markle's nudes are headstrong, sensuous and have self-awareness. Like slashing streaks of light emerging from a deep background they are almost fearsome."

In addition to his torrent of paintings, Robert was busy in other ways during his first year in the Niagara Street studio, ways that focused his mind and talents elsewhere and probably enabled him to better cope with his personal situation. Before he applied to the Ontario Arts Council for a live-in painter's apprentice, he looked around for extra funds to support his coming double life. John Fillion, a Toronto sculptor in charge of the Department of Fine Arts at the University of Guelph, supported his application for a one-term position of undergraduate teaching. From the beginning of January to the end of April, 1979, Robert was paid $3800 plus a $150 travel allowance to teach Monday and Wednesday from 2 to 5 p.m. (*Drawing I*) and the same evenings from 6 to 9 p.m. (*Painting III and IV*). Robert never liked the formalities of assessment in academic programs, and the hours he spent on highway commuting during the winter months must have been arduous, but he needed the money and was prepared to do a good job.

His philosophy of teaching had to be written down for university students to see what they were paying for, so he had to devise formal statements of intent out of the more flexible style of teaching he'd done for thirteen years at New School and Art's Sake. Terms such as "experimentation," "investigation," "self-awareness," "inquisitive," "imagination," and "intuition" were important in the statements he produced for the university classes. He was there as a mere "guide … to encourage, to assist, not to stifle."

"After the initial knowledge of painting skills such as how to stretch a canvas, how to prepare it, how not to suck your brush, the so-called 'general' or basic fundamentals, the idea of 'teaching' painting could become dangerous," he wrote. "The teacher of painting must know what the student needs, and he must give the student that much, and no more … thus demanding of the student personal solutions of invention." He told his drawing class, "I believe that drawing is the basis of all forms of visual expression … whether the final work result is in abstract, figurative, non-objective, or realistic form, its ultimate worth will owe much to the artist's understanding of the rudimentary lessons found in the drawing discipline." Engagement with the basics meant they would do a lot of work on newsprint with big hunks of charcoal so they couldn't fine-tune line and tone. Despite the nude model that would be in front them, he stressed *the figure as a point of departure.* Marlene came down from Mount Forest one day to observe the only class she ever saw him teach. "He put a sheet of paper on the floor and made great graceful lines with charcoal. His body was moving like a dancer's, a light-footed dancer with a sense of rhythm." To interfere with a predetermined gaze at subject matter, he made his students draw with their eyes closed. To reduce the gap between them and the model, he got them to assume the same pose before they began to draw. He was a tough marker, as his grades sheet indicates. Of the thirty-two students in his drawing class only three received final marks of 75 per cent or above. Despite his dislike of "official education," word must have gotten around about his unorthodox but effective teaching methods, because in September 1979 Robert was offered a permanent position in the Design Arts Department of Georgian College in Owen Sound, Ontario. He declined with thanks, saying he was committed to his duties as an instructor and member of the board at Art's Sake.

When the Guelph term ended, he became involved in "almost a marriage between business and art"—a huge project that meant his life would be necessarily compartmentalized, a fact that probably contributed to the survival, at least in the near term, of his relationships with Marlene and Johanna. As with his students, he could give them "that much and no more, thus demanding of [them and himself] personal solutions of invention." The project originated with Stephen Centner, a computer systems expert who had invested in Les Copains restaurant on Wellington Street, in downtown Toronto, in 1975. Two years later he opened the Café des Copains downstairs, a French-style cabaret that Robert and his companions began to frequent. One day Robert, Stephen, and Tom Hedley were talking about the ceiling tiles in Italian chapels and came

up with the idea of inviting guest artists do paintings for the café ceiling. Soon twenty-five to thirty coloured works by Markle, Coughtry, Rayner and others were set into the ceiling behind glass panels above patrons' heads, along with a very erotic image of Margaret Trudeau provided by Dennis Burton. Each of the artists was paid with a $300 bar tab.

Seeking to expand but recognizing that another French restaurant was not viable, and perhaps noticing the eating habits of one of his favourite artists, Centner conceived the idea of a high-quality hamburger bistro that would carry the creative presence a giant step further. Robert was hired to design "a celebration for the eye, mind, and palate" at 55 Colborne Street, also downtown. Everything was sketched out and brought to final form in the Niagara Street studio over a six-month period in the fall and winter of 1979–80.

The result was a "total art environment"—a lower-level ceiling completely painted over with sexy figures and forms; some fifteen large figure paintings on Plexiglas with certain aspects of shape emphasized in blue, white, and red neon lighting; sixty Plexiglas panels hanging from the upper-level ceiling decorated with tumbling, spinning, and floating nudes; and three twelve-foot-high "angel" panels depicting nude dancer-strippers with neon wings, their bodies outlined in black and white and their haloed heads tinted with neon of various colours. The art was everywhere, surrounding the diners and capturing their lines of sight. If it was serious art intended to enthrall an urbane audience, a certain lightness and playfulness were crucial in its presentation so that viewers glancing anew at a work would see aspects of the figures not glimpsed before. Robert said he "wanted to create a feeling of angels in a baroque kind of space," but he also depicted cloud-like hamburgers being zapped by lightning bolts. In a note to himself while the work was in progress, he wrote "make all figures less strong … more joyous." Centner insists that he got Robert to make his nudes "plumper" for the restaurant clientele: "I wanted a celebration, not a heavy thing" that leaner, more realistically shaped figures presumably would have conveyed.

Centner's wife, Maryvone, gazing up at the ceiling, suggested an appropriate name for the place—Markleangelo's—and the restaurant opened on April 29, 1980. The menu reflected the blend of high and popular culture by offering hamburgers with "a choice of 15 accompaniments … including marinated julienne of vegetables, caviar and sour cream, *herbes de province*, and caponata (a cold eggplant and condiment combination)." There were six inexpensive California wines available and, for the true hamburger connoisseur, Dom Perignon. For

dessert there was a variety of puddings, mousses, and cakes, and, "in honour of Robert Markle, the world's largest (and best) butter tart." All this was served on white Rosenthal china in banquettes of charcoal-grey velvet. Marlene attended the opening celebration. Johanna did not.

In a publicity statement, Robert promoted the business with some prose that almost fell over itself trying to sound wise and hip at the same time: "Markleangelo's will slowly reveal itself. You could go there once a week for a year and you'd always be discovering something new in the paintings. It's a place where there's attention to detail that's transforming and enlightening. Lights and activity. Chrome and glitz. Plush seating and fine china. Plus really terrific food. And it has a sense of humour, from the name on." He received $8000 for his work plus a $4000 bonus, but he was most delighted with a special perk: the one-year use of a white 1962 Cadillac convertible with red leather seats that he would drive "top down, rain or shine."

Media response to Markleangelo's centred on the issue of popular art's relationship to sanctified creative expression in Western culture. John Bentley Mays said that in the restaurant art had met capital "in an atmosphere of trust and respect" and the result was "a sexy Sistine Chapel." Adele Freedman disagreed: "Markle's fantasies are totally integrated into a commercial framework: therein lies their success and their limitations…. The point about Markleangelo's is that it is *not* a chapel, nor is it a ballet set." Freedman went on to state that Robert's displays shouldn't be compared to the Chagall windows in Jerusalem or the Matisse Chapel in Vence, France.

Robert's achievements in neon and Plexiglas prompted him to commend these media in his successful application, later in 1980, to design a mural for the Ontario Government Services Building in Hamilton, for which he also proposed to use stainless steel and acrylic. The finished work was significantly titled *Mohawk*, but since no extant notes reveal the title's origins, the viewer is left alone to consider the layered abstract shapes of glass over steel. Patterns of lightly applied red and blue acrylics appear on the glass, and curving neon lines in yellow and white tubing prompt the gaze in a flow from right to left. The piece is approximately three metres high and seven and a half long and was a prelude in form and content to his most ambitious, and ultimately most accomplished, publicly funded work—the installation, in 1984, for the new Metropolitan Toronto Convention Centre.

His success in this period of enormous creativity had its limits. In 1982 Toronto dancer Patricia Beatty, whose Toronto Dance Theatre

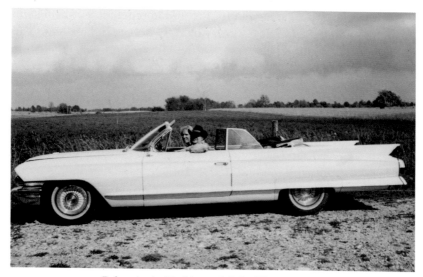

Robert in the Markleangelo's Cadillac, July 1980

on Cumberland Street was "right around the corner from the Isaacs," brought her love of contemporary painters to a project she called *Painters and the Dance*. She asked Graham to do a poster and Robert and Gord to design costumes and a set for two pieces she had created. To inspire them she cited previous collaborative productions such as *Parade* in 1917, which featured music by Erik Satie, a scenario by Jean Cocteau, and sets by Picasso. Perhaps of more immediate interest to her artistic trio were more recent collaborations between dancer Martha Graham and painter Robert Rauschenberg and, in 1946, the use of a de Kooning painting as a large backdrop in the ballet *Labyrinth*. According to Beatty, Robert finally told her "it was too big for him." What he meant was that he had too much on his plate as an artist, teacher, and lover. The show did go on, with three performances at the St. Lawrence Centre, and Graham's and Gord's sets and paintings were left to the National Gallery.

However ordered the production of art was on Niagara Street, Robert's life there could be tempestuous, centred as it was on his relationship with a mistress-muse-artist who, as time went by, had dwindling hopes of a lasting life with him. Whatever promises he might have made, whatever indications he might have given that she would be his inevitable preference, by the end of their third year together, she must have known what so many around them had always believed—he could never leave Marlene. Indeed, there was evidence that he and Marlene were sharing new experiences and interests during their weekends at the farm together. She had been

going to some local auction sales for fun and to purchase practical items for the farmhouse, and one Saturday in 1981 Robert came along to an auction in the Mount Forest arena. Of the hundreds of items there, the one that caught Robert's eye was a white milk-glass candy container in the shape of a hen on a nest. Milk-glass was generally considered a throwaway, but Robert spoke to older female dealers about it and learned about the qualities of different pieces. Gradually he acquired a collection of the containers, bought books on antiques, and expanded his interests. With a bag of egg-salad sandwiches, a big Thermos of coffee, and a copy of the *Woodbridge Advertiser* ("dedicated to antique sales"), he and Marlene would drive to small towns within about a hundred kilometres of Mount Forest—Elora, Port Elgin, Nottawa, Stayner, and others. They looked at, and sometimes bought, clocks, forged tools, pitchers, and bowls, as well as the occasional bigger item. At a Cookstown show they spent a tidy sum on a Ukranian cupboard from the 1920s—a perceptive buy, given that it is worth "vastly more now." Robert would have had to sell more than one painting for them to afford that cupboard, but by February 1982, when he had his third solo show in three years at the Isaacs, he had a reasonable expectation of income from this source. The irony is that much of his best work was based on visions of Johanna and of the beautiful but disturbing bonding of her body with Marlene's.

Whatever dancers Robert watched perform at the Zanzibar Tavern, Gimlets, or on the drives with Stephen Williams up through Orangeville and Arthur, it is Johanna's image that dominates the coloured-ink-and-acrylic paintings of 1981–82. Dressed in spangled G-strings, black stockings, and stiletto heels, with blue eyeshadow and her usually white hair streaming against dazzling abstract swirls of rainbow colours, she arches, curves, twists, and bends to such extremes she becomes a sacrificial figure on the altar of the artist's need to make her so. This need is all about the process of passionate presence moving toward desired absence. In *The Light Scrapes Her Away*, from the *Zanzibar Series*, her scarecrow form with pointed nose and blue eyeshadow transformed into an open staring eye disappears into the surrounding colour. In *A Delicate Victory*, from the same series, her form seems to disintegrate into orange-brown earth tones that will soon swallow her *without trace*. In *Meadow Spotlight* she bends backwards so radically over a blood-red shape beneath a brilliant yellow sky that no recovery from the position seems possible. To be sure, the Johanna image appears in many other works as charged and confident in her self-display, but in these paintings Robert is revealing nothing new. Indeed, the lines and gestures seem repetitive for the first time, despite

the remarkable explorations in tone and colour. In works such as *Rosy Whispers*, *Parts of Memory*, *The Agile Lie* (all from the *Zanzibar Series*), and *Teaser Façade 2*, he was at the height of his powers in his consideration of the sexy female figure whose sinuous form and movement had haunted him for so long. The viewer wants to cry, "That's it, what you're doing here can't get any better!"

"I wouldn't have to do anything else if I could do a drawing so sensuous that I'd never have to see another woman again, if I could paint a picture so erotic that I'd never have to fuck again," Robert had declared. The sensuous and erotic are in these paintings in ways that cannot be surpassed by any increase in technical excellence or by the artist's somehow apprehending this particular subject more deeply. The result was that he didn't have to see (in the sense of *be with*) the other woman again. As for fucking, that's what he had been doing to Johanna and Marlene, psychologically as well as physically, for all his love for both of them. His recognition of this is found in *Ebony Swoon*, in which a darker female figure lies over a lighter, white-haired one in an act of sexual possession strongly suggested by the positioning of the couple's arms and legs. The form of the dominant figure is fluidly female, but projecting from her nether parts is a phallic shape that undeniably adds a third-party male dimension to the exchange. In *California Carnal (Zanzibar Series)* an amorphous red shape seems to mount the white-haired figure from behind to threaten rough sex or worse.

In at least three paintings his vision of his two women perhaps represents the idealized legacy or trace Robert wished to leave for posterity. In *Glossy Bloom*, from the *Zanzibar Series*, the white-haired slim figure looks back affectionately over her shoulder to a darker female form behind who is visible through one crossed leg leading down to her stiletto heel and one hand with long red fingernails resting on her lover's ribcage. In *The Beguiling Assault* (see page 168), two flesh-coloured figures, so close in appearance as to be almost twins, float in tentative embrace, eyes closed, lips parted in anticipation of possibilities. Feathered brushstrokes and trailing boa shapes suggest the wings of angels. But it is in *The Glamour Sisters* that a peaceful reconciliation between rivals occurs. Robert paints a blond and a dark-haired woman lying side by side, their profiles, *at first glance*, almost indistinguishable, the leg of one dropping down in line with the other's rising up. Their interchangeability is emphasized by a reversal of the oppositions we have seen before. The blond's skin is, for the most part, the darker of the two, and her breasts are monumental compared with the modest swellings of her sister.

The Glamour Sisters, 1982 (coloured ink and acrylic on paper, 65 × 100 cm)
COLLECTION UNKNOWN; IMAGE TAKEN FROM SLIDE

Many of these paintings appeared in the *Zanzibar Series* shown first at the Mohawk College Art Gallery in Hamilton in late 1981 and then at the Isaacs in February 1982. "The painting and the space exist within the figure, rather than the figure existing within a definite spatial context," Robert said. "And I want each figure to be unmistakably the figure of a woman, being painted by a man. The sensuousness must be there." Undoubtedly such sensuousness was present in the works shown, such as *The Beguiling Assault, Rosy Whispers, Glossy Bloom,* and *California Carnal,* but his emphasis on distinct gender boundaries between artist and model did not address the blurred space of feeling inhabited by more than one figure at a time. Comments by viewers of the Mohawk Gallery show ranged from "strong and alive" and "vibrant," on the one hand, to "warped" and "not anatomically correct," on the other. One person went further in the search for proper bodily proportions: "I want to see you draw a foot— other than a Markle foot." Perhaps the most memorable response was the seemingly supercilious "Promising work." The signature immediately to the left was "Av Isaacs."

Robert had said what he could in his work about the splendour and the destructiveness of his relationships with Johanna and Marlene. Their time

Robert and Av at the Isaacs Gallery, Toronto, 1982

together had inspired and battered him for almost five years, not least because he knew he was mainly responsible for what they had all gone through. But unless he were to embody the artist-as-Sisyphus, doomed to begin the same painting over and over, he had to pick up his palette and move on. That meant, of course, making a choice: "It's this left edge, the Toronto edge, that is giving trouble. It sits like an unwelcome suitor, and the broad expanse of the canvas is like a treacherous dance floor, corsage, patent leather pumps, and the inevitable disappointment of the last waltz, dreams never being what they are made out to be."

In the end he decided to go home in more ways than one. The way was prepared by the closing of Art's Sake in 1982. Dennis Burton, the school's most effective administrator, had moved to Vancouver in 1979 and accepted a position at Emily Carr College. Without his tireless fundraising and administrative abilities, creative dedication alone could not sustain the program. The loss of a regular teaching income, however minimal, meant that the Niagara Street studio could no longer be maintained unless Robert was prepared to live in Toronto full-time. He made his choice before the studio lease was due to expire at the end of June 1983. His decision was final, though he and Johanna must have had many painful conversations about their impending separation.

If the farmhouse was his real home, he did not own it, but in 1985 the house and a few surrounding acres would be offered for sale. He and Marlene would take out a mortgage on the property, finding the money for a down payment in a $12,000 off-reserve housing grant and $5000 borrowed from Marlene's parents, with additional funds from a Registered Home Ownership Plan to which Marlene had been contributing. Robert had never owned a home before, and the combination of the purchase and renewed life with Marlene would create a powerful emotional partnership with which Johanna could probably have not have competed had their relationship lasted any longer.

Another factor in the decision to leave the city might well have been Robert's growing acknowledgement of his roots. In order to obtain the housing grant, he would travel to Tyendinaga to obtain his Native status card, a visit that can be explained in practical terms—that is, his simply and cynically using his heritage to get the money—but which Marlene says wouldn't have occurred if he hadn't "felt comfortable being Native." Robert had never worn his red heart on his sleeve, but his incipient sense of his heritage had been somewhat visible in his *Mohawk* mural for the Hamilton government building, and, before that, in his submission of Iroquois stamp designs to the Canada Post Office in 1973 and in the moving notes he wrote about his father and brother on high steel. This sense had become true connection when he inquired about his Native status in 1977 and through his research for and design of the Metro Toronto Convention Centre mural in 1984. The connection was emphasized in the statement he wrote to accompany his unsuccessful submission to create a mural for the University of Calgary the following year: "Being a Mohawk Indian certain imagery based on primal markings and petroglyphs directly related to my culture are slowly being absorbed into my work." But his *belief* in being Native clearly came out of his Tyendinaga visit and his delight that the residents "looked like me."

That a lot happened between the giving up of Niagara Street and the journey to Tyendinaga is indicated by Robert's response when asked by *The Toronto Star* in September 1983 to provide a list of those he would invite to a "best-ever dinner." The only visible minority person of the dozen famous people he named was Kawabata. Crazy Horse, Leonard Peltier, Joseph Brant, and Deganawida would have to wait. Even with the dramatic and full-scale incorporation of his heritage into his art over the next two years, however, and the probability of a more inclusive dinner list, he was certainly not planning to *become* Native on a day-to-day basis.

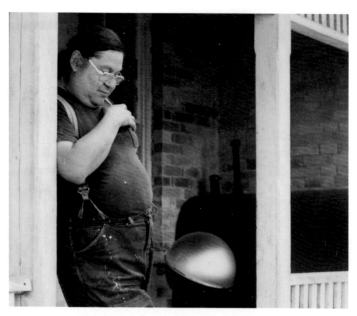

Robert on the farmhouse porch, 1982

Johanna went back to university in a southern Ontario city and wrote him brief notes from there over a period of time, continuing to profess her love. Robert drove down to see her at least once but told Marlene they didn't sleep together. Eventually the letters stopped. What comes readily to mind in consideration of Robert's Niagara Street experience is Bob Dylan's song "Visions of Johanna," about the shifting shapes and influences of the singer's two muses on him, along with its references to the "opposite loft," the "little boy lost [who] likes to live dangerously," Mona Lisa and her "highway blues," the flowing "cape of the stage," and the singer's exploding conscience. The cruellest judgment of Robert's self-centred behaviour, as well as of the self-protecting needs of the two most important women in his adult life, may be found in Dylan's lines "Name me someone that's not a parasite / and I'll go out and say a prayer for him," but such cynicism is undeserved. In the end, Dylan pays tribute to one muse who, for a while, "conquered [his] mind" and "kept [him] up past the dawn," a tribute that implicitly contains the entire creative process of the song, including the contributions of the other muse, Louise. Dylan's final words in his song powerfully and ironically represent the collective heart of so many of Robert's paintings between 1978 and 1982, created by him *and* both artist models: "these visions of Johanna are now all that remain."

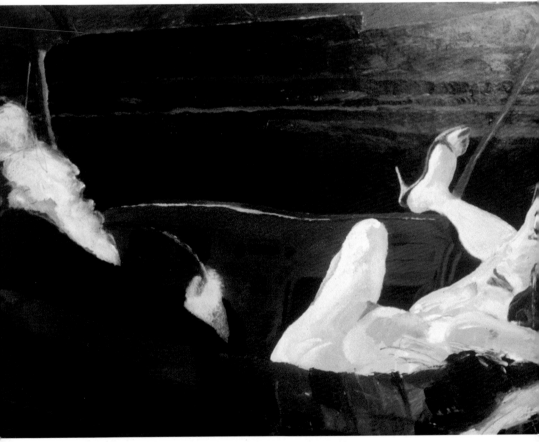

Country Twang, 1989 (acrylic on tempered hardboard, 91.1 × 122.1 cm)

COLLECTION OF LORNE EEDY AND NANCY PATRICK

VIII

MEETING PLACES: MOUNT FOREST 1983–1990

No sudden radical changes occurred in Robert's work when he moved back to the farm for good, but certain subtle differences were noticeable in his presentation of the figure. In a number of paintings in coloured ink and acrylic during 1983–84, she was less urbanely sexual and more elemental, a kind of grounded rural deity whose fertility was emphasized rather than her pleasure-giving potential. Titles like *Some Golden Soil, Some Classical Greenery, Dancing in the Gardens of the East,* and *Formal Flora* indicated Robert's interest in setting her amid the abundance of growth he saw anew in the fields and forests around him. In *Gardens* the figure's torso is a quilt of vibrant colours stretching back in tufts of green fronds with red-brown tips about to blossom. In *Formal Flora* she has a similar patchwork body but lies on a green-blue-black eruption whose traces are found in her legs, ribcage, eyeshadow, and beneath her neck. It is *Set Peace* that offers the most memorable portrait of the earth goddess. She reclines across the entire width of the canvas, dividing the green, tilled fields above her with the lines of her bent right leg and feeding a darker rectangle of brown soil with the blood-red milk from her breast. Beneath her torso and her buttocks is nature's underworld, where neat agricultural arrangements are swallowed by streaks of colour and unpredictable lines. In the lower left of the frame an intense blaze of orange is contained by her heel and calf as if the sun itself, whose afterglow glimmers in the upper left-hand corner, is just a subject in her domain. Even though it was not the case, the impression given by all these works is that Robert was painting outdoors, and washes from dirt and Humber River water come to mind.

In late 1983 he submitted a proposal to create a mural for a huge interior wall in the new Metro Toronto Convention Centre, on Front Street West, that took him further into his Mohawk background than he had ever been before. Typically, he spoke to no one about his specific plans. Marlene knew he was preparing a submission but didn't catch any glimpses of his preparations. The Tyendinaga visit in 1985 would require a formal admission of his Native identity that paintings like *Indian Blood* could allude to but not directly represent. Although he admired the individual works of Norval Morrisseau, he had "shunned the emergence of ... Morrisseau's Aboriginal image-making" and "resisted trading his heritage for Art," perhaps feeling that Morrisseau's national reputation at the time was based on limited perceptions of him as an "Indian artist" who, if he tried to paint from outside the perceived Native paradigm, would have to struggle like most of his creative colleagues. Robert felt himself an artist who happened to be Mohawk, not a Mohawk who painted pictures. In his late forties, however, after years of making fun of his inability to paddle a canoe and his fear of heights, after finally embracing where and with whom he wanted to live out his life, and after almost twenty-five years of establishing himself as a consummate expressionist painter of the figure, he was ready to bring his skills and heritage together as never before. He wasn't announcing himself as a Native artist who had finally seen the light, but he was indicating publicly that Mohawk history and myth were part of his creative vision in compelling and efficacious ways.

The Convention Centre competition was a two-stage affair in which a long list of nine applicants was, by February 17, 1984, whittled down to four finalists—a Toronto-based group of artists called General Idea; painter Paterson Ewen, who taught in the visual-arts department at the University of Western Ontario; internationally famous Michael Snow, a recent inductee into the Order of Canada; and Robert. The selection committee consisted of the president and a board member of the Convention Centre, one of the chief architects of the building, an art consultant, and the director of the Art Gallery of Ontario. The four finalists were invited to prepare final proposals for the mural, for which they were to receive $1200 each, and to make their twenty-minute presentations to the committee on April 16, complete with maquette, budget breakdown, and schedule. The winning artist would receive $80,000, from which all his project expenses would be taken, and would have four months to install his artwork. Queen Elizabeth was scheduled to open the Convention Centre in October, and everything had to be in place before then. Robert's interview was at 11 a.m., between those of Snow and Ewen. A Convention Centre press release described what happened:

He didn't attempt to dress up for his appearance in front of
the selection committee. He dressed as he does habitually, in
a denim jacket, workman's coveralls, and a fedora he wears,
indoors and out, over long hair fashioned into a queue. But
his effect on the committee was electrifying.

President John Maxwell says, "He came in and reminded us
what we were all about. Once he'd begun to speak there was
no doubt in anybody's mind that here was a guy who under-
stood what we were trying to do here, and knew how to do it."

Robert's self-confidence was strongly based on his ability with words.
Apart from the elimination of four-letter terms and the maintenance of
a respectful tone that suited the occasion, he would not have addressed
the committee members about his art any differently from the way he
addressed his Toronto friends, his students in the Brunswick, or the
Flyers in the Mount Royal. But he was supremely confident about the
nature of his proposed mural. The suggested subject matter had been
the "Bicentennial of the Province of Ontario, Toronto." Robert called his
piece *Mohawk: Meeting Place*, and clearly explained how its fourteen related
parts in painted stainless steel and neon light related to the Convention
Centre's purpose and function:

> Toronto is an old word, from before anybody from Europe
> ever came here. It means "place of meeting." It seemed
> obvious to me that the underlying concept of the mural
> should be just that—a historic look at the whole idea of
> meeting on this site, between the mouth of the Humber
> River in the west and the Don in the east. People have been
> getting together here for thousands of years. They came to
> meet, to exchange information, to socialize. And isn't that
> exactly what this place is all about?

He likened working in neon to drawing "in space with lights," and
then took the committee through his detailed plans for his Native-based
design, saying that even though the medium in which he would work might
seem "untraditional" for the subject matter, "primitive artists have always
worked with what they have. In my case the materials are sophisticated,
but the imagery goes right back into the roots of the Indian culture in
Canada." So convincing was he that by the time he drove home to Mount
Forest, the committee had made its unanimous decision to hire him. The

199

Details from *Mohawk: Meeting Place*, 1984
(mirrored stainless steel, neon light, and acrylic, entire work 4.5 × 48 metres)
COLLECTION METRO TORONTO CONVENTION CENTRE / IMAGES TAKEN FROM SLIDES

very next day he was back touring the site with one of the Convention Centre architects to discuss such matters as anchors for the stainless steel and electrical outlets for the neon. His contract stated he was to have the work installed by the end of August. The cost for materials and labour for fabrication and installation by Yerex Neon was originally projected to be $3200, though this figure greatly increased, and what Robert eventually took home after Av's $5000 commission was $16,000.

What he produced was spectacular and a completely original use of contemporary material and forms to carry his clearly informed display of ancient symbols and create a Toronto story from them. Perhaps the best way to present the results here is to combine the concise, formal descriptions on the Convention Centre plaques with his more colloquial commentary (in italics) from the press release. On the concrete north wall of the building, near the entrance to Constitution Hall, the mural narrative moves from left to right in distinct parts:

I & II: *Humber.* The defining western edge of Toronto in early days. Here the shapes and painted areas suggest a homage to the Group of Seven and the way Canadians see the Northern landscape, with patches of brilliant fall colours, landscape evocations of rushing water, mist and blurred horizons, and formalized animal symbols of elk, deer, and wolf.

It echoes the kind of feel that Tom Thomson produced in "Jack Pine." There's a jaggedness to it that reminds you of trees and hills.

III, IV, V, VI: *Solar Figure.* The central figure of the Shaman embodies the concept of harmony; of man's reverence for Nature; of his place in the universe, sharing and exchanging knowledge for the good of all humanity. The imagery goes back to authentic Indian examples of scrimshaw, embroidery, fringes, formal Navaho designs, etc. It culminates in the Sun, represented as spreading out its warmth, embracing all mankind.

The imagery here is based on the authentic lore. The visual ideas come from the rays of the sun. The idea behind it is the sharing of wisdom. In the Indian mind, wisdom, like the land itself, belongs to everybody. You don't hoard it away for yourself, you share it.

VII, VIII: *Ceremony.* The whole piece represents elemental nature, inspired by the very formal aspects of design expressed in Plains Indians' hide paintings and basket weaving. Hunting and fishing are suggested in the background painting, with the Horned Serpent forming a central image of intertwining snakes on all three levels. The idea of harmony and

peace is alluded to in the visual reference to the Iroquois Confederation wampum belt.

These images have their roots in beadwork and weaving. Between the units there is a negative shape of a serpent and they're overlaid with a neon representation of a horned serpent, something that occurs in petroglyphs from all over the world. The intertwining of the serpents has medical symbolism.

IX, X, XI: *Moon Shaman.* Another view of the Shaman as a source of knowledge to be shared, embodying the central concept of Man as Landscape and Man as Universe. The neon Solar Boat, drawn by the Sun, creates multilayered imagery referring to the source of knowledge and reverence for the intellect.

[The unit points back toward the Solar Figure section, which he sees as the core of his idea—the notion of people gathering and learning to share.] "*That's what the place is for, after all.*"

XII, XIII: *Turtle.* The title is derived from the images of two turtles with intertwining necks—one is drawn in neon, the other in shaped metal moving through the water and among a group of large and small snipe. The turtle is the symbol of Markle's own clan within the Mohawk tribe. The red zigzag line coming out of the Turtle's head symbolizes sound and means that the voice of the Turtle has been heard. On the back of the large Turtle is the Mohawk symbol of the Tree of Peace, its roots growing out of the four corners, and, buried deep beneath its roots, a hatchet.

That's where the old idea of burying the hatchet comes from. You bury it and peace springs up.

XIV, XV: *Don.* The eastern boundary of Toronto in the early days of Toronto's history. Like *Humber,* this is another elemental piece dealing with constantly changing seasons, weather, and landscape—clouds, sky, water, birds, sweet grasses in the landscape, wintery weather, storms, and lightning.

The right-hand end of the mural is the geographic end of the idea. It's the mouth of the Don River. This one is set in winter. The colour is smoother and more lyrically applied. And there's more lightness to it, a kind of sky and water feel. Because it deals with the sky there are bird symbols and lightning among the neon.

At the right edge of the last unit Robert placed his family name in neon—Maracle. As a signature for the entire piece it is an extraordinary

gesture, the name of course the same as the one that appeared on his status card and with which his steel-working father and brother always identified themselves. His personal identity was officially connected to a collective Native experience in his creative documentation of the past.

Robert had certainly done his cultural homework, which is further indicated in his commentary about the mural's unity: "All the units in all the elements, they're separate, but they're like parts of the same puzzle. What I was trying for was a sense of the different individual rocks that make up one rock face up north. A native artist would use a rock face, but he would think of the whole rock, not just the piece he was painting on. I tried for that same feeling of wholeness."

It was a unity, as his private preparatory notes reveal, based not only on a sense of the Peterborough, Ontario, petroglyphs and Inuit graphics from farther north but also the drawings on Ojibwa birchbark scrolls and Mexican cave art. He had studied the mnemonics of Iroquois chiefs' titles, read *Seven Generations: A History of Kanienkehaka* (People of the Flint), *Tales of the Mohawks*, and the syllabus of the Kahnawake Survival School, and was in touch with Chief Wellington Staats at the Six Nations reserve in Brantford, Ontario, and the Woodland Cultural Centre there. He was particularly interested in Deganawida, the legendary Great Peacemaker, and the founding of the Iroquois Confederacy, and would produce a draft screenplay about the Confederacy for Patrick Watson's CBC *Heritage Minutes* shortly before his death.

Writing in *The Globe and Mail* John Bentley Mays said, "Markle's *Mohawk Meeting* is a glitzy, marvellously decorative piece which incorporates traditional Canadian motifs from native beadwork to Group of Seven landscape painting, and serves it all up in a tumble of brilliant neon, scrappy drawing and gleaming steel." Looking at the work, which today, given its inside location, remains as pristine and clear as it was at the Convention Centre opening, it's not easy to ascertain where the Group of Seven comparison comes from. Robert's suggestions of landscapes emerge from the unique qualities of the Mohawk symbols that Jackson, Lismer, and the others simply could not have felt or known in the same way as he did. Diane Pugen believes a "shamanistic sense" came into his work at this time, "a tapping into more indigenous ways of seeing things." What the Group of Seven painters saw and painted was there, as Gordon Lightfoot points out, "long before the white man" but, as has already been said, "the green dark forest" wasn't "silent," and it was "real" in profound ways for Native peoples. Robert had moved along the edges of this reality for a long time. Now he walked into it, creative tools in hand.

For all of the seriousness with which he approached and completed the project, Robert remained the same easygoing friend of his Mount Forest hockey and softball buddies. He invited them to the Convention Centre opening attended earlier in the day by Her Majesty, on October 2, 1984. According to Craig Kenny his outfit was more memorable than the Queen's. He showed up in a sweatshirt that looked like a tuxedo jacket, overalls, and paint-speckled shoes. He re-introduced the Flyers to Av, Graham, Gord, and others who had met them before in Mount Forest, and all fifteen stayed at Stephen Williams's glamorous apartment at the top of Sutton Place, using empty cardboard beer cases as pillows. "We went in [to the Convention reception] like a bunch of hillbillies," says Tim Noonan, "but Robert never made us feel that way." There is no record of Her Majesty's response to the UIC crew if, in fact, she glimpsed them from afar.

Three years later Robert would involve the Flyers more directly in his creative process and Native heritage. In the spring of 1987 he told Craig Kenny, Tim Noonan, and one or two others that he needed help with some cedar fence rails. What he meant was he wanted them to pull over one hundred carefully selected rails from the bottom of a pile in a farmer's field and load them in his pickup truck.

"I want that one," he'd say, and the artist's apprentices would pull and haul until the approved piece emerged from the stack.

"We had no idea what he had in mind," says Tim, but assumed he needed to replace some rails on his property. However, they unloaded the wood in the middle of the field in front of Robert's house, far from the perimeter fences. Over the next few weeks he constructed by himself *The Horned Serpent of Egremont*, a 3.6-metre-high zigzag rendition of the snake form that had such an important role in the Convention Centre mural. He had brought the Native symbol home and made it a permanent part of his landscape for all to see. Reactions differed. The Flyers couldn't find the serpent no matter how much they twisted and turned. Stephen Williams, on the other hand, called it a "profound work," though this judgment was likely based as much on Robert's intentions as on the results of his efforts. It is, without doubt, an expressionist rendition of the fabled snake, especially as seen from the side on ground level. Robert always insisted it had to be seen from the air, but whatever the viewer's perspective, the Mohawk artist had engaged in a crucial and original depiction of an ancestral totem. That October, he placed a photo of *The Horned Serpent* on the flyer for his show Recent Work at the Durham Art Gallery, twenty minutes north of Mount Forest.

It was clear that Robert didn't feel the Convention Centre mural was a one-time public manifestation of what he had to say about Native mythology and tradition. In October 1985 he was selected as one of three finalists out of seventy-eight applicants in a sculpture competition for the courtyard of the Engineering Complex at the University of Calgary. His proposal involved "a natural continuation of my investigation of primal native imagery: petroglyphs, rock and cave painting, scrimshaw, carving, etc., as authentic source material for contemporary iconography." His work would be in durable Corten steel, and its whole length would be filled with "authentic markings which are universal to all cultures: horned serpent, solar boat, ceremony, shaman, solar figure, elk, wolf, turtle, tree of peace." Instead of neon light, this outdoor sculpture would rely on the sun to cast shadows and "project ... shapes onto other images on other surfaces." He liked art, he wrote to the selection committee, whose meaning unfolds like the Horned Serpent, "a favourite symbol of the Shaman, Keeper of Knowledge, Teacher, appropriate for a university setting."

He did not receive the commission, and it is interesting to speculate on how the selection committee members viewed him and his art. They would have known what he had done at the Convention Centre and that he was an "Indian artist" quite naturally working with indigenous subject matter. How did this view factor into his position on the short list? Whatever the merits of his fellow competitors, did the committee decide in the end that it didn't want Native material or Robert's specific design? Correspondingly, if he had won the competition, what would this have done for his reputation as an "Indian artist" and *to* his reputation as an artist? Would those looking for public displays of Native creativity have begun to approach him for submissions, and how would Robert have responded? That he was now profoundly aware of himself as an artist who was Native is indicated in his March 1985 application to the Department of Indian Affairs for the off-reserve housing loan; he was applying, he said, because of the "state of the 'artistic climate' in Canada" and the fact that his average annual income as a painter between 1981 and 1984 had been $5,601.64. He signed the application "Robert Maracle." Five months later he received enough funds to enable him and Marlene to acquire a mortgage on the farmhouse, which he and Marlene would have almost paid off by the time of his death.

His next two murals would be, literally, closer to home—one in Mount Forest (1986) and the other in Owen Sound (1987)—and Native iconography would figure in neither. They received a great deal of local attention, but not as much as would have been given Robert had he won the Eaton Centre

competition for which he submitted a proposal in 1989. In his application he is brash in his assessment of the "pinball atmosphere" there: "Placing anything of obvious subtlety [there] would be like displaying the Bayeux Tapestry in the bazaars of Marrakech, just another carpet. (It's no wonder Mike Snow's wonderful geese take to the rarified air of the Centre's stratosphere, there is just nowhere to land)." But it is his playing down of the specific nature of the imagery he intends to employ that suggests something of a split between what he wanted to work with and how he did not want to be perceived. He referred to his "neon drawing" for module panels as "looking *like* the primitive etchings on cave walls, petroglyphs on painted steel" (italics mine) but stressed the "organic … indications of animals, rock, boulder, river edges, fish, flora, and fauna, the stuff of water." He does not refer to his own background or to any intentions in regard to Native symbolism, and if he wasn't retreating from whom he was and what he knew, he was drawing back from public declarations of identity. The result is a curious lack of focus and an admission to the selection committee that his ideas were still "in flux." It turned out they weren't fully formed enough to convince the committee, and the commission went to another artist.

As he approached fifty Robert's physical health declined. He took beta blockers daily for his high blood pressure, a condition Marlene feels was exacerbated by the stress of the Niagara Street period. His years of alcohol abuse had damaged his liver and given him gout. He suffered from extreme fatigue and was sleep impaired, and once he got to sleep he had vivid bad dreams caused by his medication. He still managed to play slow-pitch softball with the Flyers, hitting bloopers into right field and making up in enthusiasm what he now lacked in speed and agility. They were a .500 team in 1987 when they pulled "the biggest upset" and won the local league championship against a much more talented group of Ontario Provincial Police players. Robert and Stephen Williams went to the year-end dance to accept the trophy and lorded it over their opponents amid much laughter and banter.

But if his body was failing him, his creative vision was not, and the last five years of his life were replete with remarkable explorations of various media and subject matter. While still preoccupied with the figure, he expanded the context for her presentation in terms of form and content. For one thing, the nude female quite often wasn't alone anymore.

In her essay "The Painter and His Model: Markle since '85," written for the catalogue of Robert's solo show at the Thunder Bay Art Gallery in

Marlene and Robert at the Mount Forest farmhouse, 1985
PHOTO BY MARSHA BOULTON

1989, guest curator Carol Podedworny addresses the origins of Robert's inspiration for his *Artist and Model Series*, which opened for the usual three-week run at the Isaacs on March 30, 1985:

> The series is composed of eight paintings [he actually did nine] and was inspired by an article written by David Hockney, in which he articulated an appreciation for Picasso's late work, specifically his *Artist and Model Series* of 1963. Markle had long admired the series but felt ill at ease with his admiration, as many art historians and critics harshly criticize this period of Picasso's oeuvre. The Hockney article [published in 1984] became a welcome and positive confirmation of Markle's initial feelings about Picasso's late work. Thus uninhibited, Markle embarked on what would become, in part, a homage to Picasso.

Podedworny goes on to point out significant distinctions between Robert's series and that of Picasso in that the Spanish painter "rarely presented himself as the artist" in these paintings, while Robert's self-image is prominent in all of his works. As well, "Picasso always created a 'place' for his figures, either in the studio or *en plein air*; Markle, however, generally leaves his figures floating in an anonymous field of colour."

What is perhaps most important is that Picasso's artist figure is "detached" from his model, while Robert-as-artist actively examines her. The power of his scrutiny, however, is undermined by the parodic essentialization of the Markle profile and by the fact that his close-up assessment of her body is often hilariously overdetermined. This is a long way from the artist as the "silent, introspective observer invisible to others" that Dennis Reid posits as the Markle position in relation to his earlier work.

In #*1* a little figure in a black T-shirt, brush in tiny hand, peers between the spread legs of a woman four times his size. He is wearing glasses to aid his vision, but her eyes are closed. His white face and hands are in sharp contrast to her brightly coloured body and the surrounding hues. This may be the brave artist valiantly approaching his subject in order to *see* her, and the brush may be phallic and meant to offer some protection, but he looks as if he'll be swallowed if he gets any closer. In #2 the artist, with a reddish tinge to his skin, peers over the knees of the white-skinned woman, unable to see her crotch that is turned away and hidden from him. If she knows he's there, she's not letting on, as her head is turned directly upward to the top of the frame. His mouth is slightly open as he strains to get a view of her breasts. His T-shirt is the same one that appears in all the paintings. He assumes a position of power in #*3*, looming over her body as she appears to offer her breast to him. But he is virtually cross-eyed from his close-range inspection of her pointed nipples. His head is oversized, as if to emphasize that he is thinking too hard about where he is and what he wants to see. Still above her in #*4* but farther away, he peers at her breasts but is surely distracted by the brilliant blue curve of her torso and left leg and the red glow of her right breast. His white hands are prominent, almost touching her, but give the impression they are cupped and moving as if he is trying to swim through the deep mauve background to get to her. If he can only get so close or too close, there are other ways to know her, so in #*5* one white profile with tiny puppet hands peers from the upper left side of the frame across her torso towards the V of her spread legs. But since he can't get the view he wants, his almost doppelgänger profile gazes

from the top right past her knee and directly into her pubic area, once again the hands "swimming" but this time as if to keep him in the same place. Two profiles are necessary again in *#6*, one white and relatively distant from the woman, one greyish and right above her breasts. Their lips are parted, those farther away in awe and those nearby in studious measurement of what is upthrust before them.

The position of the artist in relation to the woman is one thing, but relative proportion can be helpful too. In *#7* the artist's head is as large as the model's torso and head combined and she seems, for the first time, pinned by his gaze. His victory is deceptive, however, as her knee and calf are delivering a direct blow to the left side of his face, which perhaps explains his rather grim expression. The peaceful, upward-looking profile in the bottom right corner of *#8* appears to have his eye(s) shut and vision blocked by the black swath of paint on which the woman reclines. Yet she and this swath rest on him as well, and her arm and hand trail gently down as if to stroke his already serene face. In the final *#9* three profiles, mouths open, look down from across the top of the frame, as if there is strength in numbers. But one eye of the middle face is being poked by the long red nipple of the woman below, and the implication is that close proximity to any body part will result in the same kind of jab.

Non-profile pieces like *Some Golden Soil* and *Some Classical Greenery* were also included in the show, along with *Cushioned Corner*, in which the provocative suggestion of a pool game to be won by deftly sinking the eight ball between the V'ed legs of a reclining stripper-dancer, who bends to accommodate the task, conjures up a sexual exchange of shared talents and grace.

The artist's pursuit of his muse is playfully rendered in the *Artist and Model Series*, and what can be *heard* in these paintings is laughter. Robert still took his quest for the figure seriously, but from this point on he lightened the mood of his work by including some image of himself in virtually every one of his works, whether in acrylic, wood, metal, or lithograph, with the exception of public murals. Perhaps he could do so because he had been through a kind of refiner's fire during his split life between Niagara Street and the farmhouse and was appreciative of his survival. Perhaps it was because he felt, nearing the age of fifty years, that the sense of humour always central to his personal expression deserved a pivotal place in his art. Perhaps his muse told him to lighten up. Whatever the cause, his work had a greater range than previously in terms of medium and subject, and became more inclusive a portrait of what he saw and felt around him. This

inclusivity led him to accept a commission for the mural on an outside wall of Freiburger's Grocery Store in Mount Forest in 1986.

To make room for the expansion of the store, the owners had purchased five adjoining buildings on Main Street and, instead of having the usual plate-glass windows face the street, they built a 24.4-metre brick wall, behind which went the freezers. Their plan was to have a mural of old photographs of the facades of the original businesses on the street. Bill Koehler, the store manager, had long admired Robert's work and approached him to do the mural. After completing the preliminary drawings, Robert worked for two hot summer months in a relatively small space above the store with, as part of the agreement, plenty of free beer in stock. When the Flyers met him in the Mount Royal at the end of the day, he would complain about how hard his task was.

"You would swear to God he was working in a coal mine, he went on whining so," Tim Noonan recalls. "But he didn't get any sympathy from us."

Bill Koehler insists he knew from the start that whatever Robert painted "wouldn't just be storefronts." After all, he had planned to include the star-shaped emblem of a vanished jewellery store and do another section of the mural in a black-and-white homage to the old photographs of the buildings. But what he came up with overall was radically different from anything the owners or Bill Koehler had imagined. On ten 1.2-by-2.4-metre panels of treated crezone Robert painted a panorama of the Mount Forest area before European settlement, in its agricultural heyday, and as a developing town on a highway that led north to the waters of Georgian Bay. There were rivers and waterfalls, fields ripe with harvest, animal and bird life, all in vivid acrylics and supremely confident brushstrokes that, Robert said, portrayed "the idea of the passing of time, how it was in Mount Forest before man, how it is now, and man's responsibility to the future." It is interesting that the mural contains no reference to the Native peoples who gave the Saugeen its name.

When Robert was finished, the store held a grand opening on August 19 with wine and cheese on the checkout counters. Outside, the plastic garbage bags covering the mural were pulled down to the applause of more than a hundred spectators. Someone, probably a Flyer, shouted "Where's the nude?" and the party was under way. Robert had already combined business and art in his Markleangelo's pieces, and he told the *Durham Chronicle* that this Main Street painting was "an expression of a kind of acknowledgement of a corporate body like Freiburger's and its dealings and sense of responsibility to the community." He viewed what he had done as "a gift to Mount Forest and all the people who go by." In typical Markle fashion he added the caveat "whether they like it or not." In

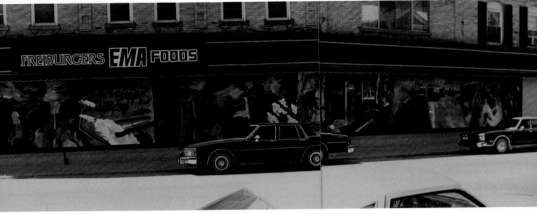

Freiburger's mural, Main Street, Mount Forest, Ontario, 1987

addition to a $3000 payment, he received a $1000 gift certificate for food, which delighted him as much as the free beer.

The mural remains a stunning work of art, but its impact has faded through the years as the acrylic colours have grown fainter through exposure to the elements, the Main Street traffic emissions, and the "passing of time" that is its very subject matter. Store employees washed it twice a year with soap and water until Bill Koehler's retirement in the early 1990s. After that Marlene did the cleaning and removed graffiti marks from the panels, but when she tried to touch up the colours she found she couldn't make Robert's marks. Gord Rayner told her they "couldn't be emulated."

"I learned to loosen up a little and stand back," she says, describing how she worked several hours a day for a week to restore some of the original brightness. Over twenty years after its inception, Marlene is not certain what will happen to the mural: "These things have a life and one day it won't be there." She has had many inquiries of concern about the loss of Robert's "gift" to the town and where the individual panels will end up. When the work disappears from the wall there will be a "big hole" on Main Street, not only because of the mural's historical representations but also because it embodies Robert's vision of and feelings for the community that, despite his long-time affiliation with Toronto, he unquestionably called home.

This unequivocal sense of his kinship to Mount Forest and the country around it was underlined one winter night in the mid-1980s. Stephen Williams's licence had been suspended for his driving under the influence. To get home he took a train to Guelph, an hour southeast of Mount Forest, and arranged for Robert to pick him up there. Since they planned

to go to a strip bar and have a few drinks, Robert paid a Mount Royal regular (though not a member of the Flyers' inner circle) to be their designated driver. This man had a few drinks as well, however, and after leaving the bar they found themselves weaving back and forth across the centre line as they drove north on Highway 6. Robert decided they should travel the rest of the way on the back roads he insisted he knew well, but when they turned off the highway, around 10:30 p.m., they quickly became lost. It began to snow heavily. As they drove slowly along looking for familiar signposts the conversation turned to a recent burglary at Stephen's house in which some china, an expensive duvet, and several pieces of furniture were stolen. To Stephen's and Robert's surprise, the driver announced that he knew who committed the robbery and went on to brag that he and his country pals did such things all the time. "We go in and help ourselves to city people's things." Robert's reaction was immediate:

"Stop the fucking car and get out!"

He himself then got behind the wheel and drove off with Stephen, leaving the man stranded on a concession road late at night in sub-zero temperatures. He would not have condoned any robbery, let alone one at the house of a close friend, but what offended him most was the rural–urban division between "us" and "them." He must have been affected too by his memory of the 1971 break-in at his and Marlene's first farmhouse, when so many personal items of his own were stolen.

In 1987 Robert did another outdoor mural, this time for the wall of a building in an Owen Sound parkette, which was commissioned by the city. Clearly influenced by his own creative foray into regional history and landscape, he designed a 2.4-by-8.5-metre acrylic-on-crezone painting about "family, recreation, the beauty of land and seascape, farm and harbour, rural and urban, all in a vibrant harmony." To the right of recognizable Owen Sound buildings and surrounding trees and fields at the base of the Bruce Peninsula he placed three large ships under full steam, and in the upper left of the scene, others—including the mayor and artists Harold Klunder and his wife, Catherine Carmichael—painted a group of multi-coloured children and adults floating in a deep-blue sky and looking down on familiar territory from a new perspective. Robert called the landscape in the mural "very Tom Thomsonish" and told the Owen Sound newspaper that the floating people had been used by Chagall and were "out of an old European tradition." Clearly Thomson was a painter he liked to compare himself to. When some of his work was shown at the Innuit Gallery in London, Ontario, in mid-1985, he provided a reporter with a maxim and illustration: "Every artist needs a central issue. My nudes

are like Tom Thomson's jack pines." But in the Owen Sound mural there is also a young-and-easy-under-the-apple-boughs quality to the figures' experience that summons up Dylan Thomas's imagery in *Fern Hill* before mortality intervenes. Like parts of Thomas's poem, the painting was a celebration of an innocence of vision tinged with the weight of experience that gave depth to the tribute.

The 1986–87 acrylic-on-paper and acrylic-on-masonite paintings continued with Robert's own image as a dominant motif, but the cultural context within which his gaze existed, along with his relation to the figure he watched, was often enlarged. From the first group shown at the Isaacs in June 1987, *The Elemental Icon* underlines the apparent power of the gaze and its ability to fix the figure by having the artist's profile *and* torso beneath the arched realistic body in dark-brown contrast to her pink-white flesh tones. The size of his presence adds to the sense of his ostensible strength. In *Newman Ornamental,* an homage piece to Barnett Newman with its distinct horizontal bands of colour, the two facing female forms, again more or less realistically portrayed, are balanced by a thin mask face in profile that is as tall as they are, its red skin bleeding into orange, blue, and brown off the edge of the left-hand frame to suggest its occupancy of unseen space. In *A Brutal Truth,* two highly expressionistic female figures seem engaged in sexual exchange. But is the brutality of their exchange to do with the act itself or perceptions of it? Long phallic shapes make up their bodies as if to emphasize a strong male perspective that is emphasized by the full-frame artist's profile on the left, with a raised index finger that might suggest a question but appears more likely to be directing the action.

Two other homage pieces, based on photographs of Marlene, interrogate the controlling strength of the male gaze. In *Excuse Me, Madame Bonnard* and *Marthe Again,* with their extremely bright palettes, the wife of the famous French artist luxuriates in a bath of blue-white water while the splayed fingers of the painter, who is shown in profile, seem to reach for the tub rim as if to get a necessary grip (in *Marthe Again,* the fingers are shown slightly closer). Madame Marthe Bonnard is very much in charge here, paying no attention to the artist's efforts, her head tilted back over the edge of the tub in the first painting and resting against it with her eyes closed in the other. In one other separate bathtub work, *Class Act II (Buffalo),* the head, arms, and breasts of the expressionist figure turn toward the artist's profile, but *her* gaze is directed above his head to something or someone beyond. His mouth is open and fingers raised as if about to ask her to wait, but she's already left him behind.

213

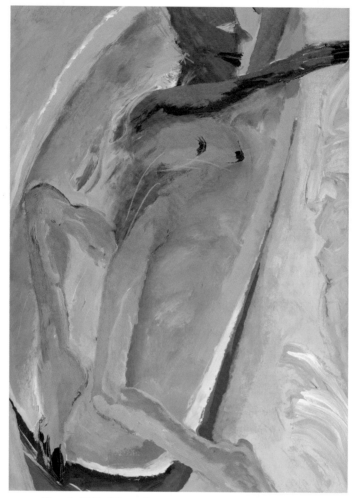

Class Act II (Buffalo), 1987 (acrylic on paper, 97.5 × 68.75 cm)
COLLECTION OF MARLENE MARKLE

How complex it gets for the artist onlooker is evident in work that would be included in The Artist and His Model: Markle since 1985, at the Thunder Bay Gallery. In *The Fine Line* his full head and shoulders are positioned in front of what appears to be the torso, breasts, and arms of a figure painted on a white canvas. He is pointing at her, his index finger touching her image, but it is not clear whether he has Pygmalion-like powers to make her come to life or whether she will evade his possession by remaining within the frame. In an untitled work a large profile along the entire left side of the painting has hands raised in contemplation

or supplication before a fragmented female body that could be coming together before his eyes but is more likely falling apart. This disintegration is strongly suggested by the presence of two other, smaller, artist profiles in the lower right of the frame that are not identical and are placed back to back, as if they do not know from where or how to look at the woman.

Perhaps a compromise between the strength of the woman and the creative onlooker is reached in three paintings in response to a 1983 novel about ancient Egypt by Norman Mailer. *Ancient Evenings I, II,* and *III* each contain female forms with a complete or partial horned head of a bull, a powerful combining of animal and human that calls up mythic images of the Egyptian god Anubis and of the Greek minotaur. In *I* the figure's legs are bent back impossibly and spread apart to allow the profiled face to peer with a smile directly into her crotch. The smile is not one of indulgent self-satisfaction but of pleased participation in a ritual exchange of intense beauty between gods and mortals. In *II* the figure's evocative colours and lines are viewed by the artist looking up from beneath her reclining figure with his right index finger touching her hand. In *III* this exchange seems to have led to an agreed-upon emergence of the woman from the guise of the god, as the horns are still present but the figure's facial profile—in addition to the rest of her body—is female. She floats across the top half of the frame, her right arm descending toward the bottom, her left arm extended with one finger pointing off the canvas to where her gaze is focused. The artist is beneath her, his long ponytail replicating her extended limbs and his own finger's action emulating hers. The mythic figure of the muse/model here announces her difference but is nonetheless aligned with the artist's need for and use of her.

The other notable homage painting is *Magritte's Forest*, which emphasizes the necessity of the artist to recognize that perspective has to do with position (not just physical) in relation to the muse. Along the entire left-hand frame a dark-brown bespectacled profile, hand raised and mouth open, looks at a "forest" of moving legs, his long nose touching the nearest one. *Within* the forest a yellow profile, similar in form, but more sharply defined and without glasses, his face partly obscuring a red leg, looks back at the figure outside. His mouth too is open, and the two profiles seem to be engaged in a dialogue that, if it is working, will not leave them hanging from individual trees, speaking of single bodies but voicing the infinite variety inherent in the female form.

By placing himself in paintings that he titles after famous artists, Robert stresses the tradition within which his originality works. The relationship between artist and muse is private and public, over and ongoing, in black

Magritte's Forest, 1987 (acrylic on board, 58.4 × 88.9 cm)
COLLECTION OF MARLENE MARKLE

and white and colour, possessive and obsessive to the point of ruling out possession, self-reflexive and a reflection of so many selves that its place in collective expression becomes paramount. As he grew older, Robert did, in crucial creative ways, grow wiser. It did not mean that every one of his works of art was a success. It did mean that he would explore and challenge the boundaries of his craft as never before.

In the early 1980s Robert had become friends with Otis Tamasauskas, a master printmaker who lived in Priceville, about twenty-five kilometres from the farmhouse, and, beginning in 1986–87, Robert regularly made the drive to Otis's studio to work on lithographs and etchings. Otis had been master printer and director of etching at Open Studio in Toronto and had taught printmaking at McMaster University and the University of Toronto. His work had appeared in solo shows across Ontario and in group exhibitions in the U.S. and England. Robert had a great deal of respect for what Otis could teach him, and he loved handling the old lithographic stones with their images of history embedded in them. Gordon Hatt, then director of the Durham Art Gallery, proposed to the Ontario Arts Council that a film be made about their friendship and joint creative

Robert, Otis Tamasauskas, and Harold Klunder at Otis's studio, 1987,
in a still from *Priceville Prints*
COURTESY JOHN VAINSTEIN

efforts. The OAC agreed, and Hatt secured filmmaker John Vainstein
to direct the production, which would be called *Priceville Prints*. He also
brought in Harold Klunder, who was living in nearby Flesherton, to make
up a trio of artists. Over several days in May 1987 Vainstein filmed Robert,
Harold, and Otis collaboratively making art in the studio with its old
hand-wheel presses, which Robert said could produce great pizza dough.

The opening shot of the film has Robert driving into Priceville in his
red Ford truck, without a seatbelt, while the soundtrack plays a country
song. He is wearing his green Red Man Chewing Tobacco hat, black jeans,
and a denim jacket over his black T-shirt. His grey-brown ponytail hangs
down his back almost to his waist as he lays his jacket aside and gets down
to work in the studio. A Dürer etching is glimpsed on the screen as Robert
brushes a stone's surface with a greasy black liquid (*tusche*) and then
draws on it with a litho crayon, working in the tradition of Daumier and
Toulouse-Lautrec. He is shown engrossed in the intricate process that
ensues once he has completed his figure image. Vainstein's editing omits
some of the steps, but Robert would have watched Otis rub resin and talc
onto the stone, brush on nitric acid diluted with gum Arabic to make the
image grease-receptive, buff the stone with cheesecloth, apply turpentine
to wash out the image, and leave a ghost of the original drawing in the
stone that ink adheres to. He would have seen Otis dampen the stone and
roll it initially with blue and red inks that stuck to the ghost image and
then place a sheet of paper over the stone and wind it through the press.

Robert views it all as an "exquisitely complicated process that allows us to keep the original [creative] drive" and compares the choices he can make with regard to colours and the "finishing" of the image to a "restaurant with a huge goddamn menu." But he is most fascinated with the "weird tie-in" between his own image and all the images that have ever appeared on this particular stone. Later, as Robert works on an etching, Harold Klunder's creation of a lithograph unfolds from start to finish. Some attention is then given to the etching process, with onscreen subtitles providing explanation. The camera throughout is unobtrusive, and the three colleagues move comfortably through the crowded studio, intent on their respective tasks but communicative about them. The entire film is only twenty-two minutes in length, and Robert is visible and audible for probably half that time, but here is the only recorded view of him creating his art rather than simply talking about it as he did in *Cowboy and Indian* or *This Hour Has Seven Days*.

Sitting on the porch during a lunch break, he, Otis, and Harold reflect on who they are in relation to what they do. Harold says that the fact that's he's of Dutch origin doesn't make any difference to his art, just as if he were a woman it wouldn't make any difference. Robert, having dealt his entire career with the complexities and implications of female distinctiveness, immediately replies, "You don't know that, about the woman part of it." He then playfully interrogates his own identity: "I don't like being outside, so what kind of Indian am I? I don't even eat fish." But he knew, of course, how his Native heritage had shaped him. He tells his friends how "exhilarating" it is to have deep conversations about art, but that "ultimately what I like is the celebration of the fact that it's being done, good or bad, and someone else is trying to understand … it keeps the river flowing."

Apparently what Vainstein had done with his film was a vital part of that river. In 1988 *Priceville Prints* won a Silver Apple Award at the National Educational Film and Video Festival in Oakland, California. In the film's closing scene Robert and Harold share a stone and do a collaborative drawing with the ink left over "to mark the occasion." Robert's final words interfere with any profound conclusions: "Don't look for *The Last Supper* here. I don't think it's going to happen."

Robert completed over two dozen lithographs and etchings over the next year. Most of them he left untitled, except for those he called *Table Dance*, *Table Dancer 2*, and *The Kolbassa Kid at the London Forum*. In these and almost every other work done at Otis's studio his profile considers the woman. As he made the drive to Priceville, he never took his eyes off her. His interaction with the female figure had always been a moveable feast.

Robert in Otis Tamasauskas's studio, 1987

In the mid- to late 1980s, much of Robert and Marlene's attention was given to their growing collection of rather crudely carved action figures or whirligigs that included men sawing or chopping wood or milking cows, their movements controlled by intricate gears and metal rod connections: an Indian chief in full headdress paddling a canoe, a washerwoman at a tub, a woman churning butter. Just how focused Robert had become in collecting this folk art material since he and Marlene had first begun to attend antique shows and auctions was emphasized in 1985, when he traded *The Glamour Sisters* for some carvings of dentist action figures (a roughly $500 exchange) and that same year sold $1700 worth of paintings in return for folk material he found at a local antiques store. After Robert's death, Marlene would lend forty-nine of their whirligigs to the Dufferin County Museum and Archives, at the corner of Highway 89

Creation Whirligig, 1988 (acrylic and wood, 123 × 94 × 157 cm)
COLLECTION THUNDER BAY ART GALLERY / PRIVATE DONATION / IMAGE TAKEN FROM SLIDE

and Airport Road, for a year-long show. Later she donated most of them to the museum.

In 1986, Robert began to experiment with abstract forms in sculptured steel, foamcore, and wood, and then created two plywood folk carvings containing three of his own profiles (as usual, not replications of one another). In one, these profiles look at a series of cartoon-like faces that form the base and, in another, at eight painted dancer-strippers surrounded by stars and the announcement "GIRLS." These are limited whirligigs in which only his profiles are designed to turn in the wind, but soon he made a more complex version of these originals in which, above an independent base and below his turning profiles, the girls in acrobatic poses revolve as well. He also placed an additional profile on a level with different parts of their anatomy. These and various maquettes he made for other carved figures, moving and otherwise, remained untitled over the next year, but in 1988 he created a number of memorable, named whirligigs that spoke more profoundly to his lifelong relationship with his muse and that first appeared publicly in the 1989 show at the Thunder Bay Art Gallery.

In *Acrobat*, a 1.5-metre female figure formed from polychromed wood balances upside down as a hook-nosed, ponytailed profile turns around

her. What is intriguing, along with what seems to be the independent movement of each figure, is the snake-like form that curls around her arm and out away from the sculpture and is redolent of the stripper with her boa. From certain angles his ponytail seems to replicate this sinuous motion, but from others the serpent appears to be part of the woman's act and threatening to the artist. This snake motif is further developed in *Serpentine Art*, an even larger, multicoloured carving, in which the artist's presence is conveyed in startling fashion. There is no profile, only a snake curling beside and around parts of the woman's body, its open mouth right above her face with an orange-tipped paintbrush protruding. One primary interpretation is that the serpent is painting/creating her, but she is so serene, lying back with her eyes closed and apparently unperturbed by the snake's gesture, that its phallic efforts might well go unnoticed. If it is difficult to tell the dancer from the dance, it is more difficult to know who is calling the tune. Robert's attention to the complex relationship between the artist and the artist model is amplified in a horizontal whirligig called *Artist with Model and Mentors.* Here his large profile, brush in hand and cheeks seemingly puffed from exertion, pursues a female figure far in front of him and visible through a window-like frame. Another woman, with a noticeable resemblance to Marlene, is slightly behind him, her right breast touching the end of his extended ponytail. She is emerging from a group of male profiles that belong to Gord Rayner, Graham Coughtry, Toulouse-Lautrec, Bonnard, and Picasso. The pursuit is endless as each figure is on an independent base and turns every which way at the wind's whim.

By titling one of his whirligigs *Creation* and designing it the way he did, Robert went to the heart of the intricate interchange between himself and the woman-muse figure in his art. She is a reclining nude with the artist profile and upper torso between her legs, flame-tipped brush in hand. Two other profiles, not exactly the same, are behind her, turning on their own independent bases. She rests on flames whose colours partially replicate the tip of the artist's brush, while he sits, stands (or kneels?) in what seem to be puffy blue clouds. A coming together of the sacred and profane is certainly suggested, an interpretation augmented by Marjorie Stone's questions about the brush as candle: "Is [it] held up to illuminate the dark interspaces of female otherness? Or as a votive offering to the creative powers of the goddess reclined?" After all, Stone points out, it is not the artist who moves the female body but the wind. The resulting response to this whirligig is a "dialogue or polylogue about gender" rather than independent, essentialist statements from artist and audience.

What complicates the approach of the male figure to the woman is the painted circle shape attached to his back that is highly suggestive of the bustle of eagle, hawk, or turkey feathers that some Native American dancers wear in celebration of their traditions. Iroquois cultural tradition is matrilineal, with women viewed as the connection to the earth from whom men gain energy and courage. In Robert's circle is an image of what appears to be a chief in full headdress. Under Haudenosaunee law female members of the Confederacy hold positions of influence and respect and have the power to remove offending chiefs. So the artist can be seen as dancing before the female figure in homage to her, and the vertical pieces of flame on which she rests could well be strands of growth supporting the earth goddess.

"Imagine the whirligig shifting its shape before you in the wind. View it from the other side, another angle," Stone writes. "Try, impossible endeavour though it may be, to follow it into the crucible of another mind to find what it en/genders there. The polylogue is under way and the questions multiply."

This is art at its most provocative and demanding, and yet some critics unfortunately failed to deal with its possibilities, presenting instead a primitive monologue lacking in cultural or intellectual perception. Writing in *The Globe and Mail* in 2003, Sarah Milroy dismissed *Creation* as "rubbish, the female muse in his work as a "creature without agency, a feral demi-human," and Robert himself as "a slobbering dinosaur from the swamps of misogyny." Peter Goddard countered archly, "If it's trash, it's *great* trash." Milroy, in her forties at the time, strangely claimed to be a "wind-dried, first-generation feminist," which appears to have been the basis for her response to Robert's work. She is best answered by Stone's appraisal of *Spadina Cut-out,* in which the G-stringed figure seems to be flying with serpents as smiling companions rather than any kind of threat. Stone, in her late fifties and a professor of women's studies, calls herself "barely second-generation," but she knows her feminist history and the place of female imagery in it:

> It says something about the complexity of Markle's play
> with female iconography that *Spadina Cut-out* would
> not seem out of place in the entry hall to an Institute of
> Women's Studies…. Works like [this] also suggest the
> affinities between the potent nudes in Markle's work and
> the resurgence of goddess iconography that has been such a
> notable consequence of the Seventies and Eighties women's

movement. The nineteenth-century women's movement was
accompanied by a similar fascination with figures of the
goddess … typically cast as demonic, thus reflecting male
fears of women's empowerment. There are many parallels
between the 1890s and the 1990s … and we do not have
to look far to find demonic images of women in popular
culture today. Yet Markle's potent nudes are empowered
manifestations of the female that are celebratory rather than
sinister. They reflect fascination, not fear.

What is perhaps most evident in the whirligigs is that Robert discovered
ways to involve his viewers directly in the movement of his figures, to offer
them a palpable sense of the traces left behind after the wind has brushed
against a breast or thigh. The invitation to observers is not to remain
static but to move around the carvings as the women and artist change
like those Native shape-shifters who left their familiar bodies behind to
assume new perspectives.

In 1988 Robert painted a number of artist-profiles with the muse that are
memorable not only for the actions of the figures but for the implications
of the titles he gave them. In *The Visit* a smiling, conically breasted woman
in bright skin tones descends from the top of the frame to come almost
nose to nose with the black-hued man as if to say, "Here I am, what are you
going to do now?" The man's shape is altered by the woman's presence—
languid in *Wilderness* and energetic in *Waterloo One-Step*. In the former
work his profile is cartoon-like and its yellow-orange colour doesn't lend
it a serious air. His mouth is agape and his fingers spread as if jerked
open. She rests above a blue lake-like form, her head touching a forest
outline, and the question is, Whose wilderness is it—hers in which he
finds her or his in which he is lost? In the Waterloo strip bar the artist's
profile rather than any part of the dancer's body is bent impossibly back
to view her from beneath. Her high-heeled shoes are centimetres from his
squashed face. Is he one step away from the attainment he seeks or is she
one step from obliterating his desire? *The Muse Home for the Holidays* shows
a recognizable Marlene figure, full-breasted and standing in thigh-deep
water behind a figure submerged to the chest who appears to be wearing
a Native headband. Both figures gaze serenely into the same distance
as if those involved in the creative process are taking a break for a long
weekend or some celebratory occasion.

But it is *Persephone* that stands out among these works. Here two Markle-
like profiles in the middle of the canvas, beers in hand, stare, from their

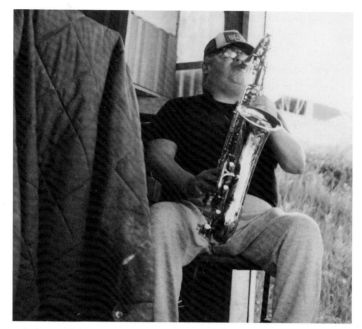

Robert with his Selmer Mark VII saxophone, near Mount Forest, 1988

respective positions, at the breasts and crotch of a white, spread-eagled figure before them whose hand is clutching her crotch (the expression on her face indicates the pleasure gained). From her far side another profile looks at her neck. On the right-hand side of the canvas a head-to-toe Markle figure twists around from his table (beer also in hand) to make his own grab at the crotch of the nude dancer/waitress. The painting's title contextualizes everything. In classical Greek myth, Persephone was Queen of the Underworld, who sometimes carried a sheaf of grain, but she was also Queen of the Dead, who promised acolytes immortality beneath the earth and her frightful gaze. Some modern mythologers, influenced by Frazer's *The Golden Bough*, see her as a life-death-rebirth goddess. Robert has created another polylogue piece that asks questions about the fate of the three males who exist in relation to the power of the white-skinned woman who holds their gaze, and about the desperate efforts of the twisting male whose wide-open mouth may represent his last gasp for air. Is it a frozen tableau of the doomed or one stage in a process of renewal suggested by the creative vision of the perceiver outside the deity's frame?

Aspects of contemporary cultural myth are addressed in three related paintings shown at Thunder Bay—*Jazz Licks* (1988), *Jazz Licks* (1989), and

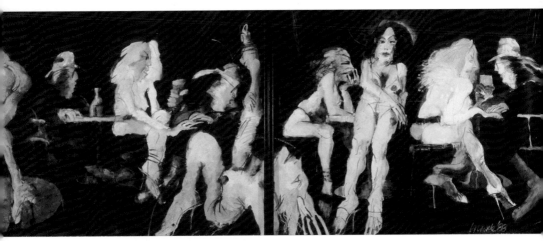

Hanover Hustle, 1988 (diptych; acrylic and pastel on paper;
left panel 120.2 × 149.2 cm, right panel 120.6 × 149.4 cm)
COLLECTION ART GALLERY OF ONTARIO / GIFT OF MARLENE MARKLE, 2001

Jazz Lover (1989) (see page 82). In the first, an entirely black wraithlike
saxophone player stretches across the top half of the canvas and over a
reclining female figure whose conical breasts reach up toward the bell
of the horn. All the curving rhythmic lines that escape her human
form imply she is her own instrument, despite the power of his startling
presence. In the second work a more realistically portrayed sax player and
his horn are beneath the wide-open legs of the woman. The bell of the
horn is either pouring music up into her crotch or receiving music from
there. The enormous energy of both figures suggests the encounter is a
standoff. In *Jazz Lover* the heads and black-garbed torsos of two musicians
(as always, Robert but not Robert) play on either side of a nude who is
sitting comfortably in a wooden chair that does not promise comfort. The
sax player on the left seems locked into his music, while the piano player
on the right has turned away from his instrument to say something to the
woman. What unites this trio is not only the equal space given to each in
the frame but also the two sets of long fingers with which the musicians
play, the fingers of one of her hands resting against the digit-like wooden
slats of the chair, and the elongated white and black piano keys that are
the colour of her skin and the men's T-shirts.

Always Robert was concerned with what he could do with what was
at hand, which included, among other things, his small-town strip-club
experience and his knowledge of art history. Describing his efforts in his
large black-and-white diptych *Hanover Hustle*, he quoted Ingres ("Drawing

is the Integrity of Art") and Matisse ("drawing is the cardinal discipline through which the Artist can gain possession of his subject"). The painting shows Robert in profile (in one case his entire body) in animated discussion with, or simply observing, a bevy of strippers whose bodies gyrate, rest easy on stools, or lean casually against the bar. In his notes he joined his subject matter and the creative process as he had rarely done before about a specific work:

> 'Hanover Hustle' is the attempt to gain possession of
> the often dreary, sometimes surprising *demi-monde* that
> once sat safely and mysteriously at the outer edge of our
> societies, a periphery of dubious intent that now invades
> the most bucolic of settings. Raucous bars and taverns, full
> of wonder and waste, nightmare and fantasy, now spot the
> once calm, sun-baked mainstreets of small town Ontario;
> third generation proprietors of these historically necessary
> watering holes now, in this pervasive age of economic
> purgatories and the rampant unearned climax, turn to
> the flesh of the night for the big score. This is the stuff of
> drawing. The moving image, the immediate gesture frozen,
> made permanent. You see things that knock your socks off,
> and you *get it down*. The smoky blacks separate for the errant
> light, the defining line, the blurred caress. Black and white.
> Wash. Scratches. Light as an intruding truth, laying bare
> small secrets: the gleam and shine of the stiletto heel, the
> sweet mist of the feather boa (the uniform of the hustle),
> light forming flesh, angels of the hazy night. Drawing is the
> first draft, the first sip of the world around you, and drawing
> is the final mark.

If *Hanover Hustle* is a homage to the miraculous grit of that demimonde, there were in 1988 other tributes to be paid, chief among them paintings of four of his closest friends in what he called the *Conversation Series*, also in the Thunder Bay show. The two painters, Gord Rayner and Graham Coughtry, were treated somewhat differently from the two "civilians," Michael Sarrazin and Patrick Watson, who were artists in other media. The very identifiable actor in profile faces a barely recognizable Robert in profile across a table with two beer glasses in place. Michael's hands are clasped in front of him, and Robert is either reaching for his glass or gesturing toward his friend (it was possible for him to do both at once).

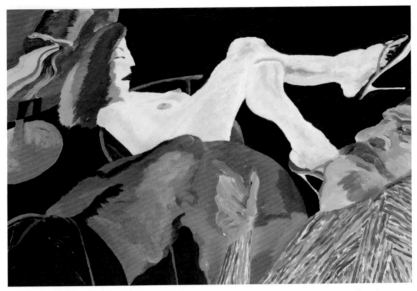

Conversation Series (Gordon Rayner), 1988 (acrylic on board, 76.2 × 111.8 cm)
COLLECTION OF RUTH GROGAN

An intense exchange is suggested by their unsmiling expressions. Between their faces, but not blocking their view of one another, are the bent thighs and calves of a high-buttocked, stiletto-heeled nude who just happens to be floating by. Neither man pays any attention to this figure, but she is *there* to shape whatever words they are saying. From the upper left side of the canvas and behind Michael the artist's profile looks down at her and them, either the director of the scene or a "best boy" there to refill their glasses. When he first saw this painting, Michael told Robert he never held his hands like that, and Robert assured him he did. "And he was right," Michael admits.

Patrick Watson, with his grey hair streaming, sits staring intently over the rims of his glasses at a nude beside him. She is bathed in a red glow, like the light fixture that says "On Air," and seems completely relaxed despite that she is seated on the requisite thin-slatted farmhouse chair. If this is an interview, she might well be the one asking the questions. On Patrick's right a dark Markle profile whispers in his ear as if to advise him to say something before she takes over completely. Her naked body has, of course, already taken over to a great extent. If this painting had a soundtrack, Robert's glee would be audible.

There are no Markle profiles in the paintings of Gord and Graham. If Robert had tried to impose them, the painters would have naturally

asked where *their* profiles were. Instead, Gord leans back confidently, even arrogantly, his gesturing finger mere centimetres from Robert's forehead, which is inclined toward him. As if to emphasize the intimacy of their give-and-take and their relationship with the white-skinned Marlene-like nude behind them, Gord's gaping right nostril stands in for the examining eye of the absent profile. Or is Robert's vision found in the woman's perfectly formed, pupil-shaped nipples? She leans back, eyes closed, legs crossed, and on another plane of perception entirely. This is Robert's painting, so the figure is of course paramount, and if Gord, still loyal to design and topography, is pronouncing on her death, one of her stiletto heels is kicking him right in the chin.

In the remaining conversation piece, a long Pavlychenko-like nude lies stretched across the top of the canvas above the two men. Robert, on the right, leans forward, one hand raised forcefully and speaks to his friend. Wearing a form of striped Spanish serape and holding a cigarette in one raised hand, Graham bows his head gracefully in acceptance of the moment. The cigarette enters the nude's space like the orange-tipped brush or candle in the *Creation* whirligig, and there is a strong sense of Robert's garrulity in creative accord with Graham's relative reserve.

His strong relationships with these four men prompted the paintings, and it is interesting to speculate whether Robert, had he lived, would have returned to the conversation concept and portrayed other figures of influence such as Sonny Rollins and Lester Young, Picasso and Bonnard, Kawabata, and perhaps Deganawida. Over the next two years, however, he turned much of his inventive attention to what was even closer to him—his daily life with Marlene in the farmhouse and surrounding landscape.

The artist can't always be "on," and neither can the muse. There are days when they are simply a regular couple together, sharing conjugal space and small delights. In his three *Domesticity* pieces from 1989 and 1990, Robert plays with the mundane, eroticizing the everyday nature of experience while emphasizing that stability at home can sometimes provide a greater charge than the sexual frisson of the strip club. In *Domesticity I* (see page 118), the most accomplished of these three works, the red-skinned artist, once more in profile, lies in bed beside his paler partner. She seems to be asleep, with her eyes closed and her head turned away from him, while he, on his side, is preoccupied with what's on the colour television (painted in grey) a short distance away. Formally this is a wonderfully conceived painting with many intersecting horizontal and

vertical lines working to keep the couple in the slightly tilted bed. The top of the angled iron headboard runs beneath the window sill and above the similar lines of the pillow tops, the blanket's upper border, and the intersection of the floor and wall. These are met, if not always on the same plane, by the patterned floor and quilt designs and the contours of television, dresser, and bed. Her breasts are provocatively displayed, her large nipples peeking over the edge of the blanket and matched by the orange-yellow metal tips of the bedposts. Can they be the same breasts that will light up another painting with sexual energy? Is this the same artist who has shown himself in virtually every one of his paintings over the past four years looking *at* the naked muse, unable to turn away? The answer is yes, it's just that we are viewing an aspect of his existence that normally exists outside the painter's frame yet constantly supports it as a kind of easel of the ordinary. The work could well have been titled *At Home in Their Own Skins*, because that combination of the room as accepted abode and the body as uncomplicated dwelling place is what is warmly portrayed. Even so, the artist and the muse are but briefly at rest. A section of the back wall visible between the bed and the dresser looks much like a rough canvas awaiting the brush stroke and the move *on*, not back, into depths of the creative process that would be unattainable without this acknowledgement of life supposedly closer to the surface.

What takes place when the television is turned off is love-making that demands a shedding of roles and an embrace of shared pleasure unadulterated by artist-muse perspectives. This is indicated in *A Likeness of Being* by the couple on the same farmhouse bed joined in carnal celebration of their human partnership, his face hidden behind her upraised right leg that is in line and position matched exactly by his right leg below. The literal point of their sexual union occurs at the V of their left legs that, but for contrasting skin tones, might belong to the same body. And these skin tones—his brown, hers white—emphasize the gap that is closed when two individuals become one. His hand and outstretched fingers, so prominent in their directorial or interrogative gestures in the various artist and model paintings, are *at rest* on her ribcage just beneath her breast and immediately over her heart.

In a related domestic scene, *Rooms: The Dish*, the artist and his nude partner sit side by side at the kitchen table with the farmhouse kitchen spread out before them. The loving attention Robert gives to the material details of their existence recalls the affectionate portrait in words he provided of his Hamilton boyhood house in his 1977 essay about Christmas there. He could not go back to Adeline Avenue with the image of

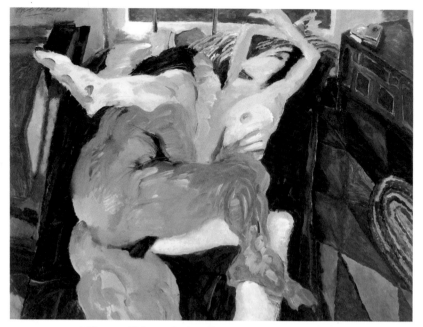

A Likeness of Being, 1989 (acrylic on masonite, 90 × 120 cm)
COLLECTION OF MARLENE MARKLE; IMAGE TAKEN FROM SLIDE

the naked woman who accompanied him everywhere, and he certainly couldn't place her in his mother's kitchen. But in this painting he has the best of both worlds, as the past comes alive in the form of the antiques that line the walls and cupboards, and the present is vitally realized in the articles of clothing by the open door and the food on the stove and table. The milk-glass hens are on their dish-nests, a whirligig hangs in the window with another atop a pine hutch, and an oversized container of ripe fruit (not so surprisingly breast-like in shape) occupies a large part of the space between the two figures and in front of a large blue dish containing a newspaper and placemats. His finger is on the television remote, and he has either just tuned in to or is about to tune out a reclining nude in the rectangular frame. The vision is always there, but right now the art station is just one of many channels. The title of this painting can refer to any or all of the blue dish, the breast-shaped container, the china and glass in the hutch, the circular satellite receiver outside that allows him to select programs, and the female "dish" beside him whose buttons he could not push even if he wanted to. There is texture and variety to the forms and colours in this work that reflect the quality and range of lived experience displayed.

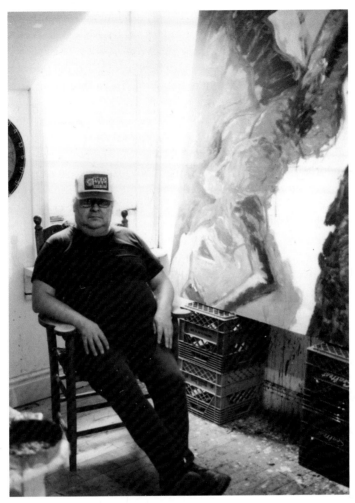

Robert in the farmhouse studio, May 1990

In the painting *Rooms: West Wall* (see page 240), completed just a few months before his death, Robert revealed his most developed glimpse of the extraordinary in the ordinary in a kind of folk-art tableau. In the left-hand section, a nude Marlene and black-clad Robert sit on opposite sides of the kitchen table, both pairs of legs crossed, her feet in high heels and his resting comfortably on a little mat. If you had first seen *Rooms: The Dish*, you know that they are watching the television beyond the frame to their left. Once again, everything is in its domestic place, including the painting that hangs above a small dish-lined hutch and is mirrored in the glass door of the microwave opposite. In the foreground of the middle panel,

Marlene lies back, Madame Bonnard–like, in a blue tub of water reading a book. In the background, pants around his ankles, Robert sits on the toilet doing the same and something more elemental besides. This is both a time out and a time in, signified by her high heels resting on the floor between them and the intricate attention to detail that the seated figure would see in his mind's eye if he were not otherwise occupied—little pictures on the wall, a bamboo curtain on the window, a small radio playing jazz or country tunes on a stool beside the bath, its cord running out to a plug in the kitchen. In the right-hand panel, Robert, in the bedroom, lies on his side watching television. His stockinged foot protrudes from the blanket to emphasize, along with the snowflakes falling outside the windows, that it must be cold for the partially clad, high-heeled Marlene crawling toward him from the bottom of the bed. The propellers of the whirligig high on the left wall are partnered by the windmill blades of the carving across the room that itself has a circular quality as if it is constantly turning on an axis of possibility. The rotational force will keep her moving endlessly in place and the work of art always in flux. Herbert Read could well have been looking at *Rooms: West Wall* when he wrote, "It is only when the widest commonplace is fused with the intensest passion that a great work of art ... is born." Perhaps as his vision of deceptively small space and routine experience merged with the traditionally larger issue of the dancer and the dance, Robert came as close as he ever would to a way of seeing that revealed, if not everything, then at least what mattered most.

Of course he wasn't finished with the undomesticated muse, and in *Country Twang* (see page 196) he places her naked whiteness in the front seat of a car beside the dark-skinned artist as he looks through the windshield in startled awe at a cloud-lit horizon line stretching into some inconceivable distance. Has the older artist realized there's more to existence than a focus on breasts and pudenda? Will he be able to take his eyes off what's "out there"? The muse-figure, one stiletto heel resting on the dashboard, breasts turned towards him, waits rather impatiently for the visionary to come back to earth and the back seat of art to take precedence. Michael Snow says of this work, "Part of its accomplishment is that it's painting and not just some form of fantasy. The kinds of shapes like the car window [provide] a formal unity that's more than the fantasy of being in a car with a stripper." Snow is simply confirming that anyone confusing Robert's dancer-stripper, wife-muse, artist model with a purely objectified figure would misunderstand his art entirely. It always was about the integrity of the painting, and he knew, better than anyone else, that he couldn't realize that integrity without *her* independence and power, *her* honesty as willing

subject. Peter Goddard says emphatically that *Country Twang* has "greatness all over it. It opens up your conception to who Markle is" and purposefully cuts against the usual white-guy ownership of country culture.

His last series of paintings was of table dancers working hard at their trade with him as active or passive observer of artful contortions. For the most part, these works are not particularly complex, lacking the ironies of *Country Twang* or the memorable details of the domestic paintings. In three of them, however, Robert showed he had not abandoned his long-held principle of the figure as starting point for the exploration of ideas and feelings. For then-curator Anna Hudson, this beginning again at the end of his life was bound up with his Native heritage. In the last work on his easel (see page 2), "His dark-haired, long-legged woman sits sidesaddle on a four-legged beast. The horizon burns red and she turns to look at a circle of yellow light fixed by her left hand. The beast and circle appear here as symbols.… a short stroke of red pigment across the perimeter of the yellow circle strikes it like a stick. This goddess beats a drum and recalls the tradition of Aboriginal drummers, men who play to the rhythm of their mother's heart."

This circle is repeated in another piece in which a slightly more realistic and high-heeled figure lies back with one arm and hand resting on an artist's round palette of colours that with its feathered internal shapes resembles a dream catcher, the Haudenosaunee symbol that either caught bad dreams in its web and let good ones fly free into the universe or kept the good ones close to the dreamer and let the bad ones dissipate. Clearly this symbol had significance for Robert, as it appears in yet another work in which the woman reaches back for something with one hand while with the other she grasps a red circle with trailing streamers that once again suggest the dream catcher. But these paintings remain incomplete, partly because he was not ready to title any of them and thereby provide some direct or metaphorical insight as to their meaning. That Native concerns were on his mind during this period is revealed in his visit to the Six Nations Reserve near Brantford and his conversations there with Tom Hill, the director of the Woodland Cultural Centre.

Tom Hill, a Mohawk from Six Nations, was seven years younger than Robert but had heard of him by the time he attended OCA in the early 1960s and during his subsequent employment at the National Gallery of Canada in Ottawa. He "suspected Robert was Native because … his [early] drawings, although not directly reflecting Indianness, kind of reflected an Indian approach." There is no female trickster in Iroquois culture, but in Robert's drawings of women Tom saw figures with a sense of humour

and a laughing or floating trickster quality as found in the lore of other tribes. When he went to work for the Department of Indian Affairs in the 1970s, a colleague was putting together files on Native artists who had answered department questions such as "Where did you learn to paint, and who were your role models?" Nothing Robert had written revealed his Native background in any way, so Tom's colleague wrote in a report that Robert "wasn't interested in his Indianness." Eventually Tom became secretary to the cultural director of Indian Affairs and was involved in the grants program and the shaping of a national Native art collection.

In 1972 or 1973 he introduced himself to Robert, who was holding court at Club 22 with Michael Sarrazin and others. He remembers that Robert seemed "taken aback" by his comment on Native connections in his work, but the camaraderie and loud talk quickly took over as Tom walked away from the table. Over the next few years Tom got to know Av Isaacs and, as a result, kept in touch with Robert's work. He recalls being "floored" by his Markleangelo's figures "coming down on you ... their hands almost scooping up your pasta.... I thought, this guy has really made it." But he also believed "whatever trauma [Robert] may have had growing up Native, he chose to escape and isolate that by totally changing his personality. I didn't want to intrude." This response to Robert's aggressive public persona is remarkably similar to that of Patricia Beatty, who felt he was "tragic as a Native figure trying to be like the white man" and that his going to the Six Nations late in his life was "an important part of his moving beyond his persona to a kind of peace." Native theorist Gerald Vizenor provides a more nuanced view of Robert's public persona when he refers to "an active, ironic distance to dominance" taken by some Natives in their resistance to non-Native perceptions of the "imaginary Indian."

The Six Nations visit occurred in 1989 because Patrick Watson wanted Robert to write a piece on the Iroquois Confederacy for his *Heritage Minutes* series, and brought him to the Woodland Cultural Centre to learn about Deganawida and the Tree of Peace. Tom didn't think of Robert as a writer and thought it "a bit ridiculous" that he would be considered for the job. But when Robert arrived and began asking informed, probing questions about Iroquois history and tradition, Tom became "moved and excited by his different personality." Lunch lasted all afternoon as Robert sought to understand the role of individuals and communities within the Confederacy. He also talked to Tom about his background, about his father and brother in high steel, and how he hadn't known he was Native until he was a teenager. When Tom revealed that the Indian Affairs report back in the 1970s made mention of his indifference to his Indianness,

Robert was "shocked." It was clear that "he was in search of something more" than just the knowledge necessary for the television program, and he responded enthusiastically when Tom suggested he come back and learn about the longhouse. That second visit never took place, but Tom speaks movingly of the Mohawk belief that after your death your spirit stays for ten days with those who knew you, then leaves, and after a year briefly returns. In the summer of 1991, Tom felt Robert's presence "for a fleeting second," and remembered that when they'd met on the reserve Robert had pointed to the black thick-rimmed glasses they both wore and proclaimed, "Hey, we're brothers."

"Yes, we are," Tom replied simply.

After the 1969 motorcycle accident Robert regained the use of his hands and fingers, and for a brief period in the mid-'70s the rest of his body was, relatively speaking, in peak condition due to his diet and exercise regimen. But as time passed and his drinking stayed steady, his problems with blood pressure and blinding headaches became more evident. In the late 1980s, "everything was going into his art," and there wasn't much left after a day's work, yet something in him must have remembered his advice to Stephen Williams years before about the need for hobbies. He saw a television program about a classical pianist who, to offset the demands of endless touring and concerts, kept himself sane with some dry fly-fishing. Robert became fascinated with the process of flicking out a line to land the fly in a precise spot, as all sorts of things worked against success—wind, sun, overhanging branches. It was akin to the painter's gesture with the brush and the mark made against all odds on paper or canvas. He bought all the necessary gear—rod, reel, line, chest waders—and stood in his driveway practising "the flick" "more or less successfully." One of the Mount Royal crew made flies for him, and when Robert saw the hook and iridescent feathers dancing for the fish in the ripples of the Saugeen River he might have been reminded of those onlookers who believed in the reality of the stripper's fantasy lure. Once, Marlene says, he even got a fish on the line and was surprised at how heavy it felt, like a puck on his hockey stick. So taken with the experience was he that he wrote his first magazine article in twelve years. "Hooked" appeared in *Toronto Life* in April 1989.

In this comical but carefully constructed portrait of the artist as fly fisherman. Robert first of all addresses, from a slight angle, the toll his health and hard work were taking on him: "At some point, all creative people confront their inability to create a leisure time for themselves, a time outside the demands of their art." Having watched the show about

the pianist relaxing, rod in hand, in the river, he thought, "Gee, I should do something like that. I'm feeling kind of burned out myself." Although he doesn't mention his Native ancestry, he parodies his lifelong distance from the outdoors, much the way he did in *Priceville Prints*, though he goes even further in satirizing his room-service mentality and physical limitations: "Now, I'm not your outdoorsy type. I don't fish, never have. In fact I don't even like eating the stuff unless it's completely covered with crisp batter and is lying beside one hell of a mess of French fries.... So shunting aside my from-the-city, long-haired, knee-jerk liberalism, I consider the ecstasies of solitary contemplation in the midst of rippling waters and the buzzings of forest folk, nature's splendor catching the bits of fur and feather tethered to a swaying graphite pole.... And I like the fact that I don't have to touch worms with my bare fingers."

In preparation for his river journey, he reads plenty of fly-fishing literature and practises his cast assiduously. "I had pretty well caught every pebble of any significance in that unyielding driveway." As he later guides his Jeep down narrow sideroads and eventually into four-wheel-drive country, the "wilderness beyond his windshield is threatening to him, like something out of James Dickey's *Deliverance*," a novel he knew well: "The Saugeen, the river that writhes its way over and through this part of the world like a Medusa head scattering tendrils of streams and creeks through time and space." He gets to a likely spot and turns it, for comfort's sake, into art: "The far shore a wall of forest not unlike the painted backdrop of a sylvan ballet.... this is fly-casting country just like the pictures in the books." He imagines an even better book with a picture of *this* pool and a large X marking the spot where trout lie waiting, and then, flicking back his arm and wrist, engages in the perfect cast. Unfortunately, the hook stays somewhere behind him and an "offending knot" is wedged in one of the wire line guides: "So let's get this straight: I'm up to my ass in water, I'm waving an eight-foot rod about, looking for approximately ten feet of transparent line on the end of which is a *dangerously* sharp barbed hook, and I'm a short fat guy with short fat arms and there's only so much usable space above the water line." He discovers the hook is caught in his hair beneath his Red Man cap, and after extricating it with difficulty calms himself by remembering why he is here: to get away "from the lonely jeopardy of the easel." An acceptable cast follows, but the wind picks up and he begins to "imagine the other side of Disney: bears and snakes and rabid foxes tearing Thumper's throat to pieces." He then looks down to find a small fish has taken his hook, and realizes that in order to free it he will have to *touch it* with his bare fingers. As he struggles with his needle-nose pliers, "the little bugger wiggles and twists and falls off

the hook into the water and *swims away*!" Exhausted, he heads for the bank where he sits and contemplates his experience, coming to the conclusion that he's had a "wonderful if hilarious time." It will be his one venture into the river, because what prevents any subsequent immersion in this "warm watery landscape ... [to] find harmony and joy ... beyond the pale colours of my palette" is the absence in his fly box of a barbless hook. So he returns to his studio, where he would never consider painting with a bristleless brush.

Patrick Watson suggested a way to get Robert out of the studio for a while but keep him creative. While on a trip to Ireland, Patrick and his partner, Caroline Bamford, saw a BBC production of a tour of Scottish distilleries and immediately thought of doing a similar program with Robert and Canadian microbreweries. The result was a pilot show for a proposed thirteen-part series produced by Caroline and directed by Patrick. The ambitiously worded press release indicated that, as was usual with Robert, more than beer would be on the table:

> *Something Brewing* will be a series of personal essays by
> Robert Markle in which he will travel throughout Canada
> visiting micro breweries located in beautiful and interesting
> settings. He will talk to local farmers, business tycoons,
> artists, children, teachers, and quilters. There will be items
> of interest relative to the location such as art, antiques,
> architecture, history, scenics, philosophy, environment.
> The tone of the series will be very positive and celebratory
> as Markle and his motorcycle explore this uncharted
> territory. Markle will call on his personal background as
> an artist, writer, humorist, and antique collector to create a
> spontaneous element of discovery and invention which will
> include sketching and painting of local scenes.
> *Something Brewing* will be Markle's search for the beautiful
> Canada, for the atmosphere, the camaraderie and the
> characters that accompany the "perfect pint."

The village of Creemore, about an hour's drive from Mount Forest, and its Creemore Springs Brewery were chosen for the half-hour pilot show because of the articulate nature of one of its owners and because Robert loved the beer. Patrick persuaded a Harley-Davidson dealer to provide a new bike, a black 1340-cc Low Rider that would have Robert's now thoroughly grey ponytail streaming in the wind. The plan was to pack the bike so that the fold-down easel, attached blank white panels, and

paintbox would always be visible. The blank panels would be replaced, as each trip went on, by Robert's finished paintings. In the pilot show, taped in the summer of 1989, Robert rides north from his house to the highest point above southern Georgian Bay, where he chats a bit about the bay, the bike, beer, and the Creemore Brewery. As he moves to the southeast and gets closer to the village he does a series of country sketches and talks about what he sees. Once in Creemore he provides some general history of the village and region and studies the local architecture. He also does interviews with the editor of the *Creemore Star*, the brewery founder, and other townspeople. Most compelling is what Robert wrote himself as part of the script, because it's the only time he publicly discussed, in realistic and idealistic terms, painting and landscape in extended fashion:

> As I move through this area, a place so rich in water and forest, these rolling hills offer so much for the artist, or the interested traveler. Each bend in the road offers new wonders, each county road, its gravel shoulders edged in wildflowers and moss, the wood[s] with their carpets of green, all this ... magic is fine food for the artist, it's wonderful, and wonderfully hard for someone like me to get it right, to accurately render this wild place in a manner that's part me and part all of you.... We all carry with us the necessary tools to appreciate, if not totally understand our absolute ties with the world around us, but we often need the artists, the poets of the world to remind us of that fact.... We look at the nineteenth-century French landscape of Corot and Courbet, that innocent space, and we look at those loving portraits of this very country by Thomson, Harris, and A.Y. [Jackson] and the rest of the group, and we see more of that innocent space, dream country, truth and beauty in the excellence of that vision. But as I stand here, daubing away, I've got the greenhouse effect. I've got soapsuds swirling in the still pools of most rivers and streams. I've got acid rain.... I've got the evils of the twentieth century to contend with. I can't find innocent space. Yet I continue to splash rainbows of colour, going for the beauty.

He did at least four small oil-on-masonite paintings for this initial episode. The first has him leaving the farmhouse on the Harley, his ponytail flying out behind him, and a propped-up panel showing a bottle of Creemore and a full glass beside it. The next is probably based on the

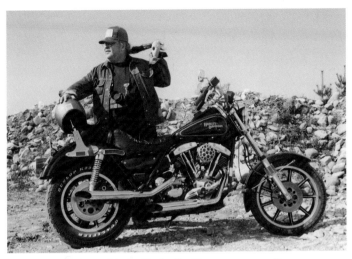

Robert with the Harley-Davidson, summer 1989

old mill pond at Lavender Falls on the Noisy River near Dunedin, a few kilometres from Creemore, and is more expressionistic in nature. The third is filled with bright yellow and subdued green tree shapes and the intense blue of a winding river, and the last is more abstract, though still recognizably a landscape of fields, trees, and sky. Perhaps memories or anticipation of such scenes are what distracts the artist in the front seat of *Country Twang* as he gazes into an elusive country distance to the apparent chagrin of the muse beside him.

Patrick stresses how "professional" Robert was to work with and that plans were under way for future shows when he died. On the other hand, Michael Sarrazin, who watched the pilot at the farmhouse, says, "It wasn't dynamic [and] just seemed not quite Robert." Perhaps sensing his friend was trying too hard, Michael told him to speak in his own voice and, more important, "get a thinner bike."

If ever Robert was going to die in a vehicular accident, it would have been on that Harley. It was too big and too fast, and he told Marlene during the filming of *Something Brewing* that he "couldn't handle" a big bike anymore. The quickest way back to Mount Forest from Creemore was along a winding roller-coaster road by the banks of the Noisy River, through Dunedin to Highway 24 and south to Shelburne. If he had wiped out on those racy curves, the pain of his loss wouldn't have been any less for Marlene and his friends, but tales of the Harley and his earlier biking mishap would have grown into legends of life in the fast lane and a fitting death. It didn't happen that way.

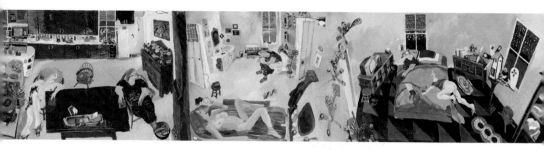

Rooms: West Wall, 1990 (acrylic on tempered hardboard, 46.9 × 203.5 cm). Detail below.

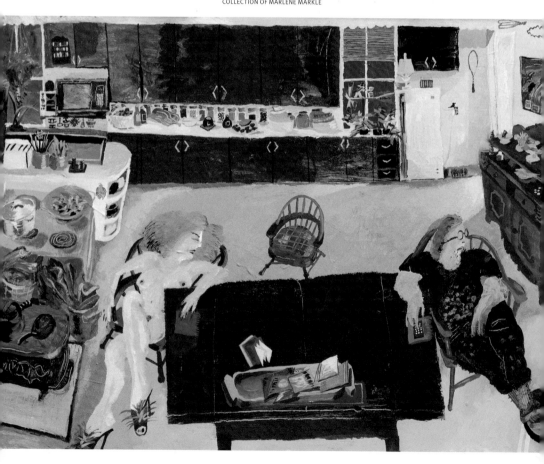

IX

AFTERLIFE: 1990–

*There are people who occupy their time on earth completely. There
are not many like that, and others don't recognize it until they're
gone. When Robert died there was a lessening because he showed
up in so many ways.*
—Peter Goddard

On Thursday night, July 5, 1990,
Marlene prepared the food, set the table, and waited for Robert. Just as in
the Pilot days, it was not unusual for him to get home later than he said
he would, and she would often be in bed before he arrived. Around ten
o'clock she heard a car come up the driveway. Two OPP officers appeared
at the door. They told her there had been an accident, that Robert had
been killed, and that they would take her to the hospital. The policemen
offered no explanations or small talk as they drove her into town, and
when they passed the scene of the accident, where Robert's truck had hit
the tractor, everything had been cleared away. At the hospital she was met
by a doctor who took her to a small room, where Robert lay in his clothes
on a gurney, "all cleaned up," as if blood and pain had not brought him
there. But she knew about internal damage because of the 1969 accident,
and that this time there would be no reprieve. She kissed him and held
his hand. "What have you done?" she asked, perhaps unconsciously hop-
ing for one of his quick comebacks, but he was gone. Far too soon the
doctor returned and asked her if she "was done."

When she dialed Stephen and Marsha's number from the hospital, there
was no answer. The OPP drove her home. She phoned her good friends
Dinah Christie and Barbara McLean, and spoke to Barbara's physician
husband, Thomas Wilson, who confirmed what the hospital doctor had
said—there would have to be an autopsy for an accidental-death victim.
Word got around town quickly. Craig Kenny came over before Dinah
arrived. Marlene reached Robert's oldest sister, Lois, at her home in
Rhode Island, where his mother, Kathleen, was staying. She phoned Susan
Maracle, who got in touch with her brother Mitchell. In the early-morning

hours Marlene spoke with Michael Sarrazin, who was in California, and Patrick Watson, who was on a diving trip in the Bahamas. Before that she had contacted Gord Rayner, who called Graham, Nobi, and the others who had created art and music and caroused with Robert for over thirty years. The next afternoon family and friends began to arrive, but before that neighbours "just started to come up the lane."

Marlene never saw Robert again. The autopsy was held in Owen Sound the day after his death, and she made the decision to have him cremated as soon as possible, because "my feeling was he wouldn't want to be looked at." The coroner's report showed that his blood–alcohol was over the limit, but still Marlene wondered how he failed to see the tractor. "In my emotional state, the first thing I imagined was his suicide. But I dismissed that immediately because he was doing such fabulous work." Maybe he was entranced by the full moon, or had fallen asleep. Perhaps there had been a heart attack that the autopsy couldn't pick up. She would never know. What she did know was that from the moment they met she had been prepared for such an ending. He told her when they were in OCA together that he was going to die young. He had almost died at thirty-three on the Don Valley Parkway. Referring to that 1969 accident, his sister Lois put it aptly: "At least we had him for twenty more years." Somehow, despite his hard-drinking behaviour that led him off the straight and narrow pavement on many occasions, Robert had made it well into middle age.

For some, the freak nature of the accident on a concession road he knew like the back of his hand meant that the manner of his death had not been inevitable. John Reeves says, "He wasn't going 120 miles an hour, and he didn't even knock the guy out of his tractor seat." Murray McLauchlan insists that "Robert's death was not part of his lifestyle." Ruth Grogan claims that in the many years she drove with him she "never saw any evidence of careless driving." Patrick Watson goes further when he admits, "I think I thought he was invulnerable." Paul Young, however, remembers Robert telling him "back in the late '50s … that he would die before his time in a car crash." It just didn't happen in the "red sports car" that he had predicted. For Laura Berman it wasn't *how* Robert would die that was fated, but *when*: "I have a hard time imagining him as an old man."

With all the people at the farm that weekend, Marlene says, "it was wonderful that Kathleen could see how admired and loved Robert was." Michael Sarrazin, who describes himself as "exasperated and angered" by what had happened, arrived at the farmhouse to find it "like a scene from a movie. All the guys were in a [receiving] line outside the front door. I shook all their hands. Inside were Mrs. Markle and Susan. She [Kathleen]

was dignified and showed real pride in Robert." Later, people milled about on the small front lawn and in the driveway, telling "Robert stories," hardly able to believe they could do so with impunity, without a stinging retort lightened by laughter from a short fat guy with artist's eyes.

By Monday afternoon everyone had gone home, into Mount Forest, down to Toronto, and beyond. Dinah, Barbara, and Marsha stayed on call, though there wasn't much more they could say to comfort Marlene. She admits to being angry at Robert for the suddenness and arbitrariness of his leaving her, but after "three days of just standing in the kitchen" she went back to work in town because there was nothing else for her to do. Later, having read *A Grief Observed*, she recognized the truth in what C.S. Lewis wrote about dealing with the death of his wife: "No one ever told me that grief felt so like fear." Eventually an insurance company representative got in touch about the accidental-death insurance payment that was part of the policy on the truck. When she told him she didn't want any kind of reward for Robert's death, the agent replied that there was lots of time to think things over. Eventually she did accept the money, and it became the nest egg on which she built the rest of her life.

Despite her grief, or perhaps to deal with it, Marlene decided there should be a celebration of Robert's life on what would have been his fifty-fourth birthday, on Saturday, August 25, 1990. It was held at Stephen and Marsha's farm, and over the several weeks leading up to the event, the Flyers cleaned up the grounds, cut the grass, cleared away some trees, and put up several large tents near the stage that was already in place for musicians to perform at various holiday festivities. Marlene, a number of friends, and Freiburgers supplied the food, individuals brought their own booze, and over three hundred people turned up in the afternoon to party and to listen to music and the many tributes to Robert. Noted bluesman Michael Pickett, married to Marlene's sister Louise, sang with the AJB and other musicians, as did singer-songwriters Shirley Eikhard and Dinah Christie. Tom Hill spoke about Robert's exploration of his Native heritage. Graham, increasingly frail with heart disease through the 1980s, read his eloquent remembrance of things past, ending with "He was as strong and graceful as his tumbling, long-limb-strewn pictures and as beautiful. I loved him." In a poem he called "Visions of Robert," Andy Wainwright wrote:

> we could drive for miles
> in the truck in silence
> but it was always an empty page

> we knew we'd paint with words
> like chiaroscuro and bullshit
> on our way to pool halls
> studios Georgian bay cruisers
> no place of destination
> we would ever want to frame.

Composer Udo Kasemets created "Marklewake," a "structured improvisation for one or (preferably) more instrument(s) and voice(s)," in which the letters, syllables, and phonemes of Robert's and Marlene's names were sounded by speakers and musicians. Tim Noonan, who had always assumed Robert's Flyer affiliation was the essence of his attachment to Mount Forest, was "shocked" by the many other people from the community who had known him and turned up to commemorate his life and honour his memory. Dorothy Cameron, who could not be present, had written to Marlene: "He was a personality so uniquely vast (in more ways than one!) that his vibrations were felt and sensed and treasured by many of us who were on the outer fringes of his and your lives."

The honouring of his memory recently took an ironic twist that Robert would have loved when the site of the Standard Theatre for Yiddish theatre productions, which opened in 1922, was designated a heritage site by the Toronto City Council on April 24, 2007. The Standard, at the corner of Dundas and Spadina, became the Victory Burlesque palace in the early 1940s, housing a different kind of heritage that Robert commemorated in his art.

Through the 1990s and into the new century Robert's work was exhibited in half a dozen solo shows, including a large 1991 retrospective at the Isaacs, which had moved to 179 John Street five years previously and was about to close for good. Marlene went through all his work, selecting over one hundred pieces from every period and medium so that viewers would be able to see the progression through his career. This was the show whose whirligigs Marjorie Stone responded to so positively, stating as she did that while Robert may not have been one of the "men in feminism" or a feminist man, he was "a male who inhabits and explores the fe(male) in a way that provokes us into grappling more intensely with images and issues of gender." After Av Isaacs retired from his gallery work, the Leo Kamen Gallery displayed Robert's work three times between 1991 and 1997. The Geraldine Davis Gallery in Toronto held a graphics retrospective in 1991. In 1994 the Moore Gallery in Hamilton (it moved to Spadina Avenue in 1997) included among Robert's paintings the 1987

work *Snake Charmer*, valued at $5000, which gallery owner Ron Moore bought. In 2001 the Winchester Gallery in Victoria, B.C., hung black and white drawings from 1967–68 and coloured ones from the early 1970s with the small oil paintings from 1990. That same year, the exhibition Exposed: Aesthetics of Aboriginal Erotic Art started out in the MacKenzie Art Gallery in Regina and travelled to the Woodland Cultural Centre in Brantford, Ontario. It included an early black-and-white tempera drawing and, in its catalogue, a colour photo of the *Creation* whirligig. In 2001 Robert had a two-person show with former student Lorne Wagman at the Flesherton Art Gallery, some fifty kilometres northeast of Mount Forest. Despite the big payment for *Snake Charmer*, sales at these events were few and far between. Marlene was working hard to keep his profile in the public eye, but it was the interest of two AGO curators that led to a unique retrospective that focused vital critical and public attention on Robert's artist model over thirteen years after his death.

In July 1998, Marlene met Dennis Reid, then curator of Canadian art at the AGO, at Joyce Wieland's memorial service, and asked him if he could come to the farmhouse and look at Robert's work. Reid agreed, and a few months later Marlene wrote him a letter in which she listed all the paintings, drawings, and sculptures in her vast collection. In 1999, Reid and assistant curator Anna Hudson spent an entire day going through the material, and Hudson followed up with a second visit the same year and three more over the next three years. She learned much from viewing the paintings and sculptures and from Robert's writing, and from the beginning she had the idea of pairing Robert's work with Joyce's. Marlene wanted a Markle retrospective only, but was willing to let Hudson make her case.

As a young woman, Hudson had seen *Powdery Tremble*, from the Johanna years, in a group exhibition at the University of Toronto. "I had trouble with it," she says candidly, speaking of the flagrantly displayed female form and the stiletto heels. But when she went to the farmhouse and saw aspects of Robert's life and art together, she began to think that enough time had passed for his work to be seen afresh, without the possible encumberment of his personal reputation. This might have been true, but how did Anna imagine she could posthumously bring together Wieland and the man many knew as "Bob-noxious," despite that both painted nudes and did needlework? Dennis Reid recalls standing with Joyce in the Isaacs in the late 1960s when Robert came in and immediately rattled her with his greeting of "Hey, man." They were like "oil and water," Reid says, adding that he's not sure they even respected each other's work. On the other hand,

Michael Snow insists Wieland did not leave Av's dealership after a last show at the gallery in 1974 because she felt isolated from the male artists.

For Anna Hudson, Robert and Joyce had been on "parallel courses … both convinced they had to face the grand tradition in their work." Much of the strength of their creative expression lay in their remarkable drafts(wo)manship. Wieland, in often "frank and bawdy" ways, portrayed earth-mother-goddess mythology, and sometimes appropriated Native identity to do so. Robert sexualized creation one step further and dealt with the muse as wife-stripper-goddess who danced through his drawings, paintings, and whirligigs. Hudson believed the circle in Wieland's paintings began "to emerge as a palette for Robert" and became a "deeply rooted aboriginal symbol." They both placed themselves in their work—"She is the woman in her paintings," says Hudson, and of course Robert had his profile. This didn't seem to be enough to justify a joint show, however, and in her essay "Wonder Women and Goddesses: A Conversation about Art with Robert Markle and Joyce Wieland," Hudson went much further, making a case for uniting them through similarity *and* difference:

> I dare you to put Robert Markle and Joyce Wieland in a
> room together, alone, and ask them to discuss Art. My bet
> is they would start by fighting. A good verbal free-for-all
> would erupt, the kind that happens when the intellectual
> and emotional stakes are high, like "what it means to be an
> artist." Markle and Wieland were obsessed with being artists,
> with creativity, and their responsibility for art in Canada.
> They were, in their youth, artists of the 1960s conversant
> with counterculture ideals of democracy and individual
> freedom. They were Toronto artists, schooled during the
> waning of the Group of Seven's call for a Canadian painting
> and freshly washed by the great wave of post-war abstrac-
> tion and Toronto's own Painters 11. They idealized art as an
> expression of beauty, accessible to all, and joyful. For them
> the artist's studio was a place of refuge from the heavy bur-
> den of the everyday, the regular, the ordinary and the unre-
> markable. In the midst of the 1960s advocacy for women's
> liberation, Aboriginal rights, "make love, not war," all those
> imaginings of hand-in-hand global harmony, creativity took
> on the unmistakable innuendo of physical union. And that's
> precisely where Markle and Wieland would differ—on the
> subject of sex.

Imagine a time when two ambitious artists, gifted and obsessed, one a man and the other a woman, were pitched against one another as a result of sex. Does art make manifest sexual difference? It did, and does, when creativity lies too heavily on the body of the artist's model—the studio nude, invariably female, and always available. Markle and Wieland knew it too. "Nudes and whores—women with no identity beyond their identity as sex objects—were made to embody transcendent, 'universally' significant statements." Just who was she anyway? This image of beauty was forged in the history of Western culture from antiquity through the Renaissance. When she stepped out of the bright light of the sixties sexual revolution, Art cast a dark shadow of chauvinism. For Markle and Wieland, whose roots were firmly working class, the female nude embodied their desire for transgression and for imagery cut on the bias of their own disenfranchisement. The nude remained irresistible. Markle loved her ability to straddle social strata, and he revelled in the exquisite irony of her enduring seductiveness. Wieland felt the nude's power as a symbol of Art. She was compelled to measure herself as an artist and as a woman against Art's feminine forms. Both Markle and Wieland were drawn into an exploration of her place, of Art in contemporary society.

Hudson goes on to examine aspects of Robert's and Joyce's life and works in light of the above analysis, imagining a creative dialogue between them as social and creative outsiders who nevertheless have great difficulty in recognizing their shared humanity and ongoing capacity to remake themselves as artists. It is their paintings and sculptures that have the potential to include others in the exchange, to create that polylogue that Marjorie Stone emphasizes. Dennis Reid supports Hudson's stance when he speaks of the "yin and yang compatibility at work at the same time as their distinctiveness. They were both deeply engaged in their time."

The show that Hudson curated—Woman as Goddess: Liberated Nudes by Robert Markle and Joyce Wieland—ran at the AGO from late November 2003 to late February 2004. The over one hundred drawings, paintings, lithographs, and sculptures (and Robert's embroidered jean suit images) drew a variety of responses, ranging from Sarah Milroy's supposedly feminist dismissal of the pairing to the views of practising artists like Vera Frenkel, who saw "phenomena beautifully and importantly rendered" by

both artists, and Rick Gorman, who liked Robert and Joyce's "beautiful whimsy and sense of humour." Wieland's deserved international reputation is unthreatened by the fact that some of Robert's male friends, perhaps expectedly, liked his work a lot better than hers. Paul Young felt, for example, that the match was a "weird idea" and that their work didn't hang together because hers "lacked real conviction and power." But loyalty to Robert's images wasn't split along gender lines, as Hana Trefelt opines that many of the Wieland pieces were "a little bland, clever, and intellectual," while Robert consistently held his line. Dawn and Beth Richardson assert that the show revealed Robert "had more of a sensitivity to women than [Wieland] did," and praise his "judicial use of line with no window dressing." Ruth Grogan didn't like Wieland's work, insisting that the "humour and lusciousness of Robert's work were poles apart from hers or in a different universe." Av Isaacs says simply of the artistic union, "Joyce would turn over in her grave," not mentioning what Robert's response would be—though, as we know, he was open to most kinds of coupling. Peter Goddard feels that the Wieland–Markle combination did not succeed as intended and that Robert's work should have been put up against that of another Native artist or an artist from another country who took, for example, similar kinds of routes along the Mexican border that Robert followed in his truck around Grey and Wellington Counties.

In the end, of course, it depends on who you are and the perspective you bring. Sarah Milroy can state with confidence that the nudity in Wieland's paintings is "experienced as an expression of power, candour and elemental strength rather than titillation." Another female critic, Corinna Ghaznavi, can say with equal conviction of Robert's presentation of the nude, "It started traditionally, almost like a study of the human form, became an embodiment of the beautiful and alluring, until finally the form became content and the female figure a sign for the dynamics of life itself." In the end, then, it might just be a matter of different dancers, same dance.

Twenty years have passed since Robert's death. The quality of his drawings, paintings, and sculptures will speak for itself as long as viewers pay attention to his line, tone, colour, and use of space, and to the narrative aspect of much of his art. Av Isaacs indicates that his work is "being re-examined and re-acknowledged" and in 1999 sold two black-and-white tempera drawings to the British Museum. Robert had, as Dennis Reid says, "an amazing eye that opened things up for you" and that made Patrick

Watson "constantly aware of my visual and tactile environment.... It was like having a tour guide into places you'd seen but hadn't seen before." There was something else besides, something that led him to paint, as Paul Young suggests, "from the inside out." For Vera Frenkel, it had to do with his being a Zen master whose brushwork was extraordinarily intuitive, for Av Isaacs with the evolutionary and ever-expansive nature of his development, and for Jerri Johnson with his "sensuous energy," which created transcendent figures on paper and canvas. Of course no one who followed his career claims that he was flawless as an artist. Robert certainly didn't think that, as he destroyed five or six times as many works as he kept. But many agree with Dennis Burton that he got "better and better" through the years as he moved toward his whirligig figures and his profiled self that expanded his presentation of the figure. His ability as a draftsman showed itself early and remained indisputable over time, but Burton claims that "nobody else was doing his later kind of work." Scott Townson states simply, "He was brilliant at the end." To Marlene, who had watched everything unfold and who always saw his art with the demanding eye of the artist model and the independent convictions of the muse, the last painting on his easel "looked like that of an old master. It must have been a wonderful place he was going to in his work."

That "place" was and is under siege, according to Peter Goddard, who situates Robert's work in the context of a time and of individual and collective efforts that have not been properly appreciated or supported: "The art market never really hit Toronto and Canadian art the way it did in the U.S.," and since the market determined the direction of a whole generation of American artists, "these guys [Robert, Graham, Gord, and others] "were left on their own to work things out. All kinds of emotional strands run through their work as opposed to economic or intellectual strands." This emotional component, for Goddard, emerged from anti-American attitudes, Native elements, jazz, and rock 'n' roll, and resulted in a style that was "looser" than that of friends "who weren't in competition with one another." The art market failed these artists, especially but not only in terms of its dealers. Av Isaacs deserves celebration, but it is ridiculous, Goddard asserts, that he has had to be singled out, given the quality of the work in front of everyone. "The great failure in this country has been the systematic lack of ways of developing its [visual] talent.... Norval Morrisseau was one of the hottest artists in the world in 1962–63 and has just got his first show in the National Gallery [2007]. It's a tragedy." Goddard emphasizes that things are the "same now. Incredibly talented painters have nowhere to go." He points to the support for and

continuing success of musicians and writers in Canada. "Jazz musicians like Peterson and Kaufman got better rides [than painters], and, among the writers, even bizarre fringe players like Milton Acorn got their due."

One might argue that while Acorn might have been bizarre to some, he was not a fringe poet, but Goddard's point still stands about the backing of writers since the formation of the Canada Council and the explosion of small literary presses in the 1960s. As for the AGO, it has "never figured out its mandate" and is too dependent on philanthropists' whims, philanthropists who "have failed this country." Meanwhile, national papers like *The Globe and Mail* have art pages that involve the mere "tying of professional knots together. They have nothing to do with art per se." Even when books have been published on artists like Thomson and Town they have not done justice to them and their contribution. Goddard's judgments of the Canadian art scene are harsh but important, because they draw attention to the cracks in a canvas that is framed for the public in seamless and unproblematic ways. Certainly such judgments call to mind the letter Robert sent in 1978 to Pierre Trudeau in which he spoke of the "disastrous slicing at the very soul" of Canada, which was made clear by the wholly inadequate funding of artists in general and, on a personal level, by the Canada Council's subsequent rejection of his Senior Artist's grant application.

In 1984, Norman Snider paid powerful homage to Robert's generation of painters, arguing that in its way what they represented mattered as much as what they produced in visual terms: "The painters of the 1960s will be remembered in the social histories of the period as well as the art histories.... For those of us who were coming to consciousness in those days, the Toronto painters were kind of living models of how it was done. Film directors, actors, broadcasters, journalists were drawn to these guys, not just because they were artists *pur sang* where some of us were perhaps a little doubtful of the total artistic purity of our own vocations, but because they were pure exemplars of style, life as it ought to be lived."

The outer life ranged, of course, from Gord's hand-tooled leather boots to Robert's rubber ones and to general appearances—Graham "reminiscent of Whistler or Augustus John in their grand-old-man phase" and Robert "beginning to look like a beach ball with glasses." But it was the inner life of turmoil and integrity that mattered, the one that manifested itself in betrayal and loyalty, alcoholic haze and clarity of vision, self-centredness and "great love for the world." It was this inner life that created the complex relationship between the two figures Robert referred to in a letter he wrote to Marlene in 1957: "Call me not an artist, call me an honest man."

•

Whatever the lasting impact of Robert's individual creative expression, his personal and professional influence on his former students continues to this day. "The measure of a man is in those who mourn his passing," say the Richardson sisters, and, it might be added, in how they remember him. Kathryn Bemrose hears Robert as Rembrandt saying, "'Light. I paint the light.' His words stayed with me forever and when I lost him I lost my mentor and someone who respected my way of painting." Laura Berman claims, "Everything I look at [as a photographer] is through what he taught me." Sheryl Wanagas adds, "He gave me the affirmation that I could be an artist." Jerri Johnson recalls his humour and generosity and that he was a "very sexy man [who] had something in his soul that was … empowering." Sheryl refers to the effect of his "cerebral sexuality." Beth Richardson says, "Robert listened to you as if you were the only person in the room," and Rae Johnson states that despite his dark side, especially revealed in his drinking, "he made you feel anything was possible. Being fearless and in-your-face in your work. That's what I got from him…. He still is the most intrinsically honest human being I ever met."

Vera Frenkel, who had a well-developed feminist consciousness during the New School era, admits that Robert "brought out strength in me…. The world would enter him and he would give it back spontaneously … [but] he was at home in his own skin and there was grace in his movement and thinking." Hana Trefelt, who didn't like a lot of his behaviour but feels his work "was not a put-down of women," offers a remarkable response to Robert that she is well aware complicates his character and art: "I didn't like Turner as a man either."

As for his friends and artistic peers who saw him more often and over a longer period of time than did his students or Vera and Hana, they consistently describe their relationship with him in a celebratory fashion that somewhat eases their great sense of loss. Craig Kenny speaks movingly for all the Flyers when he describes missing Robert's "point of view … asking questions, finding out." "When you were with Robert you were always on a journey," says Patrick Watson, who goes on to place this voyage not in the expected painterly context but in the memorably mundane: "He would make you aware of the funny mark the lawn mower left when it went around the lawn." He, like Scott Townson, professes "there's not a day goes by I don't think about him." Michael Sarrazin, who calls Robert his "best friend, teacher, and mentor," tells the tale of how he unconsciously "did Robert" when he was being interviewed by a *New York Times* reporter.

He adopted Robert's brash persona, mimicking his voice and manner-isms, and realized only later that he had done so and how far from his real self his performance had been. To his surprise, Robert phoned him after reading the interview and said, "It sounds just like you." "Just like you as an actor" is probably what Robert meant, because he couldn't help but recognize the clamour of his own public persona in the interview. Dennis Burton should have been in the audience for Michael's performance, because he feels that the uniqueness of Robert's body motions and move-ments meant "no one could ever do him in a movie." For Michael Snow, "being with Robert was always inventive ... he lived creatively." For Harvey Cowan he was the "most intellectual" of the Isaacs group, but "we laughed ourselves stupid every time we got together." For Nobi Kubota he had a larger-than-life, even outlaw quality that Nobi associated with his motor-cycles as well as his painting and music. Paul Young feels that Robert was "far and away the most important human being I ever met" and that there was no difference between what he said and what he did. While Robert's impact on others was profound, Diane Pugen points out that his exchanges with them weren't always complete. She recalls his "sincere love for people [in general]," but feels a "sadness that he didn't connect as he would have liked with his own people."

Perhaps the discussion about Robert that Gord Rayner and Graham Coughtry had the night before Graham died, in 1999, best reveals the personal lawn-mower track that Robert left behind. Gord asked Graham if he ever thought of Robert, and Graham replied that he couldn't help but do so every day, because whenever he dried himself with a towel after a shower he recalled that Robert taught him to do the Twist. Then he said, turning the grass cuttings into green brushstrokes of love, "He's always with me."

Marlene still lives in the farmhouse. Over the years she has made some changes, remodelling parts of the kitchen and adding a laundry room and garage. Robert's paintings hang in different places—*Magritte's Forest* in the kitchen, *Class Act II (Buffalo)* above the bathtub, *Rooms: West Wall* in the front room, and *Domesticity I* in the bedroom. Periodically Marlene changes the work in the kitchen. *Newman Ornamental* has been there, and pieces from the *Artist and His Model Series*, as well as *The Beguiling Assault* and earlier black-and-white drawings. Small whirligigs and folk carvings are still present, and milk-glass hens and ducks line bureau shelves, some of them old and some acquired since Robert's death. It is her space now,

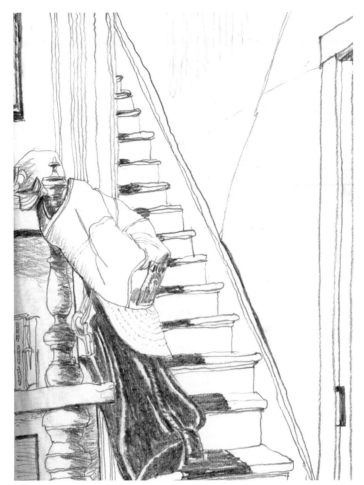

A drawing of the farmhouse interior, from Robert's last sketchbook, 1990
COLLECTION OF MARLENE MARKLE

and she has made deliberate choices about his prominence in it. That said, "every object in this house has a memory of when and where"—the Ukranian cupboard, the wooden kitchen table that belonged to Robert's mother, the four chairs (only one of which has a cushion—Robert's), the high-quality McIntosh sound system that rests unused in the front room, where hundreds of his books remain shelved, and, of course, the many paintings stacked against one another in the studio upstairs. In what was once an open field on the east side of the house, row upon row of pine trees, planted as seedlings in the mid-1990s and now nearly four metres tall, whisper in the wind.

Although Robert is "an alive living presence," Marlene doesn't feel any "hand on my shoulder" or spiritual attendance, and when asked if she believes she'll see Robert again she says no. Much of her belief in who they were together is centred on his work, which she is convinced will endure. People who weren't especially close to him have told her how beautiful the images are and how strong is the physical expression of his paintings. "So," she says, "fifty years from now why won't fresh eyes look at him and his work again?"

When she considers the man she knew so well, she remembers his intelligence, curiosity, and sense of humour. There's no need for her to confirm that Robert was boisterous and outgoing in public, but she speaks eloquently, as a lifelong witness, about his gentle and soft-spoken manner in private. Her description of him as a great romantic and a shrewd judge of character who was absolutely honest with others about life's realities is verified by those many who were recipients of that honesty, though some suggest that the romance sometimes interfered with how candid he could be with himself. She attests to his deep-seated love for his family, emphasizing how devastated he was when his mother sold the Adeline Avenue house without recognizing how much of her son's feeling was bound up in a profound sense of feeling for the past. Never uncomfortable about discussing Robert's unconcealed love for other women, she notes that his advances to them weren't always welcome. When she says, "I regret I didn't enjoy myself as much as Robert enjoyed me," those who remain critical of his behaviour could well see this as an indication of his dominance of her. A more generous and perceptive reaction would be to try to understand her modest self-assessment and intrinsic self-awareness of her role as model and muse in relation to the artist's view of her. The simple truth is that she did take pleasure in their creative partnership but is able to acknowledge the enormity of his delight in her company and the opportunity to *re*-create *her*, which is not the same thing as a godlike conception of the female figure. Indeed, she insists, it was only that delight combined with his hard work and discipline in the face of so much physical trauma that kept him going. He worked every day, painting or thinking about painting, drawing on paper or canvas or with his finger in the kitchen's air.

To commemorate his creative efforts and to encourage those of young Native artists, Marlene established the Robert Markle Scholarship, which was "awarded annually to a First Nations student in the first or later year of a visual arts program at a postsecondary institution." The scholarship, administered by the Woodland Cultural Centre and worth $1200, was given out thirteen times between 1994 and 2008 (the final year). The

younger artist expelled from OCA strongly preferred the informality of alternative schools and wore his Native heritage lightly for many years, but it is the older painter's increasingly developed connection of his origins to his work that made the aboriginal focus of the scholarship so appropriate.

Marlene's own life continues. She curates exhibitions and volunteers at the Durham Art Gallery, is a member of two choirs, and has designed sets and directed for a local theatre company's productions. She was on the board of directors of an Owen Sound women's shelter for many years. She has acquired a range of new friends, and every spring goes on a two- or three-day canoe trip on southwestern Ontario rivers with several female companions. Perhaps after years of mourning and adjusting to loss, she began to move into these new experiences when Robert finally visited her in dreams, a long time after he appeared to others. Or perhaps the movement had its beginnings in the summer after his death, when she lay on the ground outside the farmhouse watching a magnificent aurora borealis display, in which shapes and colours shimmered and swayed for two nights like figures that could never be framed but put everything human into perspective.

SOURCE NOTES

Chapter I / Gesture: July 5, 1990

3 **"The previous day"** Author interview with Marlene Markle, May 28, 2004.

4 **"Stephen Williams—a writer"** Author interview with Stephen Williams, May 15, 2005.

4 **"After a beer with Marlene"** Marlene Markle, 2004.

4 **"wagon-burners"** Author interview with Craig Kenny, March 8, 2003.

4 **"He loved to 'move, all wine white gleaming'"** Andy Wainwright, *Notes for a Native Land*, 103, 106.

4 **"careful driver"** Author interview with Gordon Rayner, February 27, 2003.

5 **"It was 10 p.m."** Ontario Provincial Police report, November 28, 1990.

5 **"deep impression marks on his abdomen"** Wellington County Coroner's Report, August 3, 1990.

Chapter II / Indian Blood: Hamilton 1936–1955

7 **"Captain John Deserontyon"** http://www.tyendinaga.net/history/index/html.

7 **"Nelson Maracle was one"** Tyendinaga Band records.

8 **"In the year 1872"** http://www.collectionscanada.ca/aboriginal/020008-2000-e.html.

8 **"Amelia Claus … George Clute"** Tyendinaga Band Records.

8 **"The family moved to Hamilton"** Author interview with Susan Maracle, March 2, 2003.

9–12 **"The Iroquois had been joined … international attention was focused on the situation"** *People of the Pines*, pages 146–47, chapters 4, 6, 7; also "The Iroquois Dream Experience and Spirituality," http://www.webwinds.com/yupaqui/iroquoisdreams.html.

11 **"over one hundred and thirty years"** *The National*, CBC News, May 31, 2007. Interview with Diane Pugen, April 26, 2007.

12 **"toxic junk"** Naomi Klein, *Globe and Mail*, May 4, 2007, A15.

12 **"he had many ideas"** Clifford Brown, letter to Marlene Markle, 1990. Series 23, Art Gallery of Ontario Archives.

12 **"We could get a helicopter"** Craig Kenny, March 8, 2003.

12 **"The house sat on the corner"** Susan Maracle, March 2, 2003. Author interview with Mitchell Maracle, March 1, 2003.

13 **"During the war"** Robert Markle, unpublished notes, Series 2, AGO Archives; author interview with Jack Foster, March 3, 2003.

14 **"residential schools across Canada"** *The Dispossessed*, 24.

15 **"violent deaths, suicides"** *Atlas of the North American Indian*, 209.

15 **"The first rush hit"** RM, unpublished notes, Series 2, AGO Archives.

16 **"looked like me"** Interviews cited above with Susan Maracle, Mitchell Maracle, and Diane Pugen.

16 **"i really [knew] nothing"** RM, unpublished notes, Series 2.

16 **"The house at 299 Adeline"** Interviews cited above with Susan and Mitchell Maracle.

17 **"a very skinny child"** Mitchell Maracle, March 1, 2003.

18 **"I wonder how my mother did it"** Robert Markle, "In the Heart of the Heart of Christmas," *Toronto Life*, December 1977, 48.

18 **"they'd follow the pipeline"** Author interview with Ray Hanson, May 4, 2005.

19 **"scrap metal drives … other apparel"** *Hamilton: The Story of a City*, chapter 6, pp. 21–22.

20 **"Mohawks had been employed as ironworkers … out of mind to the privileged"** *High Steel*, 136, 145, 157–58, 162.

20 **"Sky Dweller"** *Indian Time Newspaper*, January 7, 2000.

21 **"my father used to tap dance," "innovations in steel construction," "it would be like Christmas"** RM, unpublished notes, Series 2, AGO Archives.

21–22 **"you know, my father," "fathers die," and "uncle remus stories"** RM, unpublished notes, Series 2.

23 **"He was unable to acquire the stamp"** *The Citizen* newspaper (Mount Forest Edition), May 17, 1990.

23 **"original thought"** RM, letter July 8, 1974, Series 1, AGO Archives.

24 **"took lessons on Saturdays"** Jack Foster, March 3, 2003.

24 **"Sixteen years of age"** RM, unpublished notes, Series 2.

24 **"the music came at me"** RM, unpublished notes, Series 2.

25 **"6:1 ratio of paintings"** Marlene Markle, March 7, 2003.

25 **"One night in the dark"** RM, unpublished notes, Series 2.

Chapter III / Early Figures: Toronto 1955–1960

27 **"The Ontario School of Art"** http://www.ocad.on.ca/about_ocad.history.html.

27 **"teachers were a problem"** Author interview with Dennis Burton, February 24, 2005.

28 **"perspective of a chair"** Author interview with Hana Trefelt, May 21, 2004.

28 **"only a couple of abstract painters"** Author interview with Paul Young, May 25, 2004.

28 **"Carl Schaeffer, who headed"** Author interview with Richard Gorman, May 21, 2004.

28 **"presence of the Group of Seven"** Author interview with John Reeves, March 4, 2003.

28 **"Twenty-five years ago"** RM, "On Portraiture," Series 2, AGO Archives.

29 **"Man, that's it!"** Gordon Rayner, February 27, 2003.

29 **"how skinny he was"** Interviews cited above with Marlene Markle, Richard Gorman, Paul Young.

29 **"talked like a jazz musician"** Interview cited above with Gorman.

29 **"'sweet' personality"** Interview cited above with Trefelt.

30 **"Robert's Mohawk ancestry"** Interview cited above with Young.

30 **"we were colour-blind"** Interview cited above with Burton.

30 **"you can't hold your booze"** Interviews cited above with Rayner and Reeves.

30 **"the issue of race"** Author interview with Nobuo Kubota, May 19, 2004.

30 **"humour was a defensive weapon"** Author interview with Patricia Beatty, May 18, 2005.

31 **"You either loved him"** Marlene Markle, March 7, 2003.

31 **"arrogant, self-centered"** RM, unpublished notes, Series 2.

31 **"Baldwin Street"** and **"Beverley Street"** Marlene Markle, March 6, 2003.

31 **"This could be Montmartre"** Richard Gorman, May 21, 2004.

31 **"master at pool"** Paul Young, May 25, 2004; author interview with Harvey Cowan, February 25, 2003.

32 **"We walked up the middle of the street"** Richard Gorman, May 21, 2004.

33 **"awash in music"** John Reeves, March 4, 2003.

33 **"I remember lugging"** RM, "On Portraiture," Series 2.

34 **"Nothing can be done to change matters," "liberating necessity of art," "social change lay in a change of attitude," "the magic of each individual" and "indescribably complex"** David Burnett and Marilyn Schiff, *Contemporary Canadian Art*, pp. 13, 21, 22, 27.

34 **"died," "so energetic," "awful palette"** Gordon Rayner, February 27, 2003.

35 **"To express his ideas"** Kay Woods, *Painters 11, 1953–1959*, 5.

35–36 **"There is no manifesto"** *Contemporary Canadian Art*, 43–44; **"What might seem novel here,"** 46; **"painting as a direct expression,"** 47; **"from the conventions,"** 49; **"forms seem to rip away,"** 56.

36 **"This is crap"** Gordon Rayner, February 27, 2003.

36 **"every damn tree"** Author interview with Michael Snow, May 20, 2004.

36 **"declared 'offensive'"** Ihor Holubizky, *Small Villages, The Isaacs Gallery in Toronto: 1956–1991*, "Making the Frame," 6.

36 **"wrong … put the figure"** Gordon Rayner, February 27, 2003.

36 **"memorize the entire silhouette"** Paul Young, May 25, 2004.

37 **"the most talented technician"** Author interview with Peter Goddard, April 29, 2007.

37 **"Eaton's stood for quality"** Holubizky, 2.

37 **"Abstracts at Home"** *Contemporary Canadian Art*, 42.

37 **"the most stimulating"** Author interview with Avrom Isaacs, May 24, 2006.

37 **"the only dealer at that time"** *Isaacs Seen*, 35.

38 **"Hale described Av's manifesto"** Barrie Hale, *Toronto Painting 1953–1965*, cited in Holubizky, 3.

38 **"In choosing this exhibition"** *Isaacs Seen*, 37.

38 **"The artists in my first show"** *Isaacs Seen*, 8.

39 **"great differences of temperament"** (McCarthy), **"pulls the visitor up"** (Macdonald), and **"firm kick in the pants"** (Thomson) cited in Kay Woods, *artscanada*, May/June 1979.

39 **"one of twenty significant events"** Robert Fulford, *Imperial Oil Review*, Summer 2000.

39–43 Marlene Markle, March 6, 2003.

43–44 **"I sat there riding"** and **"flat and green"** RM to Marlene, 1957. Series 1, AGO Archives.

44 **"Fred Hagan's etching class"** Marlene Markle, March 6, 2003.

45 **"it wasn't a big deal"** Richard Gorman, May 21, 2004.

45 **"he was going to do"** Hana Trefelt, May 21, 2004.

45 **"always be on your side"** Kathleen Maracle to RM, Series 1.

45 **"terrible beauty of creation"** RM, unpublished notes, Series 2.

45 **"middle-class conservative"** Stephen Williams, May 15, 2005.

45–46 **"We're getting married"** and **"I was foolish"** Marlene Markle, March 6, 2003.

46 **"Marlene was the least likely"** Author interview with Helen and Marty Poizner, May 25, 2004.

47 **"if 'my son' did anything"** Marlene Markle, March 6, 2003.

48 **"three or four times a month"** Richard Gorman, May 21, 2004.

48 **"I remember immersing myself"** RM, unpublished notes, Series 2.

48 **"calligraphic and intensely personal"** Author interview with Dennis Reid, May 25, 2006.

70 **"The sustained energy"** Harry Malcolmson, *Toronto Telegram*, January 2, 1965.
71 **"Francis Bacon"** quoted in Holubizky, 4.
71 **"The thing about de Kooning"** *Contemporary Canadian Art*, 85.
71 **"lover of great juicy paint"** Gordon Rayner, February 27, 2003.
71 **"Where does graham stop"** and **"Daylight leaving"** RM, notes for "On Portraiture," Series 2.
72 **"Find a way here"** Graham Coughtry to RM, October 1967, Series 3.
72 **"flamboyant, gregarious"** Marlene Markle, March 7, 2003.
72 Interviews cited above with Hana Trefelt, Vera Frenkel, Patricia Beatty, Harvey Cowan, Don Obe.
72 **"characterized by brilliance"** *Contemporary Canadian Art*, 92.
72 **"We found rusty implements"** Gordon Rayner, Retrospective Catalogue, McLaughlin Gallery, Oshawa, 1979.
73 **"he never went to art school"** RM, unpublished notes, Series 2.
73 **"his space"** and **"[Art is] really a kind of searching"** RM, unpublished notes, Series 2.
73 **"the gordon rayner story"** RM, unpublished notes, Series 2.
73–74 **"deep in the woods," "I don't eat fish," "trembled"** Marlene Markle, March 7, 2003.
73–74 **"dressed in black," "After some three or four days"** Gordon Rayner, "Robert Markle: Two Baptisms," unpublished tribute to RM, 4.
74 **"a quick glance"** RM, unpublished notes, Series 2.
75 **"he 'loved the wilderness'"** Interview with Marlene Markle, April 27, 2007.
75 **"Back then"** David Silcox, *Isaacs Seen*, 85.
75 **"And through it all"** RM, unpublished notes, Series 2.
75 **"in a filthy basement"** RM, Series 2.
76 **"I invented it"** Gordon Rayner, February 27, 2003.
76 **"Rashomon"** RM, accompanying text to *Signatures in Time*, a suite of nine signed prints by each AJB member, 1980–81.
77 **"exuberance and excitement"** Nobuo Kubota, *Isaacs Seen*, 77.
77 **"But the thing that baffled me"** Michael Snow, *1948–1993: Music/Sound*, The Michael Snow Project, 83.
76–78 Interviews cited above with Marlene Markle, Gordon Rayner, Nobuo Kubota, Richard Gorman, Harvey Cowan, Michael Snow.
78 Interviews cited above with Rayner, Watson, Williams. Interview with Dawn and Beth Richardson, May 19, 2005.
78 **"Improvisation"** Michael Borshuk, *English Studies in Canada* 31, nos. 2–3 (June/September 2005): 350.
79 Interview cited above with Hana Trefelt.
79 Peter Goddard, *Toronto Star*, June 8, 1974.
79–80 Gregory Gallagher, *The Canadian Composer*, February 1976.
80 **"The shock waves of these [1973] recordings"** John Norris, *1948–1993: Music/Sound*, The Michael Snow Project, 72.
80–81 Interviews cited above with Nobuo Kubota, Don Obe.

Chapter V / Glory Days: Toronto 1965–1970

83 **"Drawing is the first draft"** RM, unpublished notes, Series 2, AGO Archives.
83 Interview cited above with Patrick Watson.
83–84 Interviews cited above with Harvey Cowan, Dennis Burton, Watson.

85 **"another charlies"** RM, unpublished notes, Series 2.

85 **"transparent butterfly"** RM, unpublished notes, Series 2.

85 **"Behind every tree"** RM, "On Portraiture," Series 2.

86 **"rocky canada country"** RM, unpublished notes, Series 2.

86 **"terrible August weather"** Marlene Markle, March 7, 2003.

86 **"you are my summer"** and **"into sadness"** RM, unpublished notes, Series 2.

86 **"centre of town"** RM, unpublished notes, Series 2.

87 Author interview with Michael Sarrazin, May 17, 2004, and Marlene Markle, March 7, 2003.

88–89 **"They're uptight," "he's tired"** RM, "Emerging," *The Telegram Showcase,* July 8, 1967.

89–90 Author interview with Gordon Lightfoot, May 24, 2006.

90 Gordon Lightfoot, "The Last Time I Saw Her," from the album *Did She Mention My Name* (United Artists), 1968.

90–91 RM, "Markle on Lightfoot," *Telegram Showcase,* January 7, 1967.

92 **"I'm really sick"** RM, unpublished notes, Series 2.

91–92 Gordon Lightfoot, "Canadian Railroad Trilogy," *The Way I Feel* (United Artists), 1967.

92–93 RM, "Early Morning Afterthoughts," *Maclean's,* December 1971.

93 Gordon Lightfoot, "If You Could Read My Mind" (Reprise Records), 1970.

93 **"high-gloss picture book"** undated letter from RM to Lightfoot, Series 1, AGO Archives.

93–94 RM, "Knowing Lightfoot," *Canadian Magazine,* April 16, 1977.

94 Interview with Lightfoot, May 24, 2006.

94–95 RM, "Gordie Howe ... Forever ... Yes, Yes! And Then Some!" *Telegram Showcase,* April 8, 1967.

95 RM, "Tim Hardin," *Telegram Showcase,* May 9, 1969.

95 "Chips with Everything," *Telegram Showcase,* November 13, 1965.

95–96 "Golden Spike-Heeled Fascination Four Legs Moving ... Why?" *Telegram Showcase,* March 11, 1967.

96 Interview with Don Obe, May 27, 2004. **"God, the stuff reads beautifully"** Don Obe, "Shared Moments," *Toronto Life,* November 1990.

96–97 RM, "Landscape," *Notes for a Native Land,* 103–6.

97 Barrie Hale, *Toronto Telegram,* April 5, 1967.

97–98 Interviews cited above with Dennis Burton, Diane Pugen.

98 New School goals: contained in letter from Harvey Cowan to Gerald Gladstone, June 29, 1967, Series 1, AGO Archives.

99–100 Interviews cited above with Burton, Rayner, Dawn and Beth Richardson, Diane Pugen; author interview with Jerri Johnson, May 19, 2005.

99 Lorne Wagman to author, May 5, 2007.

99 **"Like a big kid"** Rae Johnson to author, July 17, 2005.

99 Author interview with Laura Berman and Sheryl Wanagas, May 17, 2005.

99–100 Interviews cited above with Rae Johnson, Dawn and Beth Richardson, Jerri Johnson.

100 Paul Young, May 25, 2004.

100 Ronald Weihs, "Markle," *Workseen,* September 1990, 27.

100 Interviews cited above with Vera Frenkel and Hana Trefelt.

100 **"cookie recipes"** Dawn and Beth Richardson, May 19, 2005.

100 **"hubby gets home"** Rae Johnson, May 20, 2005.

101–2 Interviews cited above with Rae Johnson, Dawn Richardson, Laura Berman, Sheryl Wanagas, Diane Pugen.

101–2 Interviews cited above with Berman, Rae Johnson, Jerri Johnson, Frenkel, Watson.

103 RM, letter to Kathleen Maracle, dated 1967. Series 1, AGO Archives.

103 **"she is young"** RM, unpublished notes, Series 2; RM, unpublished notes, Series 2.

104 **"never gratuitous"** Diane Pugen, April 26, 2007.

104 Marlene Markle, March 7, 2003.

104 Cited interview with Reeves.

105 Cited interview with Marlene Markle, March 7, 2003.

105 **"She allied herself with me"** RM, unpublished notes, Series 2; Letters to RM, 1968. Series 1.

105–6 **"i really think," "i have a picture"** RM, 1968 letter, Series 1.

106 Letters to RM, 1969, Series 1.

106 **"strangeness between them"** Marlene Markle, March 7, 2003.

106–7 Carsten Jensen, University of Western Ontario *Gazette*, February 2, 1968.

107 Lenore Crawford, *Toronto Telegram*, January 26, 1968.

107 Student comments, University of Western Ontario *Gazette*, February 2, 1968.

107–8 Gwendolyn MacEwen film, Canadian Broadcasting Corporation Fonds, Item Number 111971, Series 3.

108 Nobuo Kubota, May 19, 2004.

108–9 Marlene Markle, March 7, 2003.

109 Cited interviews with Rayner and Marlene Markle.

109 **"struck the centre rail"** *Toronto Telegram*, July 22, 1969.

109–10 Marlene Markle, March 7, 2003.

110–11 Patrick Watson, Lois Markle, Michael Sarrazin to RM, Series 1, AGO Archives.

111–12 Marlene Markle, March 7, 2003.

112 Gordon Rayner's records of Markle benefit, Series 4, AGO Archives.

112 *Moving Outward* drawings: Andy Wainwright.

112 Marlene Markle, March 7, 2003.

113 Poetry lines reproduced from *Moving Outward*, 1970.

113 **"slapped mortality"** and **"thinking miles ahead"** Marlene Markle, March 7, 2003.

113 **"drawing and colour are not separate"** Philip Callow, *Lost Earth: A Life of Cézanne*, 156.

114–15 Paul Young, May 25, 2004.

115 **"grace in desire ... skin proudly"** RM, unpublished notes, Series 2.

115–16 **"focus on the dynamic movement"** Corrina Ghaznavi, *Robert Markle: A Retrospective*, Durham Art Gallery, 2002, 7.

116 Ghaznavi, 7; Herbert Read, *A Concise History of Modern Painting*, 257.

116 Georgia O'Keeffe, *Georgia O'Keeffe*, 1976, n.p.

Chapter VI / Promised Land: Mount Forest 1970–1978

119–20 Gordon Rayner, February 27, 2003; Marlene Markle, interviews March 7, 2003, and May 28, 2004.

119–20 *zaagiing*, meaning "inlet" (or "mouth of river"). This was the name of the permanent Native Settlement at the outlet of the Saugeen River into Lake Huron. http://correlator.sandbox.yahoo.net/index.php/people/Saugeen.

120 Cited interviews with Cowan, Watson, Isaacs.

120–21 **"the most challenging thing"** RM, *Toronto Star*, May 18, 1972.

121 **"sexuality was up for grabs"** Marlene Markle, May 28, 2004.

121 Author interview with Tim Noonan, March 7, 2003.

122 Steve Gravestock, "Don Owen: Notes on a Filmmaker and His Culture," cited in *Canadian Film Encyclopedia*, http://www.filmreferencelibrary.ca/index.

122 Don Owen, *Cowboy and Indian*, National Film Board of Canada, 1972.

122 **"nourishing environment"** Marlene Markle, May 28, 2004.

123 **"These trees"** RM, unpublished notes, Series 2.

124 RM letter to Kathleen Maracle, 1967, Series 1.

124 Cited interviews with Paul Young and Dennis Reid.

125 **"turning the drawings sideways"** Marlene Markle to author, May 9, 2007.

127 Wayne Edmonstone, "Fifty Works at Isaacs," *Toronto Star*, May 18, 1972.

127 Merike Weiler, "The One and Only Robert Markle," *Toronto Citizen*, June 1–14, 1972.

127–28 **"The trouble with the head"** RM quoted in Weiler.

128 "Nudes in a Cold Climate," *Maclean's*, October 1972.

128 Jerrold Morris, *The Nude in Canadian Painting*, 73.

128–29 Interview with Murray McLauchlan, May 18, 2005.

129 McLauchlan, "Barroom Ladies and Michaelangelos," from the album *Heroes* (True North Records), 1984.

129–30 Stephen Williams, May 15, 2005.

130 Michael Sarrazin, May 17, 2004.

130 Marlene Markle, May 28, 2004.

130 Letter to RM from Grant & Deverell (lawyers), December 16, 1974.

131 Tim Noonan, March 7, 2003.

131 Craig Kenny, March 8, 2003.

131 **"extraordinary change"** Marlene Markle, May 28, 2004.

131–33 RM, "Starring on My Own Bubble Gum Card," *Canadian Magazine*, January 17, 1976.

133 Ramsay Derry to RM, February 6, 1976, Series 1, AGO Archives.

133–34 Tim Noonan, March 7, 2003.

135 Letter to RM from Elton A. Brant, Mohawks of the Bay of Quinte Band Adminstrator, June 10, 1977; letter to RM from Canada Post Office, May 4, 1973; Susan Maracle, March 2, 2003.

135 Craig Kenny, March 8, 2003.

135 RM, "Haida Ways," *Books in Canada*, October 1971, 18.

135–36 "Norval Morrisseau" Exposed: Aesthetics of Aboriginal Erotic Art, MacKenzie Art Gallery, Regina, September 24–December 5, 1999.

136 RM quoted in Kate Taylor's review of Innuit Gallery show, *London Free Press*, June 22, 1985.

136 RM Canada Council application, October 1973, Series 3.

136 **"I remember"** Gordon Rayner, "Two Baptisms," 5.

137 Patrick Watson, May 27, 2004.

137 Simon Schama, *Rembrandt's Eyes*, 393.

138 **"like a princess"** RM, unpublished notes, Series 2.

138–39 **"the inside of the mill," "subject matter," "modern art"** RM, unpublished notes, Series 2.

139 **"jaw-dropping"** Marlene Markle, May 28, 2004.

139 **"the armature," "the ideas of the painting,"** RM, unpublished notes, Series 2.

139–40 Watson, May 27, 2004.

140 Michael Sarrazin, May 17, 2004.

141 **"Tricksters liberate"** Gerald Vizenor, "A Trickster Discourse: Comic and Tragic Themes

in Native American Literature," *Buried Roots and Indestructible Seeds: The Survival of American Indian Life in Story, History and Spirit*, 67–83.

141–43 *Witness to Yesterday*, "Rembrandt," History Television, May 21, 1974; RM, unpublished notes, Series 2.

143 RM to James Logan, October 11, 1975.

143 RM to University Art Committee, University of Western Ontario, February 9, 1976,

143 Reply from University of Western Ontario, Lynne D. DiStefano to RM, February 17, 1976, Series 1.

143 **"honorarium"** Ramsay Derry to RM, September 9, 1974.

143 **"Eaton Centre"** Series 3.

144 RM, "Alternative Cuisine," *Maclean's*, March 1973.

145 RM, "The Glory That Is Grease," *The Canadian*, March 19, 1977.

146 RM, "The Passionate Listener," *Toronto Life Audio Guide*, Autumn 1976.

146–47 RM, "The aesthetics of the drive-in movie," *Toronto Life*, May 1977.

148 RM, "The Moral Shape of Sexy Sadie," *Toronto Life*, October 1977.

149 RM, "In the Heart of the Heart of Christmas," *Toronto Life*, December 1977.

150 Peter Synowich to RM, November 1967.

150 Fan letters, 1974, 1977.

150 Huron College letter to RM, November 5, 1977.

150 Dorothy Cameron to RM, October 10, 1977.

150 *Playboy* letter to RM from Ron Moppett, Curator, Alberta College of Art Gallery, October 24, 1977—all in Series 1.

150 Karen Richardson to RM, June 1977, Series 1.

150–51 RM, "Definitive Book List," Series 4, AGO Archives.

153 Marlene Markle, quoted in Ghaznavi, 17.

155 **"rental house"** Marlene Markle, May 28, 2004.

156 **"We had gotten"** Dennis Burton, "The Integrity Project," March 27, 1985, http://www.metameta.ca/bans/Integrity%20/Project.

155–56 Burton interview, February 25, 2005.

157 Diane Pugen, April 26, 2007; Gordon Rayner, February 27, 2003.

157–58 Adele Freedman, *Toronto Life*, November 1977.

158 Norman Snider, *Toronto Life*, March 1979.

158–59 Kathryn Bemrose to author, April 2, 2007.

159 Author interview with Scott Townson, May 24, 2005.

159–60 **"Only here"** RM, *Toronto Life*, 1980.

160 **"very opinionated"** Townson to Marlene Markle, August 1990.

160 Peter Goddard, *Toronto Star*, February 1, 1973.

160 RM to Gordon Lightfoot, September 26, 1977.

160 RM to Pierre Trudeau, August 29, 1978.

160 Pierre Trudeau to RM, September 12, 1978: Series 1.

161 Michael Sarrazin: RM, unpublished notes, Series 2.

162–63 RM to Sonny Rollins, July 1, 1974, Series 1.

163 Artists' Jazz Band records, Series 3.

163–64 Gordon Rayner, February 27, 2003.

164 Rayner, "Two Baptisms," 6–7.

165 **"Miss Marlene"** RM to Jack and Esther Shuster, May 7, 1978, Series 1.

165 Rayner, February 27, 2003.

165 Rayner, "Two Baptisms," 8–9.

165–66 Patrick Watson, May 27, 2004.

166 RM to Canada Council, December 12, 1978, Series 1.

Chapter VII / Visions of Johanna: Toronto and Mount Forest 1978–1983

169 "postcard" RM, unpublished notes, Series 2. Berman and Wanagas, May 17, 2005.

169 Don Obe, May 27, 2004.

169–70 Ruth Grogan, May 24, 2004; "part of the reason" RM, unpublished notes, Series 2.

170–71 "She had two rooms" and "After one of his many absences" RM, unpublished notes, Series 2.

171 Marlene Markle, May 28, 2004.

171 "Johanna's work" Marlene Markle, May 28, 2004.

171 "optimum operating order," etc.: RM, application to Ontario Arts Council, Series 3.

172 "Volkswagen Beetle" Marlene Markle, May 28, 2004.

172–74 "Occasionally," "Sometimes," "In the mirror," "She worked," "He would see her," "some way to touch," "The girlfriend" RM, unpublished notes, Series 2; "bereft," etc., Marlene Markle, May 28, 2004.

175–76 "He was a figure painter," "What am I supposed to do" RM, unpublished notes, Series 2.

176 "were upset" Gordon Rayner, February 27, 2003.

176 "The artist is extremely lucky" John Kissick in David Morris, *The Culture of Pain*, 195.

176–77 Interviews cited above with Michael Sarrazin, Stephen Williams, Av Isaacs, Patrick Watson, Ruth Grogan (quoting Ed Grogan), Laura Berman, Sheryl Wanagas, Dawn and Beth Richardson, Patricia Beatty.

177 Interview cited above with Rae Johnson.

177 "didn't want a family" Marlene Markle, May 9, 2007.

177 "There is a way to see" RM, unpublished notes, Series 2.

178–79 RM, "Blazing Figures," *Exile* 6, nos. 1–2 (1979): 69–147.

178 "Pablo Neruda's 'Fable of the Mermaid and the Drunks'" (London: Jonathan Cape, 1970), 356.

179 "The Waverley" RM, unpublished notes, Series 2.

180 "In the brushstrokes" RM, unpublished notes, Series 2.

180 "Somewhere, down the hall" RM, unpublished notes, Series 2.

181 "He wondered about" RM, unpublished notes, Series 2.

183 Paul Young, *Artists' Review* 11, no. 17 (May 23, 1979).

184 Diane Pugen, April 26, 2007.

184 James Purdie, *Globe and Mail*, May 20, 1979.

184–85 John Bentley Mays, *Globe and Mail*, June 21, 1980.

185 "headstrong, sensuous" Teresa Ames, *The Virginian-Pilot and The Ledger-Star*, March 16, 1980.

185 "one-term position" letter to RM from Dean of Arts, University of Guelph, November 30, 1978. Series 1.

185 "philosophy of teaching," etc.: RM, Course Descriptions, Series 3.

186 "He put a sheet of paper" Marlene Markle, May 28, 2004.

186 "Georgian College" letter to RM, September 14, 1979, Series 1.

186 "almost a marriage" RM, Markleangelo's press release, April 22, 1980, Series 3.

186 "that much and no more" RM, Course Descriptions, Series 3.

186–87 "ceiling tiles" telephone interview with Stephen Centner, March 2007.

187 **"a celebration for the eye,"** etc.: Markleangelo's press release, April 22, 1980.

187 **"plumper"** Stephen Centner, in Adele Freedman, *Toronto Life*, May 1980, 209.

187 **"Centner's wife"** Marlene Markle, May 29, 2004.

188 **"in honour," "slowly reveal"** Markleangelo's press release, April 22, 1980.

188 **"top down"** Marlene Markle, May 29, 2004.

188 John Bentley Mays, *Globe and Mail*, June 21, 1980; Adele Freedman, *Toronto Life*, May 1980, 209.

189 **"right around the corner," "too big"** Patricia Beatty, May 18, 2005.

190 **"auction sales"** Marlene Markle, May 29, 2004.

191 **"I wouldn't have to do anything else"** RM, Series 2.

192 **"The painting and space exist"** RM, 1982, quoted in Moore Gallery catalogue for show April 7–30, 1994.

192 **"Comments"** Mohawk Gallery viewer's book, November 10, 1981.

193 **"It's this left edge"** RM, unpublished notes, Series 2.

194 **"offered for sale," "felt comfortable"** Marlene Markle, May 29, 2004.

194 University of Calgary project submission, August 1985, Series 3.

194 **"best-ever dinner"** *Toronto Star*, September 25, 1983, Series 4.

195 Bob Dylan, "Visions of Johanna," *Blonde on Blonde* (Columbia Records), 1966.

Chapter VIII / Mount Forest: 1983–1990

198 **"shunned the emergence"** and **"resisted trading"** Anna Hudson, "Wonder Women and Goddesses," in AGO catalogue for Wieland–Markle show, November 29, 2003–February 29, 2004, 54.

198–202 Metro Toronto Convention Centre and Centre records, Series 3. Ironically, the unjust Toronto Purchase by the British from the Mississauga people "dates to a 1787 meeting at Tyendinaga." For details see *The Globe and Mail*, January 27, 2010, A5.

203 **"All the units"** RM, Convention Centre preparatory notes, Series 3.

203 John Bentley Mays, *Globe and Mail*, October 6, 1984.

203 Diane Pugen, April 26, 2007; Gordon Lightfoot: "Canadian Railroad Trilogy" was commissioned by CBC for a January 1, 1967, broadcast.

204 Craig Kenny, March 8, 2003.

204 Tim Noonan, March 7, 2003.

204 Stephen Williams, May 15, 2005.

205 University of Calgary project submission, August 1985, Series 3.

205 RM to Department of Indian Affairs, March 25, 1985, Series 3.

206 Notes for Eaton Centre project submission, Series 3.

206 **"physical health"** Marlene Markle, May 29, 2004.

206 **"slow-pitch softball"** Tim Noonan, March 7, 2003.

206–8 Carol Podedworny, "The Painter and His Model: Markle since '85," Thunder Bay Art Gallery catalogue, 1989.

208 Dennis Reid, May 25, 2006.

210 **"You would swear to God"** Tim Noonan, March 7, 2003.

210 **"storefronts," "the idea of the passing of time," "a gift to Mount Forest"** *Durham Chronicle*, August 20, 1986, Series 9.

210 **"where's the nude?"** Marlene Markle, May 29, 2004.

211–12 Stephen Williams, May 15, 2005.

212 **"old European tradition"** *Owen Sound Sun-Times*, July 4, 1989.

SOURCE NOTES

212–13 **"Tom Thomson's jack pines"** Kate Taylor, *London Free Press,* June 22, 1985.

213 **"based on photographs"** Marlene Markle, May 9, 2007.

216 **"Gordon Hatt"** Marlene Markle, May 9, 2007.

216–18 John Vainstein, *Priceville Prints,* Ontario Arts Council, 1987.

219 *"The Glamour Sisters"* and **"$1700 worth of paintings"** Series 3.

221–22 Marjorie Stone, "Gender and Creation: Feminism and Robert Markle," *Descant* 23, no. 3 (Fall 1992): 87–94.

222 **"Haudenosaunee law"** Degiya'göh Resources, http://www.degiya'göh.net/great_law.htm.

222 Sarah Milroy, *Globe and Mail,* December 13, 2003; Peter Goddard, April 29, 2007; Stone, *Descant.*

225–26 "Hanover Hustle," RM, April 1988, Series 2.

226–27 Michael Sarrazin, May 17, 2004.

232 Hebert Read, *A Concise History of Modern Painting,* 162.

232 **"its accomplishment"** Michael Snow, May 20, 2004; Peter Goddard, April 29, 2007.

233 Anna Hudson, "Wonder Women and Goddesses," 55.

233–34 Interview with Tom Hill, May 16, 2005.

234 Patricia Beatty, May 18, 2005.

234 Gerald Vizenor with A. Robert Lee, "Discursive Narratives," in *Postindian Conversations,* 1999, 84–85, cited in Hudson, 54.

234 **"imaginary Indian"** Daniel Francis, *The Imaginary Indian: The Image of the Indian in Canadian Culture,* 1992.

235 **"everything was going into his art," "more or less successfully"** Marlene Markle, May 29, 2004.

235–37 RM, "Hooked," *Toronto Life,* April 1989.

237 "Something Brewing" notes, drafts, and script, Series 3.

Chapter IX / Afterlife: 1990–

241 Peter Goddard, April 29, 2007.

241–43 Marlene Markle, May 29, 2004.

242–43 Cited interviews with John Reeves, Murray McLauchlan, Ruth Grogan, Patrick Watson, Paul Young, Laura Berman, Michael Sarrazin.

242 **"At least we had him for twenty more years"** Marlene Markle, March 19, 2009.

243 C.S. Lewis, *A Grief Observed,* 1.

243 Marlene Markle, May 29, 2004, and March 19, 2009.

243 Graham Coughtry, August 1990.

243–44 Andy Wainwright, "Visions of Robert," *Landscape and Desire: Poems New and Selected,* 1992.

244 Udo Kasemets, "Marklewake," August 1990, Series 23.

244 Tim Noonan, March 7, 2003.

244 **"personality so uniquely vast"** Dorothy Cameron to Marlene Markle, August 1990, Series 23.

244 Marjorie Stone, *Descant,* 94

245 Marlene Markle, May 29, 2004.

245–46 Interview with Anna Hudson, March 5, 2003.

245 Dennis Reid, May 25, 2006.

246 Michael Snow, May 20, 2004.

246–47 Anna Hudson, "Wonder Women and Goddesses," 41. Hudson's own citation at "Nudes and Whores" is from Carol Duncan, "The Aesthetics of Power in Modern Art," *Heresies,* January 1977.

247 Dennis Reid, May 25, 2005.

247–48 Interview cited above with Frenkel, Gorman, Young, Trefelt, Dawn and Beth Richardson.

248 Interviews cited above with Grogan, Isaacs, Goddard.

248 Sarah Milroy, *Globe and Mail*, December 13, 2003.

248 Corinna Ghaznavi, *Robert Markle: A Retrospective*, Durham Art Gallery, 2003.

248–49 Interviews cited above with Isaacs, Reid, Watson, Young, Frenkel, Jerri Johnson, Burton, and Townson.

249 Marlene Markle, May 29, 2004.

249–50 Interview cited above with Goddard.

250 **"the painters of the 1960s"** Norman Snider, *Globe and Mail*, November 14, 1984.

250 **"reminiscent of Whistler," "beach ball"** Snider *Toronto Life*, March 1979.

250 **"great love for the world"** Marlene Markle, May 28, 2004.

250 **"call me not an artist"** RM to Marlene Markle, 1957, Series 1.

251–52 Interviews cited above with Dawn and Beth Richardson, Bemrose, Berman, Wanagas, Jerri Johnson, Beth Richardson, Rae Johnson, Frenkel, Trefelt, Kenny, Watson, Townson, Sarrazin, Burton, Snow, Cowan.

252 Interviews cited above with Kubota, Young, Pugen, Rayner.

252–54 Marlene Markle, May 29, 2004.

BIBLIOGRAPHY

Brant, Beth. *I'll Sing 'Til the Day I Die: Conversations with Tyendinaga Elders*. Toronto: McGilligan Books, 1995.

Bruckert, Chris. *Taking It Off, Putting It On: Women in the Strip Trade*. Toronto: Women's Press, 2002.

Burnett, David, and Marilyn Schiff. *Contemporary Canadian Art*. Edmonton: Hurtig Publishers, 1983.

Callow, Philip. *Lost Earth: A Life of Cézanne*. Chicago: Ivan R. Dee, 1995.

Duncan, Carol. "The Aethetics of Power in Modern Arts." *In Feminist Art Criticism: An Anthology*, Arlene Raven, Cassandra L. Langer, and Joanne Frueh, eds. New York: Icon Editions, 1992.

Evans, Lois C. *Hamilton: The Story of a City*. Toronto: Ryerson Press, 1970.

Finlay, Victoria. *Colour: Travels through a Paintbox*. London: Hodder and Stoughton, 2002.

Francis, Daniel. *The Imaginary Indian: The Image of the Indian in Canadian Culture*. Vancouver: Arsenal Pulp Press, 1992.

Fraser, James. *The Golden Bough: A Study in Magic and Religion*. London: Macmillan, 1922, 1990.

Fulford, Robert. *Best Seat in the House: Memoirs of a Lucky Man*. Toronto: Collins, 1988.

Ghaznavi, Corinna. "Contemplating Robert Markle." In *Robert Markle: A Retrospective*. Durham, ON: Durham Art Gallery, 2003.

Girard, Philip. *Bora Laskin: Bringing Law to Life*. Toronto: Osgoode Society for Canadian Legal History, 2007.

Gombrich, E.H. *The Story of Art*. London: Phaidon Press, 1995.

Holubizky, Ihor. *Small Villages, The Isaacs Gallery in Toronto: 1956–1991*, "Making the Frame." http://www.ccca.ca/history/isaacs/english/sv-ihor/hol1005t.html.

Hudson, Anna. "Wonder Women and Goddesses." In *Woman as Goddess: Liberated Nudes by Robert Markle and Joyce Wieland*. Toronto: Art Gallery of Ontario, 2003.

Isaacs Seen. Toronto: Hart House, University of Toronto/University of Toronto Art Centre/Textile Museum of Canada/Art Gallery of Ontario, 2005.

Kearns, Emily. *The Oxford Dictionary of Classical Myths and Religion*. Oxford: Oxford University Press, 2003.

Lewis, C.S. *A Grief Observed*. London: Faber & Faber, 1961.

Lieber, Edward. *Willem de Kooning: Reflections in the Studio*. New York: Harry N. Abrams, 2000.

Lindquist, Mark, and Martin Zanger. *Buried Roots and Indestructible Seeds: The Survival of American Indian Life in Story, History, and Spirit.* Madison: University of Wisconsin Press, 1994.

Lord, Barry. *The History of Painting in Canada: Toward a People's Art.* Toronto: NC Press, 1974.

Lucie-Smith, Edward. *Toulouse-Lautrec.* New York: Phaidon, 1977.

Morris, David B. *The Culture of Pain.* Berkeley: University of California Press, 1991.

Morris, Jerrold. *The Nude in Canadian Painting.* Toronto: New Press, 1972.

Nasgaard, Roald. *Abstract Painting in Canada.* Vancouver/Halifax: Douglas and McIntyre/Art Gallery of Nova Scotia, 2007.

Podedworny, Carol. *The Painter and His Model: Markle since '85.* Thunder Bay, ON: Thunder Bay Art Gallery, 1989.

Rasenberger, Jim. *High Steel.* New York: HarperCollins, 2004.

Read, Herbert. *A Concise History of Modern Painting.* London: Thames and Hudson, 1959.

Sassoon, Donald. *Mona Lisa: The History of the World's Most Famous Painting.* London: HarperCollins, 2001.

Schama, Simon. *Rembrandt's Eyes.* New York: Knopf, 1999.

Snow, Michael, ed. *1948–1993: Music/Sound, The Michael Snow Project.* Toronto: Art Gallery of Ontario/The Power Plant/Knopf Canada, 1993.

Stevens, Mark, and Annalyn Swan. *de Kooning: An American Master.* New York: Knopf, 2004.

Stevens, Wallace. *Poems by Wallace Stevens.* New York: Vintage Books/Random House, 1959.

Stone, Irving. *Lust for Life.* Garden City, NY: Doubleday, 1937.

Stone, Marjorie. "Gender and Creation: Feminism and Robert Markle." *Descant* 78, vol. 23, no. 3 (Fall 1992).

Vizenor, Gerald, and A. Robert Lee. *Postindian Conversations.* Lincoln: University of Nebraska Press, 1999.

Wainwright, Andy. *Notes for a Native Land.* Ottawa: Oberon Press, 1969.

——. *Moving Outward.* Toronto: New Press, 1970.

Waldman, Carl. *Atlas of the North American Indian.* New York: Facts on File Publications, 1985.

White, Patrick. *The Vivisector.* New York: Viking Press, 1970.

York, Geoffrey. *The Dispossessed.* Toronto: Lester & Orpen Dennys, 1989.

——, and Loreen Pindera. *People of the Pines: The Warriors and the Legacy of Oka.* Toronto: Little, Brown, 1991.

PHOTOGRAPH ACKNOWLEDGEMENTS

Chapter II

Page 9. J.A. Wainwright
Page 11. Marlene Markle
Page 14. Jack Foster
Page 17. Susan Maracle
Page 19. Susan Maracle
Page 23. Jack Foster

Chapter III

Page 32. Library and Archives, Art Gallery
of Ontario, Toronto. © 2009 Art Gallery
of Ontario
Page 42. Jack Foster
Page 47. Marlene Markle

Chapter IV

Pages 58 and 76. Library and Archives,
Art Gallery of Ontario, Toronto. © 2009
Art Gallery of Ontario

Chapter V

Pages 89 and 108. Library and Archives,
Art Gallery of Ontario, Toronto. © 2009
Art Gallery of Ontario
Page 91. Early Morning Productions and
Gordon Lightfoot

Chapter VI

Pages 123, 133, 134, 140, 154, 164, 166,
and 167. Library and Archives, Art
Gallery of Ontario, Toronto. © 2009
Art Gallery of Ontario

Chapter VII

Page 170. Ruth Grogan
Pages 189, 193, and 195. Library and
Archives, Art Gallery of Ontario,
Toronto. © 2009 Art Gallery of Ontario

Chapter VIII

Pages 200, 211, 224, 231, and 239. Library
and Archives, Art Gallery of Ontario,
Toronto. © 2009
Page 207. Marsha Boulton
Page 217. John Vainstein
Page 219. J.A. Wainwright

GENERAL INDEX

abstract expressionism, 33–35, 71, 77, 126

Académie de Paris, 166

Acorn, Milton, 250

Adeline Avenue (Hamilton), 12–13, 16–18, 29, 42, 229, 254. *See also* Robert Markle: boyhood

Albright-Knox Art Gallery (Buffalo), 48

Allen, Woody, 127

"Angie," 104–6, 108, 169–70, 176. *See also* Robert Markle: affairs

Art Gallery of Ontario (AGO), 43, 48–49, 51, 65, 78, 152, 245, 247, 250. *See also* Anna Hudson; Dennis Reid

Arthur (Ontario), 129, 190

Arthur Murray Dance Studio, 56

Artists' Jazz Band, 33, 76–80, 88, 98, 106, 107–9, 111, 119, 136, 162–63, 165, 176, 243

Artists' Review, 183

Artscanada, 96, 100

Art's Sake Inc., 101, 156–61, 169–71, 185–86, 193. *See also* Robert Markle: students/teaching

Atikokan (Ontario), 75

Bacon, Francis, 71

Baez, Joan, 94

Baldwin, Kenny. *See* Artists' Jazz Band

Ballard School (Hamilton), 18, 22

Balmoral Avenue (Hamilton), 9, 13

Bamford, Caroline, 165, 237. *See also* Patrick Watson

Band, The, 109

Banfer Gallery (New York), 63

Banner Signs, 51, 48–49

Bassett, John, 61

Bata Shoes, 143

Batten, Jack, 89

Beat Generation, 77

Beatles, 77

Beatty, Patricia, 30, 72, 177, 188–89, 234. *See also* Robert Markle: Native issues/identity

Beauchemin, Micheline, 63

Beckett, Samuel, 72, 151

Beethoven, Ludwig van, 176

Belafonte, Harry, 95

Bemrose, Kathryn, 158–59, 251. *See also* Art's Sake Inc.; Robert Markle: students/teaching

Berman, Laura, 99, 102, 169, 177, 242, 251. *See also* Robert Markle: students/teaching; New School of Art

Berryman, John, 176

Berton, Pierre, 84, 92

Beverley Hotel, 29

Beverley Street (Toronto), 31, 42–43

Blakey, Art, 29

Bloor Street Billiards Room, 46

Bonnard, Pierre, 123, 150, 213, 221, 228, 231

Books in Canada, 135

Borduas, Paul-Émile, 34, 37–38. *See also* *Refus global*

Boulton, Marsha, 129, 175

Brant, Joseph, 7, 194

Brantford (Ontario), 16, 203, 233, 245

Brasserie Lipp (Paris), 187

British Broadcasting Corporation (BBC), 97, 237

British Museum, 248

Britnell's bookstore, 52

Brown, Clifford, 32, 75, 146

Browndale Camps, 53

Brubeck, Dave, 31

Brunswick Tavern, 94, 102, 106, 108, 128, 155, 159, 199. *See also* Robert Markle: drinking; New School of Art

Burton, Dennis, 27–30, 34, 36–37, 57, 63, 68, 77, 84, 97–101, 111, 155, 160, 171, 187, 193. *See also* New School of Art; John Sime

Bush, Jack, 34–36, 72, 155

Business Council on National Issues, 156

Café des Copains, 186. *See also* Stephen Centner

Cage, John, 77

Calgary, University of. *See under* university

Callaghan, Barry, 177

Cameron, Dorothy, 49, 53, 60, 63–66, 83, 113, 128, 148, 150, 244. *See also* Eros 65

Canada Council, 136, 156, 163, 166, 171–72, 250

Canadian, The (magazine), 89, 94, 131, 144–45, 158, 161

Canadian Art (magazine), 65

Canadian Broadcasting Corporation (CBC), 31, 53, 67, 88, 106–7, 128, 203

Canadian Composer, The, 79

Canadian Embassy (Paris), 163

Carmichael, Catherine, 212

Carr, Emily, 59, 135, 193

Carr-Harris, Ian, 53

Cary, Joyce, 31

Cash, Johnny, 95

Casino Burlesque, 55

Centner, Stephen, 186–87. *See also* Markleangelo's

Chagall, Marc, 188, 212

Charlie's Place, 72–74, 85, 120. *See also* Magenetawan River; Gordon Rayner

Chassériau, Théodore, 169–70

Chicago, Judy, 145

Chichester, Francis, 111

Christie, Dinah, 241, 243

Clark, Guy, 129

Clarke, Irwin & Company, 129

Claudel, Camille, 173

Claus, Amelia, 8. *See also* Robert Markle: family; Tyendinaga

Claus, Michael, 8. *See also* Robert Markle: family; Tyendinaga

Club 22, 128–29, 131, 160–61, 169, 234

Clute, George, 8. *See also* Robert Markle: family; Tyendinaga

Cocteau, Jean, 189

Cohen, Leonard, 38, 121

Coleman, Ornette, 77

Colonial Tavern, 29, 75, 77

Coltrane, John, 24–25, 74–75, 77, 163

Contact Press, 38

Cooke, Garry, 32, 47. *See also* Robert Markle: marriage; Ontario College of Art

Cookstown (Ontario), 190

Corman, Roger, 68

Corot, Jean-Baptiste-Camille, 238

Coughtry, Graham, 29, 33, 35, 36–39, 46–49, 51, 63, 67–68, 70–79, 98–101, 107–9, 120, 122, 124, 130, 136, 156, 158, 163–65, 169, 185, 189, 204, 221, 226–28, 242

Courbet, Gustave, 167, 238

Cowan, Harvey, 31, 46, 69–70, 72, 77–79, 83, 120, 252

Cowboy and Indian, 122, 145, 218. *See also* Don Owen

Crawford, Lenore, 106–7

Crazy Horse, 194

Creemore (Ontario), 237–39

Creemore Springs Brewery, 237. *See also* *Something Brewing*

cubism, 34

Cudmore, Mr. (art teacher), 22. *See also* Robert Markle: artistic ability/interest (teens)

Curnoe, Greg, 45

Dachau, 113

Danby, Ken, 90

Darin, Bobby, 95

Dash (dog), 121–22

Daumier, Honoré, 217

David (Michelangelo, Verrocchio, Donatello), 166

da Vinci, Leonardo, 27, 137

Davis, Miles, 75, 111, 146, 165

Deganawida, 10, 194, 203, 228, 234. *See also* Iroquois Confederacy; Tyendinaga

Degas, Edgar, 28, 150

de Kooning, Willem, 34–35, 48, 71–72, 86, 96, 135, 138–39, 142, 148, 150, 152, 182, 189

de Menil, Adelaide, 135

del Sarto, Andrea, 166

Delta High School (Hamilton), 15, 23

Derry, Ramsay, 133

Deserontyon, Captain John, 7. *See also* Iroquois Confederacy; Tyendinaga

Deux Magots (Paris), 166

Dickey, James, 236

Dobbs, Kildare, 63

Dofasco/Dominion Steel Company, 13, 15

Dolphy, Eric, 79

Don River, 199, 202

Downchild Blues Band, 112

Dreyfus, Richard, 137

Dufferin County Museum, 219. *See also* Index of Works by RM: Whirligigs

Dunedin (Ontario), 238–39

Dürer, Albrecht, 144, 216

Durham Art Gallery, 204, 216, 255

Durham Chronicle, 210

Dylan, Bob, 89, 92, 94, 195. *See also* "Johanna"

Eaton's (Toronto), 37, 43, 158, 205–6

Edmonstone, Wayne, 127

Eikhard, Shirley, 243

Elora (Ontario), 190

Eros 65, 63–67, 88, 107. *See also* Dorothy Cameron

Esquire, 46, 145

Exile, 177–79

Fairfield Public School (Hamilton), 18

Fauvism, 34

Federal Indian Act (1876), 10

Fenton, Telford, 28, 33

Ferlinghetti, Lawrence, 108

Fillion, John, 185

Findley, Timothy, 129

First Floor Club, 43

Fitzhenry and Whiteside, 93, 133

Flesherton (Ontario), 216

Flesherton Art Gallery, 245

Flynn, Errol, 127

Fonda, Henry, 88

Forster, Terry, 79. *See also* Artists' Jazz Band

Foster, Jack, 13, 15, 16, 22, 47. *See also* Robert Markle: boyhood

Frazer, James George, 224

Freedman, Adele, 157, 188

Freiburger's Foods, 3, 209–11. *See also* Index of Works by RM: Installations and Murals

Freifeld, Eric, 28

Frenkel, Vera, 59, 70, 72, 100, 102, 247, 249, 251. *See also* Brunswick Tavern; Robert Markle: gender issues/feminism

Frye, Northrop, 112

Fulford, Robert, 39, 49, 51–52, 65, 70

Gage Park (Hamilton), 9, 21

Gagnon, Clarence, 33

Gallagher, Gregory, 79–80

Gaucher, Yves, 63

Gauguin, Paul, 31

Georgian Bay, 72, 84–85, 121, 210, 238, 244. *See also* Index of Works by RM: Go Home Lake sketchbook

Georgian College (Owen Sound), 186

Geraldine Davis Gallery, 244

Ghaznavi, Corinna, 115–16

Gimlets, 190

Ginsberg, Allen, 109, 113

Glass, Philip, 163

Globe and Mail, 39, 66, 159, 184–85, 203, 222, 250

Godard, Jean-Luc, 67

Goddard, Peter, 37, 79, 160, 222, 241, 248–50

Gogol, Nikolai, 176

Go Home Lake, 84–86, 104

Gorman, Richard (Rick), 28–29, 31–33, 35–36, 45–46, 48, 63, 68, 75–79, 97, 248

Grace Street Public School, 39

Gravestock, Steve, 122. *See also Cowboy and Indian*; Don Owen

Great Law of Peace/Tree of Peace (Iroquois), 9–10, 202, 205, 234

Greco, El, 107

Greenwich Gallery, 38–39, 52. *See also* Avrom Isaacs

Greenwich Village (New York), 64

Grogan, Edward (Ed), 111, 120, 122, 137, 169, 170, 176

Grogan, Ruth, 61, 69–70, 120, 122, 169, 242, 248

Grossman, Irving, 76

Grossman's Tavern, 109

Group of Seven, 28, 33–35, 52, 68, 85, 201, 203, 238, 246

Guelph University. *See under* university

Guggenheim Museum, 84

Hagan, Fred, 28, 144. *See also* Robert Markle: expulsion from OCA

Haggard, Merle, 129

Hale, Barrie, 38, 52–53, 98, 157

Hamilton (Ontario), 4, 8–9, 12–25, 29, 37, 40, 43, 47, 56, 68, 75, 111, 131, 135, 149, 188, 191, 194, 229, 244. *See also* Robert Markle: boyhood

Hamilton Art Gallery, 22

Hamilton Spectator, 19, 65

Hamilton Tiger Cats, 19

Hammett, Dashiell, 121, 151

Hancock, Herbie, 111

Handy, Arthur (Mickey), 97, 111

Hanson, Ray, 13, 16, 18, 23–24. *See also* Robert Markle: boyhood

Hardin, Tim, 94–95. *See also* Index of Works by RM: Writings

Harper, Elijah, 11–12

Harris, Lawren S., 238. *See also* Group of Seven

Hart House Gallery (University of Toronto), 34, 36–37

Hatt, Gordon, 216

Hayes, Fred, 65–66, 106. *See also* Eros 65

Hedley, Tom, 83, 96, 145, 186. *See also* Index of Works by RM: Writings; Don Obe

Hedrick, Robert, 49, 97. *See also* New School of Art

Hemingway, Ernest, 40, 163

Hendry, Thomas. *See* Art's Sake Inc.; Robert Markle: students/teaching

Henstrich, Ian, 79. *See also* Artists' Jazz Band

Henstrich, Wimp, 79. *See also* Artists' Jazz Band

Highways, Department of (Ontario), 33, 44, 85, 138

Hill, Tom, 233–35, 243. *See also* Robert Markle: Native issues/identity

Hockey Night in Canada, 68, 94, 144

Hockney, David, 207

Hodges, Johnny, 77

Hodgson, Tom, 78. *See also* Painters 11

Hoffer, Eric, 96

Holiday, Billie, 29, 31

Holstein (Ontario), 155

Holubizky, Ihor, 37, 52

Horsburgh, Kevin, 5. *See also* Robert Markle: death

House of Hamburg, 32

Howe, Gordie, 94–95, 132, 150. *See also* Index of Works by RM: Writings

Hudson, Anna, 233, 245–47. *See also* Art Gallery of Ontario; Robert Markle: one-person shows; Robert Markle: gender issues/feminism

Humber River, 37, 197, 199, 201–2

Humewood Public School, 40

Huron College (London, Ontario), 150

Huston, John, 29

Hutt, William, 137

Hyatt Regency Hotel (Toronto), 105

Ibiza, 120, 165, 169. *See also* Artists' Jazz Band; Graham Coughtry

Imperial Oil, 156

Imperial Order of the Daughters of the Empire (IODE), 23, 25, 44. *See also* Robert Markle: artistic interest/ability (teens)

Indian Affairs, Department of (Canada), 205, 233
Ingres, Jean Auguste Dominque, 225
Inner Sanctum (radio program), 16, 40. *See also* Marlene Markle: girlhood; Robert Markle: boyhood
Innuit Gallery, 212
Inuit Treaty (1999), 11
Ipperwash (Ontario), 12
ironworkers/high steel, 8, 13, 20–21, 122, 135, 194, 234. *See also* Kahanawake; Bruce Maracle; Mitchell Maracle
Iroquois Confederacy; 9, 202, 234
Iroquois/Mohawk history and culture, 7–8, 9–12, 14–15, 20, 29–30, 74, 111, 134–35, 139, 165, 184, 188, 194, 198, 199–204, 199–204, 221, 233–34
Isaacs, Avrom (Av), 3, 37–39, 51–52, 64–70, 192–93, 234, 248–49
Isaacs Gallery, 49, 51, 53, 57, 60, 63, 67–68, 79–80, 83–84, 87–88, 90, 97, 99, 108–9, 112, 119, 120, 123, 126–28, 143, 151, 176, 183, 184, 188, 190, 192, 207, 213, 244–45, 252. *See also* Robert Markle: one-person shows
Ivon Avenue (Hamilton), 13

Jackson, A.Y., 203, 238
Jay Treaty of Amity, Commerce, and Navigation (1794), 20. *See also* ironworkers/high steel
Jennings, Waylon, 129, 146, 159
Jensen, Carsten, 106
Jerrold Morris International Gallery, 78
"Johanna," 169–86, 189–95. *See also* Bob Dylan; Marlene Markle; Robert Markle: affairs
Johnson, Jerri, 98, 99, 102, 249, 251. *See also* Robert Markle: students/teaching; New School of Art
Johnson, Rae, 57, 59, 64, 99–100, 102, 113, 177, 251. *See also* Robert Markle: friends/colleagues; Robert Markle: students/teaching; New School of Art
Jones, Jim, 79, 163, 164. *See also* Artists' Jazz Band; Ibiza
Julian Avenue (Hamilton), 13

Kahnawake, 10, 12, 20, 122, 203. *See also* Iroquois/Mohawk history and culture; Robert Markle: Native issues/identity; Oka
Kanesatake, 10, 12. *See also* Iroquois/Mohawk history and culture; Robert Markle: Native issues/identity; Oka
Kasemets, Udo, 244
Kaufman, Moe, 250
Kawabata, Yasunari, 180, 183, 194, 228. *See also* Robert Markle: paintings, books
Kenilworth Cinema (Hamilton), 18
Kenny, Craig, 4, 131, 135, 204, 241, 251. *See also* UIC Flyers
Kerouac, Jack, 72, 77, 109, 113, 151
Kerr, Doug, 4, 134. *See also* Robert Markle: Native issues/identity; UIC Flyers
Kilbourn, Elizabeth, 39, 61, 70
Kitchen Club (New York), 162
Klunder, Harold, 212, 217–18. *See also* *Priceville Prints*
Koehler, Bill, 210–11. *See also* Freiburger's Foods
Kratcheck, Steve, 22
Kristofferson, Kris, 94
Kubota, Nobuo (Nobi), 30, 33, 46, 68, 72, 74–77, 79–80, 104, 108–9, 111, 113, 119–20, 122–23, 130, 143, 163, 242, 252. *See also* Artists' Jazz Band; Robert Markle: Native issues/identity
Kurelek, William, 63
Kurosawa, Akira, 67

Lady Chatterly's Lover, 64
Laing Gallery, 37, 102
Lake of Two Mountains, 10. *See also* Iroquois/Mohawk history and culture; Oka
LaPierre, Laurier, 67
LaRose, Rose, 24, 178. *See also* Robert Markle: artist model; Robert Markle: dancers/strippers
Laskin, Bora, 66. *See also* Eros 65
Latner, Al, 37–38
Layton, Irving, 38, 151
Leary, Timothy, 77
Lederer, Ruth, 111

Lee, Gypsy Rose, 148. *See also* Robert Markle: artist model; Robert Markle: dancers/strippers

Lee, Peggy, 56

Leigh, Vivien, 40

Leo Kamen Gallery, 244

Leween, Susan, 7–8. *See also* Robert Markle: family; Tyendinaga

Lightfoot, Gordon, 83, 89–94; "Canadian Railroad Trilogy," 92; "Early Morning Rain," 92; "If You Could Read My Mind," 93; "The Last Time I Saw Her," 90; *Sunday Concert*, 92

Lismer, Arthur, 27, 203. *See also* Group of Seven

Logan, Dan; 23. *See also* Robert Markle: artistic ability/interest (teens)

Logan, James, 143

London Free Press, 136

Losey, Joseph, 17

Louvre, 54, 166, 167

Lust for Life, 31. *See also* Robert Markle: influences

Lyman, John, 34

Lywood, Kenny, 97. *See also* Artists' Jazz Band

MacCormack, Denyse, 163. *See also* Artists' Jazz Band

MacDonald, J.E.H., 27, 33, 85. *See also* Group of Seven

Macdonald, Jock, 28, 34–37, 155. *See also* Ontario College of Art; Painters 11

Macdonald, Rose, 39

MacEwen, Gwendolyn, 38, 107–8

MacKenzie Art Gallery, 135, 245

Maclean's, 92, 96, 128, 144. *See also* Robert Markle: publications/writing

Magnetawan River, 72–74, 81, 108, 120, 165. *See also* Charlie's Place

Mahoney Park (Hamilton), 13, 15, 19, 94, 131. *See also* Robert Markle: boyhood

Malcolmson, Harry, 65, 70, 157

Manet, Édouard, 165

Maple Leaf Gardens, 68, 131, 133

Maracle, Bert, 13. *See also* Robert Markle: family

Maracle, Bruce, 8–9, 11, 13, 15, 16–17, 19, 21–22. *See also* Robert Markle: family, boyhood; ironworkers/high steel

Maracle/Markle, Kathleen, 8–9, 13–17, 21–23, 25, 29, 42, 45, 46–47, 241–43. *See also* Robert Markle: family, boyhood

Maracle, Mitchell, 9, 13–14, 16, 18, 20–22, 25, 46, 241. *See also* ironworkers/high steel; Robert Markle: family, boyhood

Maracle, Nelson, 7–8, 10. *See also* Tyendinaga

Maracle, Susan, 9, 13–14, 16–17, 21–22, 46, 135, 241–42. *See also* Robert Markle: family, boyhood

Markle, Lois, 9, 13, 16, 22, 25, 109, 111, 241–42. *See also* Robert Markle: family, boyhood

Markle, Marlene: as artist model/muse, 56–59, 61, 74, 115, 153, 180, 183, 213, 220, 223, 227–28, 230–32; birth, 39; views of: Graham Coughtry's views on, 71–72; death of Robert Markle, 3–4, 241–43; domestic relationship with Robert Markle, 67, 95, 108–9, 122, 130, 145–46, 155, 190, 194, 205; drinking (Robert Markle), 41, 68–69; early employment, 45–46; girlhood, 39–41; Go Home Lake, 85–86; health of Robert Markle, 206; Isaacs Gallery employment, 51; life after Robert Markle's death, 252–55; marriage to Robert Markle, 46–47; motorcycle accident (Robert Markle, 1969), 109–12; move to Mount Forest/farmhouses, 119–21, 135; Native issues/identity, 194, 254; Ontario College of Art experience, 41–44; other women (Robert Markle), 69–70, 84, 104–7, 169–77, 191, 194; Gordon Rayner's views on, 71–72. *See also* "Angie"; "Johanna"; Markle, Robert: artist model; Rembrandt (Robert Markle's performance), 137, 139; Michael Sarrazin's views on, 87; teaching (Robert Markle), 186; whirligigs donation, 219–20

Markle, Robert: affairs, 41, 69, 84, 103–6, 169, 177, 254 (*see also* "Angie";

"Johanna"); antique shows/collections, 190, 218–19, 230, 237; artistic ability/ interest (teens), 21–25; artist's model, 25, 55, 57, 104, 124, 137, 174, 178, 195, 220, 232, 245, 249 (*see also* dancers/strippers); birth, 9; books/ reading, 16, 27, 31, 52, 73–74, 93–94, 102, 112–13, 129, 133, 137, 140, 143, 146, 150–53, 171, 175, 190, 231, 236, 253; boyhood, 4, 9, 12–25; colour (introduction of, view of, use of), 85, 99, 113–14, 117, 123–24, 126–27, 138, 154, 165, 176, 183–85, 238; dancers/ strippers, 54–55, 59m 84, 95, 105, 117, 125, 136–37, 148–49, 152, 166, 177–78, 180, 187, 220, 232 (*see also* artist model); death, 3–5; reaction to, 241–44; draftsmanship/calligraphy, 38, 47–48, 101, 117, 124, 126–27, 180–81, 183; drinking, 4, 28–29, 68–69, 75, 109, 119, 139, 160, 162, 175, 211, 242, 251; early employment, 19, 22, 46, 49, 51; eroticism/erotic art, 48–49, 53–54, 56, 67, 115, 127–28, 135, 151, 191, 228; family, 7–9, 12–22, 25 (*see also* Bruce Maracle; Kathleen Maracle/Markle; Lois Markle; Mitchell Maracle; Susan Maracle); films/television (*see* BBC; Gwendolyn MacEwen; Don Owen; John Vainstein; Patrick Watson); finances, 25, 31, 46, 67, 87, 98, 111–12, 123, 143–45, 155, 157, 185, 194, 243; gender issues/ feminism, 55, 57, 59, 84, 100–103, 145, 150–51, 192, 218, 221–22, 244, 247–48, 251; health issues, 95, 235; influences, 16, 25, 44, 36, 99, 123, 165, 212, 251 (*see also* abstract expressionism; Paul-Émile Borduas; Graham Coughtry; Willem de Kooning; Group of Seven; jazz, Painters 11; Jackson Pollock; Rembrandt; Jean-Paul Riopelle); jazz, 24–25, 29–33, 43, 64, 71, 75, 76–80, 108, 111, 123, 146, 151, 159, 162–63, 224–25, 232, 249–50 (*see also* Artists' Jazz Band; *see also* musicians' names); marriage, 45–47 (*see also* Marlene Markle); motorcycles, 24, 58, 67–68, 72–73, 86, 98, 143, 172, 237, 252; motorcycle accident (1969), 4, 110–14, 117, 122, 127, 159, 172, 235, 239; muse, 4, 25, 39, 56, 58–59, 69, 148, 153, 171, 175–76, 182, 189, 195, 209, 215–16, 220, 222–23, 228–29, 232, 239, 246, 249, 254; music, 4, 17, 24, 40, 52, 69, 74, 83–84, 94, 112, 122, 129, 146–47, 165, 178, 180, 225, 250, 252; Native issues/ identity, 4, 7–12, 13–16, 20, 30, 42, 74, 88, 92, 104, 111, 134–36, 140–41, 177, 183–84, 194, 198–206, 210, 218, 221, 223, 233–35, 243, 246, 248–49, 254 (*see also* Elijah Harper; Tom Hill; Iroquois Confederacy; ironworkers/ high steel; Iroquois/Mohawk history and culture; Jay Treaty, Kahnawake; Kanesatake; Doug Kerr; Bruce Maracle; Kathleen Maracle/Markle; Mitchell Maracle; Susan Maracle; Robert Markle: boyhood, family; Meech Lake Accord; Oka; Six Nations Reserve; Tyendinaga Mohawk Territory; Woodland Cultural Centre); Ontario College of Art, 4, 24–25, 27–34, 36, 44–45, 97, 123, 156–57, 242, 254; physical appearance, 17, 29, 41, 95–96, 100–101, 139, 179, 236; pornography, 53, 62, 112, 115, 128; residences, 12–25, 47, 49, 67, 107–9; farmhouses: 120–21, 155–56; reviews of/responses to work, 61–65, 106–9, 127–28, 183–85, 188, 192, 203, 206–8, 221–23, 244, 247–48; sports, 4, 13, 19, 46, 68, 94–95, 99, 101, 144, 147, 235 (*see also* UIC Flyers); students/ teaching (*see* Art's Sake Inc.; Kathryn Bemrose; Laura Berman; Brunswick Tavern; Thomas Hendry; Rae Johnson; Jerri Johnson; New School of Art; Dawn and Beth Richardson; Scott Townson; Lorne Wagman; Sheryl Wanagas; Ronald Weihs; Ontario College of Art; University of Guelph); travel (*see* Ibiza; Paris); works (*see* Index of Works by RM)

Markle, Robert: friends/colleagues. *See* Kenny Baldwin; Patricia Beatty; Dennis Burton; Stephen Centner; Graham

Coughtry; Harvey Cowan; Jack Foster;
Richard Gorman; Telford Fenton;
Vera Frenkel; Peter Goddard; Ruth
and Edward Grogan; Arthur (Mickey)
Handy; Ray Hanson; Tom Hedley; Tom
Hill; Anna Hudson; Avrom Isaacs; Rae
Johnson; Jim Jones; Craig Kenny; Doug
Kerr; Harold Klunder; Nobuo Kubota;
Gordon Lightfoot; Kenny Lywood;
Murray McLauchlan; Tim Noonan;
Don Obe; Helen and Marty Poizner;
Diane Pugen; Gordon Rayner; John
Reeves; Michael Sarrazin; Michael
Snow; Peter Stollery; Otis Tamasauskas;
Scott Townson; Hana Trefelt; Andy
Wainwright; Patrick Watson; Stephen
Williams; Paul Young
Markle, Robert
—one-person shows: Geraldine Davis
Gallery, Toronto (1991), 244; Durham
Art Gallery, Durham, Ont. (1987,
2002), 204; Innuit Gallery, London,
Ont. (1985, 1988), 212; Isaacs Gallery,
Toronto (1963, 1972, 1979, 1980, 1982,
1985, 1987, 1988, 1991), 6–61, 123–28,
183–85, 190, 192, 207–9, 213–16, 244;
Leo Kamen Gallery, Toronto (1991,
1994, 1997), 244; McIntosh Gallery,
University of Western Ontario, London,
Ont. (1968), 107; Mohawk College,
Hamilton, Ont. (1982)—not discussed;
Moore Gallery, Hamilton, Ont. (1994),
244; Thunder Bay Art Gallery, Thunder
Bay, Ont. (1989), 206–8, 214, 220; Tom
Thomson Memorial Art Gallery, Owen
Sound, Ont. (1990)—not discussed;
Winchester Galleries, Victoria, B.C.
(2001), 245
Markle, Robert: works. See Index of Works
by RM
Markleangelo's, 187–88, 210, 234
Martin, David Stone, 36
Martin (Dean) and Lewis (Jerry), 22
Massey Hall (Toronto), 32, 89, 92–94
Matisse, Henri, 188, 225
Mays, John Bentley, 184–85, 188, 203
McCarthy, Pearl, 39

McKuen, Rod, 113
McLauchlan, Murray, 128–29, 242
McLean, Barbara, 241
McLuhan, Marshall, 156
McMaster University. See under university
Meech Lake Constitutional Accord, 11
Melody Mill, 32, 75
Mendes, Ross, 102
Metropolitan Toronto Convention Centre,
188, 194, 198–205. See also Index of
Works by RM: Installations and Murals
Michelangelo, 27, 152, 166
Milne, David, 37
Milroy, Sarah, 222, 247–48
Milton, John, 176
Mingus, Charles, 77, 146, 159
Mohawk College Art Gallery, 191–92
Monet, Claude, 164
Monk, Thelonious, 31, 75, 77
Moore, Henry, 86
Moore Gallery (Hamilton/Toronto),
244–45
Morris, Jerrold, 128; Jerrold Morris
International Gallery, 78
Morrisseau, Norval, 135, 198, 249
Mossman, Jim, 97
Moulin Rouge (film), 29, 173
Mount Forest (Ontario), 3, 23, 107,
119–20, 129–31, 142–43, 153, 169, 172,
186, 190, 199, 204–5, 209–11, 237, 239,
243–45
Mount Royal Hotel and Tavern, 3–5, 120–
21, 129–30, 133–34, 143, 155, 171, 175,
199, 212, 235. See also UIC Flyers
Mulligan, Gerry, 31
Munro, Alice, 144, 147
Murray, Joan, 48–49, 54
Museum of Modern Art (New York), 64,
86, 158

National Film Board of Canada, 121
National Gallery of Canada, 52, 66, 70,
189, 233, 249
Nelson, Willie, 129, 159
Newman, Barnett, 48, 148, 213, 252
Newman, Paul, 88
New School of Art, 59, 83, 97–103, 108,

111–13, 119–20, 122, 128, 130, 143, 155–56, 169, 251. *See also* Brunswick Tavern; Robert Markle: students/teaching

New York City, 28–29, 33–36, 44, 52, 57, 63–64, 77–78, 80, 86–87, 92, 109, 136, 148, 161–63

Niagara Street (Toronto), 171–72, 176–77, 181–85, 187, 189, 193–95, 206, 209. *See also* "Johanna"

Nisga'a Treaty (1996), 11

Noisy River, 238–39

Noonan, Tim ("Spider"), 121, 131, 133–34, 204, 210, 244. *See also* UIC Flyers

Normanhurst Community Centre (Hamilton), 16, 23

Northern Telecom Corporation, 157

Notre Dame Cathedral, 166

Nottawa (Ontario), 190

Oasis, the, 51–53. *See also* Peter Stollery

Obe, Don, 69–70, 72, 80, 83, 96, 145, 169. *See also* Robert Markle: Tom Hedley; Index of Works by RM

Ojibway, 11–12, 119

Oka crisis (Quebec), 12, 135

O'Keefe, John, 74

O'Keeffe, Georgia, 116

Ontario Arts Council, 143, 156, 171, 185, 216

Ontario College of Art (OCA), 25, 27–34, 36–37, 39, 41–47, 56, 58, 72, 98, 111, 123, 156–57, 233, 242, 254. *See also* Dennis Burton; Richard Gorman; Marlene Markle: OCA; Robert Markle: OCA

Ontario Court of Appeal, 65–66. *See also* Eros 65

Ontario Institute of Painters, 35

Ontario Provincial Police, 5, 206, 241

Owen, Don, 121–22, 142. *See also* Cowboy and Indian

Oxford University Press, 129

Painters 11, 34–37, 39, 78, 246. *See also* Tom Hodgson; Jock Macdonald; William Ronald; Harold Town

Palace Burlesque Theatre, 24–25, 56, 178

Paramount Tavern, 109, 159

Paris (France), 31, 33–34, 52, 153, 163–66, 169, 183. *See also* Robert Markle: travel

Park Gallery, 35, 37

Parker, Charlie, 24, 75, 146

Parker, Harley, 28, 44

Pavlychenko, Larisa, 24, 32, 46–47, 51, 93. *See also* Graham Coughtry

Peace Bridge (Fort Erie, Ontario), 21. *See also* ironworkers/high steel

Peltier, Leonard, 194

Peterson, Oscar, 250

petroglyphs, 194, 202–3, 205–7

Phillips, Nathan, 36

Picasso, Pablo, 27–28, 70, 151, 173, 189, 207–8, 220, 228

Pickett, Louise (Shuster), 46, 243

Pickett, Michael, 243

Pilot Tavern, 29, 31, 68–69, 75, 87–88, 90, 92, 95–96, 98, 104, 107–9, 112, 130, 133, 161, 241. *See also* Robert Markle: drinking

Podedworny, Carol, 207–8

Poizner, Helen and Marty, 46–47, 69

Pollock, Jackson, 35, 48, 139, 148, 150

Pompidou Centre (Paris), 166

Poor Alex Theatre, 99

Port Elgin (Ontario), 190

Prentice-Hall Limited, 93

Presley, Elvis, 94

Priceville Prints, 216–19, 236. *See also* Harold Klunder; Otis Tamasauskas; John Vainstein

Pugen, Diane, 12, 98–99, 102, 104–5, 156–57, 184, 203, 252

Purdie, James, 184

Purdy, Al, 38

Quebec Bridge disaster, 20. *See also* ironworkers/high steel

Queen Elizabeth II, 198, 204. *See also* Metropolitan Toronto Convention Centre

Rauschenberg, Robert, 189

Rayner, Gordon, 4, 29–30, 33–36, 39,

46, 53, 57, 59, 63, 68–79, 88, 97–101,
105, 109, 112, 120–22, 124, 130, 136,
156–58, 163–65, 169, 176, 189, 204,
211, 221, 226–28, 242, 249–50, 252

Read, Herbert, 116, 232

Reeves, John, 28, 30, 33, 63, 69, 78, 105,
109, 242

Refus global, 34, 38. *See also* Paul-Émile
Borduas

Reid, Bill, 135

Reid, Dennis, 48, 59, 124, 208, 245,
247–48

Rembrandt, 100, 136–43, 146, 150, 183,
251

Rensselaer Hotel (New York), 64

residential schools, 11, 14. *See also*
Kathleen Maracle/Markle

Reynolds, John McCombe, 107

Richardson, Beth, 78, 98–99, 177, 248,
251. *See also* Robert Markle: students/
teaching

Richardson, Dawn, 98–99, 101, 177, 248,
251. *See also* Robert Markle: students/
teaching

Richardson, Karen, 150

Rickaby, Peter, 64–66. *See also* Eros 65

Riopelle, Jean-Paul, 34

Rio Theatre (Hamilton), 22

Riverboat, 90

Roach, Max, 32

Rodin, Auguste, 173

Rolling Stone (magazine), 94

Rolling Stones, 109

Rollins, Sonny, 162–63, 228

Ronald, William, 34–38. *See also* Painters 11

Royal Canadian Academy of Art, 158

Royal Ontario Museum, 109

St. Cyr, Lily, 24, 56, 117, 178. *See also*
Robert Markle: artist model; dancers/
strippers

Sarah Lawrence College, 78. *See also*
Artists' Jazz Band

Sarrazin, Enid, 139

Sarrazin, Michael, 68, 70, 83, 87–89, 94,
110–11, 122, 130, 139–40, 150, 161–62,
176, 226–27, 234, 239, 242, 251–52

Saugeen River, 3, 5, 119, 121, 210, 235–36

Schaeffer, Carl, 28, 44

Schiele, Egon, 113, 150

Scott, Cynthia, 152

Scott, George C., 88

Scott, Gerald, 38

Segovia, Andrés, 43

Seven Years War, 10

Shahn, Ben, 36

Shannonville (Ontario), 7. *See also*
Tyendinaga

Shea, Red, 90

Shearer, Moira, 40

Shorter, Wayne, 111

Shuster, Jack and Esther (Calstein),
39–41. *See also* Marlene Markle: birth,
girlhood

Silcox, David, 75

Simcoe, John, 7. *See also* Six Nations
Reserve; Tyendinaga

Sime, John, 97, 99, 155–56. *See also* Dennis
Burton; New School of Art

Simpson's (Toronto), 37, 41

Sistine Chapel, 135, 188

Six Nations Reserve, 7, 10, 203, 233–34

Skudra, Gintz, 109

Skudra, Tom, 109

Snider, Norman, 158, 250

Snow, Michael, 36, 38, 49, 54, 63–64, 77,
79, 127, 148, 162–63, 198, 232, 246, 252

Solursh, Coleman, 46, 51

Spencer, Charles S., 70

Staats, Wellington (Chief), 203

Standard Theatre (Toronto), 244. *See also*
Victory Burlesque Theatre

Star Weekly, 150

Stayner (Ontario), 190

Steppenwolf (John Kay and the Sparrows),
90

Stockfish, John, 90

Stollery, Peter, 51, 67. *See also* the Oasis

Stone, Irving, 31

Stone, Marjorie, 221–23, 244, 247. *See
also* Robert Markle: gender issues/
feminism; shows

"Stop the Spadina Expressway," 53

Strasberg, Lee, 87

Streisand, Barbra, 94
Sulpicians, 10
Supreme Court of Canada, 64, 66
surrealism, 34
Sutherland, Donald, 31
Synowich, Peter, 150

Tamasauskas, Otis, 216–18. *See also*
 Priceville Prints
Tate Gallery (London), 71
This Hour Has Seven Days, 53, 67, 83, 218
Thomas, Dylan, 149, 213
Thompson, Hunter S., 96, 146, 151
Thomson, Hugh, 39
Thomson, Tom, 33, 85, 201, 212, 238, 250;
 Tom Thomson Gallery, 143
Thunder Bay Art Gallery, 207, 220, 224,
 226
Time (magazine), 53, 67, 128
Titian, 137
Tom Thomson Gallery, 143
Toronto Citizen, 127
Toronto City Council, 244
Toronto Life, 18, 55, 96, 144–45, 148–49,
 157, 159, 177, 235. *See also* Tom Hedley;
 Index of Works by RM: Writings
Toronto Maple Leafs, 68, 94
Toronto Parks and Recreation, 44
Toronto Police Morality Squad, 49. *See also*
 Eros 65
Toronto Star, 120, 127, 160, 194; *Star Weekly*,
 150
Toronto Telegram, 39, 65, 88, 106. *See also*
 Index of Works by RM: Writings
Toronto Telegram Showcase, 89–90, 94–96.
 See also Index of Works by RM: Writings
Toronto, University of. *See under* university
Toulouse-Lautrec, Henri de, 28–29, 145,
 217, 220
Town, Harold, 34, 36–37, 53, 66, 68. *See
 also* Painters 11
Town Tavern, 29
Townson, Scott, 150–60, 249, 251. *See also*
 Robert Markle: students/teaching
Trefelt, Hana, 28–29, 45, 59, 69–70, 72,
 79, 100–101, 103, 248, 251. *See also*
 Robert Markle: gender issues/feminism

Trudeau, Margaret, 187
Trudeau, Pierre, 35, 160–61, 250
Truffaut, François, 67
Tuileries (Paris), 166
Turf Tavern, 41
Tyendinaga Mohawk Territory, 7–10,
 12, 16, 134–35, 184, 194, 198. *See also*
 Robert Markle: Native issues/identity
Tyner, McCoy, 29

UIC Flyers, 4, 130–34, 144, 199, 204, 206,
 210, 212, 243, 251. *See also* Craig Kenny;
 Tim Noonan
United Artists, 90
university: of Calgary, 55, 194, 205;
 Guelph, 185–86 (*see also* Robert Markle:
 students/teaching); McMaster, 123; of
 Toronto, 34, 37, 41, 46, 83, 113, 129,
 216, 245; of Western Ontario, 106, 143,
 198

Vagabonds, 110
Vainstein, John, 216–18. *See also Priceville
 Prints*
van Gogh, Vincent, 31, 48
Vanguard Club (NYC), 162
Varley, Fred, 68. *See also* Group of Seven
Varvarande, Robert, 38
Vaughan Road Collegiate, 40–41, 46
Victoria Bridge (St. Lawrence River), 20.
 See also ironworkers/high steel
Victory Burlesque Theatre, 48–49, 55, 57,
 130, 178, 244. *See also* Robert Markle:
 artist/model; dancers/strippers
Vizenor, Gerald, 234
von Wagoner's Beach (Hamilton), 18

Wagman, Lorne, 99, 245. *See also* Robert
 Markle: students/teaching
Wainwright, Andy, 78, 112–13, 143, 165,
 243–44. *See also* Index of Works by RM:
 Drawings
Waits, Tom, 159
Walker, Jerry Jeff, 92
Wanagas, Sheryl, 99, 101, 169, 177, 251.
 See also Robert Markle: students/
 teaching

Ward Mallette Company (Mount Forest), 3, 172

Warhol, Andy, 78

Warrendale School, 53

Watson, Patrick, 53, 67, 68–70, 78, 83–84, 86, 95, 102, 106, 110, 120, 130, 137, 139, 140–43, 161, 163, 165, 166, 176, 203, 226–27, 234, 237, 239, 242, 249, 251

Wedlock, Diana, 119, 155

Weihs, Ronald, 101. *See also* Robert Markle: students/teaching

Weiler, Merike, 127

Western Ontario, University of. *See under* university

Wheat Sheaf Tavern, 129, 159–60

Wieland, Joyce, 39, 57, 63, 101, 143, 245–48. *See also* Anna Hudson

Williams, Stephen, 4, 45, 78, 84, 129–30, 134, 175–76, 190, 204, 206, 211–12, 235, 241, 243

Williams, Tennessee, 161

Wilson, Erica, 152

Wintario Lottery, 156

Withrow, William, 65

Woodbridge Advertiser, 190

Wood Gundy Inc., 156

Woodland Cultural Centre, 203, 233–34, 245, 254. *See also* Tom Hill; Six Nations Reserve

Wren, Christopher, 136

Young, Lester, 31, 77, 165, 228

Young, Paul, 28, 30–31, 34, 36–37, 44, 47, 97, 100, 102, 114, 183, 242, 248–49, 250

Zanzibar Tavern, 190

Zen Buddhism, 59, 77, 108 , 159, 249

INDEX OF WORKS BY ROBERT MARKLE

Note: Page numbers in italic type refer to pages on which images are reproduced.

DRAWINGS

Burlesque Series (1963), *50*, 59–61, 178
Drawings for Pale Blue Marlene (1968), 115, 178
Lovers I (1963), 64–65
Lovers II (1963), *60*, 64–65
Lovers III, IV, V (1963), 107
Marlene III (1964), 61
Marlene: Summer Bronze (1967), 115–16, *116*
Moving Outward (1970), 112–14, *114*
Paramour (1965), 61–64, 115, 178
The Requiem Journals (1976), 143

EMBROIDERY

Jean Jacket (1975), 152–54, *154*

INSTALLATIONS/MURALS

Ontario Government Services Building, Hamilton (1981), 188
Food and Drug Building, Scarborough, Ont. (1973), 136
Freiburger's supermarket (Mount Forest, Ont., 1986), 209–11, *211*
Health Sciences Centre, McMaster University, Hamilton (1973), 123
The Horned Serpent of Egremont (farmhouse yard, 1987), 204
Markleangelo's (Toronto, 1980), 186–88
Metropolitan Toronto Convention Centre (1984), 188, 194, 198–200, *200*, 201–3

City of Owen Sound, Ont. (1987), 205, 212–13

LITHOGRAPHS

The Kolbassa Kid at the London Forum (1987), 218
On the Runway (1965), 61–62, *62*
Table Dance (1987), 218
Table Dancer 2 (1987), 218
Untitled (1977), 152
Victory Series I–V (1976), 152

PAINTINGS

Acrobat Series I–VI (1970), 124
All I See in the Purple Night (1980), 182
Ancient Evenings I, II, III (1986), 215
Artist and Model Series (1985), 207–9
As I Remember I–IV (1971), 125
At the Angel's Edge (1980), 183
Back in the Spell (1980), 182
Beach Blonde (1972), 126
The Beguiling Assault (1981), *168*, 191–92, 252
The Brutal Night (1980), 183–84, *184*
A Brutal Truth (1986), 213
Class Act II (Buffalo) (1987), 213–14, *214*, 252
Conversation Series: Gordon Rayner (1988), 226–27, *227*, 228
Conversation Series: Graham Coughtry (1988), 226, 228
Conversation Series: Michael Sarrazin (1988), 226–27

Conversation Series: Patrick Watson (1988), 226–27

Country Twang (1989), *196*, 232–33, 239

Cushioned Corner (1984), 209

Dancing in the Gardens of the East (1984), 197

Dark Privacy (1971), 125

Deep Purple Privacy (1971), *125*

A Delicate Victory (1981), 190

Domesticity I (1988), *118*, 228–29

Domesticity II (1988), 228

Domesticity III (1989), 228

Eastern Leap (1971), 125

The Elemental Icon (1986), 213

Excuse Me, Madame Bonnard (1986), 213

Fields Faraway (1979), 180, 184

The Fine Line (1986), 214

Formal Flora (1984), 197

Glamour Glow (1980), 183–84

The Glamour Sisters (1982), 191–92, *192*

Go Home Lake sketchbook (circa 1968), 85–86

Good Friday (1972), 126

Hanover Hustle (1988), 225, 225–26

High Step (1971), 125

Hot Spell (1980), 183

Indian Blood (1979), *6*, 179, 181

The Japanese Screen Affords Secrecy … Even So, It Seems to Her That She Waits Forever (1979), 180, 184

Jazz Licks (1988), 224

Jazz Licks (1989), 224–25

Jazz Lover (1989), *82*, 225

Kawabata (1979), 180

A Likeness of Being (1989), 229, *230*

Lunging Figure I–VI (1971), 126

Magritte's Forest (1987), 215, *216*, 252

Marthe Again (1986), 213

Meadow Spotlight (1982), 190

Memories of Sexy Sadie (1979), 183

Newman Ornamental (1986), 213, 252

Ontario Shimmer (1972) , 126

Persephone (1988), 223–24

Pin-Up I–II (1971), 125

Powdery Tremble (1980), 245

The Remnants of Her Life (1979), 181

Roiling Clouds (1979), 180

Rooms: The Dish (1989), 229–30

Rooms: West Wall (1990), 231–32, *240*, 252

Second Story Strip I–IV (1971), 125

Set Peace (1984), 197

Some Classical Greenery (1984), 197, 209

Some Golden Soil (1984), 197, 209

Something Brewing series (1990), 237–39

The Sound of the Mountain (1979), 180–83, *182*

Speaking Easy (1980), 182

Stretch (1971), 125

Summer Burlesque I–VI (1971), 125

Summer Matinee (1972), 126

Sunpose I–III (1971), 126

Sunset Fire (1980), 182

Swift Fade (1979), 182

Teaser Façade 2 (1982), 191

This Fire Was Sent By Paris (1980), 183

Untitled Landscape (1956), *26*, 47–48

Untitled (Table Dancer) (1990), *2*, 233, 249

The Visit (1988), 223

Waterloo One-Step (1988), 223

White Way (1980), 184

Wilderness (1988), 223

Zanzibar Series: The Agile Lie (1981), 191

Zanzibar Series: California Carnal (1982), 191–92

Zanzibar Series: A Delicate Victory (1981), 190

Zanzibar Series: Glossy Bloom (1981), 191–92

Zanzibar Series: The Light Scrapes Her Away (1981), 190

Zanzibar Series: Parts of Memory (1982), 191

Zanzibar Series: Rosy Whispers (1981), 192

WHIRLIGIGS

Acrobat (1986), 220–21

Artist with Model and Mentors (1988), 221

Creation (1988), *220*, 221–22, 228, 245

Serpentine Art (1988), 221

Spadina Cut-out (1989), 222–23

WRITINGS

"The Aesthetics of the Drive-in Movie," Toronto Life (May 1977), 147–48

"Alternative Cuisine," Maclean's (March 1973), 144

"Blazing Figures," Exile, vol. 6, nos. 1 & 2 (1979), 177–79

"Chips with Everything," *Toronto Telegram Showcase* (November 19, 1966), 95, 144, 150

"De Kooning," *artscanada* (August 1969), 96

"Early Morning Afterthoughts," *Maclean's* (December 1971), 92–93

"Emerging" (Michael Sarrazin), *Toronto Telegram Showcase* (July 8, 1967), 89

"The Glory That Is Grease," *Canadian Magazine* (March 19, 1977), 145

"Golden Spike-Heeled Fascination Four Leg Moving … Why?" *Toronto Telegram Showcase* (March 11, 1967), 95–96, 113, 148, 150, 177

"Gordie Howe … Forever … Yes,Yes! And Then Some," *Toronto Telegram Showcase* (April 8, 1967), 94–95

"Gordon Rayner," *artscanada* (1969), 96

"Hooked," *Toronto Life* (April 1989), 235–37

"In the Heart of the Heart of Christmas," *Toronto Life* (December 1977), 18, 149–50

"Knowing Lightfoot," *Canadian Magazine* (April 16, 1977), 94

"Landscape," *Notes for a Native Land* (1969), 96–97

"Markle on Lightfoot," *Toronto Telegram Showcase* (January 7, 1967), 90–91

"The Moral Shape of Sexy Sadie," *Toronto Life* (October 1977), 55, 148, 177–79

"The Passionate Listener," *Toronto Life, Audio Guide* (Autumn 1976), 146

"Starring on My Own Bubble Gum Card," *Canadian Magazine* (January 17, 1976), 131–33

"Tim Hardin," *Toronto Telegram* (May 9, 1969), 5